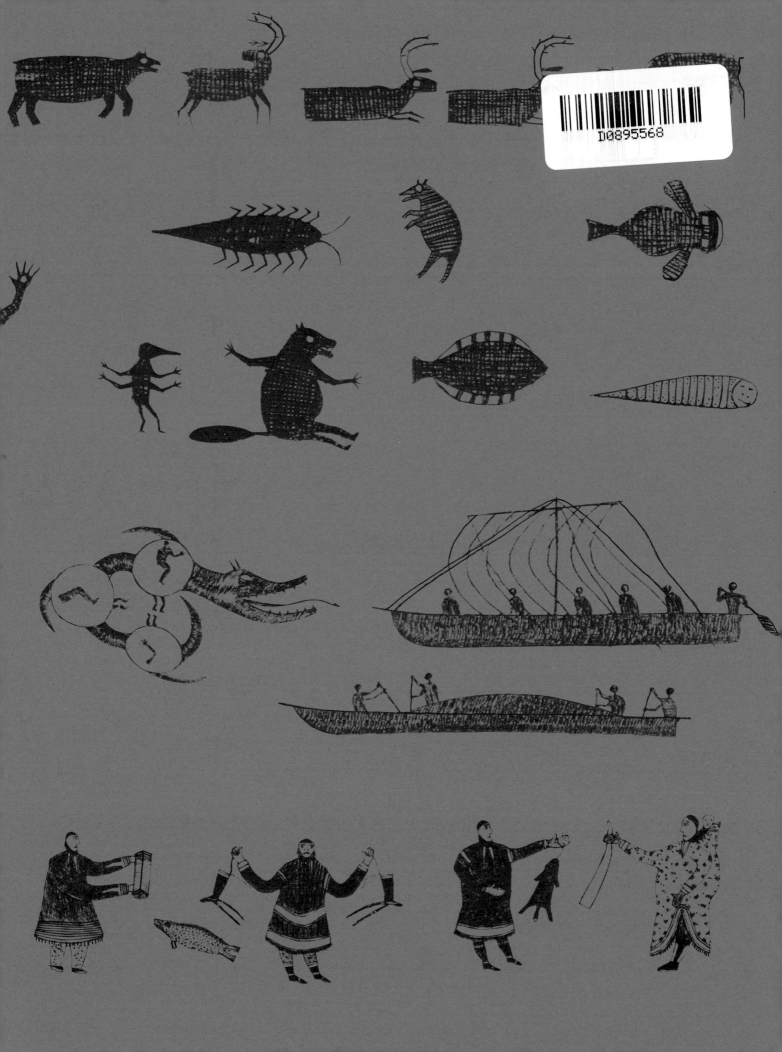

ART

in North Alaska

DOROTHY JEAN RAY

Eskimo Art: Tradition and Innovation in North Alaska was published in connection
with an exhibition shown at the Henry Art Gallery, University of Washington, April 21–
May 15, 1977, and is Number 11 in the Index of Art in the Pacific Northwest, published
for the Henry Art Gallery by the University of Washington Press.

Copyright © 1977 by Dorothy Jean Ray
Printed in the United States of America
Designed by Audrey Meyer

This project is supported by a grant from the National Endowment for the Arts
in Washington, D.C., a Federal agency.

All rights reserved. No part of this publication may be reproduced or transmitted in
any form or by any means, electronic or mechanical, including photocopy, recording,
or any information storage or retrieval system, without permission in writing from
the publisher.

Published in Canada 1977 by
J. J. Douglas Ltd.
1875 Welch Street
North Vancouver, Canada

Canadian Cataloguing in Publication Data

Ray, Dorothy Jean, 1919–
 Eskimo art

 Bibliography: p.
 Includes index.
 ISBN 0-88894-130-7

 1. Eskimos—Alaska—Art. I. Title.
E99.E7R39 709'.01'109798 C77-002047-X

Foreword

IN THIS volume, Dorothy Jean Ray tells a story that has been repeated in many cultures and places. It happens whenever a native people who have lived in isolation come under the influence of the outside world and find their culture, their ethos, eroding, changing underfoot like a melting floe.

Folk arts are never the same after they stop being made by a people for their own uses, including magic and ceremony. They die, to rise again transmuted, borrowing life from the marketplace. But the market rarely prizes that which is most peculiar to the vision of an exotic culture, asking the native artist to pretend to be someone else more familiar, less outlandish. Disoriented, the artists seem for a time in danger of becoming caricatures of themselves, wandering in some limbo between cultures, neither here nor there. The situation is full of pathos. At first some Eskimos, says Ray, "would not make souvenirs because they thought such activity would bring them into conflict with the spirits." But they could not long resist.

In this book we see the process in action clearly, step by step, and in this sense it is a classic account. Some will find it a sad story, realizing that when true folk arts die, we all lose something precious. But surely it would be most sensible for us to take our cue from Dorothy Ray, who is thoroughly unsentimental, wasting no tears over a past we cannot alter. Instead, she tells exactly where we may see fine collections of Eskimo art of the past in museums, and she speaks of young people who are "in the vanguard of the new Alaskan art." Have we learned anything? Let us welcome them. Let us be sensitive to their individual accents and encourage them to be themselves, to make art that is theirs alone. If they have this daring, they may be certain that the spirits will never object.

RICHARD GROVE
Director, Henry Art Gallery

v

Preface

ALTHOUGH THE Vikings had known Greenland Eskimos as early as A.D. 1000, and Martin Frobisher and John Davis had seen Eskimos of other Atlantic areas in the 1570s and 1580s, the world did not learn about the northern Alaskan Eskimos until the 1700s, when English and Russian explorers began expanding their trade routes. The men of Captain James Cook's expedition in 1778 were the first to observe directly the people of northwest Alaska, but their journals and publications rarely mention any Eskimo handiwork at their three landings—on Sledge Island; near present-day Elim; and at Cape Denbigh on "Chaktoole" Bay. With the exception of a sled of "admirable" construction on Sledge Island,[1] they described very few of the Eskimos' handicrafts. Their only other observations were brief mentions of houses, "canoes," and clothing (some jackets were described as being "made with a good deal of Taste"), and reports that they used birchbark pails, bows and arrows, and "a kind of drum."

In 1791 the Russian expedition of Joseph Billings gave us the first record of the varied arts of Eskimos living north of the Aleutian Islands. Members of the expedition landed at Cape Rodney, about forty miles northwest of present-day Nome, after having sailed across the Bering Strait from Siberia, and were led to a sealskin tent a few miles away on the beach by several Eskimo men. Carl H. Merck, the expedition's naturalist, reported that a plank frame around the tent's smokehole was decorated with ivory chains and carvings of fish and sea mammals. He also saw a wooden hat, which had three vertical rows of walrus heads on the front and a fish on each side, all made of ivory, probably similar to the one in figure 7a. Personal ornamentation was much in evidence. Men wore labrets (plugs inserted into the flesh below the mouth), and women had tattoos of straight lines on their chins and circular ones on their arms. They wore a variety of well-made clothing; their short boots were made of beautiful white leather embroidered with colored hair and sinews. They had pots made of clay and bowls, buckets, and spoons of wood. They eagerly traded these objects, as well as "trifles" made of "walrus teeth" and "vests" of caribou fawn and rabbit skins.

1. The historical reconstruction in the preface is from Ray 1975, where it is discussed in detail.

From Otto von Kotzebue's voyage in 1816 we have the first published examples of Alaskan Eskimo art. Ludovik Choris, artist of the expedition, illustrated his own account of the journey with a number of sketches (see figs. 1–3). The engraved drill bows in figure 2 were probably collected near Cape Deceit, east of Cape Espenberg on the northern coast of Seward Peninsula, where, according to Kotzebue's account, the Eskimos brought them "all sorts of objects sculptured from walrus teeth, and pieces of these teeth on which they had drawn designs."

Reports of the next voyages to the coast of western Alaska in the 1820s did not mention any handicrafts except clothing which the crews admired, and everyday household utensils and hunting implements. In 1820 two Russian sloops, the *Good Intent* (*Blagonamerennyi*) and the *Discovery* (*Otkrytie*), under the commands of Mikhail N. Vasiliev and Gleb S. Shishmarev, spent several days at Kotzebue Sound and Eschscholtz Bay, where they visited a large encampment of Buckland River people. In 1821 and 1822 Vasilii S. Khromchenko sailed in the *Golovnin* as far north as Golovnin Bay. One of the interesting observations of the Buckland people, made by Karl K. Hillsen, was that the women not only had tattooed dark blue lines on their chins but also had painted circular lines above and below their eyes, joined with a blue line across the nose.

Frederick William Beechey, who wrote the first comparative account of the eastern and western "Esquimaux" in the two-volume narrative of his journey in 1826–27, traded blue beads, cutlery, tobacco, and buttons for "skins, fish, fishing implements, and nic-nacs," among which was a "walrus tooth shaped something like a shoehorn [an object used for taking blood from dying animals]" engraved with "a variety of figures of men, beasts, and birds, &c. with a truth and character which showed the art to be common among them." Beechey collected these "nic-nacs" at Kotzebue Sound. He also collected a number of drill bows, eight of which are now in the Pitt Rivers Museum at Oxford University. Their engraving style and subject matter are surprisingly similar to those collected fifty years later by Edward William Nelson, Signal Corps officer at Saint Michael. Beechey's collection of artifacts was the last one made before the first permanent nonnative settlement, Saint Michael, was established in northwest Alaska in 1833, after which a greater flow of European ideas began substantially altering Eskimo material culture.

Crews of the various vessels searching for Sir John Franklin in the Bering Strait area between 1848 and 1854 noticed this European influence. In 1849 Commander T. E. L. Moore of the *Plover* said that the Buckland people, with whom both Shishmarev and Beechey had had great troubles, appeared to be friendly and helpful. The difference in their conduct was attributed to their having traded with the Saint Michael post for sixteen years, obtaining many kinds of European goods, including handkerchiefs "of gaudy colours, cotton printed with walrus, reindeer, and all the other animals that they are in the habit of catching and representing in ivory." This expedition collected one of the first known examples of engraved ivory with the white man as subject matter (fig. 238).

It is difficult to ascertain how much of "traditional" designs and objects of exploring days was indebted to outside sources before 1833. Eskimo crafts at the beginning of the historical era were already the totality of many generations' experience based on local heritage and innovations, as well as on ideas borrowed from neighboring tribes in Alaska and Siberia. A market-type of art had probably been stimulated by the very first foreign ships the Eskimos saw; and trade in European goods

from Siberian traders across the strait had undoubtedly altered their handicrafts since the early eighteenth century.

Before the 1880s the most common proveniences attached to artifacts were "Norton Sound," "Kotzebue Sound," and "Port Clarence." These bodies of water were officially discovered by Europeans in 1778, 1816, and 1827, respectively, and were the most commonly used anchorages for sailing vessels in northwestern Alaska. These proveniences may seem to be specific enough within the huge expanse of Eskimo territory stretching from Siberia to Greenland, but each one included many miles of coastline inhabited by tribes speaking several different dialects (at Norton Sound there were two separate Eskimo languages) and having different styles of art.

In historical usage, "Norton Sound" included the coastline from Nome to Pastol Bay; and "Kotzebue Sound" embraced both Cape Espenberg, with its definite relationship to Seward Peninsula, and Cape Krusenstern, with its alliance to tribes to the north. People from as far away as Cape Prince of Wales and Siberia also journeyed to the Kotzebue trade market during the nineteenth century, and thus many objects were obviously purchased from people who were not residents of the area. "Saint Michael" is also a comparatively indefinite label, not only because native traders sold their goods there but also because styles hybridized after 1833. Even so, these proveniences are more useful than ones reading merely "Alaska" or "Eskimo."

Not until a U.S. Signal Service Station was established at Saint Michael in 1874 and the International Polar Expedition had begun work at Point Barrow in 1881 was definite provenience provided for the majority of objects collected in northwest Alaska. The painstaking work of E. W. Nelson, who was commissioned to collect for the Smithsonian Institution while serving as a Signal Corps officer at Saint Michael, provided information permitting positive identification of other unlabeled, but similar, objects. During his employment, from 17 June 1877 to the end of June 1881, Nelson traveled to various villages, including a trip in 1881 aboard the revenue steamer *Corwin* to northern Alaska, where he collected objects at ports of call. The bulk of his collection was illustrated by him in *The Eskimo about Bering Strait* and by Walter James Hoffman in "The Graphic Art of the Eskimos."

By Nelson's time many of the collected objects were inspired by ideas from the Alaska Commercial Company and other traders. Although Nelson learned in 1881 that some of the people, especially King Islanders, were saving, and perhaps making, objects for him, members of the Western Union Telegraph Expedition at Port Clarence fifteen years earlier found that Eskimos would not make souvenirs because they thought that such activity would bring them into conflict with the spirits.

The Saint Michael souvenir trade was well established during Nelson's stay, and we know from the words of a journalist, Herbert L. Aldrich, that it was also fully accepted at Port Clarence and other places along the coast at that same time. As yet there was no permanent European settlement at Port Clarence, but more than thirty ships anchored every year about 4 July to get provisions and mail from the supply ship for the whaling fleet, and coal from a stockpile that had been established in 1884. Eskimos went out every day to the ships in their skin boats when the vessels were at anchor. Aldrich, who sailed with the fleet in 1887, said that the young men sold "fancy carved ivory pipes" and the girls and women made "little [skin] bags decorated with fancy needlework . . . to trade with the ships." The new ma-

terials brought by trade had already become a part of Eskimo crafts, which thereafter were a blending of non-Eskimo materials and ideas with traditional subjects and forms.

This study brings together information gathered during several anthropological field sessions in Alaska between 1950 and 1974 and extensive investigations of many private and public collections of Eskimo art. Observations made when I lived in Alaska before 1950 have also been invaluable. It covers a larger geographical area and wider use of materials used by the artisans than *Artists of the Tundra and the Sea,* which was a study of the contemporary attitudes and products of the Bering Strait ivory carver from my field work of 1955. The present treatment includes all of northwest Alaska and objects made in all media. Many persons have contributed information and help for this work, and they are acknowledged at the end of the book; but at this point I want to express my gratitude for the nonnative custom of collecting for collecting's sake. Without the white man's compulsive dedication to buying, trading, swapping, and coveting things that he would not use in the ordinary sense, but instead would display, admire, and look at in a decidedly un-Eskimo fashion, most of the objects now resting in both public museums and private collections would not have been saved for future generations—Eskimo and non-Eskimo alike—and this study could not have been made.

Objects have been chosen principally to illustrate textual discussions of historical and esthetic developments and cultural changes, and only incidentally because they are the work of a particular artist. This is not a listing of individual craftsmen, and the works of many talented artists are necessarily omitted. Each year, with increasing interest in the arts, and continued sources of funding for study and support while producing their works, many more competent craftsmen emerge.

The illustrations are placed according to both chronological time and materials used. For the most part, the first sixty-nine illustrations are objects that were made before 1900, but numerous others of the nineteenth century are illustrated under subsequent numbers. Others overlap in time, but dating and other aspects are explained in the main text or under the descriptions of the objects.

Contents

Tradition and Innovation

1 Discovering Eskimo Art

DURING HISTORICAL times there were no Eskimo peoples who did not attempt to decorate tools and utensils or to shape sculpture; but the degree of absorption in the making of objects, the technical and imaginative excellence, and the total production varied from group to group. The subject of Eskimo arts covers a broad geographical area (from Siberia to the east coast of Greenland) and a long time span (an almost unbroken involvement in art for two thousand years). Consequently, there was a wide variety of forms, styles, and materials. Ways of life and natural resources differed from one geographical area to another and even between neighboring villages. The Siberian Eskimos lived more than three thousand miles from the Greenlanders, and the Point Barrow Eskimos lived almost eight hundred miles from those who formerly lived at Prince William Sound. Some, like the Kobuk people, lived in wooded areas; others, like the King Islanders, lived in rocky places where only tiny bushes grow. Materials used in the arts resulted to some extent from their resources; but the form, and sometimes a preference for a particular medium, developed from cultural heritage, innovation, and borrowing.

The resulting styles, and the names applied to each, especially in the prehistoric eras, not only connote distinctive art styles but serve as identification of provenience and culture: for instance, Okvik and Old Bering Sea of Saint Lawrence Island and Siberia; Ipiutak and Birnirk of western Alaska; and Dorset of the central Canadian Arctic. All of these periods fall roughly in the first millennium of our era. The Thule culture, which developed from Birnirk, spread from Alaska throughout the north after A.D. 1000 and subsequently gave rise to the cultures with which most Europeans became acquainted during the eighteenth and nineteenth centuries. The Eskimos whom Martin Frobisher saw in 1576 and 1577, however, were undoubtedly Thule people, and Erik the Red had probably encountered Dorset people in southwest Greenland in A.D. 1000 (Taylor and Swinton 1967, p. 36).

This study covers a time span of two hundred years, from the first meeting of the Alaskan Eskimos with Europeans in 1778 to the mid-1970s.[1] In other words, it deals

1. The only "prehistoric" objects included in this book are several wood and baleen Birnirk figurines, which are used to illustrate various historical practices (figs. 10, 29a, 29b, 50). Some of the ivory sculptures in figures 33–35 and 44–47 may have been dug up by Eskimos to sell to E. W. Nelson during the years 1877–81; but if so, they had come from fairly recent sites.

3

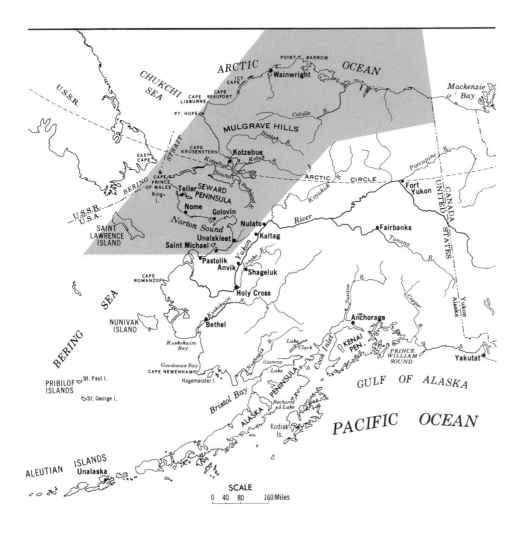

Region of Northern Alaskan Eskimo Art

with the art of recorded history. Although the study describes and analyzes the arts that grew out of the Birnirk–Thule tradition north of Saint Michael, Saint Lawrence Island is included (despite its linguistic and cultural relationships to Siberia) because of its Birnirk and Thule antecedents and a nineteenth-century tradition in art similar to the Alaskan mainland and its adjacent islands. (Many Siberian Eskimo and Chukchi handicrafts, derived from a common heritage and cultural exchange across the Bering Strait, were almost indistinguishable from those of northern Alaska.) The history of Saint Lawrence Island's participation in the later market art was also closely related to northern Alaska, mostly as a consequence of nonnative trading patterns and routes, and the emergence of Nome as an economic center for a large area.

Many of the early European explorers viewed the unique Eskimo way of life with both repugnance and admiration, yet they agreed that the Eskimos were super-survivors existing in a bleak and inhospitable environment. Streams of printer's ink have flowed to describe the wonders of the Eskimos' physical and psychological

adaptation to a land that seemed to offer few resources other than subarctic plants, and animals that lived mainly in the water.

But the Eskimos used the animals in an incredible variety of ways. They lived within, around, beneath, and on the animals they caught, which provided their warmth, protection, sustenance, and materials for art: the hide and other pliable parts became tents, boats, shoes, storage containers, raincoats, parkas, rope, and drumheads; the sinews, their thread; the oil, their light, heat, and condiments; the meat, their food; and the bone and teeth, their tools, utensils, and sculptured and engraved objects. But even more, a large part of their religion and concept of art was derived from the need to pursue and capture the animals they used so imaginatively merely to survive. (In Alaska the only nonliving substance that the Eskimos used regularly was driftwood, which washed up log by log onto many beaches from the forests of southern Alaska and a few streams around Norton Sound.)

To Europeans, the beauty that the Eskimos wrought from unusual resources was as much of a surprise as their ability to live in such a precarious and unpredictable land. The seal, the walrus, the caribou, and the whale, which came and went with the seasons or with the weather, sometimes failed the people altogether. The Eskimos, who were always faced with this uncertainty, had devised a workable relationship between their anxieties and an effort to exert some human authority over the unknown forces that controlled the weather, the seasons, and the animals' movements. This they did in two ways: by prohibiting certain activities during important hunting times; and by bringing the spirits—which they thought controlled the forces—into their own world. Although every Eskimo had some firsthand acquaintance with spirits, the only person who could satisfactorily communicate with them or interpret their actions was the shaman or medicine man (angutkuk). He was also able to visit the spirits in their own world on the moon or at the bottom of the sea through his psychic powers.

The spirit of a game animal could also enter the realm of human beings by means of its human guise, which permitted a very special relationship between the pursued and the pursuer. In this relationship, the shaman negotiated with the spirit (actually the generic spirit of all animals of that species) for continuing abundance in return for special observances and homage. Such pacts were made visible to the general public in various ceremonials in which the spirits were treated with great honor and for whom special ivory and wooden sculptures, including masks, were made as beautifully as possible. Many shamanistic objects were made of wood and burned at the end of a ceremony. Thus the materials used and the secrecy and deception, which were usually required for the anticipated effects, were directly related.

During early historical times Eskimo art was often identified exclusively with ivory objects, partly because of the rare and unusual qualities of walrus ivory and partly because many objects were collected from places where this material was used most, or had been best preserved. Nevertheless, wood was a widely used material in Alaska, not only for ceremonial figures and masks but for dwellings, tables, benches, racks and frames of all kinds, boats, sleds, buckets, spoons, ladles, handles for tools and utensils, eyeshades, and drums. In 1778 the first object to be described in accounts about Alaska north of the Aleutian Islands was a wooden sled, whose admirable workmanship prompted James Cook to commemorate the place where it was found as Sledge Island.

When archeological excavations were begun in Alaska in the 1920s and 1930s,

the impression that ivory was of greater importance to the Eskimos than wood for artistic uses was partly substantiated because of the preponderance of ivory; yet sites more than a thousand years old contained some well-preserved wood. We do not know why the prehistoric Eskimo might have preferred ivory over wood—if indeed he did—but during the nineteenth century the people were using spruce driftwood in abundance for sculpture of considerable artistic merit. If little wood is found in old sites, it is because of cultural preference or preservation in the site, not lack of tools for working: the Eskimos have used metal blades for more than two thousand years, presumably employing the same ones for wood and ivory, as does the twentieth-century carver. Some writers have contended that the Eskimos used stone tools until well into the nineteenth century, yet none of "the famous carved ivories from the Old Bering Sea Style, Ipiutak, Punuk, and other old cultures of the [Bering] Strait [two thousand years ago]" was made with stone tools; they showed "distinctive marks of steel cutting edges. These cutting edges were hook-shaped burins, adze blades with extremely acute edge-angles, crooked knives, and perfectly cylindrical drill-bits. None of the distinctive tool marks could have been made by stone" (Witthoft and Eyman 1969, p. 20).

A few of the old metal blades have been found. "Chemical analyses have demonstrated that these cutting edges were carburized furnace steels, not meteorite, native iron, or soft iron. They were the product of Siberian or Chinese metallurgical centers. Typologically, these ancient tool edges are like the steel edges of nineteenth century Eskimo tools" (ibid.). Almost all archeologists who have excavated the oldest cultures on the western Alaska–eastern Siberian coast have found either indirect or direct evidence of the use of metal during the first millennium, yet it is probable that corrosion has done away with the majority of metal blades (McCartney and Mack 1973, pp. 338–39; Chard 1960).

Most ivory objects come from the narrowest part of the Bering Strait, where the walrus migrated within range of hunting; but the people of this area also made sculpture of wood. In northern Alaska the shamans of Point Hope were the great artists of wooden objects in the nineteenth century, although they had less wood than Eskimos of Norton Sound, where driftwood was especially abundant but where comparatively fewer wooden objects were made. Wood was apparently a conscious choice in other areas, too, because some northern groups used cured heads of the wolf, fox, and birds for ceremonial use while other groups, who had less wood, carved wooden masks.

In the historic and prehistoric time immediately prior to European arrival in Alaska, there were three general Eskimo culture and art areas: (1) the Gulf of Alaska; (2) the "southwest," from the Aleutians north to the Stebbins–Saint Michael area, including Nunivak Island; and (3) the "northwest," north of Saint Michael to the Mackenzie River. (The Aleut, who are close relatives of the Eskimos, constitute a fourth area on the west coast of Alaska.) In this general division there were many village and tribal variants. Certain motifs, styles, and forms were exclusively characteristic of each area. This is especially true of masks, which, though collected without record of provenience, can usually be attributed to a specific area, or even a village.

The dividing line at Saint Michael between the northwest and southwest areas roughly indicated the boundary between the Inupiak- and Yupik-speaking Es-

kimos.[2] Objects made during historical times in the Yupik-speaking Saint Michael area combined northwest and southwest styles. The fusion of styles in the Saint Michael area resulted from actual movements of people. First, toward the end of the eighteenth century, Eskimo traders and caribou hunters (called Malemiut) came from the Seward Peninsula and the Kobuk River; and second, after Saint Michael was founded by the Russians in 1833, Sledge and King Island traders made regular trips to the south. Northerners who lived in Saint Michael were the principal craftsmen for the souvenir arts (which I hereafter will call "market art") fostered by the Alaska Commercial Company after the United States purchased Alaska in 1867.

Of all Eskimo areas, northwest Alaska has uninterruptedly produced the most varied and largest quantity of arts in both traditional and market art categories. Each area had its traditional and market specialities, but none could match the industrylike aspects of dozens, and even hundreds, of persons turning out thousands of objects at the gold rush centers of Saint Michael and Nome around the turn of the century. Earlier, in the 1880s and 1890s, crews of whaling and trading vessels had bought souvenirs, but their visits to the Eskimos living north of Saint Michael were much more frequent than to those living south of there.

The term "traditional arts" includes works of sculpture and decorated items made for the Eskimos' own use. "Market art" is generally made for nonnative consumers. Almost two hundred years have elapsed since Captain Cook saw the coast of northwest Alaska, and for half that time the Eskimos have been producing nontraditional objects for the market. But the market art of the 1970s has diverged as widely in form, style, and subject matter from that of the mid-nineteenth century as the new forms of market art had departed from the old traditions.

In traditional art, the work of different craftsmen was recognized individually despite the anonymous character of the art to an outsider. No objects were signed in preliterate days, of course, but beginning in the 1890s a few carvers were asked to scratch their names on their engraved ivory pieces (but not their works of sculpture). Signatures were generally uncommon, however, until several Eskimos began to use the flat surfaces of paper and reindeer skins in the 1930s and 1940s, and by the 1970s collectors wanted the identity of the artist permanently affixed to all objects made in traditional media—ivory, stone, wood, and baleen—as well as on paper and skin.

One of the characteristics of Eskimo art is the variety of forms produced at one place and at one time over the centuries. The illustrations in this book serve only as a sampling of the wide range of objects made during the historical period, but the resulting impression is surely that there was no end to what an Eskimo person could make. The most dramatic examples in recent times are the graphics and works of soapstone sculpture produced by the Canadian Eskimos since 1949.

By the mid-1970s the arts and crafts were not flagging. Possibly fifteen hundred Alaskan Eskimo men and women were active producers in a total population of about twenty-six thousand adults and children; but the character of the arts and production methods were changing rapidly, and participation was on a broader geographic basis than before. For example, the city of Bethel on the Kuskokwim

2. At first European contact, the dividing line was at Golovnin Bay, about eighty miles north of Saint Michael. The people of Prince William Sound and Nunivak Island spoke Cux, another variant of Eskimo speech. See Oswalt 1967 (pp. 2–9) for Alaskan tribal résumé.

River, once a small village with relatively little artistic output, grew to a population of almost thirty-five hundred in 1974 and now serves as a center for handicrafts from the nearby river communities and as the home of many craftsmen. Eskimos have also moved from their western Alaskan villages to Anchorage and Fairbanks, where they pursue their work in the arts.

II Traditional Art

THE OUTPUT of Alaskan arts has not only been prodigious and varied from earliest times, but most of the objects were well conceived and executed. Women sewed delicate, almost paper-thin designs of fur and fish skin in parallel insets on parkas and mukluks (see figs. 194, 259), and men carved animal figurines with attention to the smallest details of anatomy. Even the tiniest animals, like the seal only .75 centimeter long in the bear's mouth in figures 35 (lower left) and 36, had eyes, nostrils, and ear holes carefully inlaid with old ivory or baleen. (Curiously, such attention was usually not paid to human figurines.)

Ivory and wood carving was man's work and sewing was for the woman, although a woman could make a wooden ladle, bowl, or special pattern-cutting tool if she had to. Women were also shamans, but did not make their own masks. Once, on King Island, a woman shaman instructed a man to make a mask (one called *yeyehuk,* fig. 65, right), which she had seen as an image in a cumulus cloud.

We, from another culture (and this includes the Eskimos of today), always search for meanings in the old sculptures, especially since we know that most of them were made during the Eskimo's own attempt to understand his world. The majority of objects, however, were collected without knowing what they meant or how they were used because such information was withheld from the outsider. A shaman usually took the meaning of a mask to the grave with him, so a conscientious man like E. W. Nelson was able to get only a small amount of information about masks and many other religious and ceremonial artifacts in his collection. The language barrier was also a handicap. Consequently, interpretations about traditional objects are necessarily limited to the collectors' information and some additional data later obtained through anthropological field work, although the Eskimos of the mid-twentieth century know relatively little about the carvings made one hundred or one hundred fifty years before in a vastly different Eskimo culture. But despite our ignorance of their original reasons for existence, these objects cross cultural boundaries as fine works of craftsmanship or art. Not all objects were made for religious, magical, or ceremonial purposes, and each man and woman apparently strove for an ultimate goal of perfection and enjoyment in

9

designing and shaping commonplace objects like clothing, tools, and utensils, and in engraving pictures on drill bows and bag handles.

The items made and collected during the historical period fall into the following categories: masks; sculptured objects of wood and ivory; wood and ivory implements and weapons; miscellaneous wood objects like containers and paddles; engraved ivory, especially two-dimensional scenes; skin and fur products; and various pieces made of stone and bone. Sometimes an object was both a sculpture and utilitarian object, such as toggles (figs. 5, 35–38), needlecases (figs. 6, 40), handles, boat hooks, flint flakers, and net gauges (figs. 5, 6, 19, 20, 29a, 29b, 30, 35, 40), harpoon rests (figs. 15, 16), net sinkers (fig. 25), arrowshaft straighteners (figs. 27, 232), net floats (fig. 39), fishing lures (fig. 41), and spear point boxes (fig. 18). Objects like hats, drill bows, oar rests, arrowshaft straighteners, paddles, and dancing gorgets were used as media for engraving, painting, or the attachment of small sculptures (figs. 1, 2, 3, 6, 7a, 7b, 12, 15, 27, 231, 235–39).

During the historical period of northwest Alaska, the production and artistic quality of both wood and ivory sculptures were greatest in the Bering Strait area of Seward Peninsula and adjacent islands, and at Point Hope. A large part of many collections consists of animal and human figurines, which were made as amulets, shaman's figurines, or toys. It is not easy to differentiate between toys and those objects used in religious and magical practices; but in general most of the human figurines made of ivory were dolls and those of wood were charms and fetishes. Eskimo fathers, furthermore, made many dolls for their little girls, who dressed them in tiny jackets and pants made of bleached skins and rodent furs, and decorated them with hair and beads (figs. 44–47). On Saint Lawrence Island there have been found numerous ancient headless dolls, which had been broken at a special site after the death of a child. This practice was still common during the late 1920s.

If a human figurine does not have holes for fastening, suspending, or "feeding," it is generally a toy; but there are exceptions, like the seated figurines from Little Diomede Island (fig. 49) and the blocklike ivory dolls from Saint Lawrence Island, which were ceremonial objects apparently made for flat surfaces. One of the Little Diomede figures has a shallow hole in the neck.

Toggles and handles in animal and bird shapes also have holes, but these are for fastening to buckets or bags — not for feeding or hanging. Yet many of them did have certain magical qualities, especially when used in connection with whaling or special hunting festivities.

Objects dating from the eighteenth and nineteenth centuries were usually in use when collected. Comparatively few have been scientifically excavated from sites of that time, although some had been dug up from abandoned villages, which the Eskimos had been raiding for objects to sell since early whaling and trading days. At places like Port Clarence, Nome, and Point Barrow, the looting was systematically undertaken. When the whalebone business declined at Point Barrow, Charles D. Brower, the well-known trader, hired many Eskimos "to help excavate the old mounds in this vicinity," and one summer Vilhjalmur Stefansson, the arctic explorer, was able to buy twenty thousand pieces excavated in this manner by the Eskimos (Brower 1942, pp. 243, 244).

William B. Van Valin, a former Alaskan teacher, made a collection for the University of Pennsylvania in 1917 and 1918. "In Nome," he said,

I found that I had four strong competitors: Mr. Blackwell; Joseph Chilberg; Dr. Neuman, United States Bureau of Education contract doctor (who was writing a history of the Eskimo Stone Age and who has made a large archaeological collection); and Mr. Shields, Superintendent of the Bureau of Education, Northwest Alaska Division. It looked as though I would have to dig my own antiquities, because my rivals had already engaged all the natives available for that type of work. But as I felt that there would always be antiquities to be found, if I put forth the effort, I was not greatly discouraged. [1944, p. 130]

Despite the enactment of the Antiquities Act of 1906, which prohibits digging without a permit on federal lands, and similar state laws, some Eskimos continue this unscientific raiding; at the same time, however, they discourage scientifically trained archeologists from working on their village and regional lands acquired after settlement of the Alaska Native Claims Settlement Act in December 1971.

WOODEN OBJECTS

Wood was the major material for shamanistic use and ceremonial performances. It was light in weight and lent itself to wearing; it was a substance that could be destroyed, a quality that was important for many ceremonies; and it was a medium that permitted a wide latitude of artistic expression. The principal objects used in ceremonial performances were masks and sculptures of human beings, animals, birds, and boats. The making of these objects was concentrated for the most part in the larger villages that had developed because of exceptionally good hunting. There various ceremonial practices evolved relating to the animals hunted, and a large and appreciative audience was assured for the complex and skillfully integrated performing arts of dancing, story-telling, and puppetry with the carving and painting of art objects—all ingredients of ceremonial festivities from Barrow to the Gulf of Alaska.

Large statues of wood were rarely made north of the Yukon, although masks and carvings of birds and animals were sometimes placed on boards or poles near a tent, house, grave, or caribou corral.

Masks

One of the ways in which the shaman organized his experience for use in the ceremonials that brought man, spirits, and subsistence animals together was in the making of masks. Almost every inanimate object and living entity had a spirit, which could be used by any Eskimo as a tutelary, or helping spirit. Many masks were entirely, or partly, a representation of a shaman's tutelary—usually an animal or bird. Eskimos living in the Yupik-speaking area south of Nome carved its *inua,* or human aspect, in low relief as a human face. Eskimos north of Nome usually depicted an animal and its humanness as a whole being in both masks and figurines used as shamans' charms. The human and animal aspects were one, so perhaps many old masks are not always recognized as spirit masks today.

Although northern masks were less elaborate than those from the southwest, the shamans of both areas created and used them under similar circumstances. Many were visual reports of their dreams or journeys to the spirit world. Because of the

unique origin of each mask, no two should have been alike; but since the artist worked within current styles, and ceremonies were repeated year after year, similarities existed. Toward the end of the nineteenth century, duplicates were made for sale.

Masks were used mainly in dances, but the shaman also wore them while working his power for good hunting, weather, and health. An ordinary man could have a mask, which was usually placed on his grave after death, and certain masklike images with stone or ivory eyes were used in hunting ceremonies. In the 1890s Sheldon Jackson, Presbyterian missionary and the first general agent of education for Alaska, found the graveyard at Point Hope a most fruitful collecting spot for masks now in the Sheldon Jackson Museum, Sitka. The masks collected by E. W. Nelson from the Yukon and Kuskokwim areas were used for shamanistic and ceremonial performances.

Hundreds of masks have been collected from northwest Alaska, mostly from Point Hope, King Island, and Saint Michael, but also from Point Barrow, Little Diomede Island, Port Clarence, and Unalakleet. There are considerable stylistic differences between masks from Point Hope and the Bering Strait area (for examples from Point Hope, see figs. 22a, 22b, 24, 68, 69; for Bering Strait, including King Island, see figs. 6, 62–67; the Port Clarence mask in fig. 6 resembles the Point Hope style). Many Point Hope masks were used in whaling ceremonies. The masks in figures 22a and 22b, for example, represent whale spirits, the whale's tail forming the nose in the former and the whale's huge mouth forming the lower half of the face in the latter. The one with the tail-nose also has the whale's mouth and blowholes carved on its chin. The mask in figure 24 from the Field Museum might be one that Knud Rasmussen, explorer and ethnologist, called "Amêko," which "has a seal in his mouth, showing that he has command of the game" (1952, p. 133). The anthropologist James W. VanStone showed this photograph to various Point Hope men: one thought that a whale's head was protruding from the mouth; another stated that the figure was a seal (VanStone 1968/69, p. 836). Jimmy Killigivuk from Point Hope identified a similar mask in the Washington State Museum also as one with an emerging seal. He told me that when the ice came to the shore and seals were wanted, the medicine man put on this mask and sang a song to the seal spirit. If the spirit then came out of the mask's mouth, it indicated a successful harvest of many seals the next day. (See fig. 159 for a modern version of this mask.)

At Point Hope a shaman's power-spirit came out through his mouth as whale flukes, walrus tusks, polar bear teeth, or sometimes only as blood. At Kauwerak, a nineteenth-century village east of Teller, a mask-face, erected on top of a pole near the caribou corral, was used to predict success in caribou hunting: a strong flow of blood from the mouth meant that hunting would be good. At Point Hope, flukes came out of the mouth only if the shaman was to have good luck.

The King Islanders were imaginative mask-makers of the Bering Strait proper. They painted them lavishly with natural pigments of hematite or alder (red), graphite (black), and clay (white). Interlocking teeth were characteristic, and a motif of triangles representing the peaks of the Kigluaik Mountains was placed on both masks and a special box drum that was used in certain ceremonies (figs. 64, 65, 144–46). The combination of the triangular motif and teeth represented the wolf spirit as portrayed in the wolf dance, or *nilga,* of the mainland messenger feast, a trading festival which, according to mythology, began at Kauwerak.

The few Wales and Little Diomede masks that have been preserved were made even more simply than the mask in figure 63. "Port Clarence" is a provenience designated for masks in several museums, especially the Field Museum's collection made by Miner Bruce in 1896. Some of them, however, while sold to the museum as Port Clarence objects, may have come from King Island and Saint Michael because Bruce, after spending the year 1892/93 as reindeer superintendent at the Teller Reindeer Station (now Brevig Mission), became a trader to widely separated points, including Siberia. A large part of his business was collecting Eskimo-made objects for resale. It would not have been unusual, though, to find King Island masks on the Alaskan mainland, for the "Port Clarence" people, especially those of Kauwerak village, were close politically and socially to the King Islanders and spoke a similar dialect. When Ivan Kobelev, a Cossack, visited King Island in 1791 as a participant in the Billings expedition, he met ten Kauwerak persons who had come the year before for trade to the island (Ray 1975). The close relationship of the islanders to the mainland extended into the mythological past: King Island supposedly came into being after a Kauwerak man, fishing in the Kuzitrin River, hooked a gigantic fish which towed him out to sea. It then lodged on the bottom of the ocean to become King Island. On its way to the sea it gouged out Imuruk Basin, Grantley Harbor, and Port Clarence (Curtis 1930, p. 105).

Sculpture

The Alaskan Eskimo rarely made "art for art's sake," but integrated his artistic concepts into ordinary, everyday objects. We are often uncertain about the purpose of an ivory or wooden sculpture that lies on a museum shelf, parted from its functional life. Take the small carving of a kayak, for instance. Perhaps it was a toy or a wooden model tied to a string to signify what a man wanted to trade. Maybe it was a personal charm or an amulet or, most likely, part of a shaman's kit.

For the most part, wooden figurines were impossible to buy at any price when they were in use. In 1881 a man refused to sell small wooden whales, three inches long, to E. W. Nelson because they were indispensable for whale hunting. At Kotzebue Sound Nelson was also unable to buy a unique wooden creature, which grasped a beluga in a row of ivory "teeth" inserted in its abdomen. He had discovered the object hanging inside the kayak of a young Malemiut man, who became alarmed and "said he would die if he parted with it . . . and he quickly went ashore and hid it." Nelson, however, made a sketch, which was subsequently published (fig. 9; originally published in Nelson 1899, p. 436).

In 1879 at Port Clarence, A. E. Nordenskiöld, the explorer, unsuccessfully tried to buy two "tent-idols . . . roughly-formed wooden images of birds with expanded wings painted red" in exchange for a new felt hat, which before would have purchased "almost anything whatever," even a "dazzlingly white *kayak* of a very elegant shape" with the addition of only five hundred Remington cartridges (1882, p. 579). He took from a grave, however, two masks smeared with blood and a "strangely-shaped" animal figurine (figs. 6, 8).

Wooden objects were used mainly by shamans in both private séances and public ceremonies to honor the various food animals, although ordinary citizens also wore masks and manipulated puppets in public performances. An important category of wooden objects was the shaman's helper, or tutelary. A popular helper

throughout northwest Alaska was a monster with a long head and sharp teeth. (It was called *kikituk* at Point Hope.) The "strangely-shaped" figurine that Nordenskiöld found on the Port Clarence grave in 1879 was one of these creatures (see fig. 8). Johan Jacobsen, a collector for the Royal Ethnological Museum of Berlin, witnessed a curing session in the Koyuk area where a shaman had a number of reluctant "wooden fetishes in his skin sack." Having finally induced a wolf with "an alligator's head" to wriggle out, he placed it inside his gutskin parka; but the alligator-wolf tried frantically to get out and back into the sack. Eventually, the shaman squeezed it, blew on its head and tail, and returned it to the other fetishes (Jacobsen 1884, p. 246).

The Point Hope *kikituk* (fig. 176) was used to "kill opposing shamans in deadly battles between the supernatural powers of the titans in the profession." It was believed that a shaman, Asetchuk (also spelled Asetcuk and Asetcak), gave natural birth to this creature during a séance, and once he used it to kill a powerful Siberian shaman (Rainey 1959, p. 13). Shortly after its birth, the shaman cured some sick persons by placing it in his parka sleeve with its head sticking out, its teeth gnashing in its movable jaw (Rainey 1947, p. 278)—a performance reminiscent of the one observed by Jacobsen.

The skin boat owners of the whaling villages kept their charms and weapons in large boxes like the one from Sledge Island illustrated in figure 18. These boxes, which imparted certain magical qualities to the weapons, were often shaped like a whale, but a box found in 1927 at Cape Prince of Wales was in the shape of a bird, thirteen inches long, with a wing-spread of thirteen inches (Curtis 1930, pp. 138–39).

Wooden figurines were very important in whaling observances. At Point Hope a four-day religious ceremony called the "sitting" was held in honor of the killed whales' souls just after new ice had formed in the fall. Sacred drawings were first painted on the whale jaw beams of the ceremonial house. The subjects most often drawn were whales struck by a harpoon, boats pursuing a whale, or a man ("Atcuraq," who prevented the whales from escaping) standing in front of a whale, hands outstretched.

From information obtained by Froelich Rainey, an anthropologist who did archeological and ethnological research at Point Hope thirty years after the last ceremony in 1910, we learn that there were two principal kinds of sacred figures made for the sitting—the "qologogoloq" and "pogok"—but it was sometimes difficult to differentiate between the two from the descriptions given by Rainey's informants. *Qologogoloqs* were "sacred objects, masks, small boat models, and figures of animals or men kept permanently in the *qalegis* [ceremonial houses], probably for generations. Each one represented a famous ancestor, a well-known incident of the past, or some peculiar circumstance described in the *unipqaq* tales, and each *qologogoloq* had to be justified by a special tale. These sacred objects were utilized only during 'the sitting'" then were dismantled and put away until the next year. (Information about these figures is taken from Rainey 1947, pp. 247, 248, 252. The *kulugugḷuq* was also prominent in Point Barrow ceremonial houses, according to Spencer 1959, p. 339.)

A *pogok* was a figure, commemorating a certain event, which was carved by men and boys to help them become good hunters. They were burned, one by one, at the end of the ceremony at a special place near the ceremonial house. Water from

a special pot, which was poured over each, "allowed [them] to go to the sea." A diagram of a ceremonial house with sketches of eighteen such figures was drawn for Rainey, but I have not seen it. Such a sketch would be helpful in identifying the numerous Point Hope figurines in museums, like the three in the American Museum of Natural History (fig. 59), which are probably figures of the "flying shaman," the subject of many folk tales in Siberian and Alaskan mythology. In these tales, the shaman was bound with rope or thong in various ways to fly to the spirit world (usually the moon), although a shaman, visiting in the Kauwerak area, once flew to San Francisco and back (D. Ray field notes). On Little Diomede Island the shaman's neck was lowered to his knees and his wrists tied to his elbows behind his back (Weyer 1932, p. 437). The Point Hope shaman, Asetchuk, carved a figurine after a particular flight to Siberia where he met a Siberian shaman "also in flight over a village. This man assumed a curious position in flight, with one leg drawn up under him." The Alaskan shaman "then carved two wooden figures of flying [shamans], himself and his Siberian friend, as *pogoks* to be hung in his [ceremonial house]" (see information also under the description of fig. 59 in Chap. V). Other *pogok* carvings were not so dramatic, but they, too, commemorated some remarkable event, such as the time a man once killed six wolverines in a single day; "hence, his son . . . carved and hung six small wooden images of wolverines each fall during this ceremony."

Each ceremonial house at Point Hope had its own sacred objects. In one, "a wooden whale, two small model umiaks with crews and hunting gear, and a bird" were suspended above the lamp. Men who wanted good hunting washed the figures in urine when they were first hung. The figures were constructed as puppets and at one point of the "sitting" were manipulated in a performance that commemorated a past event. In the other ceremonial house, the principal sacred object was a large wooden mask with ivory eyes, labrets, and ear pendants, which was also placed above the lamp; but the first object to be hung for the "sitting" was "the daylight begins," a foot-wide plank with painted spots, which represented the sky and the stars. (Knud Rasmussen understood that a part of the hall itself was painted for this representation of the night sky [1952, p. 61]).

Puppets were made not only for whaling ceremonies but for other performances along the entire western coast of Alaska. In 1842 L. A. Zagoskin of the Russian navy described a "bladder festival," which he observed successively at Saint Michael, "Kikkhtaguk" (Kikiktauk, between Saint Michael and Unalakleet), and Unalakleet. Bladders from animals that had been killed "with a missile" were blown up at the beginning of December, painted different designs and colors, and hung in the ceremonial house. "Among them the natives put all kinds of fantastic figures of birds, beasts, and fish. These figures, like some animated dolls, can roll their eyes, move their heads, flap their wings, and so on, and demonstrate the cleverness of the natives in mechanical things. . . . The owl could flap its wings and turn its head [and] the gull, pecking the floor with its iron beak, appeared to be catching a fish, and the partridges [ptarmigan] coming together, kissed each other" (Zagoskin 1967, pp. 123, 129).

Knud Rasmussen said that for the Point Hope ceremonies to the souls of dead whales, a

carved wooden image of a bird hangs from the roof, its wings being made to move and beat four drums placed round it. On the floor is a spinning top stuck about with feathers; close by

is a doll, or rather the upper half of one, and on a frame some distance from the floor is a model skin boat, complete with crew and requisites for whaling.

The proceedings open with the singing of a hymn; then a man springs forward and commences to dance; this, however, is merely the signal for mechanical marvels to begin. The bird flaps its wings and beats its drums with a steady rhythmic beat. The top is set spinning, throwing out the feathers in all directions as it goes; the crew of the boat get to work with their paddles; the doll without legs nods and bows in all directions; and most wonderful of all, a little ermine sticks out its head from its hole in the wall, pops back again, and then looks out, and finally runs across to the other side to vanish into another hole, snapping up a rattle with a bladder attached as it goes. All hold their breath, for should the creature fail to enter the hole with rattle and bladder behind it, one of those present must die within the year. But all goes well, and the company gasp in relief." [1927, pp. 332–33]

He also described a wooden doll used in the messenger feast at Igloo (Kauwerak) on Seward Peninsula: "Midway between hosts and guests is a wooden doll. . . . it is carved very ingeniously. . . . In its hand it has a small drum of very good tone, and the whole contrivance is so made that it can move its arms and head and beat the drum when a man behind pulls certain strings. When a female guest enters, the doll turns its head towards her and sends her a sigh." According to Rasmussen, this doll was made solely for amusement, but was burned along with the other ceremonial objects at the end of the festival (1952, p. 108).

John Murdoch, a member of the International Polar Expedition to Point Barrow between 8 September 1881 and 28 August 1883, illustrated two puppets from Point Barrow: one was a mechanical drum player made of whalebone, wood, and caribou skin, 11½ inches high; the other, a mechanical "kayak paddler" of whalebone and skin, which sits in a wooden kayak, 29 inches long. The paddler could turn his head from side to side and move his arms to paddle. Both were made about 1882 (the kayak paddler expressly for sale) and are now in the Smithsonian Institution (catalogue numbers 89826 and 89855; Murdoch 1892, pp. 381–82).

Puppets figured prominently in whaling ceremonies at Wales. A teacher, Suzanne R. Bernardi, was permitted to watch a whaling ceremony in 1902. Five ceremonial seal-oil lamps were lit in the *kazgi* or ceremonial house: "Under the shadow of the central lamp on the floor were mechanical figures of diminutive men, sea parrots and a twelve-inch wooden whale. The whale was made to imitate spouting by five blades of dry grass being blown from the hole in its head. The wooden sea parrots marked time to the music by turning their heads from side to side, and the little men moved heads and arms in the same manner as the real ones" (Bernardi 1912). Another feature at Wales was the chasing of two jointed ivory bears by two jointed men endlessly in one spot.[1]

IVORY AND OTHER MEDIA

Charms and Amulets

Walrus ivory has been closely associated with Eskimo art because of its durability, its unique origin, and the large quantities that have been collected from

1. I obtained this information in 1955. In 1952 I had seen a jointed ivory bear at the University of Alaska Museum, but did not photograph it. When I inquired about it during writing of this manuscript, it could not be found.

the older archeological sites. Besides its use for dolls and many utilitarian objects, ivory was widely used for charms and amulets, which were usually differentiated by their use. A charm was used to influence a hunted animal or to direct destiny in a way provided by the power of the charm; the amulet—a more personal object—was worn as a protection against bad spirits or to bring a certain kind of luck like good health, wealth, or love. Since each amulet had a specific use, a person was likely to wear several of them.

A person usually received amulets as a child from someone much older. Charms, especially for whaling, were inherited. Theoretically, most amulets were old, for they had been handed down through generations (old ones also had more power); but anyone could carve an ivory amulet if he wanted. At Point Barrow if a person made a figure of a sea animal, he refrained from eating food from the land for a season, or vice versa if he carved a land animal. Sometimes a song was given along with the charms and amulets, and food tabus were always imposed. As an example, when a boy received an ivory wolf's head, the shaman told him not to eat "the flesh of the female walrus and the shortribs of the female ugruk" (Spencer 1959, p. 283).

Personal charms and amulets in animal and human form were also made of wood, but could be of almost anything that had proved to be powerful for a person—a rock, animal bones, dried skins, driftwood, bird shot found in migrating geese, and even iron bells and trade beads. In 1791, members of the Billings expedition saw children of the Nome area (at Cape Rodney) wearing Russian bells, and in 1826 Frederick Beechey met two young Wales girls, ten and thirteen years old, whose movements caused "several bells [to be] set ringing." Beechey concluded that the bells were worn as amulets because they were placed where they "must have materially incommoded the ladies in their walking" (Beechey 1831, vol. 1, p. 295).

At Point Barrow, green and white trade beads were whaling charms, but blue beads seemed to be preferred farther south (Spencer 1959, p. 339; Aldrich 1889, p. 166; D. Ray field notes).

Amulets of human form were hung on the back between the shoulder blades, at the neck, or sewed into the clothing or to an amulet strap worn against the body. A woman, sketched in 1827, wears an amulet on her neck (fig. 4). Most amulets in human shape had to be nourished—often through a hole in the neck—and I was directed to feed fresh, not canned, crabmeat once a day to a replica amulet carved for me by a Little Diomede man in 1955 (fig. 70).

Household charms were numerous and varied from place to place. Dolls or animal figurines of ivory, bone, and wood were hung indoors near a lamp (or at the smoke hole of a tent, as Carl Merck observed in 1791 at Cape Rodney), and outdoors on stakes near tents and houses. Those erected near a shaman's dwelling publicly proclaimed his power.

Ivory and wooden dolls were used in magical practices to terminate barrenness or to effect the birth of a son. For this purpose, a shaman asked the husband to make a small doll "over which he performs certain secret rites, and the woman is directed to sleep with it under her pillow" (Nelson 1899, p. 435). The wooden figurines from Saint Lawrence Island in figures 148–50 were fertility dolls.

The faces of many dolls from the Thule period were made without features, yet during the Dorset period, which preceded Thule in Canada, as well as during post-Thule nineteenth-century culture of Alaska, facial features in both wood and ivory

were of great importance. The Point Hope carvers, above all, made faces that were so individualistic that they appear to be sculptures of specific persons. It was probably no coincidence that they were also the most productive mask-makers north of Saint Michael.

Charms were especially plentiful in the whaling areas, where all supernatural forces were called upon to help in the hunting of these huge animals. At Point Barrow special stone or ivory charms of whale shape were suspended from beaded headbands (Spencer 1959, p. 339). Whaling captains often kept charms in whale-shaped boxes like the one from Sledge Island in figure 18. Another box, from Point Hope, had a flat lid with a whale figure carved on top. On the reverse side, a triangular piece of quartzite was set in as a charm that would be available for instant use (VanStone 1967, p. 7). The insets on the flint flaker from Point Barrow in figure 29b and an inset on another whale-figure box found on Sledge Island by W. B. Van Valin (University Museum catalog number NA 4788) are probably similar charms.

Sometimes a wooden charm was fastened directly to the umiak, as was the case with the whale image from Point Hope in figure 21. Such images, as well as whaling charms in general,

were believed to have a compulsive effect that served to bring the whale close to the boat. In fact, informants called the *angoak* [charm] just described, *poesowruk* which means "luck for whale to come up close to the boat." Charms also served to make the animal more tractable and amenable to harpooning. Since it was believed that the whale's soul passed into another whale when it was killed, any irregularity of procedure was thought to disturb it. The whale could see the preparations that were being made to kill it and on that basis could decide whether to allow itself to be taken by men. The charms, therefore, served both to placate the whale and to compel it to come close by magical means. [VanStone 1967, p. 8]

Charms were used similarly for all game along the coast and in many cases had the power to see the game at a great distance. The charms then guided the hunters to the game, or else brought the game to them and sent their spears on for a direct hit (Nelson 1899, pp. 436–37). The wooden faces in figures 6 (no. 3) and 23, which are plugs for skin floats, were undoubtedly this kind of charm, as was the wooden figurine in figure 9 (see also note to fig. 23 in Chap. V).

Floats for seal nets were also made in animal shapes. In 1929 the United States National Museum received ten old wooden floats from Point Hope: eight of them were shaped like seals or seal heads; one, like a whale; and another, a bird.

Baleen, the hard (usually black), fibrous substance found in the mouth of the bowhead whale, was most commonly used for lashings, fishing lines, and strainers when a frost-free substance was needed; but it was also fashioned into amulets and charms. At Point Barrow most whaling umiaks had a whale image made of baleen hung on each side of the bow "to compel the whale to follow an even course," and one man's charms included images of whales, walrus, and seals of baleen (Spencer 1959, pp. 339, 343; fig. 50). It is interesting, though, that this material, which came from the whale itself, did not have more importance in whaling practices.

Not all art in the hard substances was wholly religious or magical, although some of the toggles and other appurtenances attached to lines, floats, and nets were charms. There is scarcely any information about the possible religious or magical

aspects of those portions of utilitarian objects that were carefully carved into the shapes of the most important food animals. E. W. Nelson said, "During the whaling season at Cape Prince of Wales the handles used for water buckets are carved to represent the forms of whales, and small images of these animals, handsomely carved from ivory, are frequently attached to the sides of the buckets. These images also figure in the winter festivals, at which offerings are made to propitiate the shades of those animals. It is with this idea of propitiation that the weights used on cords for making fast to whales after they have been killed are carved to represent these animals" (Nelson 1899, p. 439). The bucket handle from Sledge Island in figure 19 is a beautiful example of a ceremonial handle, and the stone whale in figure 25 represents one of the weights.

Special ivory rests with figures of whales (like those in figures 15 and 16) were used in each umiak: "When they are on the watch for whales the great harpoon is kept always rigged and resting in a crotch of ivory in the bow of the boat" (Murdoch 1892, p. 275).

Flint was used occasionally at Point Barrow for charms (fig. 53). In 1881 John Murdoch observed that "the flint whale is a very common amulet, intended . . . to give good luck in whaling, and is worn habitually by many of the men and boys under the clothes, suspended around the neck by a string. The captain and harpooner of a whaling crew also wear them as pendants on the fillets . . . and on the breast of the jacket." He collected five whale amulets, one of which was carved from a fragment of a ship's "deadlight" (Murdoch 1892, p. 435. For discussions of charms and amulets at Point Barrow, see ibid., pp. 434–41, and Spencer 1959, pp. 282–86).

A few other stone objects were collected in the 1880s, especially at Point Barrow, where soapstone lamps and dishes were obtained in trade from northern Canada. Murdoch and P. H. Ray, also of the International Polar Expedition, considered seventy-nine objects of their collection to be "purely works of art." Of these, seventeen were made of soapstone and nine (Ray said eleven) of bone, many of them made for sale to members of the expedition. In his catalog of ethnological specimens Ray wrote that the seventeen objects were "little images, men, beasts, and monsters carved in soapstone (tu-nă'k-tû)" (1885, p. 85). Of these, Murdoch illustrated a "walrus man"; a "quite characteristic" polar bear, four inches long; two whales (one made for sale and one that appeared to be fairly old); and an "imaginary animal" (Murdoch 1892, pp. 392, 398, 403, 404, 405). A refuge station built for whalers at Point Barrow was later rented to E. A. McIllhenny, whose collection of artifacts went to the University of Pennsylvania. Among them was a stone blocklike female figure, illustrated in figure 52.

Jade, or nephrite, which comes from only one place in western Alaska, near Shungnak (which means jade) on the Kobuk River, was rarely used for art objects. It was difficult to work, although many tools of nephrite have been collected or dug up, and oval-shaped pieces were sometimes used as shamans' charms.

Chains

Chains made of ivory were made both as ceremonial objects and as ornaments on household utensils. The nonfunctional use of chains may have been borrowed directly from certain Siberian shamans who wore them on their ceremonial cos-

tumes. The Alaskan Eskimos used chains most commonly on buckets and handles, which were often combined with swivels and animal forms, as in figure 19. In this handle, the whales are actually the links. Other ivory chains terminated in whales' flukes, seal flippers, or other animal forms (see discussion under fig. 19 in Chap. V).

Chains played a prominent part in whaling ceremonies. Although the Alaskan shamans did not wear chains, at Wales a boat owner's wife and grandchildren participated in a ceremony after capture of a whale, for which they dressed in new clothing and wore "long chains composed of walrus-ivory links wound about their necks and waists" (Thornton 1931, p. 169). The plain links of the ivory chain used by the boat owner during whaling ceremonies at Wales represented the number of whales that he had captured (Bernardi 1912). At both Wales and Little Diomede Island, special whaling buckets had chains, but apparently at Point Hope and Point Barrow they did not.

A folk tale, "The Magic Bucket," explains the origin of the special whaling bucket on Little Diomede Island. Many, many years ago a Little Diomede woman walked to Big Diomede to visit her brother. As it grew dark on her way home she met a skin boat with its captain and crew preparing to hunt; but when they saw her, they disappeared, leaving behind an ivory handle and a bucket with a chain around it. She then returned to Big Diomede and gave the bucket to her brother. En route home to Little Diomede, she again saw the captain, coming up out of the ice. Asking where his bucket was, he threatened, "If you don't give me my bucket, I'll clap and make the ice crack." When she didn't produce the bucket, he proceeded to carry out his threat; and the harder he clapped, the harder the ice cracked. To save herself from the broken, shifting ice, she jumped from ice cake to ice cake and finally dropped exhausted, where her husband found her. When she got well, she said that the people she had seen were spirits preparing to hunt and that she had taken their bucket as an offering to the "whale god to hold water so the owner could be a great hunter." The people used the bucket thereafter for offerings to the whale's spirit. It was handed down for generations, then buried, dug up, and lost again (D. Ray field notes).

Mythological Creatures

Among the objects collected by the Point Barrow polar expedition between 1881 and 1883 were sculptures of so-called mythological beings. These creatures could not turn into human beings as could most animals and birds, and they were not spirits. They had unusual shapes, including giants and dwarfs. Some of them lived in communities of like creatures, but others were the only ones of their kind in a tribal area. Toward the end of the nineteenth century, they were carved as images in stone and ivory, apparently at the suggestion of collectors, as at Point Barrow. Some of the creatures had, however, been engraved on early drill bows.[2]

One of the giants from Nuwuk (Barrow) was a superman, "Kaióasu," who could hold a whale in the palm of each hand (fig. 14). Figure 13 is another giant, "Kikámigo," who is represented on the dancing gorgets of wood from Point Barrow in figure 12 (Murdoch 1892, pp. 371, 395, 406).

2. For further readings on mythological beings see Burch 1971; Lantis 1947; Nelson 1899, pp. 441–49; and Spencer 1959, pp. 259–64.

Another mythical being carved while Murdoch was at Point Barrow was a giant polar bear with ten legs, usually called *kokogiak*. It was known from Norton Sound to Barrow, but the only examples of carving and engraving (since the 1880s) have come from Point Barrow and Cape Nome. Eskimos do not agree whether more than one existed on the ocean ice. This ten-legged bear (illustrated in figs. 11 and 118) measured five feet between its ears and was so heavy that it could break through ice six feet thick. It propelled itself forward rapidly on its ten elbows while lying on its back. To lure hunters to it for eating, it waved its legs in the air to look like people moving and howled ''ko-ko-ko'' as if calling for help. Siberian hunters were thought to have killed a *kokogiak* in 1945 (D. Ray field notes). The drill bow in figure 237 (top) probably illustrates this act of tricking hunters.

Another subject for carving and engraving was a giant caterpillar or dragon called *tirisuk*. All Eskimos other than those in the Kotzebue area considered this creature to be dangerous. One *tirisuk* lived in a hole twelve feet long on the bluff west of Elim and was feared by all who traveled in boats because it had feelers which could pluck them from the water. Boats, therefore, hugged the bluff to escape capture (D. Ray field notes; Burch 1971, pp. 156–57; Nelson 1899, p. 446). This giant does not appear to have been used on the older drill bows, but became popular as a subject on pipes and ivory tusks engraved during the 1870s and 1880s (see fig. 242). A related creature was a giant worm (or man-worm), which is engraved on the tusk in figure 241.

A giant eagle (*tingmiakpuk*) has been a favorite in both traditional and recent art (figs. 15, 291), and its adventures in Eskimo mythology would fill many pages. In the Norton Sound area this eagle was reputed to be as big as a ''Stinson plane'' and could easily pick up a fifteen-hundred-pound bearded seal (ugruk) in its talons. In the Kauwerak area a set of stories described the giant eagle's home in the Kigluaik Mountains and its gifts of song, dance, and gaiety to the Eskimo people (see, for example, Oquilluk 1973, pp. 149–66; Rasmussen 1932). Long ago, when this bird was killed, its quills were found to be as wide as berry buckets.

Another mythological creature often painted on dishes and skin boats on the lower Yukon and Kuskokwim rivers was the ''palraiyuk'' (a name first recorded by E. W. Nelson), which the Saint Michael Eskimos borrowed for their big ivory pipes. A crocodilelike being that ate people, it was drawn either in its linear form or curled up, as in figure 243. It was obviously related to the giant dragon (*tirisuk*), which lived farther north.

Mermaids also inhabited the icy waters off the west coast of Alaska. In 1955 I learned about one maiden that Shishmaref hunters encountered on the ice during the winter of 1953–54. Eight or nine hunters watched her through binoculars. One wanted to give chase, but the others thought it would be too dangerous. About ten years later, Kivetoruk (James) Moses used this episode as a subject for a painting (fig. 283).

A mythical walrus man was obtained by Murdoch from Point Barrow sometime between 1881 and 1883 (fig. 17). It was newly made for sale, but based on another ubiquitous folk tale. In a Little Diomede Island version, a hunter became a walrus man by traveling with the herds to warm places; but when he became old, he failed to return.

There were many other mythical creatures—not all, to our knowledge, created as art objects—but by the 1950s, with the exception of the rare sighting of the mermaid

near Shishmaref and the rumored capture of a ten-legged bear on the Siberian coast, these beings, which "we don't see in the dictionary," no longer exist. At Saint Michael it was thought that they had moved to another planet; and at Point Barrow, Robert F. Spencer, an anthropologist, was told that "men like this good man [a Nunamiut hero] killed them all off. That is why we do not see them around today" (D. Ray field notes 1955; Spencer 1959, p. 417).

PAINTING AND ENGRAVING

The best-known painters of two-dimensional subjects on wood were traditionally the Eskimos living south of Saint Michael, including Nunivak Island, and the best-known engravers of two-dimensional subjects on ivory were those who lived north of Saint Michael. Although the southerners did little engraving of realistic scenes on ivory before the souvenir days of the cribbage board, the northerners occasionally painted graphic scenes on wood and, in a unique example, on the vertical rocks of Tuksuk Channel, a deep, swift river between Imuruk Basin and Grantley Harbor, east of Teller.

Perhaps figure painting on wood and other media originated from the custom of painting the body and the face for ceremonial purposes. The painting of dishes, spoons, kayaks, and umiaks in the south was done for ceremonial and magical reasons, as was the making of wooden figures, charms, and amulets in the north. In the only firsthand study of the southern wood painting in 1936–37, Hans Himmelheber was unable to ascertain its origin. L. A. Zagoskin, the Russian navy lieutenant who wrote an exceptionally good account of the Saint Michael and Yukon and Kuskokwim river people, did not mention graphic designs on wood during his visit between 1842 and 1844, but wrote about body painting, masks, and puppets. We do not know how far back in antiquity body painting might have existed,[3] but the first recorded observation of representational painting on the human body in the northern Alaska area was made by Zagoskin at a village near Saint Michael. There, in an unidentified ceremony, men drew figures like a crow or a hawk on each others' backs with powdered coal mixed with fermented urine before going to various houses to taunt the women into giving them gifts of food (Zagoskin 1967, pp. 121–22).

Painting in the north appears to have been used mainly in ceremonies related to catching whales. Painting of the body and the face was done in various ways during ceremonies at the three most important whaling villages: Point Hope, Point Barrow, and Wales. During a ceremony called *suglut* at Point Hope, men drew "a narrow line at either side of the nose and a heavy line at either side of the mouth. *Umeliks* usually drew a heavy line across their eyes. Their wives were decorated with two vertical lines at the right side of the face and a horizontal line on the left side of the nose." Pictorial drawings were made on fringed forehead masks: the boat owners painted a crew attacking a whale on theirs, and the crews painted men spearing seals or shooting caribou with a bow and arrow (Rainey 1947, pp. 249–50).

3. The preserved body of a woman estimated to be sixteen hundred years old was found in October 1972 on Saint Lawrence Island. She had "alternating, parallel rows of dots and solid lines on the forearms and dots on the fingers" (*Alaska*, August 1974, p. 23).

The wife of the shaman who was chosen to officiate during the four-day festivities of the "sitting" at Point Hope drew whale flukes on her husband's chest. After the ceremonial houses were closed for the winter, the boat owners and their wives went to the end of Point Hope spit, "wearing their best clothing and with their faces painted" (ibid., pp. 249, 252).

On 9 January 1883, at a Point Barrow ceremony "consecrating" all of the whaling gear for the coming season, "a woman passed down the line [of boat owners seated in a row] marking each across the face with an oblique streak of blacklead," and one or two of the men and one woman also had streaks on their faces during the hunt (Murdoch 1892, pp. 272, 275). Both the boat owner and the harpooner wore dots of soot mixed with grease from the corners of the mouth to the ear lobes, each dot indicating a whale taken the previous season. If these men had sufficient status, they could tattoo the marks permanently (Spencer 1959, p. 340). A woman who had had a miscarriage could accompany sleds with provisions for the whale hunters only if she had two black streaks on her cheeks, but could not go near the open water (Porter 1893, p. 140). At Cape Prince of Wales all men had marks of charcoal during whaling: a line down the nose and on the chin, or two spots on the cheek, or a line across the forehead (D. Ray field notes).

The messengers who carried invitations for the messenger feast on Seward Peninsula were also painted: "each herald has 2 streaks of black and red alternately on each cheek, a circle of black on the forehead, and red rings around the eyes . . ." (Porter 1893, p. 140). In the Deering area, a man who had killed another in battle had four lines tattooed on each cheek, supposedly to protect him from revenge by the spirit of the dead man (VanStone and Lucier 1974, p. 6).

Women's decorative tattooing, as well as men's labrets, were probably merely personal decoration; but a Little Diomede man tried to explain to me that these devices differentiated men from women during war time. On the Alaskan coast, tattooed designs consisted of one to five vertical lines on the chin, although sometimes as many as nineteen were used, as seen in the mask, figure 68. In 1791 members of the Billings expedition saw a woman at Cape Rodney with circular tattoos on her arms, the usual custom of facial tattooing on Saint Lawrence Island and of arm and facial tattooing among the Chukchi women. Although the Cape Rodney woman may have been a visitor, the account reads as if she lived there (Ray 1975). Many dolls were made with tattooing and labrets (figs. 44–46, 57–59).

It seems strange that there is only one example of rock painting in northern Alaskan Eskimo territory, at Tuksuk Channel. The black and red figures can be seen in summer only by boat and in the winter, from the ice. I was told by a Kauwerak man that a shaman had painted them, presumably in the early part of the nineteenth century. Despite exposure to winds and storms, the colors and forms were comparatively stable but obviously faded when I photographed them in 1964. The red and black colors are from ocher and graphite found locally, and were probably mixed with a fixing agent like fish oil before application. In 1964 there were about fourteen figures in one group (fig. 233), and three indistinct ones several yards to the south, which were difficult to photograph. They appear to be dancers, but I was told that some figures, which had fallen into the water near the indistinct ones, had included a man shooting a caribou with bow and arrow and several persons riding in a skin boat (Ray 1966c and 1967b).

In the north, the painting of designs on wood was done most frequently on paddles.

During the nineteenth century a variety of geometric and symbolic designs abounded, especially in the Bering Strait region (figs. 3, 4, 6). In 1891 at Cape Prince of Wales the teachers saw the first skin boat go out into the strait to hunt whales on 19 April. They were not permitted to go near it, but from a distance they saw "its new and curiously painted paddles and oars, its fetish charms attached, its buoys in place, and with what appeared to be a stuffed seal placed in the bow and looking towards the open sea." About ten years later, Suzanne R. Bernardi, another teacher, said that each new paddle made for whaling was "decorated with black painted figures and tufts of deer hair" (Thornton 1931, p. 165; Bernardi 1912).

In 1955 a man recounted to me the whaling preparations he remembered going on at Wales before 1905. All of the clothes, which were brand new, "seemed like a uniform," and all of the paddles, about five feet long and made of spruce driftwood, also had to be newly made and painted with designs inherited from the father. The "paint" was charcoal rubbed on with wood shavings or weed roots, and then oil was applied with a cloth. Though the designs "did not mean anything," they were probably made for the benefit of the whale and consequently were painted with great care and neatness. The captain painted one paddle for his harpooner and two paddles in different designs for himself, one of which he used when sailing, and the other, for whale hunting. The paddles were broken after hunting, but the same designs were used again the next season (D. Ray field notes).

At Point Hope and Little Diomede the paddles were merely cleaned, not painted, at the start of the whaling season. At Point Hope they were scraped as early as January so the whale could not see them clearly, "but, if seen, they were pleasing to him in this condition" (Rainey 1947, p. 257; Weyer 1932, p. 345).

Engraving of representational subjects on ivory began before historic times, but the Alaskan Eskimos developed it into a distinctive form of art on drill bows for their own use, and later, on pipes and tusks for the art market. No pictorial designs have been found in the earliest archeological sites, but harpoon heads and other utilitarian and ceremonial objects were incised with linear and circular decorations, especially on Saint Lawrence Island and at Point Hope.[4] Pictorial designs began during the Thule culture (about A.D. 1200–1800), but comparatively few examples have been acquired, and they appear to be late, the majority having been dug up from fairly recent sites by Eskimos and purchased by collectors. The prehistoric examples ordinarily have only one subject—a single drawing of a caribou, a man, or an Eskimo boat (kayak or umiak)—on a piece of caribou bone, usually a comb. Ivory engraving was the specialty of the Alaskan Eskimo north of Saint Michael, yet no pre-nineteenth-century drill bows have been found in Alaska; the only "archeological" bow was found in Canada where the Eskimos did little pictorial engraving of any kind. Pictorial drawings on ivory were first reported in 1816 by members of Kotzebue's expedition, and L. Choris' drawings of two of the drill bows show a well-practiced use of multiple subject matter on large pieces of ivory (fig. 2).

Engraving on ivory can be divided into four styles: old engraving; modified engraving; western pictorial; and modified pictorial, or contemporary.[5] The old engraving style was used almost entirely on drill bows and bag handles. The modified engraving style was the old engraving style used on the large surfaces of a tusk or

4. For further information on prehistoric art see Ackerman 1967; Collins 1929, 1959; Geist and Rainey 1936; Oswalt 1957; Rainey 1959; Taylor and Swinton 1967.

5. Some of the material on engraved ivory that follows is adapted from Ray 1969.

ivory pipe. The western pictorial style was an imitation of printed illustrations at the turn of the twentieth century; and the modified pictorial style is a contemporary modification of the old western pictorial style, but usually of Eskimo subjects.

Old Engraving Style

In the old engraving style, the artist drew heavily on suggestion for expressing the many variations of human and animal attitudes. He used a minimum of detail to create a maximum of action. Human beings were both stick men and schematic bodies in various shapes. The ivory background was never painted, thereby offering sharp contrast to the black silhouetted or shaded figures. Horizontal or vertical incisions used for shading were filled with black ash mixed with oil, graphite, and sometimes red from ocher or steeped alder bark.

Depth, slant, and size of incisions produced an almost three-dimensional texture that is not always seen even in the best photograph. Mass was sometimes suggested by a large gouge or incision with internal contours, which added a sculptured effect.

Drill bows and bag handles had two, three, and four faces, but did not have a consistent arrangement of subject matter. On bows with four unequal faces, the two wide sides usually had pictorial scenes and the two narrow sides, geometric designs, though sometimes all four sides were covered with pictorial scenes. The engraver used one or both edges of the bow side as a drawing base, which in most cases was strongly defined by an incised line.

Many of the drill bows were said to be hunters' tallies of animals caught. This was probably true in many cases, but the carver was usually persuaded to sell them even before a side was filled. C. L. Hooper, skipper of the *Corwin*, reported in 1881 how little value seemed to be placed on the decorated drill bows. "At Cape Blossom I purchased two from an old man for a few hands of tobacco. These contain, among other things, carvings representing the vessels of the Western Union Telegraph Service. . . . The men belonging to the expedition on shore, and the houses erected by them [in 1866 across from present-day Teller] are also graphically shown" (Hooper 1884, p. 111). The journalist Herbert Aldrich wrote, "Each native is said to keep a diary of his hunting trips by carving the important events on a piece of ivory, showing his camps, shooting deer, walruses, seals or bears, or catching and drying fish. A few of the supposed diaries were offered for sale" (Aldrich 1889, p. 75).

Ways other than engraving on ivory tallies were used to depict hunters' catches. Whales at Point Barrow were indicated with soot and grease on a charm box, one mark for each whale; by a white stitch on one side of the boots for every whale obtained (Spencer 1959, pp. 339, 340); or, as we have already seen, as facial dots or tattoos. Drill bows or bag handles that might be tallies represented only a small percentage of all surfaces of these objects.

I have not worked out the statistical frequency of the various combinations of subject matter, but a detailed visual examination shows that there is little or no correlation of subjects on one side or between sides. When I began asking the contemporary carvers in the early 1950s about these engravings, I learned that they knew as little about them as I did. They, too, were unable to "read" what apparently were records or diaries in pictorial form.

The single most-used subject was the caribou, yet caribou hunting was not

especially dangerous. Neither were there many ceremonies connected with it. The caribou undoubtedly was a subject—especially in its many poses—that gave the engraver great pleasure to engrave. Except for the human being, no other living shape lent itself so well to the portrayal of complex scenes and actions. Of the 117 drill bows, bag handles, and miscellaneous objects with the old-style engraving in the Smithsonian Institution, collected mainly between 1877 and 1881, caribou or caribou hunting were engraved on 61 of the specimens. (Nine of these had the rear view of a single grazing caribou.) Skin boats (umiaks) with people (unassociated with whaling) were engraved on 48 objects, and kayaks, on 46. Summer villages or tents were placed on 37, and nets or fish drying, on 31 (of these, only 19 had both dwellings and fish scenes). Walrus or walrus hunting were on 40; foxes, wolves, or dogs, on 31; hunters in umiaks in active pursuit of whales, 30; exteriors of winter villages or houses, 28; dog teams, 25; Europeans or ships, 20; a man pulling a seal on the ice, 19; bears, 12; shamanistic ceremonies or dancing outdoors, 7; indoor ceremonials, 6; mythical creatures, 6; and men wrestling in a standing position, 5. As will be seen from an examination of the bows illustrated in this book, there were numerous other subjects used only occasionally.

I made a similar analysis of 8 drill bows (2 were unfinished) collected by Beechey's expedition in 1826–27 at Kotzebue Sound and northward. This is admittedly a small sample, but the bows are among the earliest collected with specific provenience (Kotzebue Sound, though some may have been from Wales), and are remarkably comparable in subject matter to the later ones. Caribou again emerged the great favorite on 6 of the 8 bows. (That interesting lone figure of the rear of a caribou is on 2; as examples, see figs. 235, 237, and Ray 1969, fig. 8). Umiaks with people (unassociated with whaling) are on 3; kayaks, on 4; summer villages or tents, on 3 (of these, 2 have both tents and fish drying); walrus or walrus hunting, 2; only 1 has a dog (on another, what I have judged to be bears may indeed be dogs); hunters in umiaks actively pursuing whales, 4; winter villages, 3; a man pulling a seal on ice, 3; shamanistic ceremonials or outdoor dancing, 2, or possibly 3; mythical creatures, 4; and wrestling, 2.[6]

Almost all scenes on all drill bows involving human beings represented intense action—paddling a skin boat, killing a walrus, chasing whales, pulling seals, snaring or corralling caribou, and exhibitions of athletic and dancing prowess. Men, when not otherwise engaged, rarely stood still. They waved, beckoned, threw things, gesticulated. The only tranquil scenes were the grazing caribou, resting seals, and the dead animals draped as booty across the drill bow.

Women's activities, except for fishing, were not portrayed, and sexual characteristics are not readily identifiable from the schematic drawings. I have seen only one bow on which there is a recognizable female form (Beechey bow, Pitt Rivers Museum, no. 692). That unfortunate woman appears to be dragged backwards by her hair. Since the relationship of the figures is somewhat schematic, however, the engraver may have had another meaning in mind.

Beechey's drill bows have several vignettes not found on later ones, but the engraving style and other subjects are typical of late nineteenth-century bows. On the same bow as the dragged woman are two other unusual subjects—a man using

6. I am grateful to John R. Bockstoce for providing photographs of the Beechey and Belcher collections, which will appear in the near future in his study, *The Beechey and Belcher Collections*, volume 1 of the Pitt Rivers Museum Anthropological Papers.

what appears to be a spear thrower (Beechey collected several spear throwers) and a two- or three-holed kayak, which six men are walking away from in a stooping position. On another bow (Pitt Rivers Museum, no. 693) the artist depicts the joys of pipe smoking. A man with smoke pouring from his mouth appears to be falling either helplessly, or ecstatically, backward. In the early days of the tobacco trade across the Bering Strait, the supply of tobacco was limited, so the smoker had to make the most of the tiny amount of tobacco in the small pipe bowls. He did this by swallowing as much smoke as possible in one inhalation and holding it until he became unconscious, recovering in about fifteen minutes.

There are differences between the drill bows collected by Beechey in the 1820s and those after 1850. Especially noticeable is the absence of dog teams and European subject matter on the Beechey bows, and a higher proportion of mythical creatures. Since the artist never seemed to be reluctant to sketch nonnative events (see figs. 238, 239, and discussion above), the omission of Europeans is interesting. By 1827 at least six European vessels, and possibly other anonymous traders, had been to Kotzebue Sound: in 1816, Otto von Kotzebue; in 1819, a trader named Gray; and in 1820, two Russian sloops, the *Discovery* and the *Good Intent,* and an American brig, the *Pedler.* In 1821 the *Discovery* sailed north to Icy Cape, and in 1826 Beechey arrived at Kotzebue Sound in the *Blossom* (Ray 1975).

By the 1880s and 1890s many duplicates of bows and bag handles were made for sale, a development similar to mask-making as trade objects at Saint Michael.

Modified Engraving Style

The modified engraving style was used on large ivory pipes and whole walrus tusks sold as souvenirs in the Saint Michael area between 1870 and 1900 (figs. 241–50). Nelson collected several large pipes, but no tusks, which is fairly conclusive that tusks were not engraved until after he had left the Saint Michael area. The Alaska Commercial Company fostered the souvenir trade by supplying walrus ivory to the carvers, and by buying the finished products for their museum in San Francisco. Engravers applied essentially the same techniques and subject matter of the smaller surfaces to the larger ones; but most of the schematic figures were discarded, and the human figure was usually made larger and more rounded. Sex differentiation was rarely made, but nationality of such figures as a Yankee sailor or Chukchi and Lapp reindeer herders was adroitly indicated by physical postures or by headgear. Eskimo ceremonial costume was occasionally noted by trappings placed on arms, legs, or head. Full pictorial display of anatomy, clothing, and sex was not made, however, until western-style engraving was adopted. Great concern for shading and contrast was shown through crosshatched, vertical, or horizontal lines. Incisions were often deep and heavy and filled with jet black color for an extremely effective contrast against the large white ivory surface.

Eskimos probably adopted the idea of making souvenir pipes from the Chukchi, who had copied the wooden Chukchi smoking pipe in ivory. In 1849, Lieutenant W. H. Hooper of the *Plover,* one of the vessels searching for Sir John Franklin at Bering Strait, wrote that near Emma Harbor on the Siberian coast an ivory pipe, which a skilled Chukchi carver made for him "in about six hours, had on the bowl a face in front and on either side, the back was filled up by a figure less than an inch

high seated upon a block, having one leg crossed upon the knee of the other. . . . Another man here was in great request as a maker and ornamenter of wooden pipes, particularly for inlaying them with lead or solder, which after our arrival was practised to a much greater extent than previously" (Hooper 1853, p. 184). (The making of the combined lead and wood pipe was borrowed by Saint Lawrence Islanders, as illustrated by Nelson in his plate 88. This style has been retained into the 1970s; see Chap. III, "Siberian-style Pipes," and fig. 226). The Chukchi did not engrave drill bows or ivory pipes, however, before the twentieth century. Vladimir Bogoras, the principal ethnographer of the Chukchi, said that "etchings are scarce in Asia, and those that I had an opportunity to observe are comparatively poor specimens of art" (Bogoras 1907, p. 295); but during the mid-twentieth century the Chukchi developed a remarkable style of engraving on ivory tusks, almost like painting, which is unsurpassed anywhere in the north (see illustrations in Antropova 1953 and Orlova 1964).[7]

Because pipes and tusks offered larger surfaces than did drill bows, the Eskimo engraver made his images bigger on these items. They seem more dramatic, but enlargement of the figures on the bows shows equal or better technical control; in many cases, composition is better and the action more expressive even though the larger ones were made in response to nonnative "artistic" suggestions. The engraver continued to use both old subjects, like whaling and caribou herds (especially north of Saint Michael), and new subjects on the pipes and tusks.

Whole tusks generally have three kinds of subject matter: (1) traditional "Eskimo" scenes; (2) single subjects unrelated to specific traditional events, engraved for benefit of a nonnative audience; and (3) scenes that were formerly not used in engraving. The single subjects anticipated the ivory sculptures that were sold in future years—kayaks, umiaks, dog teams, and animal and human figurines. The use of new subject matter—indoor shamanistic curing performances, certain ceremonial scenes, and intertribal warfare—reflected a breakdown of traditional values and a relaxation of prohibited behavior (figs. 247–50). Unlike the old drill bows, which reported what was happening, the new ivories began to report what had happened. Nostalgia for the "good old days" had already appeared in Eskimo art.

ICE, FROST, FEATHERS, AND DECOYS

We cannot leave traditional art without looking at some objects made of other materials. Clay was found sparingly at various places where women made pots with simple border designs, but not as sculptures or ceremonial objects. At Point Barrow, however, women made pots solely to trade to inland groups who had adopted them for ceremonial use in connection with caribou hunting (Oswalt 1953; Spencer 1959, pp. 470–74).

In pioneer America the carving of decoy ducks and geese from wood was a specialized art, but Eskimo-made decoys are rarely found in museums. Yet, on

7. During the early historical period, Chukchi carvings from northeastern Siberia were similar to many from northern Alaska, and a statement on Chukchi aptitudes made by John Dundas Cochrane, an English traveler to Siberia from 1820 to 1823, could have applied equally well to Alaskan Eskimos: "The whole of them are ingenious, cunning, industrious and excellent mechanics, which is proved by the symmetry, neatness and quantity of their [sleds], clothes, tents, arms, and ornaments" (Cochrane 1824, p. 276).

Golovnin Lagoon one day in 1946 I watched a man from that area making brant goose decoys of mud and sticks to lure the geese toward the ice (fig. 294). They looked like huge copies of the small, flat-bottomed birds of ivory used for games on Saint Lawrence Island and elsewhere (figs. 31, 34), but his lasted only as long as the ice remained. Decoys were observed in use at least once in the northern area in early times. In 1827 Beechey saw several dwellings at Cape Rodney "and a number of posts driven into the ground, and in the lake we found several artificial ducks, which had been left as decoys . . ." (Beechey 1831, 2:531).

Rocks roughly piled up to look like a human shape (inyuksut, meaning manlike) were strategically placed to divert migratory birds and caribou for hunting. At Point Barrow hunters erected a series of these piles to alter the flight of ducks over the sandspit (Spencer 1959, p. 35), and in both Alaska and Canada caribou drives were often conducted through a series of structures made of wood and brush. Bering Strait people also erected stone men for their psychological warfare with Siberians, and those of Big Diomede Island even dressed their figures in fur parkas (Weyer 1932, p. 157). Recently, a number of inyuksut made of flat rocks have been exhibited in Canadian art shows (see Gimpel 1967).

Sculpture in snow and ice was rare, but one of the important events at the beginning of the first day of the "sitting" at Point Hope was the carving of a whale from ice by a shaman's assistant while the shaman sang and beat his drum at the edge of the ice to help his tutelary obtain its full power. The ice whale was then brought to the ceremonial house, where it was placed facing the entrance hole and in front of the shaman, who sat in the middle of a row of boat owners. The "sitting" began after the wives of the boat owners had sat down at their husbands' feet and had placed the little ceremonial buckets in a row in front of them. The significance of the ice whale is not explained, but there was probably a relationship between the sea, the ice, and the whales.

Drawing in the snow with a "snow knife" was not done in the north as on the Yukon and Kuskokwim rivers and Nunivak Island (Lantis 1950, pp. 70–71; Nelson 1899, pp. 345–46, pl. 94), but at Point Hope drawing pictures in frost was a part of closing the ceremonial houses in the fall. At that time, the people "drew a crescent moon on the frost of the skylight, held a dipper of water up to it, and prayed inside the house" during brief ceremonies in private dwellings to assure good luck for the next year's whaling (Rainey 1947, p. 253).

The 1880s and 1890s in Alaska were years in which extensive changes took place in graphic art, yet sculpture remained for the most part traditional in forms and styles. The Eskimo man still made wooden and ivory sculptures for himself, but engravings for his customers. He had begun to sell his objects of everyday life to crews on ships, traders, and a few Alaskan colonists, and was raiding the ground for old objects. Many parts of his culture were changing rapidly. He had seen the white man break tabus with impunity for many years, but he did not completely abandon his charms and amulets until there was no longer a need for rapport with the spirits or a need to appease or flatter them through the making of beautiful objects to use in beautiful ceremonies. These objects were gradually replaced by a body of scientific knowledge and a technology that included guns, motors, and weather reports as well as "ikons, crucifixes, and prayers to a Christian god," as one of my old friends told me. But with the passing of the old charms and ceremonial objects, the making and ornamenting of everyday objects also disappeared; and with the

exception of fur clothing and skin boats, the Eskimo inventory came from the trader and, later, the stores and mail-order catalogs.

SEWING

The Eskimo woman was preoccupied with sewing as much as the man was with carving. The delicate designs put into well-fitted garments and boots probably reached far back into prehistory, as human figures from the Okvik stage of the Old Bering Sea culture (around the time of Christ) were incised with marks representing clothing decoration. Women's handicrafts were almost entirely confined to sewing and to pottery and basket-making. But this division of labor—and art—did not seem to disturb the Eskimo woman, and she lavished her care and creativeness on apparel worn on ceremonial occasions as well as for personal display. New clothes were made for many ceremonies to please the spirits, but "fancy" parkas and boots were also worn because of individual vanity. Eskimos of northwest Alaska were very much interested in their personal appearance from head to foot. Three examples from early historical accounts will bear this out.

In 1791 at Cape Rodney members of the Billings expedition remarked about the neat and clean appearance of the people at their camp. The men's hair, though long on the sides, was cut so short on top it looked almost shaven. Some wore a crownlike band of sealskin thongs (perhaps like that worn by a man in the Beechey illustration, fig. 4). The women braided their hair around the ears in circular design, sometimes interlaced with pieces of otter fur. Both men and women wore glass beads in their ears, and the women wore copper or iron bracelets on their arms. The women were tattooed and the men wore labrets. The men wore well-made pants of red or yellow leather and lightweight boots tied with thongs round the ankles. Short boots were made of beautiful white skin embroidered with colored hair and sinews. Jackets, now called parkas, were decorated with various kinds of furs. The peaked hoods were topped with a small fur tassle, and the bottom had a seam of short-haired caribou skin and a strip of wolverine fur. The woman's style had the distinctive rounded front and back flaps still made at the turn of the twentieth century (Ray 1975).

In 1820 at Eschscholtz Bay Lieutenant Aleksei Lazarev, an officer on the Russian sloop *Good Intent,* said that the people (from Buckland) were dressed in caribou, muskrat, and otter parkas decorated with various designs. Lazarev was surprised that they changed their clothes several times a day, and he speculated that it was either because of the weather or because they wanted to show off their riches (ibid.).

In the winter of 1854–55, Captain Henry Trollope of the *Rattlesnake,* another vessel searching for Franklin, journeyed with a man, his wife, and child to Wales from his ship anchored in the ice of Port Clarence. Trollope was greatly impressed that long before they reached their destination, "the child had been dressed and adorned by its mother in anticipation of our arriving" (ibid.).

In the early 1900s personal appearance was still important. A man who had grown up in impoverished circumstances and whose "style was rags" told me in 1950 that during and after the gold rush days "all from the north came down to Nome with beautiful clothes." Many of the people were "rich," and the richest wore the best clothes, which reflected both a successful hunter and an industrious, talented wife.

"As in the real old days, they wore them only in good weather to show off."

During the nineteenth century one of the principal trade articles across the Bering Strait was the white or mottled white and brown domesticated reindeer skins obtained from Siberian Chukchi herders. The wild caribou rarely had white fur, and the variegated domesticated skins (as shown in fig. 259) were sought as luxury material for dress-up parkas and boots. As another of my old friends told me, "Only rich peoples had white on their decoration before the white man."

Parkas and fur boots were probably the first objects made directly for sale to the white man. Many accounts by whalers and travelers mention buying clothing from King and Little Diomede islanders for the crews' use, and the various expeditions that later stopped at Saint Michael also preferred the protective fur clothing.

Eskimo clothing is tailored, that is, cut and sewed so that arms, legs, neck, and hood were fitted to individual needs, comfort, and protection. The Eskimo were among the few so-called primitive peoples of the world who made tailored clothing; and the Eskimos of northern Alaska had devised numerous garments for different uses. Besides the various fur parkas, there were rain parkas made of intestines (gut parka), trousers and boots made in one piece (often worn by women, as first reported in 1820 near Buckland by the crew of the *Good Intent*), and even a whole suit for setting nets in deep water. This suit, donned by stepping through the neck opening, was first reported in 1791 at Cape Rodney by the Billings expedition. Boots, which were made in various heights and from different materials, were also tailored to fit the legs.

The two names "parka" and "mukluk" originated with the Russians. The fur coat, or *atigi*, was called "parky" by the Russians after a Siberian Kamchadal word, and the different kinds of boots ("high," "low," "waterproof"), which had separate names, were lumped under one word, mukluk. This word was derived from the Unaluk word, *maklak*, or bearded seal, from which the heavy stiff soles were usually made.

The parka was the main vehicle for ornamentation, and it varied in style from north to south. Women of the north appear to have been more concerned with geometric and linear fur insets in garments than those south of Saint Michael (and their close relatives, the Aleuts), who decorated mainly by inserting various patterns of fur and feather tufts in the seams. Dress-up garments of the north also had many hanging strips of fur in conjunction with the inset designs (figs. 194, 196).

The most commonly used skins for both everyday and dress-up occasions were local caribou and imported Siberian reindeer. In the 1880s, before the Alaskan Eskimos began raising domesticated reindeer, John Murdoch said that Siberian skins could be differentiated from local caribou skins by the red color applied to the flesh side, whereas the Alaskan skins were worked into a white surface (1892, p. 110). For fancy parkas, the people of Seward Peninsula and Bering Strait also used squirrel skins (they preferred fall skins, when the color changed from reddish to gray), and the finer-haired shanks and belly of the summer caribou. Sometimes other skins were used. Sealskin, the most common material for pants, was usually worn only as an "outside" parka over an inner one of caribou. Bear, beaver, muskrat, hoary marmot (*siksikpuk*), and mink were used for parkas if the preferred skins were unobtainable. On Saint Lawrence Island, Little Diomede, and the Yukon and southward, the breasts of various birds, and even salmon skins, were used. Children's clothing was sometimes made of rabbit and discarded squirrel skins.

Most parkas had an attached hood with a wolf or wolverine ruff, a necessity in the freezing winds. Women's and men's styles of ruff differed. A woman's was usually bigger, and one of wolf was sometimes lined with wolverine in such a way to frame the face like a halo. A sumptuous, bushy ruff was the pride of any Eskimo woman. Wolverine fur, which does not collect frost, was also used at the bottom of the sleeves and below the bottom border as decoration and to retain body heat. The hood of the caribou parka was usually made from the head skins of the caribou, and the hood of the "fancy" squirrel parka, from tiny squirrel heads, as is clearly seen in figures 194 and 195.

Murdoch tells about a Point Barrow man who had elegant clothes. His caribou clothing was greatly trimmed. He owned one parka of alternating white and blue fox skins, and another of alternating white and brown ermine skins, each of which had been split down the back and sewed with the feet and tails attached. The shoulder and bottom border designs of this parka were further decorated with small red glass beads. It was topped off by a beautiful hood of caribou and mountain sheep skin and a wolf ruff (Murdoch 1892, pp. 116–18; USNM catalog no. 56757).

The intestine, or gut, parka, which was called "kamleika" by the Russians, was used principally as a raincoat. It was especially useful for kayak wear since the bottom of the parka was tied around the manhole to protect the occupant from spray. In the north it was made with a minimum of decoration, but in southern areas, as well as on Saint Lawrence Island, it was often lavishly decorated with bits of feathers and tufts of fur sewed into the seams (Ray 1959).

Clothing patterns were sometimes quite complicated. Murdoch describes and illustrates patterns of the major kinds of garments at Point Barrow in his comprehensive and detailed section on clothing. The patterns for pantaloons (pants and boots combined) are examples of the exacting work that went into the clothing even before the trimming and designs were sewed on. One pantaloon pattern used ten separate pieces, and another, eight, without the soles. Since the pants fitted tightly, the pieces of caribou or domesticated reindeer legs had to be cut to exact measurements with gussets provided for the calf, thigh, and half-waistband. The construction was made even more complex by the seamstress's choice of alternating white and brown fur in the design, and the placing of the coarse ankle hair on the outside ankles of the boots. The pieces were usually cut with an ulu or "woman's knife" from memory and by measuring with the eye, but sometimes a prepared pattern was used (Murdoch 1892, pp. 126–29). Steel needles and thimbles were used for all sewing during the late nineteenth century, but reindeer sinew was always preferred for sewing fur since it was long-lasting and stretched with the garment.

During the latter part of the 1800s many things were sewed for sale, some with decorations of foreign materials. The journalist Herbert Aldrich bought a little bag made at Cape Lisburne of "several kinds of fur and decorated with tips of red and blue yarn over white deer-skin. A narrow red strip was a part of the decorating, and at first glance I supposed it to be seal-skin tanned red. Instead, however, it proved to be a piece of an old flannel shirt" (Aldrich 1889, pp. 75, 85). Other trade goods like tiny beads and cotton thread were also used in designs by that time. From Point Hope, E. W. Nelson got a summer hood made of wolf-head skins, which had ten long parallel rows of blue beads on the top and shorter strings of red, white, blue, and black beads hanging on the sides (Nelson 1899, pp. 33–34). Red flannel became a distinctive welting element of parka and mukluk borders, which were formed

basically of white Siberian reindeer skin and, occasionally, mountain sheep. The parka illustrated in figure 195 from "the head of Norton Sound" [i.e., Koyuk], obtained between 1877 and 1881, illustrates this common design, which has four narrow white strips welted with thin black strips, probably black fish skin (sewed while damp), which was the ordinary welting material at Bering Strait. At Point Barrow the welting material was thin dark skin of a new-born, or possibly unborn, caribou fawn.

Mukluks varied in height from the ankle to below the knee and were sometimes decorated as conspicuously as were the "fancy parkas" (figs. 196, 198, 259). The Eskimos also had a kind of indoor slipper on which the market slippers of the twentieth century were based. Soles were usually made of cured and tanned ugruk hide, soft or hard; but even seal, walrus, beluga, and polar bear hides were used. (More is said about footwear in Chap. III.)

The same delicate stitchery in parkas and mukluks was used on mittens and gloves, particularly those worn in ceremonial dancing. They were made of caribou and reindeer skin, and sometimes sealskin, with fur trimming. Mittens were traditional, but gloves were probably adopted in historic times for shooting guns.

Belts were used by men for pants support, and by both men and women to confine the parka round the waist, especially to keep a baby snug under a woman's parka back without falling out. With the exception of a unique belt woven of ptarmigan quills, belts were made from whole natural objects like crab jaws or crab shells, wolverine toes, ptarmigan feet, and caribou incisor teeth, strung together or sewed to a backing in patterns (one kind of object to a belt) for artistic effects. Caribou teeth (as many as 150 sets of incisors) were placed in an overlapping design across the width of the belt.[8] A caribou-tooth belt was highly valued and supposedly acquired a curative power when it had been in a family for a long time. It was especially effective for rheumatism, and the afflicted part of the body was struck with the end of the belt several times for curing (Nelson 1899, p. 435). Beechey collected a caribou-tooth belt at Kotzebue Sound as early as 1826, and one is worn by the woman in Guy Kakarook's drawing, figure 259.

Ptarmigan quill work is one of the surprises that often turns up in the Eskimo inventory (figs. 205–7). Except for basketry, weaving is not an Eskimo art. In 1881 Murdoch called the quill belt the "feather belt," which he said appeared "to be peculiar to [the Point Barrow] region"; but it was also made on the Kobuk and Noatak rivers.[9]

Murdoch described the weaving of the feather quill belt in detail, but did not explain that the black strands were the tail quills, and the white, the wing quills. They

8. The Ingalik Indians, who lived adjacent to the Eskimos on the Yukon and Kuskokwim rivers, had apparently borrowed the caribou-tooth belt for their own use. Cornelius Osgood illustrates one in his *Ingalik Material Culture* (1940, pl. 9).

E. W. Nelson illustrated a crab-jaw belt and a caribou-tooth belt in his plate 106, nos. 2 and 3; John Murdoch, one of wolverine toes (1892, p. 137); and Edmonds, one of caribou teeth (Ray 1966a, p. 128).

The Alaska State Museum has one of the most unusual caribou-tooth belts that I have seen. It is decorated with 258 sets of teeth placed in a double row, 131 sets in one row and 127 in the other. Between the two rows are sewn 81½ large blue trade beads interspersed with numerous smaller beads. Two bears' teeth are also suspended from the belt.

9. A short and unsatisfactory discussion about the ptarmigan quill belt is found in William C. Orchard's monograph on quill work. His information apparently came from an examination of belts in the Museum of the American Indian, New York. The only provenience given is "Alaskan Eskimo." I was unable to determine through correspondence whether the museum still has these belts. The Alaska State Museum has two quill belts (II-A-1388, II-A-2725), which were collected from Point Barrow and the Noatak River in the second decade of the 1900s.

were woven in varying checkerboard patterns on a nine-strand warp, four cotton twine strands on either side of a heavy middle sinew braid. The woof strands were sewed tightly at the edges and bound with red-dyed deerskin. The ends of the warp were braided into a long rope to fasten into a sealskin loop in front, and an old bone spearhead was suspended at the back as an amulet (Murdoch 1892, pp. 136–37). Two belts collected at Point Barrow are in the U.S. National Museum (catalog nos. 89543 and 89544).

In 1909 a belt obtained for the Alaska-Yukon-Pacific Exposition was later deposited in the Washington State Museum by the collectors, J. Hackman and I. Koenig. Most of the objects in the Hackman–Koenig collection came from Point Hope, but the provenience of this belt (fig. 205) is not known. About the same date, in the Kotzebue Sound area, a quill belt was woven to form the words, "Hugo Eckardt mining man" (fig. 206). In the 1950s Pauline George and other women of Noorvik began a revival of this art as a cottage industry on the Kobuk River (fig. 207). I have been unable to learn whether the ones made on the Kobuk River were borrowed from the Barrow people or vice versa, or whether the technique for both was originally borrowed from Indian groups. Whatever the origin, it is a craft form that has almost disappeared.

The wearing of newly made clothing for ceremonial purposes was universal among the Eskimos. As Margaret Lantis, the anthropologist, has characterized it, the two tendencies in Alaska ceremonialism were "no clothing, and more clothing" (1947, p. 93). The "no clothing" had permitted body painting on males (as "an element of supplication," and when "portraying the spirits"—ibid., p. 94); the "more clothing" permitted the participation of the woman in ceremonials, through her making of elegant clothing for both herself and her husband to wear. Since the wearing of new and beautifully decorated clothing was common everywhere to please the spirits, especially in whaling festivities, I shall only point out some of the special ways in which apparel and personal ornamentation were used at Wales, Point Hope, and Point Barrow.

In 1891 Harrison Thornton, a Wales teacher, said that when the whaling crews set out, they were dressed in new garments, hoods, and waterproof sealskin gauntlets. Each person wore a charm down his back and soot marks on his face. The boat owner's sister and fourteen-year-old daughter, who were dressed in cotton parkas, made a fire through which all of the hunting implements were passed. They then went into their house and "emerged resplendent in new and tastefully ornamented deerskin suits and with perfectly clean faces" for further ceremonies before launching the boat.

After a whale was taken, the wife of the boat owner came out to meet him when he was still a quarter mile away. Thornton gave the following account: "She is attired in gala-dress: a long decorative fetish (made of whale skin) hangs down her back, and a large ornament (about 3 feet long and 6 inches wide), which is composed of small red, white, and blue beads strung together, lies on her breast and extends down below her waist. Her little grandson and granddaughter follow her. They too are dressed in new suits." The children wore long ivory chains. The boat owner's wife wore special large mittens to handle the ceremonial bucket, the rim of which was inlaid with ivory whales, and the shaman wore smaller mittens to handle the graphite used for drawing (Thornton 1931, pp. 166–69 passim; Bernardi 1912).

In 1901 the schoolteacher Suzanne R. Bernardi was invited to a whaling ceremony at Cape Prince of Wales, for which the participants had to have "perfectly new clothing." In the first dance, the "man of each family danced in first, followed by his wife. His costume consisted of a spotted deerskin coat trimmed with wolverine skin, red flannel pants, and fancy deerskin, knee-length boots. This costume was finished off with a pair of gloves made of white drill cloth or, in some instances, deerskin wrist-length gloves, decorated with fancy stitches. A streak of black paint from brow to tip of nose adorns each brown face" (Bernardi 1912).

At Point Hope clothes were changed frequently during the "sitting." During this ceremony as well as during whale hunting, women wore special mittens, the ruff at the tip being used to sprinkle water on certain carved ceremonial objects as they burned. They were also used to carry a special pot for offering a drink to the whale. The boat owner took the left-hand mitten for a charm in his boat, and wore his wife's belt, which had been taken off ritually at the edge of the ice (Rainey 1947, pp. 252, 259, 260).

At Point Barrow, after a careful watch for the proper whaling conditions in April, the crew went to the ceremonial house for four days and put on new double suits made by their wives, an inner coat of caribou skin with fat and sinew left on for warmth and water resistance, and an outer one of caribou or sealskin. This suit could later be reused, but not for whaling. The boat owner wore new boots with white stitching on the sides representing the number of whales he had captured. Crew members also had new boots, which could not be changed for the duration of whaling.

Meanwhile, the boat owner's wife hired an old woman to make special mittens (as at Point Hope), which were often decorated with weasel-skin tassels, for carrying the wooden vessel to offer water to the whale. The bucket was made by a specialist who knew the songs for consecrating it. Her husband took with him her left-hand mitten and her belt, which "formed a mystic tie to the land and reflected the activity which she must now carry on" (that is, her passiveness and inactivity would make the whale quiet, and she could not use a knife or sew for fear the lines would break or become tangled). She also was dressed in new clothing and had painted her face with soot and grease with the same designs that were on her husband's and the harpooner's. She was not supposed to wash the soot and grease from her hands.

After a whale was taken, the boat owner's wife bestowed "a formal greeting" on the whale; then, taking back her belt and mitten, she began to cut off the whale's snout and pour water on it from the special bucket, as did the boat owner, welcoming it to the community (Spencer 1959, pp. 333–37 passim, 340, 344, 345).

Clothing was also used in an unusual way by the shaman, who wore a gutskin parka for many of his curing performances as a protection against harmful spirits and to provide a cover-up for his conversations with his spirit helpers. When dry, this parka is stiff. The crackling noise that the parka makes when the wearer shakes it back and forth, twisting it this way and that and crushing it to his body while he talks to his helpers, is quite effective, and a little ominous, as demonstrated to me by an old man who, in his youth, had seen several performances by a shaman who used two tutelaries, the spirit of his mother and a bear.

But sometimes the origin and use of a particular item of clothing was quite poetic,

as in the following report by E. W. Nelson. At Point Hope, "a young man came on board the *Corwin* wearing a pair of gloves, on the back of which were sewed a pair of outspread feet of the sea parrot. . . . On questioning his companions they said that he was a shaman, and once while he was fishing along the shore one of these birds had alighted on his hands, leaving its feet to bring him success in salmon fishing" (Nelson 1899, pp. 429).

BASKETRY

Basket-making from grass is an almost forgotten art north of Saint Michael. Although the northerners preferred to use whole sealskins and skins of birds like swans for clothing storage, and bentwood buckets for berry picking, the women made many woven mats, baskets, and bags.

Grass baskets of coiled construction took a decided leap in the woman's work schedule after the discovery of gold near Nome. Some souvenir baskets were made as small as two inches high, like the one of 1902 illustrated in figure 218, and others were larger than those illustrated in figure 296. In a photograph taken at Teller a basket is shown large enough for a child to sit in (illustrated in Bronson 1970, p. 41). Some of the baskets were ornamented with tufts of fur, imbrications of thread, and simple bead designs. Many had lids. Sometimes a man provided small ivory carvings for attaching to the top and sides. During the gold rush an open-weave bag of various sizes was made in a simple twining process. This was apparently borrowed from the old matting technique, because there was no twined basketry in the north during the historical period, although the archeologist Louis Giddings said that the Western Thule people had made twined baskets (1967, p. 100).

Otis T. Mason, who wrote the classic study on Indian baskets, *Aboriginal American Basketry*, in 1904, said that the "art of basket making [was] not an old one with [the Eskimos]," who, as a whole, were not skillful in this endeavor. Specimens brought home at the date he was writing were "vastly better made than any of the old pieces in the National Museum" (1904, pp. 364, 400). It was probably about this time that women of the mainland across from Nunivak Island—at Hooper Bay and Nelson Island—had departed from the traditional two-strand twining technique and learned the coiling technique "with mixed and not specially noteworthy results," according to Margaret Lantis. After a trader taught the Nunivak women the coiling technique sometime after 1920, they rapidly developed an expression of realistic motifs, which had been the privilege of the men before (Lantis 1950).

The area of greatest productivity of coiled basketmaking in the early twentieth century was south of Norton Sound; and in the 1970s the northernmost center was at the village of Stebbins, nine miles northwest of Saint Michael. The baskets are of a flat rod coiled construction, which was introduced by people who moved to Stebbins from Nelson Island about 1915.

Birchbark baskets similar to those illustrated in figure 219 were made in large quantities in both prehistoric and historic times wherever birch trees grew. The two centers of birch basket-making were on the Kobuk River and around Norton Sound, from where baskets were traded all along the coast. The baskets were made in an

envelope style, which might have been borrowed, during trading, from the adjoining Indian tribes, who made similar baskets; but their antiquity suggests that they were of Eskimo origin. They were found in Nukleet deposits on Norton Sound, dating from the twelfth to the eighteenth centuries, as well as in Ipiutak (roughly fifteen hundred to two thousand years ago) at Point Hope (Giddings 1964, pp. 70–71).

III Market Art

IN 1955 I made a study of techniques, attitudes, and products of ivory carvers in the Nome area, where most of the Alaskan carving was done (Ray 1961). Carvers living in Nome represented all of the ivory-carving villages of Bering Strait. Especially numerous were those from Little Diomede and King islands. The King Islanders occupied their snug island homes in the winter and lived in shacks in "King Island Village" east of Nome in the summer. A quonset hut served as a community center where as many as ten men, seated on the floor, spent the summer days carving. The hut's only light was daylight that came from the front door facing the ocean and from four small windows at the opposite end. A gasoline lantern hung on a nail on the back wall, but was rarely lit, even on dark, rainy days.

Carvings and slippers were displayed all day long on a large wooden table just inside the front door. They were reasonably priced, especially the little seals and pendants made by the young boys who were taught the rudiments of carving by the older men.

The carvers at that time well knew the limits of their capabilities and what would or would not sell. The best carvings by the best carvers brought about a dollar an hour in wages (excluding any other costs). The largest birds sold for $6.50; the bear in figure 116, $12.50. Though some carvers supplemented their livelihood with longshoring and other odd jobs during the summer, the majority either were full-time carvers (those who lived in Nome all year) or else combined subsistence hunting with carving. The works of both excellent and mediocre carvers lay side by side on the table, and often the poorer objects were sold before the better ones because of the lower price. The carvers told me they sold readily because the customers "will buy even poor stuff if they know it is 'hand-made.'" But if the poorly carved objects had been made by machine or even polished with an electric buffer, they would not have sold, even at the lower price.

The carvers did not use power-driven machinery for their work, although they would have liked to do so where electricity was supplied. "In this way we could compete with Seattle [commercial producers]," one man told me; "but the tourists and store owners want things hand-made, and won't let us make things with power

tools." The carvers shaped objects with adzes, saws, files, and gravers, and many of the tools were commercial ones which they altered for their specific use. The adz and the bow drill (for drilling holes) were two traditional tools that the carver found indispensable.

The carvers generally were not independently innovative, but, as in the past, they would attempt anything that was ordered and paid for; and once the success of a certain category, like bracelets, had been assured, they would try variations of their own. When I asked the carvers why certain objects were not made, the answer was always, "There's no demand." I began to look upon this souvenir business as a "demand art," which could be a synonym for "market art." The tourist and the collector were powerful forces in determining what the Eskimos carved, and the individual requests for objects made contemporary Eskimo art not only diverse, but chaotic.

The key determinant of what was to be made and sold was, "Is it 'Eskimo'?" It had to *look like* Eskimo art not only to remind the buyer of where it originated, but to satisfy his desire to obtain the "genuine" thing, a somewhat artificial standard that ignored the history of both traditional art and the ready acceptance and incorporating of many foreign materials and ideas for over a hundred years. Thus, use of power machinery and elephant and sperm whale ivory was held to be tabu; objects made of wood were not considered to be "Eskimo"; and certain animals like the caribou and the moose were not a part of the regular inventory because they were not associated with the sea and ice of traditional Eskimo pursuits. Yet ivory objects on which were used foreign substances like India ink and red paint for marking, sandpaper and Brilliantshine (a metal polish) for smoothing and polishing; and fur products that were decorated with yarn, felt, calfskin, and red tear strips from cigarette packages were readily accepted. So were foreign subjects like Mutt and Jeff and knives and forks, because they were handmade by an "Eskimo" from "Eskimo" materials (figs. 84, 133).

Eskimos have purchased and used sperm whale ivory teeth since whaling days of the 1870s and 1880s, but the price of thirty-two dollars a pound in 1973 prohibited its use for all but special work. The carvers like to use it because "it's all *ivory*. It doesn't have a core [the mottled interior] like walrus tusks." Tourists were generally ignorant of the fact that wood carvings, including masks, had been one of the great art forms of all times. Wood objects were a drag on the market. Tony Pushruk, the principal mask-maker of King Island in the 1950s, made only two masks the entire summer of 1955: a "twisted mouth" or *yeyehuk* (similar to fig. 65, right) and a "crow" mask. The two masks hung on the wall of the community house until I bought them in August, the crow for ten dollars, the other for twelve.

I asked one man why more masks were not made. His answer: "Because they are too slow selling. Anything that sells fast, they make as fast as they can. Billikens, there is demand for; polar bear, demand for. No demand for fish. We tried it before — curving, in different shapes, tomcod, flounder, and they never sell. We get rid of them cheap if they don't sell."

The irony in the insistence that walrus ivory objects be handmade and "look Eskimo" is that the billiken (see discussion under "The Billiken," below), the most popular souvenir item of all time, was adapted in 1909 from a figurine patented on 6 October 1908 by Florence Pretz, a Kansas City, Missouri, art teacher and illustrator (Ray 1961 and 1974a).

In 1973 I returned to Alaska and to the Bering Strait area in particular for another firsthand evaluation of the Eskimo arts, although I had been to the state a number of times since 1955 for other purposes. Ivory carvings still dominated the market, even though new forms and media of art were being encouraged and the Federal Marine Mammal Act of 1972 was threatening the ivory and sea mammal fur supplies.[1] Carvers everywhere told me that there were "more carvers in ivory than ever before in history" and despite the "unfair" sea mammal act, they would be able to procure ivory. The domination of ivory in souvenir art and its place as a unique substance was reinforced by signs like: "When you buy ivory remember someone went out on the ice to get it" (at Sunarit Associates, a native cooperative in Nome). Ivory production also came from places other than Nome, including Anchorage, where many Eskimos had moved. Prices for comparable pieces were from six to seven times higher than twenty years before; yet groceries and other commodities were little higher than in 1955. "Green," or new white ivory, cost five to six dollars a pound in 1973, which was two to three times that of 1955 if a person had to buy it rather than get it by hunting or bartering. (I have learned that by 1976 the price had reached fifteen dollars or more a pound.)

Figurine carving had increased during the 1960s and 1970s. More human figurines were made in ivory than ever before, especially nostalgic revivals of old-time Eskimo costumes and new interpretations of Madonnas (figs. 73–81). Extremely delicate carvings were turned out as a consequence of an upsurge in collecting for its own sake. Also very popular were animals and birds typical of Eskimo country, some of them copied from printed illustrations (figs. 112, 125–28). The best carvers, who were often commissioned to make objects, were far behind in their orders. In the 1970s collectors, especially those living in Alaska, had a competitive fever to buy as many objects as possible, as if there would be no tomorrow of ivory carving.

Wood also came to be more widely used: in fact, never since the great days of traditional ceremonialism had so many wood carvings, including masks, been made. This trend resulted from two kinds of activities: participation by artists in formal studies in art schools and in several community projects that stressed new materials and designing principles; and the tourist business, especially at King Island Village. There, the old community quonset hut had been replaced by a sturdy wooden building equipped with electricity, a public address system, adequate windows, and rows of benches for tourists to watch dances performed by the King Islanders each evening for airline tours. The Eskimos were paid for each performance, which featured both traditional and newly invented dances. The wearing of masks in some of the dances lured the tourists into buying them. By this time, the crow and "twisted mouth" masks sold for thirty to forty dollars and up, and other masks, like the walrus (fig. 165) and the good and bad shamans (fig. 147), which had been revived, were selling for fifty to one hundred dollars.

The King Islanders had moved permanently to Nome in 1967, but no longer lived in shacks. They had three- and four-room houses built under an agreement in 1968 for Indian housing with the federal Housing and Urban Development Department, for which they paid reasonable rents. The men no longer carved to-

1. A thorough discussion of the Federal Marine Mammal Act of 1972, especially as it pertains to Alaska, is by Jim Rearden in *Alaska* (June 1973). This is a very complex act, but in part it allows sea mammals to be caught and used only by the natives themselves; they cannot be sold or exported. A state regulation prohibiting dealing in raw ivory without a permit or exporting uncarved ivory had already been in effect for about fourteen years.

gether in the community building, which was used mainly for the evening dances, although one or two occasionally spent the day there. A split had developed between the older and the younger craftsmen, mainly over what they thought "Eskimo art" should become. All carvers worked at home in their new, convenient houses, although the younger men, members of Sunarit ("carvers") Associates Cooperative, had until a short time before carved in *their* own building, a short distance from the old community house. A table was no longer loaded with goods in the community house, because the benches and a small stage took up all the space. Instead, ivory and furs were brought out at the end of the evening's dancing and placed on boxes on the stage.

Most of the King Islanders still did all of their carving and sewing by hand, but a few others in Nome, Anchorage, and on Saint Lawrence Island were using electric tools. (Carvers had always complained that "real" hair and fur as in fig. 74 were difficult to make with hand tools.) Because the souvenir industry was less dominated by souvenir-oriented merchants who had insisted on "handmade" goods, power tools were sometimes used, which the tourists did not generally know about. Some of the younger leaders in art education openly advocated the use of power tools. Yet adzes, bow drills, and homemade tools were very much in evidence, especially among the old-guard carvers and some of the younger men, like Lloyd Elasanga, a former Diomeder who carved in Anchorage and received a very good price for his delicate carvings (fig. 102).

Besides a larger number of wooden objects for sale, there were also more made of bone, baleen, and sperm whale and elephant ivory than two decades before, especially by persons who could not hunt walrus or buy its ivory. The use of these materials had come about by accident and individual experimentation as well as through planning by the traditionalists toward the day when walrus ivory might be unavailable; but especially it was emphasized in organized programs to broaden experimentation and to instill a more imaginative approach in form and use of materials. This attitude has broadened the scope of subject matter; and since collectors are willing to pay high prices, carvers are more willing to take a chance on unusual innovations or on time-consuming objects like the fragile caribou and moose (figs. 127, 128). On the other hand, the broadening market and hope of cashing in on the higher prices have flooded the market with many poorly made pieces. Some of the poorest are stone carvings made in imitation of Canadian sculptures. The Canadian objects reached Alaska in 1955, and in 1963 shipments of soapstone were sent to Savoonga, King Island Village at Nome, and to Mekoryuk on Nunivak Island by the Indian Arts and Crafts Board, which also provided hand tools, technical instructions, and pilot models. Soapstone carvings were offered for the first time through the Alaska Native Arts and Crafts catalog in 1964.

Graphics, especially block prints, which are made by the younger artists with formal art training, had been developing as a new art form since 1955; but there were not many good ones for public sale in 1973. The majority were displayed at the Arctic Trading Post and the Sunarit Cooperative store in Nome. Although the cooperative had not been greatly successful as a producing organization, it was holding its own as a retail outlet in 1973. Several family-oriented independent businesses had also begun operation. Milligrock's Ivory Shop was located in Nome; and in Anchorage, two King Island families, the Mayacs and the Tiulanas, were producing quantities of ivory and fur products. The Tiulanas had a shop in Mountain View.

Paul, a World War II veteran, had gone to Anchorage in 1967 and had been director of the Anchorage Native Welcome Center and recreation director for the Seward Skill Center before launching his own business.

A decided change had occurred in erotic art (see "Erotic Objects," below), and a number of changes had also taken place in women's participation in skin sewing and in crafts that had usually been considered as belonging to men. (Women's work was not included in *Artists of the Tundra and the Sea*.) The unprecedented demand for carvings of all kinds, and the high prices, have led many more women to try carving in the 1970s than ever before. A few are very good (see figs. 163, 170, 178), but the emphasis placed on "Eskimo-made" and "handmade" articles has been so strong that some women (and men, too) plunge right into carving without any technical or esthetic background and produce junk that masquerades as "Eskimo art" just because it is made by an Eskimo.

There were few changes, however, in the percentage of fraudulent "native" objects made by nonnatives, despite the use of the "Silver Hand" emblem, developed in 1971 by the Alaska Division of Economic Enterprise to attach to "authentic native products" to distinguish them from imitations made in Japan and the United States. Compared to the high proportion of Eskimo-made articles in the Nome and Kotzebue shops, the proportion in the Anchorage shops was low, and the "Silver Hand" was not nearly enough in evidence.

The clerks in some of the shops were still as ignorant about the wares they were selling as in years past, and many of them are as guilty of perpetuating the dishonest representation of the objects as the commercial traders who make and sell them. In 1973 I saw a bird, new in shape to me, in several Anchorage shops. The birds were made of elephant ivory, well concealed with black paint. This object had all of the distinctive characteristics of non-Eskimo manufacture. In answer to my queries as to its provenience, I got the classic run-around: all of the clerks gave me the stock answer that it had come "from somewhere up north"; one expressed astonishment that it was made of elephant ivory; another promised "to find out tomorrow where it came from"; and another said that it had been brought in by "a strange old man."

HISTORY OF OBJECTS

Although Eskimos had been selling their old objects and engravings to the shipboard trade and occasional travelers for years, the permanent markets created by the Klondike and the Nome gold rushes were most responsible for the market art of the twentieth century. But even at the time of the gold discovery on Anvil Creek near Nome in 1898, the character of northern Alaskan art had already undergone changes from traditional styles and forms, as we have already seen.

On the surface, Christian values were willingly accepted in northwest Alaska. Contract schools (joint sponsorship by the U.S. Bureau of Education and a church), which were established at Wales, Point Hope, Point Barrow, and at Gambell before the gold rush, and the Swedish Covenant efforts earlier at Golovin and Unalakleet, had slowly supplanted a need for the traditional religious ceremonials and objects used for the spirit world. Teachers and missionaries often overtly suppressed ceremonial activities and the use of "heathen idols"; Eskimo resistance was not overly

great because the new religion offered many attractions, such as a carefree and happy life after death, and within a generation's time it had superseded the old, except in a few holdouts of secret individual beliefs.

Women made clothing in almost unaltered design until long after the gold rushes, but men's handicrafts turned in a very different direction from traditional art. First, in the 1890s there had been the ivory pipes and whole engraved tusks; then Eskimo activities created in three dimensions, like the caribou hunting and goose corralling scenes (figs. 151, 152). All of these took a great deal of time to make, but after the gold rushes, more easily made objects were carved for the huge numbers of people who wanted proof of having been in Saint Michael and Nome even if they had not found any gold. The wares most often carried by individual Eskimo peddlers on the crowded streets of gold-rush Nome were old artifacts dug up from nearby sites, copies of various tools and implements, and fur products and baskets. Since Eskimos had learned even then that some collectors wanted "old" things, copies of traditional tools were sometimes buried in the earth to age them, so it is not always easy to know whether objects collected in such a manner are what they were supposed to be.

Pictorial Engraving

The gold-rush customers quickly learned about the Eskimo talent for copying illustrations and objects in either two or three dimensions. The first two decades of the twentieth century were probably the most bizarre in the history of Eskimo art in the transfer of subject matter from one medium to another. The new market became flooded with ivory objects long familiar in other materials: gavels, umbrella heads (a fox head was a popular design), napkin rings, tableware, penholders, cigar holders and smoking pipes, long strings of beads, belt buckles, vases, toothpick holders, and many other objects. But one of the most popular items—and the most costly— was the cribbage board. Inhabitants of early Nome loved to play cribbage, but the ivory cribbage board did not originate there. It arrived already adapted to an ivory tusk by a man from Cape Nome named Angokwazhuk, who became famous as "Happy Jack, the ivory carver." He was the first carver in Nome to be singled out as an individual artist, and was often asked to sign his work. A few others like Guy Kakarook, originally from Rocky Point near Golovin; and his son and stepson, Willie and Joe, who worked at Saint Michael; and schoolboys like Warren Adlooat Sowle of Wales also signed their engraved ivory. These men—and many others who will forever remain anonymous because they did not sign their names—developed what I have called a western pictorial style of engraving subject matter, which was usually copied from illustrations or photographs furnished by their customers.

Both the modified engraving (see "Modified Engraving Style" in Chap. II) and western pictorial styles developed simultaneously in the 1890s. Western style was used first on whole tusks and cribbage boards, but rarely on ivory pipes, whose popularity declined toward the end of the century. Later, the style was used on various objects like napkin rings, gavels, letter openers, and ivory jewelry.

Pictorial engraving style depended upon intricate details for realistic representation. Facial features and details of animal fur, bird feathers, sleds, and boats were usually carefully drawn out. The schematic vertical, horizontal, or crosshatch meth-

ods of shading were ignored, and the incised marks represented texture of the original as closely as possible. One of Happy Jack's innovations was engraving with a fine needle to simulate newspaper halftones and textile textures. (I was told by two King Islanders—one of whom was born after Happy Jack died in 1918, the other only nine years old that year—that Happy Jack sometimes pricked through a photograph laid on the ivory. I had never heard this from the older Diomede Island and Nome persons who were closely associated with him, but he might have done it occasionally. The uniform size of ivory tusks, however, would necessitate uniform size of laid-on pictures, which would not always have been available. Furthermore, certain fine textures produced by Happy Jack could never have been achieved through any means other than free-hand engraving.)

The pictorial style of ivory engraving belonged from the first to those who had never attended school (except for the Wales students), but for many years Eskimos had pored over illustrations in magazines and had seen the whalers working on scrimshaw art. Happy Jack himself had made at least two trips to San Francisco before the gold rush on a whaling or trading vessel, where he is said to have made his first walrus ivory cribbage board. Both Guy Kakarook and Happy Jack had had considerable experience with white man's ways, Happy Jack on board ship and Kakarook as a deckhand on the river boat he depicted in a book of thirty-two watercolors of native life and villages in the Saint Michael and Yukon River areas (figs. 255, 256, 259). Kakarook also drew the same river scenes in winter in a second notebook and engraved at least two of the same scenes in ivory, as illustrated in figure 257.

In reconstructing the careers of these two outstanding craftsmen, it is apparent that they worked differently. Kakarook and his sons went their individual ways, and Kakarook's artistic endeavors were unknown, or forgotten, by his old friends who were still living in the 1960s. Happy Jack's friendly personality and unselfish hospitality drew around him a circle of men in a kind of school. Happy Jack's fame was so enormous, because of his skill and his intimacy with many Nome residents, that if a beautifully engraved tusk was not signed, it was *assumed* to be Happy Jack's. This, I think, was the case with the tusk in figure 258, attributed to Happy Jack by J. E. Standley, who had established Ye Olde Curiosity Shop in Seattle.[2] It is, however, done in the Kakarooks' style, especially Joe's. The Kakarooks did not always sign their pieces; but when they did, they often rendered their name "Kakahvgook," "Joe Kakavgook," or "Kakavgook," spellings that are closer to the original pronunciation than Kakarook. Joe and Willie were later given the surname Austin by a white man who had given up on the native name.[3]

Many Eskimos who had made souvenir baskets and mats, ivory engravings, and fashionable canes and umbrella handles died in the influenza epidemic of 1918.[4] (Happy Jack and his wife also died then.) The souvenir market went into a temporary slump. Grass basket-making disappeared north of Saint Michael, and the production of ivory art marked time with the familiar engraved cribbage boards, letter openers,

2. Letter from Edward S. Rogers, Royal Ontario Museum, 13 February 1969.

3. For further information about Happy Jack and Guy Kakarook see Ray 1961, pp. 3–10, and Ray 1971b.

4. An Eskimo man who was twenty-three years old in 1918 gave me a list of objects that were most frequently made by "people who died in the flu": "dogteams, some figures, eagle or polar bear wrestling with eagle, gavels, pipes, cigarette holders, brooch, watch charm, fox handles, ptarmigans, grouse, fish, cribbage board with map, toothpicks, whale paperweight, reindeer, mastodon, kewpie, harpoon head for paper knife, dice, chess sets, leather belts with ivory, patchwork skin rugs for floor, baby sitting on can (no demand now, used to sell pretty good)."

napkin rings, and a new object, the billiken, which had been introduced to Nome in 1909 (figs. 137, 177).

The Billiken

The original billiken was a seated Buddhalike figure with a peaked head, a wide grin, and a fat stomach. Shortly after it was patented by Miss Pretz in 1908, it was adopted as a mascot for the Alaska-Yukon-Pacific Exposition. Apparently it was one of these figurines that Happy Jack copied in Nome in 1909. Since then the billiken has been made in all sizes within the limitations of a walrus tusk, and though departures from the original patented design have been tried—a hat on the head, "millikens" with breasts, milliken-billikens back to back, big ears, bigger legs, seated figures, and hermaphrodites—most of its characteristic elements have been retained: the peaked head, arms straight to the sides, feet indicated by toes or gashes, nipples, navel, broad grin, pudgy cheeks, and a big stomach. The size restrictions of a walrus tusk and the need to carve each billiken in a hurry by hand (the originals had been molded or cast) had not altered the identifying features to any degree. (The complete history of the billiken is found in Ray 1974a.)

New Engraving

With the death of many of the early twentieth-century engravers, a different style of engraving emerged, used almost exclusively by the King Islanders, who have always had plenty of tusks for large-scale engraving and who apparently had a fresh start in the souvenir market because they did not begin making ivory objects extensively for the souvenir trade until the 1920s, when they "learned from Nome" (D. Ray field notes. Few engraved drill bows or other engraved objects came from King Island during the nineteenth century). They also used the pictorial engraving on smaller objects like toothpick holders, knife handles, letter openers, gavels, and brooches.

The modified pictorial style utilizes line drawing with occasional shading to thicken the line or to fill in figures. One of the techniques used for shading is the zigzag, for both scenic engravings to indicate density and bird sculptures to indicate feathers (figs. 109–12, 271). This decorative device is used principally by King Islanders and a few Diomeders (who prefer, however, to make sculptured objects rather than to engrave). The Saint Lawrence people use entirely different techniques for representing feathers, which have been adopted by others for limited use (fig. 106). Some carvers prefer to leave their sculptures unadorned (fig. 108); and with the increased use of power tools, line drawings are not used for textural effects (fig. 103).

The consensus among carvers is that engraving is much more difficult and takes much more experience for adequate results than carving objects in the round. Little really good engraving is done today. Some craftsmen never acquire the experience necessary for good results because they either prefer making sculptures (which also requires great skill) or do not have enough ivory to engrave on a large scale. A carver can make much more money by carving a number of small objects from a tusk rather than using it whole or as a cribbage board.

Figurines

Small figurines and ivory bracelets, which constitute a large part of the carving inventory today, were not made by contemporary carvers before the influenza epidemic. They were suggested by nonnatives as a way to expand the market with greater variety and new styles of objects. The new forms were expected to be an improvement in the quality of carvings. This procedure was typical of the hit-and-miss development of all Eskimo market crafts. For example, in the 1920s Captain Edward Darlington Jones of the *Northland,* later an admiral in the U.S. Coast Guard, took illustrations of animals and birds to Saint Lawrence Island and suggested to the carvers what style and finish would be most acceptable and salable, and what the correct proportions should be. Then he bought only those that he thought were best, thus setting an arbitrary, non-Eskimo standard. At that time, the few carvings done for sale were considered by all who saw them to be crude and poorly made. The carvers concentrated at first on birds, which had always been favorite subjects, and a few large animals like bears. The animals were usually mounted on large, old ivory platformlike pieces, which were abundant in the coastal sands and archeological sites of Saint Lawrence Island. The birds, which became characteristic of Saint Lawrence carving (fig. 106), soon developed the imprint of the individual carver.

Animal figurines were made in Nome at that time mainly as ornaments on pen sets, ashtrays, toothpick holders, paperweights, or on any other object that seemed to need an Eskimo animal custodian. They were also made into salt and pepper shakers (figs. 109, 115), and various handles; but it was not until the 1940s that the animal figure became a form of sculpture in its own right. Because of the purchasers' insistence on animals that were thought to be most "typical" of Eskimo life—polar bears, seals, and walrus—other northern animals like mountain sheep, caribou, and moose were infrequently made. Furthermore these animals' appendages—tails, antlers, and thin legs—proved to be fragile, often breaking during carving or packing.

The viewing orientation of a piece of sculpture also changed from being hung or attached to other objects, or carried on the person, to being displayed on a flat surface. A few traditional objects were intended to stand or lie on flat surfaces (figs. 31, 33–35, 49), but in most cases this was only a coincidence of form and use.

Ivory Jewelry

A prized possession of the white woman of early Nome and Saint Michael was a long string of beads made either of new or dark-colored old walrus ivory. Each bead was shaped by a file as the ivory revolved around a nail. But the Eskimo woman north of Saint Michael rarely wore ivory ornaments and preferred small strings or clusters of glass beads in her ears, nose, or hair, and metal bracelets on her arms. The ivory bracelet as we know it originated in the 1920s when an Alaska Road Commission employee suggested that the carvers string ivory links on elasticized thread. The first bracelets were plain links of new or old ivory, but they quickly proliferated into an almost uncountable number of variations, among them the "animal bracelet," the "dog team bracelet," the "etched bracelet," the "story bracelet," the "inlaid

bracelet," the "double bracelet," and others with a variety of motifs like billikens, walrus heads, and bear heads.

The "animal bracelet," which has five or six links with a different animal in relief — seal, wolf, fox, beluga, whale, polar bear — originated among the Diomede carvers, and the engraved bracelet of several unrelated scenes (always called "etched bracelet" locally) was said to have begun in Shishmaref. The "inlaid bracelet," with geometric inlays of squares, circles, and Xs of contrasting material of dark ivory or baleen, has been attributed to George Washington (Sukrak) of King Island, who lived at Cape Nome during the 1940s and 1950s (fig. 184, middle). Otto Okpealuk of King Island descent was the first to make one on Little Diomede.

During the 1940s many variations came from these basic designs. A variation of the animal bracelet was the bear head bracelet, first made on Little Diomede by Jacob Ahkinga, and the dog team bracelet, by Spike Milligrock from an idea originated by him and Michael Kazingnuk, both of Little Diomede. (According to Albert Heinrich [1950, pp. 240, 241], an anthropologist who has lived on Little Diomede, the first dog team bracelet was made in 1938.) From the engraved bracelet came the story bracelet, an engraved narrative of six scenes, usually of a hunter who gets a seal and takes it home to his wife, said to have been "invented" by Andy Tingook of Shishmaref, later of Nome. In the 1950s bracelets were made larger by widening the links or by hooking two bracelets side by side, as a "double bracelet," in almost any combination that a carver thinks might appeal to a buyer: for example, a plain bracelet and animal bracelet, or a dog team and a billiken bracelet. Some are big and heavy and look more like trophies than jewelry.

Customers continued to make suggestions. For example, the original angular parts of the dogs and other animals on sculptured bracelets were eliminated after word got back to the carvers that they were catching on clothes as well as breaking off from the rest of the bracelet. The little figurines were then made sleek and streamlined. (Carvers around Bethel on the Kuskokwim copied the bracelet idea, but one of their innovations — pegging small animals to the ivory links — was not practical because the animals worked loose and fell off.)

Matching earring and necklace sets were made in profusion until the 1970s; then the demand decreased, and many of the older carvers who had made them their specialty died. An unusual necklace and bracelet of almost wafer-thin geometric slices of ivory was the "filigree necklace" invented by Robert Tungiyan of Saint Lawrence Island about the same time as the elasticized bracelets. He might have received his inspiration from Chinese bracelets of elephant ivory, but he and his two protégés (the only ones who made these necklaces) invented their own designs (fig. 182). The necklace is no longer made.

Erotic Objects

Of all objects made over the years, those catering to eroticism have had the least exposure. They led an underground existence until recent elastic interpretations of what constitutes pornography brought many of them out into open display. When I lived in Nome during the 1940s, all carvers knew who made the "dirty things," as they themselves called them in English, but were reluctant to reveal the carvers'

identities or to discuss the objects. These pieces always commanded a higher price than ordinary carvings; and the best carvers, who rarely made them, looked upon them with both contempt and amusement.

The most common forms were carvings of men and women in erotic positions, animal-human figurines, hermaphroditic billikens, "six-legged bears," the "billiken in a barrel," and the oosuk. The principal markets were saloons, where the proprietors often commissioned them. Curio shops never sold them. The saloons also obtained many beautiful carvings for a fraction of their worth from persons wanting to drink; but in the 1970s the saloons did not buy ivory as they once did because they did not want to pay the high prices the carvers could get elsewhere. Still, one man told me in 1973, "sometimes an ivory carving is just the price of a drinking session."

In the 1950s the euphemistically named "six-legged bear" made the rounds in pockets, furtively pulled out for inspection; but by the 1970s they were called what they portrayed, mating bears. They were openly displayed in stores, along with "mating seals," and were listed in catalogs as such. The baculum, or penis bone, of the walrus (always called by its Eskimo name, oosuk) is another object that was formerly viewed with secrecy and embarrassment. In traditional times these bones were utilized for little except clubs, though an unusual box made from the butt end of one was reported from Point Barrow in 1883 (Murdoch 1892, pp. 324, 325). During World War II this rather worthless bone was made into a salable souvenir by adding carved ivory bear and wolf heads to both ends. Figure 140 reflects the prevailing attitude toward them during 1955: the models holding the oosuks did not want their faces recorded in the same photograph as the bones. By the 1960s, however, almost all shops sold them; and by the 1970s large metal and wooden signs with capital letters, OOSUKS, cried for attention above the displays. Its greatest moment arrived when one was presented as an appropriate gift to the host of the Tonight Show by Eskimo participants ("Oosik [sic] Surprises TV Host," Tundra Times, 8 August 1973).

Erotic figurines, hermaphroditic billikens, and the "billiken in a barrel" (a billiken attached to an ivory or wooden barrel with rubber bands in such a way that its penis pops out when raised) were still sold surreptitiously in 1973. In the 1940s these objects were made by fairly skillful carvers who needed to provide a living for their families in a high-cost living area, but the ones that I saw almost thirty years later— some made by a woman—had no redeeming artistic features.

The Baleen Basket

Eskimo men and women have taken every opportunity to utilize all available materials to make objects that might be appealing to the collector. Most of these have come about through individual experimentation by persons not actively engaged in traditional ivory carving, but some, like jade and caribou-hoof jewelry, resulted from organized projects (see "Projects and Programs," below). Those that are still on the market include the baleen basket, the bentwood bucket, the horn ladle, the Siberian-style pipe, the caribou-jaw sled, the reindeer-horn doll, the "Anaktuvuk mask," the whalebone mask, and various replicas of needlecases, fishing lures, and fishing outfits.

The baleen basket was suggested as an object for market art sometime after 1905

by Charles D. Brower, trader at Point Barrow; but its production did not increase appreciably until baleen had declined in price after 1916, and basket-making helped to fill the economic vacuum. It was later adopted by men of Point Hope and Wainwright. The baskets, which need strong hands for their construction, are made by men. They are woven in an alternating single-rod coiling (adjacent woof strands alternate over warp strands) and were undoubtedly copied from split willow baskets that originally had been traded from Athabascan Indians, possibly from the Yukon River through Kobuk River traders. The willow basket and its technique of manufacture were not aboriginal with the Barrow Eskimos, according to John Murdoch, who collected the only four baskets (of any kind of weave) that he saw at Point Barrow during the years 1881–83. He illustrated three of them. The owner of one of the baskets said it had come from the "great river" to the south. (Murdoch interpreted this to be the Kobuk, but it may have referred to the Yukon.) Mason illustrated the same baskets in his 1904 study of Indian basketry, and called them the work of "Tinné Indians" (i.e., Athabascans) (Murdoch 1892, pp. 326–27; Mason 1904, pp. 392–93).[5]

Making a baleen basket is time-consuming. The most skillful weaver takes about fifty hours to make a basket six inches in diameter. The long blades of baleen are coiled and soaked overnight before being split into strips, each one-fourth to one-half inch wide. They are then dried in a warm room for about a week before weaving. The warp and the woof are scraped for hours to acquire a uniform shape and gloss. One of the earliest weavers was Kingoktuk, known as "the king of basket-makers," who used a close weave, or the "Kingoktuk-weave," as it was known in the 1940s (figs. 221, 222a, 222b). About the same time, Marvin Sakvan Peter, who always signed his initials on his baskets, originated the open weave, which became known as the "Marvin weave" (fig. 223). Both the warp and the woof are inserted into an ivory piece at the bottom where the weaving begins. A contrasting design is sometimes made by interweaving light-colored baleen. Each basket has a lid with an ivory knob of animal heads or other figures. In 1952 I saw an ivory replica of the Will Rogers–Wiley Post memorial at Point Barrow serve as a lid handle. Perfectly shaped baskets with well-fitting lids bring hundreds of dollars, and large ones are quoted in the thousands (Burkher 1954; Ray field notes; Spencer 1959, pp. 360–61).

Bentwood Buckets, Horn Ladles, and Horn Dolls

Bentwood buckets, which were a specialty of Shaktoolik men like Louis Nakarak and Willie Takak, are rarely found on the market now. They were patterned after those made in the nineteenth century, but usually with the addition of nicely finished ivory handles instead of the traditional wood (fig. 225).

The ladle made of mountain sheep horn was traded by inland groups to coastal people in the old days. It is still made by a few persons near Kotzebue and at Anaktuvuk Pass, but is rare because the rams are rare. The horns are steamed, bent, and smoothed so that they can be opened and shaped into bowl form. In 1973 the price of one was one hundred dollars in Kotzebue (*Tundra Times*, 7 November 1969; D. Ray field notes).

5. Nelson apparently collected only one basket in alternate single-rod coiling between 1877 and 1881. It came from Sledge Island (1899, pl. 74, no. 3) and probably had been obtained through trade.

A doll of reindeer antler, called the "horn doll," originated after World War II in Shishmaref for little girls and were later sold as souvenirs. As a doll and a souvenir it is a modern version of the traditional ivory doll dressed in typical Eskimo clothing (fig. 157). The horns have to dry out for three months before carving. About 1968 it appeared that their production would be limited because large quantities of reindeer antlers were exported to Japan for use as an aphrodisiac, but they were still made in 1973 (Harkey 1959; D. Ray field notes).

Siberian-style Pipes

In 1973 Siberian-style pipes were made by only two Saint Lawrence Island men, Albert Kulowiyi of Savoonga and Lincoln Blassie of Gambell. Mr. Kulowiyi's fine pipes, illustrated in figure 226, combine a casting and carving process found nowhere else in Eskimo material technology. They are made from walnut—usually discarded gunstocks—and a solder of 50 percent tin and 50 percent lead. Mr. Kulowiyi shapes the wood part and then ties a two-piece wooden mold over the stem, a three-piece mold over the bowl, and inserts a greased wire to form the stem hole. He melts the solder over a Coleman stove and pours it in two steps, one for the stem and the other for the bowl. The wire and molds are removed when cool and the pipe is filed and sanded. The two pipe makers are old and in poor health, and the process is in danger of being lost, according to Glen C. Simpson of the Department of Art at the University of Alaska (letter, 1974). A set of Mr. Kulowiyi's old molds is in the University of Alaska Museum.

Caribou-jaw Sled

The caribou-jaw sled, originated by Abraham Howarth of Kotzebue, is a good example of the utilization of almost unusable materials to create a salable item (fig. 228). Strips of baleen are used to finish the sled shape, which is suggested by the jaw itself despite the anomaly of teeth, which are always left in place. Other persons have borrowed his idea, and in 1972 Elizabeth Lampe from Barrow used a jaw sled in conjunction with a doll seal hunter and a seal (illustrated in Larsen 1974). Mr. Howarth, originally from Noatak, was a member of the relief party on the *Donaldson* to Wrangel Island from 1923 to 1925, and he made these sleds only in his spare time away from his various jobs over the years.

The Anaktuvuk Skin Mask

Caribou-skin masks, which are made by almost every adult at Anaktuvuk Pass, were invented for Christmas, 1951, by Bob Ahgook and Zacharias Hugo in imitation of Halloween masks, which Hugo had seen in Fairbanks shortly before. They made the masks while on their traplines, hid them upon their return home, and surprised their relatives and guests at the Christmas dance. Four and a half months later, when Ahgook and Hugo were again out on their traplines, Simon Paneak, one of the village leaders, sold them to two visitors to Anaktuvuk for five dollars each. No more

masks were made for four and a half years until an Anchorage teacher and three companions visited the village. In return for giving the villagers gifts and suggestions for souvenirs, Paneak and Elija Kakinya, another village leader, sent them a dozen wooden masks, which they had made in the same style as the original skin ones.

An Anchorage gift shop offered to take thirty masks at twenty dollars each, whereupon enterprising Susie Paneak, Simon's wife, made one of caribou skin instead of wood, which she found difficult to carve. Both she and Elija Kakinya's wife sent some of the first skin masks to Anchorage for sale. About this time (1957), Justice Mekiana, another Anaktuvuk man, invented the technique for stretching the skin over a wooden face mold now used for making masks. Mekiana's method reduced the mask-making time to only one day, and by using several forms he had a number of them drying at the same time. After the skin has dried, eyes and mouth are cut out, and the eyebrows, mustache, and ruff attached. In the 1970s the making of these masks by both men and women had become the most important economic activity of the village.[6] Skin masks are illustrated in figures 229 and 230.

About the same time as the Anaktuvuk skin mask was put on the market, masks of porous whalebone were made as souvenirs, mainly by Point Hope carvers. They were patterned after the old wooden masks, especially the plain countenance mask in figure 69. They are heavy and are made only for hanging on a wall. An unusual one is figure 159, which is a modern version of the shaman's mask illustrated and described under figure 24 and in the discussion of wooden masks in Chapter II.

CLOTH AND FUR PRODUCTS

Women have tried to carve and make objects that were traditionally unassociated with women's activities with increasing frequency since the 1930s, most of them admitting that they do it "to make money," or in phraseology consistent with the times, "for economic reasons." In the early days many had helped their husbands polish ivory and string beads, but they did not do sculptural or engraving work. In 1955 an Eskimo woman told me, "They began to carve when they needed money." The women of Saint Lawrence Island were carving long before others, since the cooperative stores concentrated on ivory and did not handle fur goods.

The few women who had earlier shown an interest in the general arts had either been absorbed into a wider world without the label "Eskimo artist," as was Edna Wilder, formerly of Bluff, forty miles east of Nome, when she moved to Fairbanks (*Tundra Times*, 22 June 1964), or had put aside their interest for other reasons, as did Florence Nupok Malewotkuk of Gambell. In the 1920s, as Florence Nupok, she made ninety-seven sketches for archeologist Otto William Geist when he was excavating sites on Saint Lawrence Island. The sketches were eventually placed in the University of Alaska archives with photographic copies in the Smithsonian Institution (fig. 268). Florence renewed her interest in art when she entered the Manpower Development and Training Act Designer-Craftsman program in Nome in 1964 (as Florence Malewotkuk), the only woman participant. Her works were

6. The basic reference for Anaktuvuk masks is Atamian 1966, which is based on field research. The short article by Cline (1969) gives a succinct description of mask-making, but mistakenly says Mekiana was one of the originators. An article in the *Tundra Times* (16 May 1973) by a college student from Anaktuvuk Pass contains an assortment of errors.

eagerly sought, and before her death in 1971 she knew that one of her drawings had been auctioned for $1,000 for benefit of Hope Cottage, an Alaskan home for mentally retarded and handicapped children (Ray 1969, p. 50; *Tundra Times,* 12 August 1970).[7]

But it is still in fur and skin sewing that the Eskimo woman feels most at home. The greatest continuity in Eskimo handicrafts is in sewing, though changes have constantly been made. Fur sewing has continued in traditional styles for the Eskimos' own use as well as diverging into a group of products adapted for nonnative wear and enjoyment. The woman's pride in making the meticulous designs for insets and borders of parkas and in developing the geometric trimmings of later years (figs. 194–96, 198, 201, 259) can be seen in the entries in statewide exhibitions that were inaugurated in the 1960s. Categories of women's arts for the Alaska Festival of Native Arts held annually in Anchorage usually include fur parkas, mukluks, cloth parkas, dolls, woven grass baskets, birchbark baskets, and miscellaneous sewing. Although the cut and fit of the parka is important, the ornamental designs are the basis for competition. Designs like those in figures 194 and 196 take many months to complete.

The "miscellaneous" category represents all of the innovations in fur, bleached skin, and cloth made since the souvenir bags of the 1870s—hats, vests, purses, belts, slippers, yo-yos, pincushions, and wall hangings.

The soft-bodied doll was an innovation of gold rush days and was made for display as much as for play. One of the most meticulous seamstresses, known far and wide for her skillful fur sewing, was the late Mrs. Ethel Washington (Napatuktoo) of Kotzebue. After the death of her husband in the early 1940s, she originated a "doll family," a set of three dolls, man, woman, and child, in which every detail of clothing, birchbark berry bucket, spoon, and man's bow is in perfect miniature (figs. 198–200; Frank W. Long in *Smoke Signals,* no. 22 [Feb. 1957]:1–2). Mrs. Washington patterned the alderwood faces after real persons. Since her death the dolls have been greatly sought by collectors at prices twenty to thirty times their original cost.

A few doll makers dress their dolls in cloth, which may become a common practice if the provisions of the Federal Marine Mammal Act are strictly enforced. One of these is Hazel Omwari of Gambell. The outer cloth parka in figure 202 is commonly known as *kuspuk,* a word adapted recently in the north from the southern Eskimo language. It is uncertain whether the Eskimos made up their own pattern for the original cloth parka with the wide bottom ruffle, as some women maintain, or whether the idea was adapted from a Hawaiian garment brought to the Eskimos by traders from the islands. This tentlike gown was adapted by Hawaiian missionaries from the "Mother Hubbard," which was apparently first illustrated in 1765 in *Mother Goose's Melody.* It has endured as a very practical garment on all parts of the Alaskan coast, especially in the smaller villages, because of cool summers and almost constant winds at fishing and camping sites. It is often worn with an undercoat of lightweight fur. Sometimes the cloth parka has an attached ruff, as seen in figure 197. But it has also been adopted in a more sporty version for many kinds of native and nonnative wear. An up-to-date version of the cloth parka was

7. Some of Florence Nupok Malewotkuk's sketches were illustrated in Geist and Rainey's report (1936). The cover of this report is shown in figure 268. Several other early sketches are illustrated in Ray 1969, p. 51. Other drawings are illustrated in Matthews 1973.

worn in 1973 by waitresses in the Nugget Inn III Coffee Shop in Nome. Most of the garments were short, and one girl had a "mini-*kuspuk*," which was very short indeed.

The origin of appliquéd pictures of skin, fur, or felt is unknown; but during the gold rush, patchwork squares of fur were made to hang on the wall or to lie on the floor. Examples of recent mosaic and appliqué work are six sealskin mosaics representing God the Father, the Son, the Holy Ghost, baptism, communion, and God's Word made by Eskimo women for Our Savior's Lutheran Church in Nome in 1958 (fig. 209); and a childhood scene made of dyed bleached seal by Hazel Omwari in 1968 (fig. 212). This kind of work is also done in felt, a material suggested to the Eskimo women of the Evangelical Covenant Church by missionaries about 1940 as a means of raising money for the church. Many women now make scenes of Eskimo life in various sizes for framing and for borders on cloth parkas. Not much work has been done in stitchery, which might be popular once the right subjects are found. One of the many possibilities is suggested by the Bible verse illustrated in figure 277, which is an example of the picture writing developed during the early twentieth century for the older Eskimos who could not read English. Although this needlework was done by a nonnative woman, it was copied exactly from a verse drawn for me by Lily Savok in Kotzebue in 1968. Mrs. Savok, an interpreter and missionary originally from Buckland, was one of the originators of this unique "scripture writing" about 1914 (see Ray 1971a).

The origin of the "Eskimo yo-yo" is also shrouded in mystery. One day there was none; the next day it seemed that these little balls were hanging or whirling everywhere on their two strings tied to a "swinger" of wood or ivory. They were not traditional toys; at least, I have found no reference to them, and I did not see them in Nome in the 1940s. I became aware of them in 1955. The object of the yo-yo is to swing the balls in opposite directions on a vertical plane while holding the swinger. The two original round balls have now taken many forms—furry animals, miniature mukluks, kayaks, birds, or anything that will utilize scraps of material or give the seamstress a chance to display originality in design (fig. 211). Some are woven of grass.

Footwear was a category of sewing that proliferated into many varieties for the non-Eskimo purchaser. Mukluks and slippers were good "tourist" items both in size for packing and in cost. Yet the Eskimos continued making them for their own use, though they sometimes differed in design and style from those made for sale. Footwear used almost exclusively by Eskimos themselves include "water [waterproof] mukluks" (fig. 196, left), "dress water mukluks," and "fancy mukluks" (figs. 198, 259). The "dress mukluk" is a water mukluk without a waterproof seam and with a top border of dainty decorative stitches and geometric designs. "Fancy mukluks," with alternating colors of fur, were the ultimate in native footwear, but by the 1960s they had become rare and had been replaced mainly by those made from only one kind or color of fur, especially for the market. They had top borders in a wide range of geometric patterns, usually made of imported black, brown, or white calfskin. Bead designs were also used on mukluk borders as well as for toe pieces of "slip ons" and slippers (figs. 196, 204). Delicate fur mosaic work for slipper toes, like those in figure 203, are almost a thing of the past because of the work and expense involved.

The most frequently made footwear in the 1970s were short mukluks, slippers

(both "hard sole" of bearded seal and "soft sole" of cold-bleached seal or bearded seal) and an outdoor boot called the "slip-on," which was designed about 1950 at the Nome Skin Sewers Cooperative Association especially for leisure-time or non-rugged wearing, when a woman from a "government boat" wanted a special boot made that "slips on." They have remained the same style for over a quarter of a century, retaining the original hard sole, bead toe-piece, fur trim at the top, and clipped reindeer lining.

The Nome Skin Sewers Cooperative Association was the first Eskimo-owned business to try to provide a central workshop and marketing outlet for the work of Eskimo men and women.[8] After receiving a bonus for a government contract making arctic clothing during the late 1930s, a group of sewers obtained a twenty-year charter in 1940, but did not renew it because of competition by private stores and government agencies and inefficient marketing methods. They were given technical help by an arts and crafts specialist from the Bureau of Indian Affairs, but the consensus of all of the women I knew was that the persons sent to help them had little knowledge of the peculiarities of fur sewing or the marketing of skin products.

One of the founders and its manager during the duration of its chartered period was Emma Willoya, an Eskimo woman who has devoted her life to the welfare of her people. She has served as an interpreter on many occasions and, as a member of the school board of the Bureau of Indian Affairs school in the 1920s, set up programs of sewing and ivory carving as practical studies for the students. In the outlying villages the girls learned to sew when they were small, but in Nome many had no way of learning except in school because their mothers could not sew.

The Skin Sewers owned a building in Nome where members sewed and held meetings. They had drawers and racks full of slippers, mukluks, parkas, raw skins, and a table of baleen baskets, ivory carvings, and old artifacts sent by villagers for sale. Members who owned shares as well as nonmembers could sew for the cooperative. As many as thirty women sewed during a busy winter. Some persons came to the building; others took their work home. Work was usually done on a consignment basis with materials provided either by the individual or by the cooperative. Finished products were also bought from local women and the villages. Even little boys and girls made tiny souvenir slippers to earn money. The standards for sewing were high, and work was sometimes rejected. Different villages had their specialties: Wales was thought to have the "best" soft-soled slippers; Shishmaref, the "best" mukluks and most bead work on the top border; and Kotzebue had the "best" hard-soled slippers. It took a sewer about a day to make a pair of slippers, including the toe designs, and two or three days to make a pair of mukluks.

Skins used by the cooperative were commercially tanned, but products made of "native-tanned" skins were willingly bought from the village women. The cooperative filled orders for retail outlets in Anchorage and other cities and also made fur clothing to individual specification: coats, fur hats, galoshes, children's snowsuits, and all sorts of bags and purses. There were many secrets in sewing for export. For example, the cooperative did not use local rabbit fur as slipper trim to send out of Alaska because it was unresistant to moths. The "Santa Claus boot" and the "Lapp

8. There was no connection between the Nome Skin Sewers Cooperative Association and a similarly named private organization in Nome during the 1970s. I collected information about the cooperative in 1950 and 1955, but I had been well acquainted with their products and personnel during the 1940s.

boot," which are no longer made, were not usually sent to the rest of the United States, where soggy snows often prevailed. These once-popular items looked almost alike. Both had turned-up toes and a fur sole, which was practical only on dry snow. The Lapp boot was patterned after one worn by Laplanders who were brought to Alaska in 1894 and 1898 for reindeer herding. The top border decorations were made of brightly colored yarns and felt, and the boot was tightened around the leg by cinching criss-crossed laces in front rather than by tying wrap-around thongs.

Until the 1950s sewing was the sole support of many families, either through the Nome Skin Sewers Cooperative, the village cooperative stores, or other retail outlets in Nome. Young girls in the northern villages still took an interest in sewing at that time, but in the 1970s—a generation later—many of the older seamstresses had died or were so incapacitated that they could no longer sew, and the younger generation had, for the most part, turned to other activities and careers, especially those who had attended high school and college. A few women are still sewing, doing beautiful work of their own designs based on the standard types of clothing (for example, Laura Beltz Wright turned her knowledge of sewing into a thriving business in Anchorage, "Laura Wright Parkas"; and Agnes Slwooko Turner has done likewise in Fairbanks); but the total production of sewing in the villages of coastal northwest Alaska is only a fraction of what it was thirty years ago, when slippers, mukluks, and parkas filled the shelves and racks of several Nome shops and were sent to all parts of the United States. The women who continue their sewing often do so reluctantly because the high cost of materials—in some cases four times that of a generation ago—results in only pennies of profit; indeed, several women to whom I talked in 1973 felt that they would have to quit altogether. The greatest output of traditional sewing was centered in southwest Alaska, and the majority of entries in both sewing and basketry in the native art festivals came from the Eskimo areas south of Saint Michael.

PROJECTS AND PROGRAMS

Except for school programs in sewing and the twenty-year operation of the Nome Skin Sewers Cooperative, all organized activities and projects have been in men's traditional pursuits. The first official attention paid to the huge reservoir of Eskimo arts and crafts was the establishment of the Indian Arts and Crafts Board, an agency of the U.S. Department of the Interior by an act of the Congress in 1935. As stated in the first issue of *Smoke Signals,* a circular for craftsmen published by the board between 1951 and 1968, "the function and duty of the Board is to promote the economic welfare of the Indian tribes through the development of Indian arts and crafts and the expansion of the market for the products of Indian art and craftsmanship" (no. 1 [November 1951]). Besides sponsoring a publications program and furnishing advice on crafts to Eskimo and Indian tribes in the United States, the board oversees three museums, the Museum of the Plains Indian (Browning, Montana), Sioux Indian Museum (Rapid City, South Dakota), and Southern Plains Indian Museum (Anadarko, Oklahoma), all of which were transferred from the Bureau of Indian Affairs after 1954.

Although the BIA had no formal connection with the Indian Arts and Crafts Board, the two often worked together. One of the first cooperative steps was organizing a department of arts and crafts in the Alaska Native Service (BIA) and establishing a retail clearinghouse in 1937. Two of the reasons for the clearinghouse were to provide a market for native Alaskan crafts, which at that time were "generally regarded as 'distress merchandise'" (aggravated by fraudulent totem poles and ivory carvings from Japan), and to try to make the public aware of the difference between the genuine native-made article and frauds (Burrus 1953, p. 7). For years the clearinghouse was hampered by lack of funds and depended on the BIA and IACB for support; but in 1944 it was able to pay the manager's salary, and in 1951 became self-supporting. In 1956 Alaska Native Arts and Crafts Clearing House became Alaska Native Arts and Crafts Cooperative Association, Inc., and in 1961 a retail shop was opened in Juneau. Villagers from all over Alaska sent goods to ANAC to be redistributed to dealers and individuals. At first almost everything was accepted, but by 1951 specially needed items were requested. Until recently, an emphasis was placed wholly on traditional designs.

ANAC has proved successful despite the competition of private traders and shops. A new store was opened in the Juneau Indian Village Crafts and Culture Center on 2 July 1973 (since moved farther downtown), but the general office and warehouses were moved to International Airport in Anchorage, where a downtown store opened in 1974. (By 1976 only the downtown store was operating.)

Probably the most serious deterrents to the continuation of traditionally oriented arts are the diversity of careers open to the younger men and women who attend college or trade schools, and the possibility that money accrued from the Alaska Native Claims Settlement Act of 1971 will be distributed to individuals. If the village Eskimos were assured of a steady income, and if money were the sole reason for carving and sewing, then the end is in sight for the majority of Eskimo arts.

There are, however, two factors not present earlier which may be attractive enough for the individual artist to continue in a full-time career: first, the substantially higher prices for most craft work; and second, the emergence of art from the confines of narrow ethnic boundaries. A full-time career in art has not been unusual among the Alaskan Eskimos, but in most cases it has resulted from chance, often an accident or illness, which prevented a man from carrying on his regular Eskimo activities. Happy Jack's career was doubtless furthered by his inability to engage in hunting because of his crippled feet, which had been frozen during his youth. Carving in the new money economy became a substitute for subsistence activities. Three of the best-known graphic artists in media other than ivory, George A. Ahgupuk, Robert Mayokok, and Kivetoruk Moses, began their careers while in the hospital, Ahgupuk and Mayokok with tuberculosis, and Moses after an airplane accident. (On the other hand, Howard Rock of Point Hope studied at the University of Washington in the 1930s and gave up his art career to guide the *Tundra Times,* a native newspaper, from its first issue in 1962.) But the young artists of the 1970s have chosen a career in art from many possible careers open to anyone living in Alaska. Much of their way is now paved with projects, scholarships, seminars, conferences, and workshops both in the villages and in the schools; but it was only a few years ago that teachers and the Indian Arts and Crafts Board specialists were struggling to find funds for the diversification of media and designs to expand Eskimo arts and income.

The Shungnak Jade Project

The first project in the joint sponsorship of the Alaska Native Service and the Indian Arts and Crafts Board was the Shungnak Jade Project in 1952. Using jade was a wonderful idea for Eskimos of the Kobuk River, as they lived near a large source of nephrite and had few other materials for market art. Nephrite is hard and tough, however, and earlier inhabitants of the vicinity used it only occasionally for adzes and large blades. It was actually a foreign material to the twentieth-century men, and the lapidary procedures that they learned did not hold their interest for more than a decade. The jade project was abandoned shortly after my visit to the new workshop in 1961, but it had produced a number of book ends, beads, and plain bracelets, pendants, crosses, and earrings, all suggested by the arts and crafts specialist. The most unusual design was an earring shaped like a seal (fig. 189). In 1960 participants in the workshop made two jade gavels, which were presented to the Speaker of the House and the president of the Senate of the first Alaska state legislature (D. M. Burlison note in *Smoke Signals,* no. 35 [August 1960]).

The Eskimos had made all of these objects from the raw boulder jade to finished product with their own diamond saw and power tools. They did not send the jade to China or Germany for cutting and shaping, as is customary for most Alaskan jade products. In the 1970s native artisans used some nephrite in various lapidary workshops, but a large amount of jade for sale in Alaskan stores has been finished abroad.

Kivalina Caribou Hoof Project

The next program aimed toward economic self-sufficiency of craftsmen was the caribou, or reindeer, hoof project, which began in 1956 at Kivalina. Snow goggles made from two halves of a single caribou hoof had been in use for many years when the teachers Bert and Isabelle B. Bingham thought that buttons and belt buckles in addition to the goggles would be good items to sell. Frank Long, the arts and crafts specialist, saw the possibilities of this material for making jewelry. He experimented with designs and ways to soften the hoofs and, along with modern hand tools and power equipment purchased by the Indian Arts and Crafts Board, handed this information over to the people of Kivalina (*Smoke Signals,* no. 21 [November 1956]: 4–5).[9]

The hoofs were boiled until soft, then flattened and cured for two weeks before they were scraped, carved, and polished. The resulting material looked like tortoise shell. The most commonly made objects were pins, cuff links, charms, earrings, necklaces, and tie clasps in various geometric designs and in the shapes of whales, ulus (woman's knife), fish, masks, and the same seal design as the nephrite earrings. The mask design (fig. 187) was not native to northwest Alaska, but was adapted from the Yukon area by the arts and crafts specialist. The project got a new shop in 1960 and continued for about a decade. In 1973, however, the ANAC catalog illustrated

9. Mrs. Bingham was also responsible for the popular "Eskimo Cookbook," which was written by Shishmaref schoolchildren in the early 1950s and is still sold for benefit of the Alaska Crippled Children's Association, Inc.

only reindeer-hoof snow goggles—a return to the original article from a once diverse array.

Noorvik Projects and Taxco

About the same time as the Kivalina project, metalcraft and jade projects were introduced at Noorvik, but they were short-lived. The arts and crafts specialist who started the metal project himself said that the Eskimos were working with materials "with which [they] were relatively unfamiliar. Copper and silver, in the forms used in craft work, were as strange to them as the special tools and equipment employed in the craft" (Frank W. Long in *Smoke Signals,* no. 10 [February 1954]: 9). Several metal earrings and brooches utilizing motifs from the Old Bering Sea culture were displayed in the Eleventh Annual Creative Arts and Crafts Exhibition in Juneau in 1955 (*Smoke Signals,* May 1955, p. 4, and November 1957, pp. 10–11). The unfamiliarity with working in metal had also been responsible for the failure of a workshop for about twelve Alaskan men at William Spratling's studio in Taxco, Mexico, in the 1940s. Not one of them went on with the work, and all viewed the trip as a lark (D. Ray field notes).

Canadian Eskimo Art and Implications for Alaska

During these years a most unusual artistic revolution in soapstone sculpture and printmaking was taking place among the Eskimos of Canada. The Canadian Eskimos, who lived in widely separated settlements with only a few white missionaries, teachers, and traders among them, were not entirely unacquainted with market art; but the objects offered for sale and the opportunities to sell them were like Alaska before the gold rushes and the shipboard trade (Martijn 1964, pp. 558–61). There was no steady demand for souvenirs such as that which developed in the Alaskan towns of Nome, Saint Michael, and Teller, where the Eskimos embarked on an uninterrupted production of artifacts for sale. Compared to the Alaskan Eskimo, the Canadians had a limited supply of walrus ivory, yet soapstone had not been used as an art medium in historical or prehistorical times (ibid., pp. 566–69). A Hudson's Bay Company attempt to stimulate a handicrafts market in the 1930s had not met with success, but in 1940 the Canadian Handicrafts Guild was asked by the Department of Northern Affairs and National Resources (present name) to provide an outlet for Eskimo crafts (in other words, souvenir knickknacks) to counteract losses in hunting and trapping. It was not carried out.

In 1948 a painter, James Houston, made a trip to Hudson Bay and returned to Montreal with a few small soapstone carvings, which the guild thought should be publicized and distributed. Houston obtained a thousand pieces the next year, which were exhibited and sold in only three days' time. He returned to various places in the Arctic thereafter with suggestions and drawings. Educational programs began, cooperatives were formed, and printmaking started. Both George Swinton and Charles A. Martijn, whose writings about this sculpture are indispensable, still do not know exactly "how it all happened," but this "unprecedented art style" resulted in something which even the most extravagant dreams or best-planned project

could not have anticipated or achieved. (Information about the origin is found in Graburn 1967; Martijn 1964, pp. 561–65, 576–79; and Swinton 1965, pp. 42–52).

Many pamphlets, catalogs, and books were written about this art from its beginning, and some of Houston's writings contributed a mystique of false conceptions. But the efflorescence of this amazing sculpture and the prints that followed have made an impact of unusual proportions on the art world. Printmaking began in the early 1960s, becoming as popular and economically successful as the sculpture. The Alaskan carvers, however, imitated the soapstone objects, but ignored the unique styles of the prints, probably because they had already begun developing their own techniques in the extension service courses provided by the University of Alaska (see below). "Eskimo art" is now more often equated with these works of sculpture and graphics than with any other form, and they are almost better known than the old pictorial engravings and sculptured ivory animals and birds of the Alaskan Eskimos, which once were so well-known as "Eskimo art."

The mystery of its excellence and imagery and quite different direction from Alaskan art forms before the 1960s is doubly perplexing when it becomes apparent that some of the same techniques were used to stimulate both the Canadian and the Alaskan carver. Martijn quotes a number of observations made between 1949 and 1953 about the Canadian techniques that read as if taken from Alaska: suggestions were given as to what would be the most "salable" objects; the Eskimos were provided with illustrations, guide manuals, filmstrips, and even other Eskimo carvings to use as guidelines (some were pictures of ashtrays, cribbage boards, and match holders!); and the "best" carvings (according to Western standards) were purchased. One carver, when asked how he decided what to carve, said that he usually sought Houston's advice. Every carving was aimed at the non-Eskimo buyer because "all carvings are destined for export to the Kabloona world, there to grace the white man's mantelpiece." The Eskimo carver "neither keeps them for himself, nor sells them to other Eskimos for their personal use" (Martijn 1964, pp. 563, 564, 570).

While the new Canadian soapstone sculpture was succeeding beyond all expectations, in Alaska ivory carvings still predominated, with the short-lived projects in jade, metal, and caribou hoof materials providing variety and opportunity for experimentation. But in the 1960s were ushered in the first new hopes that the Alaskan artist might produce works on a level other than souvenirs, although it should not be forgotten that many ivory carvings are successful works of art. The new hopes were expected to materialize through educational projects and workshop-retailing projects (mostly backed or inaugurated by the Indian Arts and Crafts Board), but again they fell short of their objectives aimed at *group* and community success. At the same time, several young artists, as *individuals,* were heading in a new direction because of their formal education in art.

The poor record of projects and organized attempts at group production and marketing of objects destined entirely for nonnative use contrasts markedly with the success of the individual artist. The northwest Alaskan men have never liked to work together in artificial cooperation—that is, one in which they are thrown together at someone else's suggestion—because of a natural reserve, and because traditional cooperation was mainly accomplished through structured kinship groups, within which a great deal of individual choice was permitted. Although the hundred-year history of market art appears to be a group capitulation to styles, designs, and use of materials, it has actually been an extremely individual art in which each per-

son was free to choose what he was to make and how he was to make it, providing he could sell it. Even though the ideas and prices were shaped by market conditions, he would have resented the interference of organized control.

I think it is worth making the point here that the ivory carvers and ivory carvings have never had subsidized programs—and it is the ivory carvings which, even in the 1970s, constitute the mainstay of Eskimo crafts (except for sewing) in Alaska—whereas all of the other projects have been fully subsidized from various sources, even with many participants receiving per diem payments and wages for learning or monthly stipends for participating. Almost without exception, the younger, academically trained artists have been fully supported with scholarships, grants, and salaries from beginning of training to their present production while using their training to carry out further projects and produce their works which command high prices.

Designer-Craftsman Training Project

A new approach to Eskimo art through the combination of formal training and production workshops was realized in a pilot program in August 1963 in Nome. The pilot program ended with the discovery that Eskimo carvers had little understanding of design, but that further projects would be feasible. Accordingly, the first project under the Manpower Development and Training Act, which originally planned to include twelve hundred native Alaskans in thirty occupations, was the Designer-Craftsman Training Project. Thirty-two trainees, including one woman (Florence Malewotkuk), enrolled in the course that began on 28 September 1964 and ended 30 June 1965 in Nome. More than half of the enrollees who were accepted came from King Island or Saint Lawrence Island; none lived north of Point Hope. Only two came from south of Norton Sound and they did not finish the course. The aim was to acquaint the participants with new equipment, materials, and designing for contemporary markets. The latest hand and power machinery was used in workshops in woodcarving, silversmithing and lapidary, stone carving, and some ivory carving. The older participants returned to their villages to continue their old ivory carving or baleen basketmaking; but several of the younger participants like Teddy Pullock, John Penatac, and Alvin Kayouktuk moved away from the Nome area and continued in the arts and crafts field as training specialists or as artists-in-residence in various villages.

Further Programs and Workshops

From this surge of activity came the establishment of workshop-retailers with varying degrees of success. Ki-Kit-A-Meut Arts and Crafts Co-op was begun in Shishmaref (the village Eskimo name is Kikiktuk or Kikiktamiut, hence the name; the cooperative's name has also been spelled "Ki-Kit-Ta-Muet" by the Indian Arts and Crafts Board), and Inupiat Arts and Crafts, Inc., was formed in Teller with nineteen members. (In 1973, when I visited Teller, they were inactive; but in 1974 they were listed again in the Indian Arts and Crafts Board circular on crafts sources.) The Shishmaref group was also still active in 1973. Arctic Eskimo Arts and Crafts Associ-

ation was organized at Nome in 1966; and equipment, funds for operating expenses, and a building, located a short distance from the King Island community building, were furnished by the Indian Arts and Crafts Board. When I visited it in 1968 only a few young persons were working, and a padlock was on the door most of the time. Later that year it was revitalized under the name Sunarit Associates Cooperative. The workshop had closed by the summer of 1973, but members brought their goods to a shop off the lobby of the Nugget Inn III. In 1975 the Bering Straits [sic] Eskimo Arts and Crafts Cooperative was organized in Nome with a federal disaster relief grant after the devastating storm of 12 November 1974 along the Bering Strait coast to sell goods for outlying villagers as well as for local craftsmen.[10]

Since 1965 there has been a steady stream of meetings, programs, proposals, and grants of money to promote native arts, both Indian and Eskimo, especially through schools and universities. By the success already demonstrated, the future of "native" art lies in the academic programs and academically trained persons in which the individual artist's talent is developed unencumbered by a narrow community program. The general day schools and boarding schools always had sufficient programs in art, but the teachers for the most part were either untrained in art or did not inspire creativity. The curriculum, however, at least provided a chance for the pupil to use his hands. The first big step to widen the horizons in design and acquaintance with a variety of materials and other art forms was the founding of the Institute of American Indian Arts by the Bureau of Indian Affairs in Santa Fe, New Mexico, in 1962. The initial enrollment included eighteen Indians and Eskimos from Alaska. The variety of studies is wide, and the intercultural influences from the beginning formed both an ethnic and cosmopolitan base for the pursuit of their own special tribal backgrounds (New 1968).

In 1965, following on the heels of the MDTA program, the Extension Center for Arts and Crafts was initiated at the University of Alaska in collaboration with the Indian Arts and Crafts Board, directed by Ronald Senungetuk, an Eskimo man from Wales, who had studied art in Rochester, New York, and in Norway. The first five students who enrolled in the fall of 1966 already knew how to carve ivory, but were interested in using new materials and methods. In the ten years of its existence, many persons who would not ordinarily attend a higher academic institution have taken advantage of the unique facilities offered them. About eight students—usually native artists already experienced in traditional media—attend for a period varying from two to four years with grants from the Bureau of Indian Affairs (Tundra Times, 18 June 1975).

The Division of Statewide Services of the university also began a program, the "Village Art Upgrade Program," in 1970, in which several established young artists visited various villages to help craftsmen with new designs, ideas, and materials. Their aims were similar to those formerly espoused by the Indian Arts and Crafts Board, especially regarding the use of old subject matter on "new" materials. After all the years of market art, and the implementation of one project after another, it was felt that the village craftsmen should make a "new" start; but some villages were found to be "too westernized" to participate in the program (Tundra Times, 13 Oc-

10. In 1972 the Eskimos of the Nome area organized the Bering Straits Native Association, using the inaccurate plural, "straits," in their title instead of "strait." This incorrect word is now unfortunately used in all of their communications and new titles (as in this cooperative), news releases, and is often reprinted thusly in other publications. There is only one strait between Alaska and Siberia, and this singular usage is noted on all up-to-date maps.

tober 1971). Apparently the initial plan was to continue Eskimo art as "Eskimo" art, yet nonnative ideas and materials had been contributing to "westernization" for over a hundred years.

This adult vocational program was still active five years later, and in April 1975 thirteen native craftsmen-teachers employed by the university from all over the state attended a workshop to discuss marketing procedures. Over the years, the original emphasis (or publicized emphasis) on improving the crafts had become secondary, the primary goal being "to increase the income or improve the economic status of individuals who earn all or part of their income from production and sale of Native arts and craft items" (*Tundra Times,* 30 April 1975).

Another community program was begun at Shishmaref by the Community Enterprise Development Corporation in 1971. The CEDC was funded by the Office of Economic Opportunity for assistance to businesses in rural Alaska. Gabriel Gely, a Canadian arts and crafts specialist whose work with Canadian Eskimos—especially at Baker Lake—was responsible for a high quality of carvings, was hired to stimulate current production of crafts into the fine arts category. Shishmaref was chosen because the CEDC was already working with the Ki-Kit-A-Meut Arts and Crafts Co-op. Gely did not teach or hold classes, but expected the people to discover their own talents over a period of time. (This small village, population 267, had already produced George A. Ahgupuk, Kivetoruk Moses, Melvin Olanna, Andrew [Andy] Tingook, Wilbur Walluk—and the horn doll.)

Gely brought photographs of Canadian styles and forms, and utilized "new" materials, like whalebone. One of his aims, to have the people create something "of great worth—maybe $1,000," was difficult for the artists to visualize because the artist would probably have to wait until far in the future to realize such a sum instead of getting a smaller amount immediately for a more salable object. A few interesting pieces came out of its first phase, but most of them looked like Canadian Eskimo art (interview with Cheryl Fisher, *Katituat* 1, no. 1 [May 1972]; *Tundra Times,* 21 March 1973; figs. 155, 156). Gely left on leave of absence in 1972 and Teddy Pullock, one of the MDTA participants and art student at the University of Alaska, became artist-in-residence for the Shishmaref Arts Project, as it was called. Meanwhile, another Eskimo artist had conducted a workshop of the "Village Art Upgrade Program" there.

In November 1971 a symposium for Alaskan and Canadian Eskimo artists and cooperative managers was held at Alaska Methodist University (Frederick 1972, pp. 40–41). In 1972 the Experimental Arts and Crafts Center, later named the Visual Arts Center of Alaska, was established in Anchorage with a $25,000 grant from the Rockefeller Foundation. In 1974 it received a much larger grant from the Ford Foundation for organizing facilities for serious development of workshops, displays, and encouragement for both nonnative and native artists to experiment with design, materials, and techniques.

During the school year 1973/74, a Visiting Artist Program began in the Nome elementary school with funds from the Indian Education Act. This program was part of a more general one begun through the junior high level. Specialists from Alaska and the lower states gave demonstrations and taught for a period of from three to five days. The specialists included Frieda Larsen, Frances Ayagiak (basketmaking), William Soonagrook, Sr., Bernard Katexac, Lloyd Elasanga, and Larry Ahvakana, whose previous work is illustrated here in figures 102, 103, 169, 204, 217, 272,

275, 287, 288, 289. Ahvakana also spent a month in Nome as artist-in-residence. The evaluation of the first year was that it benefited those on the junior high level much more than on the elementary level, and the monotony of drawing all year long, which was the main part of the work, contributed to some boredom on the students' part. The program was especially rich in equipment and art materials (*Katituat* 2, no. 10 [1974]; private communication).

In recent years a large amount of publicity for native Alaskan arts and encouragement for the craftsmen has come from native art shows. In 1967 the first state-wide juried arts and crafts show was held in conjunction with the Alaska Festival of Native Arts (*Tundra Times,* 14 April 1967 and 30 June 1967). Prizes were given in silver jewelry and in wood and soapstone sculpture, a far cry from the categories in the annual Northwestern Alaska Fair and Festival in Nome of the 1930s and 1940s: "ivory objects," "table utensils" (such as jelly spoons and butter knives), and "miscellaneous" (cigarette holders, cribbage boards). The Alaska Festival of Native Arts has continued every year since, providing public exposure for the best of native arts and helping to build permanent collections for institutions like the Anchorage Historical and Fine Arts Museum.[11] In the 1970s other native arts festivals were held in Fairbanks and in Bethel, and in 1973 a few native artists were among the more than four hundred entries in the first competition of the Salon of Alaskan Artists sponsored by Exxon Company, U.S.A. (*Alaska,* January 1974, pp. 2–3). In September 1974 Sylvester Ayek, a sculptor and printmaker from King Island, was the first participant in a new series of one-man shows begun by the Anchorage Museum to exhibit art works in various media from throughout the state (*Tundra Times,* 18 September 1974).

There have been no projects to "improve" skin and fur sewing, although in September 1968 Emma Willoya taught a skin sewing course sponsored by the Rural Alaska Community Action Program. Thirteen women enrolled in this project because of "an interest in the dying craft and industry" (*Tundra Times,* 7 March 1969).

A project not directly related to the crafts, but which ultimately will expand because of the success of its weaving program is the Musk Ox Project. It began at the University of Alaska in 1964 after a ten-year feasibility study of musk ox domestication in Vermont. Over thirty musk oxen were then captured on Nunivak Island and taken to College, Alaska, where their soft wool, called by the registered trademark name of "qiviut," is harvested and sent to knitters in several villages to be made into sweaters, scarves, stoles, and hats. Each village uses patterns derived from basketry motifs and harpoon head designs. Future plans include the care of herds and community projects in additional villages. A mature musk ox yields about six pounds of wool a year, enough to knit twenty-four forty-eight-inch-long scarves (Wilkinson 1971; *Oomingmak,* a brochure from Musk Ox Producers' Cooperative; *Alaska,* August 1972, p. 27). Indirectly, these animals have provided new subject matter for ivory and wood carving, basketry, and printmaking by both natives and nonnatives (figs. 131, 174, 175).

11. The annual festivals are counted from 1966, when the first nonjuried show consisted of objects from private collections.

IV The Past and the Future

TEACHERS, COLLECTORS, and writers about "Eskimo art" are not always neutral, or completely objective, in their appraisal of the various handicrafts. There are those who consider all objects made since 1900 by Alaskan Eskimos as curios without any artistic merit; others look upon most of them as ethnic art that transcends evaluation. Some think that the craftsmen should continue using old art forms and motifs—which readily identify "Eskimo art"—while others believe that the vitality of the arts will continue only through new attitudes, ideas, and materials. There are diverse opinions, also, regarding traditional art. Some say that *all* traditional objects are "art," but others realize that only a percentage of the total production comes up to universal critical standards. We do not know how the nineteenth-century carver judged his or his fellow carvers' objects, but we of the 1970s are judging the objects of another culture in terms of our own preferences and from a specialized viewpoint of art apart from all other activities, which the Eskimos did not do.

In traditional times, carving and sewing were activities that were often inseparable from ceremonies, which in turn were closely related to the basic activity of hunting. During the later days of market art, sewing and carving served similar purposes. There were the same needs and means, but a culturally different end. Because the present account is an interpretation of the creative activities and output in both the applied and fine arts insofar as they are produced by a specific ethnic group, I have not quibbled about whether these diverse products were "art" or "craft." As Frederic H. Douglas, anthropologist and art critic, has said, "Understanding of a culture can never be complete unless some insight into the human heart is gained, and what this heart has made to satisfy its urge to create, what is unsatisfactorily called 'art,' may often give a better key to the riddle than anything else. . . . Art in the sense used here can well be defined as 'the process of making useful things beautiful . . .'" (1955, p. 5). In these pages, the term "Eskimo arts" has pertained to all objects made for anybody's enjoyment by an Eskimo working in a current mode and style of production.

If an artist in the western art world, with his usual one-of-a-kind work, cannot support himself with his craft, he often supplements his income with another job.

The Eskimo man has found himself in the reverse position. If he could not support himself by his usual subsistence activities, he turned to crafts as a supplement. This prevailing alternative suggests that almost every Eskimo has the potentiality of becoming an artist, yet in my many years' acquaintance with these arts, I have known no one who considered himself to be an "artist" when working in the traditional materials of ivory, wood, or bone. Some of the persons who draw two-dimensional scenes of idealized Eskimo life on materials other than ivory have adopted the western term, "Eskimo artist" (the Eskimo language has no word for "art" or "artist"), but are essentially less innovative than the best ivory sculptors.

Several writers on Eskimo arts and values, including George Swinton and Edmund Carpenter, do not categorize the recent stone sculpture of the Canadian Eskimos as "Eskimo art" because of the non-Eskimo orientation in subject matter, materials, values, and marketing procedures. Carpenter, especially, has written at length on this viewpoint, carrying it so far as to classify all Alaskan objects dating from 1870 on as curios (1973, pp. 192–201). While I do not agree that the market art of Alaska can summarily be dismissed as a curio art—although the preponderance of gimmicky paper knives, salt shakers, billikens, cribbage boards, and the like has certainly overshadowed the many beautiful objects—his criticism of the use of the term "Eskimo art" for nontraditional production is a subject that demands some attention.

From the preceding discussions it is obvious that market art, beginning during the late nineteenth century, has conformed for the most part to the white man's suggestions, which slowly led it away from the old styles and, in some degree, materials. In using the term "Eskimo art" we are at the mercy of the English language in trying to reduce complex activities in diverse cultural settings to a single catch-all term. In prewhite days, there were many periods of Eskimo culture, each one with its characteristic art style. Each style invariably was different from the others, and an object could usually be definitely assigned to a certain era on visual evaluation alone. In some cases—for example, in the Ipiutak period—some objects do not look "Eskimo" in accordance to certain known diagnostic features, but the term "Eskimo art" has been used to describe objects from all periods because the only aspect they had in common was their ethnic origin. When objects were later made expressly to sell to the white man, they continued to be classed as Eskimo art since their ethnic origin was still the most important characteristic. An item was often purchased merely because it was made by an Eskimo, although sometimes better things of the same sort were made by non-Eskimos.

It is increasingly inappropriate to use the term "Eskimo art" for the professional art of the young Alaskan Eskimos of the 1970s. Theirs is "Eskimo art" only by applying an ethnic criterion; in all other respects their works should be considered art in the most universal sense. Often it cannot be distinguished from the work of non-Eskimo artists in Alaska who use both native and nonnative subject matter for prints, paintings, and sculpture; nor, indeed, from the work of artists from other parts of the world. The identification of these works arises from individual style, not ethnic origin. Recognition is deserved from being an artist first, and only incidentally an Eskimo.

Both traditional art and market art can be called "Eskimo art," but it is apparent that they are two quite different things. Few Alaskan Eskimos are able to explain the meaning of a nineteenth-century object, or why it was made; certainly none

has been able to tell whether the maker considered it art as a fulfillment of an esthetic goal. No Alaskan carver has made art objects for traditional religious or utilitarian purposes for three or four generations. In most cases, the leading artists were the shamans, whose art and performances the missionaries quickly discouraged. The "last" shaman of the Bering Strait area, Kuzshuktuk ("water drop"), died in the 1918 influenza epidemic shortly after his return from a ten-year residence in a stateside mental institution.

Thus, with the old traditions of art well out of the way for many years, the Alaskan Eskimo has had to look at his creations from a different viewpoint. He has thought in terms of western art for almost a century whether he realizes it or not. The young artists who are the pioneers in the "new Eskimo art" have grown up entirely in the contemporary mechanized age. Peter J. Seeganna, who died in June 1974 at the age of thirty-six, was a young lad of only eight when I first met him in Nome in 1946. He grew up on King Island and in Nome, where bulldozers roared, radios blared, ice cream machines churned, and movies brought the best in western and space age stories to the Dream Theater.

The passing of traditional days should not, however, prevent an artist's using subject matter of his Eskimo environment, which even in the most acculturated parts of northwestern Alaska constantly suggests what traditional life must have been like. Interpretations of present-day life can satisfy both "Eskimo" and universal points of view. For many years a prevalent practice has been the copying of old designs and forms to sell as "art" or curios. Sometimes the object (most commonly a needle-case, mask, or engraved ivory in the nineteenth-century style) was made in a different medium from the original, but even then the result was often stiff and uninteresting, and looked like a replica. With greater experimental freedom today, the Eskimo craftsman is no longer dependent on making the old objects that once assured him a dependable income. More and more fresh ideas that characterize great art are evident in the new prints and sculpture, and some of the old motifs and forms that have been adapted are given an original reinterpretation (for example, see fig. 169).

The new trends in Alaskan art today are launching another era in Eskimo art. Within the hundred-year period of nontraditional art there has been only one other time when changes could qualify as a turning point within the contemporary period, that is, the 1930s, when the ivory animal and bird sculptures were developed. For forty years they have been made by men whose own pleasure in carving is reflected in their remarkable results. This sculpture has often been criticized, though, for being "too realistic" and too repetitive. Eskimo work, however, is not realistic in the sense of being a photographic copy of nature, despite the fact that ivory carvers often try to make their animal sculpture "more lifelike." Their efforts invariably result more in stylization than realism, because what the carver sees as being "realistic" is actually an impressionistic interpretation of the essential characteristics of an animal or bird in repose or in motion—walking, flying, running—which tells the carver, as a hunter, in a glance that the animal is a red or a white fox or the bird is a Canada goose or an eider duck. Furthermore, the ivory carver employs various stylized devices for certain purposes: the zigzag to represent feathers; a highly polished smooth surface for a bear or other furry animal instead of carved-out fur; or dots in the position of ears or a nose. This stylization can be seen in the snowbirds, bears, mountain sheep, and caribou (figs. 110, 116, 125, 127). The engraved vignettes

on ivory in the latter 1800s also were not faithful copies, but were selective ways of seeing the world (see, for example, fig. 246).

Repeating subject matter and duplicating objects were the only ways the Eskimo craftsman could cope with the existing economy. The bear by Aloysius Pikonganna in figure 116 is an example of fine work with its own individuality despite his having carved a number of them over the years. To many, this repetition may lessen its worth as an art object; yet each time he carves a bear the image is created anew (he never copies) from a differently shaped piece of ivory and in a little different form.

The inauguration of new projects during the past decade, including the Visual Arts Center of Alaska in 1972, is contributing to the changing concepts of "Eskimo art." The failures of the earlier projects were, in retrospect, a result of three factors. First, the products were geared mainly to the souvenir market. Second, the artists in charge were working with the older craftsmen, who were fairly resistant to change. And third, there was not enough financial support, follow-up encouragement, or marketing experience to continue. The MDTA project was the first to disregard the souvenir market, and was provided with adequate funds for equipment and teachers. Yet it, too, would have failed if all of the participants had been of the older generation, because all of the older ones returned to their former work. The younger ones were not only receptive to new ideas but were unencumbered by families so that they could take courses away from home. These young men, and others who have had formal art training, are the ones in the vanguard of the new Alaskan art.

Although the Visual Arts Center expects to emphasize native arts, its overall inclusion of nonnatives may be a deciding factor in releasing "Eskimo art" from its ethnic bounds. Its four studios in printmaking, sculpture, weaving, and jewelry not only will permit natives and nonnatives alike to experiment freely in subject matter and materials at their own pace but will eliminate the unspoken, but very real, resistance by Eskimos and consumers alike to nonnatives' using "native" subject matter and materials. This attitude has always seemed strange to me when over the years (including the 1970s) I have observed Alaskan nonnatives carving and selling ivory as "Eskimo made." The pieces were not signed (unlike some of the nonnative commercial objects with made-up proper names like Nunuk or Naguruk, meaning "good") and were indistinguishable from Eskimo carvings.[1] Many purchasers would not have bought a piece had they known it had been carved by a non-Eskimo, though it might be superior to one that was "Eskimo carved." It is also ironical that they might unwittingly buy an Alaskan ivory made by a non-Eskimo, but turn down a piece made by an Eskimo in a commercial establishment outside of Alaska.

1. Alaskan Eskimos have rarely signed only one name to their works. From the beginning of market art, the carvers used the English binomial system: an English first name and an Eskimo or an English surname. Until recently, an object with a single name was either Canadian or a fraud; but since the recent Alaska native land claims legislation and related activities through which the Eskimos are asserting a racial identity, a few are now signing only an Eskimo name. Some who had English names have adopted Eskimo ones.

Most of the Japanese and Seattle-made objects are signed with only one name invented for the purpose. An exception is the work from Leonard F. Porter, Inc., which was designed and carved by Alaskan Eskimos, who therefore used their own names, like Wilbur Walluk and Thomas Ekak. But Eskimo-like names on nonnative Alaskan-made articles have turned up with increasing frequency during the 1970s. These names, which are usually preceded by one initial, either are completely invented (but "Eskimo-sounding") or are names of well-known artists, slightly altered. For instance, Robert Mayokok's name would, under this system, become R. Mayokiak or R. Mayokpuk.

Despite a growing tendency toward artistic freedom, there is still a widely held attitude that conforms more or less with the aims of past projects in native art. That this attitude is deeply entrenched was obvious during a year-long survey made in Alaska to discern the need for an "Institute of Alaskan Native Arts." At a conference in January 1975 it was reported that a thousand persons had answered questionnaires, but "only five people . . . did not recognize that a need exists for the creation" of such an institute. The ethnic identity of the thousand persons was not indicated (*Tundra Times,* 11 February 1975).

On 5 March the results of the survey, which was underwritten by the Indian Arts and Crafts Board, were presented at another meeting at the University of Alaska; and according to a report in *Tundra Times* (5 March 1975), lines were still to be drawn between "native" and nonnative arts, although the questionnaires suggested that "most people feel attendance at the institute should be cross-cultural." When the final report was issued, the committee in charge of the survey decided that nonnatives were to be included in any ensuing program, but they did not propose changing the name of the institute or modifying their primary goal of "an art institute to preserve, enhance, and promote traditional Alaska Native art;"[2] the inclusion of nonnatives in an organization devoted to the development of ethnic arts would seem to be contradictory.

The emphasis on who makes an object and on where it was made rather than on its artistic merit is basic for the souvenir trade, and it seems to me that the "Silver Hand" tag will further emphasize the souvenir market despite other efforts to direct the arts into more innovative and original paths. This tag was, of course, necessary to protect the unsuspecting buyer and to lessen the competition for objects actually made by the native peoples. (Several such tags identify Canadian Eskimo art.) The imitations originated from the nature of the souvenir industry itself and its repetitive production of countless tasteless creations. But the imitations deprived the Eskimos of a livelihood, since the unsuspecting tourist often picked the imitation over the authentic object. Another reason for identification was to assure the customer of getting a "handmade" object rather than one made on duplicating machines and pantographs outside Alaska.[3] The solution for protection from the imitations would be to identify the place of origin and manufacturer on the nonnative items.

The two sides of the dilemma that arise from a requirement that souvenir art be identifiably ethnic art are illustrated by two fine pieces, one of ivory, the other of spruce driftwood, both made by Eskimo men and acquired by me at a time when both were having a hard time in the market place as "Eskimo art." The first is a sculpture of a woman designed by Thomas Ekak of Wainwright while he was working in a Seattle commercial firm in 1959 (fig. 82). This figurine was Ekak's own creation; but because it was made in a commercial establishment outside of Alaska, out of sperm whale tooth (which actually had often been used by Alaskan carvers for over a century), and was suspected of having been made on a copying machine, collectors of native art were reluctant to buy it and, of course, it could not qualify for the Silver Hand tag today.

The second one, the wood walrus in figure 172, was carved in Nome by Peter J.

2. Institute of Alaskan Native Arts Committee 1975, pp. 24–25.
3. In 1974 the Federal Trade Commission brought suit against six Seattle and Portland companies, which allegedly simulate handmade native Alaskan products without disclosing place of origin or method of manufacture. The case was heard in July and September 1975 before an administrative law judge, who ruled in favor of the defendants.

Seeganna of King Island in 1968. I first saw this piece at the King Island Village community house one evening after the nightly dances. It was highly visible among the usual fur slippers and ivory knickknacks. The price was fifty dollars, but this was not high compared to curios like cribbage boards, which were always costly and without much merit except as pieces of ivory. It was high, however, in comparison with some little seals that were marked six dollars. The presence of this piece among the rather poor objects that characterized the offerings that particular evening emphasized the chasm that separated a work of art from a curio. Peter told me that he was using the walrus as an experiment in exhibiting and selling such sculptures in a souvenir setting as a part of his association with Sunarit Associates Cooperative. The walrus was everything that the typical souvenir was not: it did not look "Eskimo"; it was fairly large; it was made of wood in an untraditional style; and it was more expensive than the souvenirs that the typical tourist would be likely to choose. I decided to buy it, but in a reckless moment decided also to contribute to Peter's experiment by waiting until I returned from a short trip. Flying north from Nome the next day I regretted my decision because I was sure that at least one of the six hundred or more tourists scheduled to visit the community house during my absence would succumb to the charms of the walrus. On my return ten days later, the walrus not only was still on display, but had been reduced to forty dollars a few days before. The time had come to end Peter's experiment.

Never before had I been so aware how much the carver had been limited, not by himself or his own creativeness, but by the limitations of his marketplace and his customers. It is remarkable that the Alaskan craftsmen have maintained as high a quality and created as many memorable objects as they have. Their challenge in survival has been successful, interwoven with their world of the moment; and no matter how we criticize or value the pieces, this activity has formed an impressive adjustment to living, a bridge that linked the centuries day by day. For some time to come we will see this adjustment in the continuing souvenir arts and a growing strength in a universality of expression.

During the course of the history of Eskimo arts we have seen changes not only in style, form, and material but in the reasons for creativity. With Alaska's rapidly changing economy from subsistence resources and pioneer country to diverse economic development, it seems that support for artists and their art will be forthcoming in the contemporary world as surely as was encouragement of the artists in both ceremonial and everyday arts of the nineteenth century. Although market art has been inspired almost entirely by nonnatives, the results have conformed to an "Eskimo" mode of expression. The artists of the 1970s who depart in varying degrees from the older designs and forms need not feel that they are being manipulated by the market or their mentors any more than the carver of the 1870s when market art began in earnest, or in the days before that when it seemed that the spirits courted certain forms and styles. The artists are changing their attitudes and production in step with the cultural and social changes of Alaska.

PART TWO

Illustrations

Introduction

NOTE ABOUT COLLECTORS AND MUSEUMS

COLLECTIONS of Eskimo artifacts from Alaska have usually been deposited in museums in one of two ways: through a museum-sponsored expedition or person as collector; or by purchase or gift from assorted individuals. The provenience is usually assured by the first method, but by the second, less often. The most dependable proveniences are from archeological expeditions carried out by professional anthropologists or from collectors of ethnological objects who visited a specific area. A large percentage of ethnological objects in museums with known provenience was collected in Alaska in the 1870–1900 period by several persons, including Miner Bruce, H. M. W. Edmonds, Sheldon Jackson, Johan A. Jacobsen, Charles L. Hall, John Murdoch, Edward William Nelson, A. E. Nordenskiöld, Patrick Henry Ray, and Lucien M. Turner. For the most part, the places and dates of their collections were duly noted, although Bruce's proveniences are open to some question, and Hall's are sometimes vague.

Murdoch's, Nelson's, Ray's, and Turner's collections are in the United States National Museum, Washington, D.C.; Edmonds' and Hall's are in the Lowie Museum, Berkeley; Jackson's, in both the National Museum and Sheldon Jackson Museum, Sitka; Bruce's, in the Field Museum, Chicago, with single pieces in other museums to which he sold them. Jacobsen's collection, which was in the Royal Ethnological Museum of Berlin, was destroyed during World War II, according to Hans Himmelheber (personal communication).

In 1911 and 1917–18 William B. Van Valin collected artifacts in northern and western Alaska. His collection is in the University Museum, Philadelphia. In the 1920s Otto William Geist collected a number of ethnological and archeological objects on Saint Lawrence Island, which are in the University of Alaska Museum. A number of other museums have large collections of Alaskan Eskimo ethnological objects: the Alaska State Museum, Juneau; the American Museum of Natural History, New York; the Burke Memorial Washington State Museum, Seattle; and the British Museum, London. Other museums, like the Agnes Etherington Art Centre

(Kingston, Ont.), the Peabody Museum (Cambridge, Mass.), and the Museum of the American Indian (New York), have sizable collections.

The Pitt Rivers Museum at Oxford contains most of the objects collected by Frederick W. Beechey in 1826–27. I do not know of any publication describing Kotzebue's Eskimo collection and have not ascertained its whereabouts.

Museum collections of modern-day objects are rarer than those prior to 1900; but the Anchorage Historical and Fine Arts Museum, the Alaska State Museum, and the University of Alaska Museum are making efforts to collect them. A few choice things are in smaller museums around the state, like the Carrie M. McLain Memorial Museum and the Arctic Trading Post Eskimo Museum in Nome, and the Kotzebue Museum in Kotzebue. In Washington, D.C., the Indian Arts and Crafts Board has a permanent collection of Eskimo and Indian arts. The Museum of History and Industry in Seattle has a collection of contemporary ivory, but it is in storage and I have not seen it.

Private collections are the best sources for examination of market art made since the 1900s. Some collections are larger than any museum collection of contemporary Eskimo arts and crafts. To the credit of most of these intrepid collectors, they have recorded provenience, date, and artist's name, when known.

Abbreviated names of museums used in the text are:

AMNH: American Museum of Natural History, New York
Anchorage Museum: Anchorage Historical and Fine Arts Museum, Anchorage
Constantine Collection, Agnes Etherington: Agnes Etherington Art Centre, Queen's
 University, Kingston, Ontario
Eskimo Museum, Nome: Arctic Trading Post Eskimo Museum, Nome
FMNH: Field Museum of Natural History, Chicago
IACB: Indian Arts and Crafts Board, Department of the Interior, Washington, D.C.
Kotzebue Museum: Kotzebue Museum ("Ootukahkuktuvik, Place Having Old
 Things"), Kotzebue
Lowie Museum: Robert H. Lowie Museum of Anthropology, University of California,
 Berkeley
Nome Museum: Carrie M. McLain Memorial Museum, Nome
University Museum: University Museum, University of Pennsylvania, Philadelphia
USNM: Smithsonian Institution, Museum of Natural History (U.S. National Museum)
Washington State Museum: Thomas H. Burke Memorial Washington State Museum,
 University of Washington, Seattle

Other museums that are cited are the Alaska State Museum, Juneau; the British Museum, London; Peabody Museum, Harvard University, Cambridge, Massachusetts; Royal Ontario Museum, Toronto; the Sheldon Jackson Museum, Sitka; and the University of Alaska Museum, College, Alaska.

The abbreviation ANAC stands for Alaska Native Arts and Crafts Cooperative Association, Inc.

NOTE ABOUT THE PHOTOGRAPHS

A large part of the photographs (unless otherwise noted in the captions) were taken and printed by me. The engraved ivory objects from the Lowie Museum and a

few others were photographed by Alfred A. Blaker, photographer and writer, Walnut Creek, California, formerly chief photographer of the Scientific Photographic Laboratory of the University of California, Berkeley. For the engraved ivory, Mr. Blaker used an 8 × 10 Deardorf Studio View Camera with a 12-inch Goerz Artar lens on 8 × 10 Kodak Panatomic X sheet film. His photographs were taken under studio conditions and were contact printed.

I took my photographs of objects in two general time periods: the first in 1954, when I made a study of Eskimo materials in various museums on the east coast of the United States; and in 1973 and 1974, when I studied contemporary objects in private collections, principally in Alaska. None of my photographs was taken under studio conditions. Instead, in having to operate under makeshift arrangements where the objects were located, I was not able to obtain results up to the standard I had hoped for. Other photographs were taken at various times, the first (fig. 295) in 1946 with an ancient folding camera, "No. 1 Pocket Kodak, Series II," with a Kodar f7.9 lens, my first camera, which I still have. I used Verichrome film, but the negative looks as if it had been stored in a box of needles and pins.

My mode of operation in 1973 was quite different from that of 1954. In 1954 I struggled from the west to the east coast with a 4 × 5 Linhof Technika with a 150-mm Schneider-Krueznach Xenar lens; film holders for thirty-six exposures; a large tripod; a dozen boxes of 4 × 5 film; a changing bag; two reflector lamps, stands, and bulbs; and background cloths. At that time the photographs were made for study purposes only, without thought of publication. Therefore, each negative often includes many objects in extremely small size. I developed the Isopan film each evening in whatever bathroom I had access to, since I did not want to make a return trip of three thousand miles in case of a blank negative.

In 1973 I traveled much more lightly. I took to Alaska an Exakta XVIIa with a 50-mm Westrocolor lens, a miniature tripod, and a set of extension tubes. I bought most of my film in Alaska and photographed with available daylight, usually in the homes of collectors who seem to cheerfully accept the disruption of their daily routines. (At the Anchorage Historical and Fine Arts Museum and the Arctic Trading Post Eskimo Museum in Nome I photographed the objects under fluorescent lights.) Because I knew that my photographic sessions would be makeshift, I used Plus-X rather than Panatomic X film, which I had planned originally. I carried with me my usual black and pale yellow cloths for background, but was always furnished support for the cloths and objects—sometimes a cardboard box, but once an ingenious portable frame. My photographic sessions were invariably supervised by lovable dogs and cats, and once by a not-so-lovable parrot who gave me more attention than was necessary when he bit me on the arm.

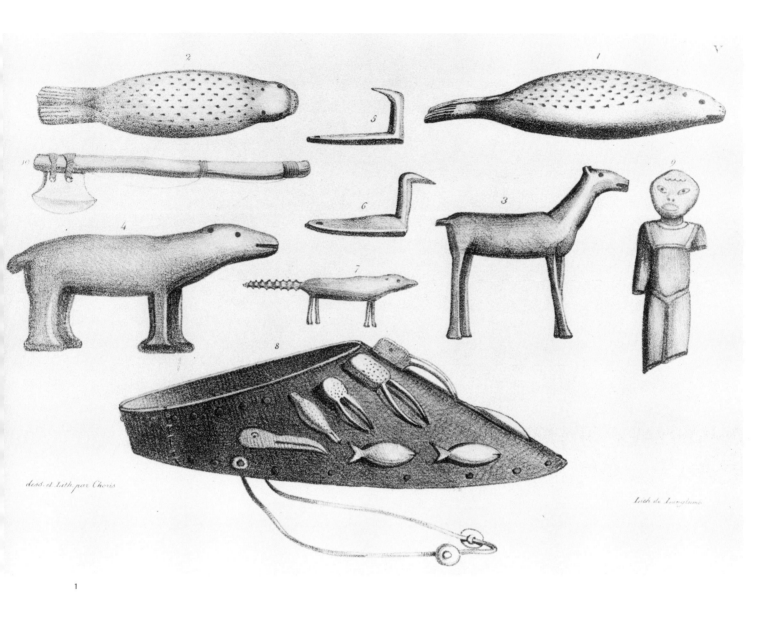

1 The first published illustration of ivory sculptures made by the Alaskan Eskimos, 1816. Reproduction of plate V in Choris 1822, entitled "Walrus tooth objects by the inhabitants of Kotzebue Sound and land of the Chukchi [in Siberia]." All but numbers 1, 2, 8, and 9 look more like Chukchi work than Alaskan Eskimo. Ludovik Choris was the artist for Otto von Kotzebue's expedition of 1816 to northwest Alaska (see also VanStone 1960).

Attachments in the shape of walrus heads were common in the Bering Strait region. The walrus motif was used not only on hats (figs. 7a and 7b), but on other objects like boat hooks and needlecases (figs. 6 and 40, left) and as subjects of engravings (figs. 2, 231, 236). John Murdoch illustrated a drum handle that terminates in a walrus head (1892, p. 387).

The harnesslike straps on number 9 of the Choris drawing may represent a device worn to protect a man from his enemies, as reported from Sledge Island (Nelson 1899, p. 435), or a strap to hold amulets, as observed on Saint Lawrence and Little Diomede islands (Weyer 1932, p. 316). In 1791 Carl Merck of the Billings expedition said that several of the women of Cape Rodney wore straps around their chest and back (Ray 1975).

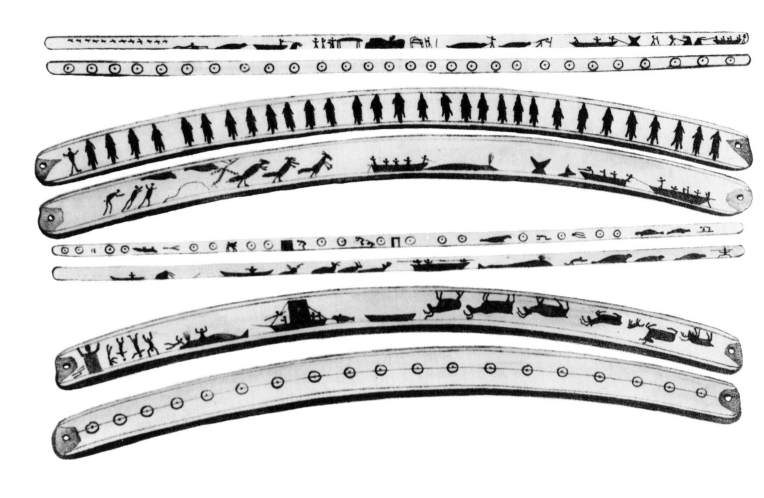

2 The first published illustration of engraved drill bows, from Kotzebue Sound, 1816. Reproduction of plate IV in Choris 1822. The eight drawings represent two four-sided bows. One side of the top bow apparently shows a man's catch of fox pelts, possibly destined for trade, because this bow was collected after the Russian-Siberian-Alaskan Eskimo fur trade was well underway. Shamanistic episodes as well as everyday activities are represented. Though collected at "Kotzebue Sound," these bows were probably made by people visiting from Wales, since there was little hunting of black whales and walrus (as depicted on the bows) at Kotzebue Sound.

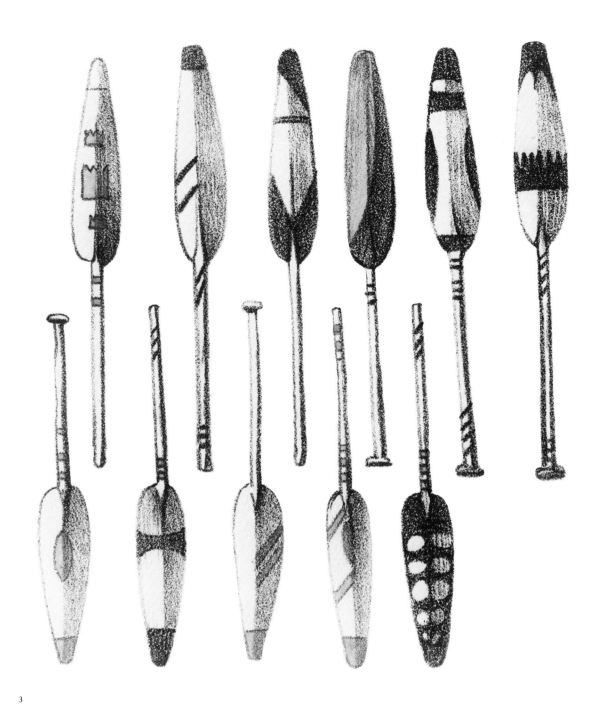

3

3 Designs painted on paddles from the Bering Strait, 1816. A portion of plate III, Choris 1822. Designs on the two outside paddles in the top row may represent the Kigluaik Mountains (see discussion under fig. 146). Nelson shows a King Island paddle design (1899, pl. 80, no. 9), and Ivan Petroff, an agent for the Tenth Census, illustrated in color a Malemiut woman holding a paddle with four red diagonal stripes, a motif that seems to be repeated on the cloth tent behind her (Petroff 1884, pl. 1). A. E. Nordenskiöld collected two interesting painted paddles from Port Clarence (see fig. 6).

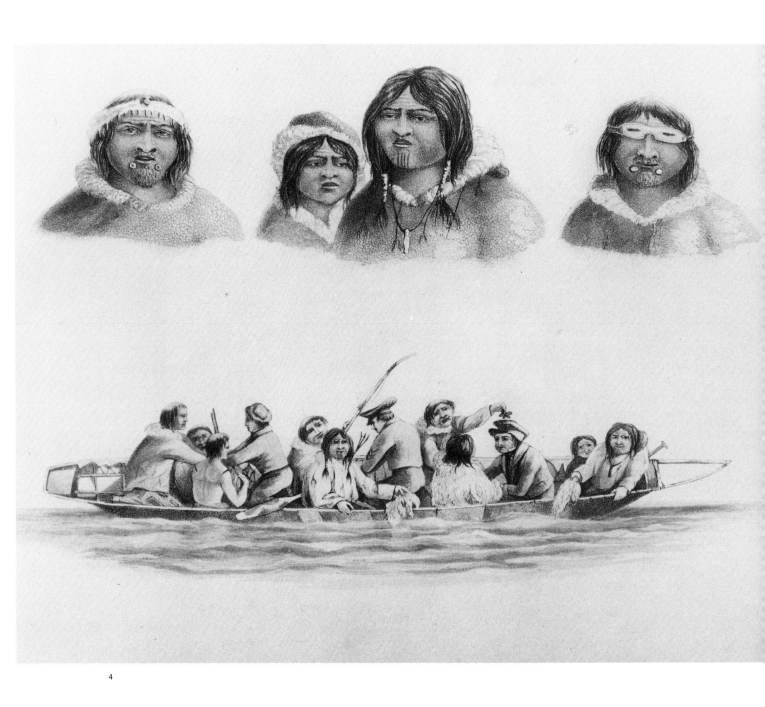

4

4 Drawings of Eskimos near Cape Thompson made during Beechey's voyage of 1826–27 (Beechey 1831, part 1, opposite p. 263). Two men in the upper drawing are wearing labrets, and the woman in the middle wears an amulet on a thong round her neck. In 1881 E. W. Nelson photographed Eskimo men who wore unbelievably large labrets (1899, pls. 13, 23).

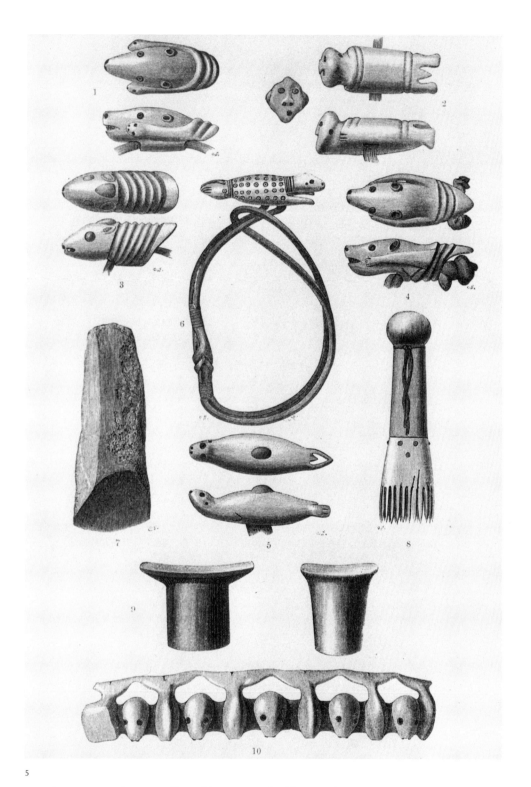

5 Walrus ivory sculptures collected by Nordenskiöld's expedition at Port Clarence in 1879 (Nordenskiöld 1882, p. 578). Numbers 1–6 are toggles used to keep carrying straps and boat lashings from slipping. The two objects in number 9 are labrets, and number 10 is a handle or decoration, probably for a container. For other toggles and drag handles see figures 35–38 and 40.

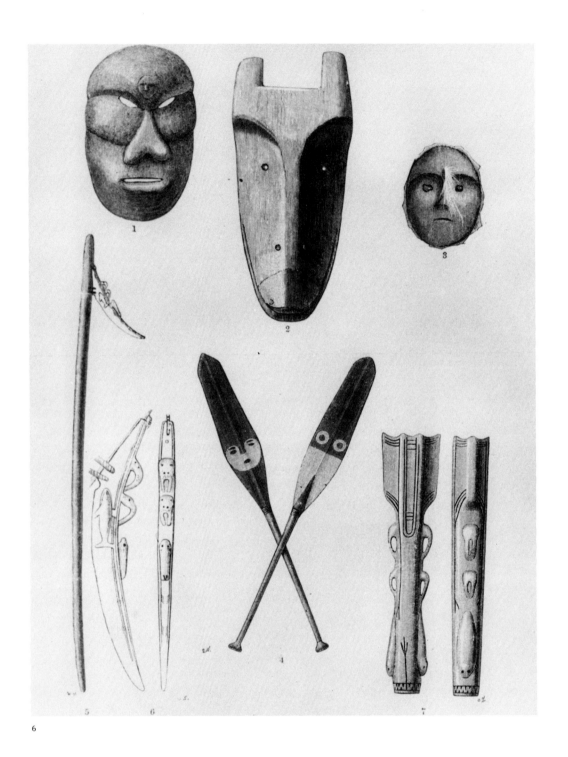

6

6 Wood and ivory objects collected at Port Clarence by Nordenskiöld's expedition, 1879
(Nordenskiöld 1882, p. 581). According to the original caption for these drawings, the
masks were found at a grave. In traditional times, the whale tail motif, as on number 1,
was widely used on masks and other ceremonial objects, and on engraved ivory (figs. 2,
5, 19, 22a, 23). The small wooden face (no. 3), which has one eye of "enamel" and
another of "pyrites," was attached to a sealskin float. Fifty years before, in 1827,
Beechey had collected one almost like it. It is now in the Pitt Rivers Museum (infor-
mation from photographs provided by John R. Bockstoce).

Walrus heads and paddles are more fully discussed under figures 1 and 3.

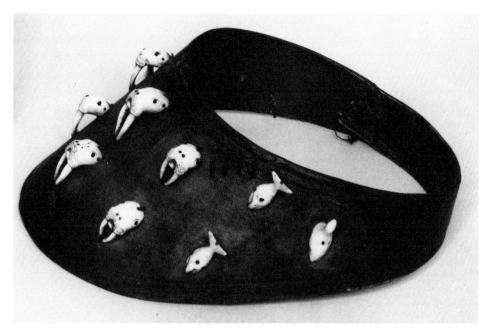

7a

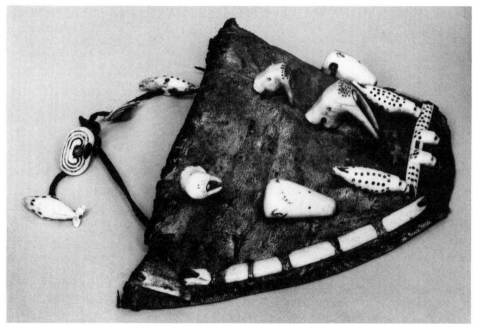

7b

7a and **7b** Hunting hats with walrus ivory figurines. Lengths: 10¾ inches (26.8 cm.) and 8½ inches (21.5 cm.), respectively. British Museum nos. 1931.7.21.4 and 9862. These two hats are good examples of how objects were attached to flat surfaces and skin lines. Each of the two ivory toggles in 7b is inlaid with half of a blue bead, and the long piece of ivory at the bottom is a double-headed seal. Both visors are illustrated in Fagg, ed. 1972, pls. 6 and 8.

Two hats from Norton Sound, probably Saint Michael (though the provenience of one reads Saint Lawrence Island), are illustrated in *The Far North,* figures 71 and 72. They also have walrus heads and stylized flat pieces representing bird beaks. Wooden hats apparently went out of style quickly north of Saint Michael after the arrival of European goods, although short visors and sunglasses continued in use.

Photographs courtesy of the Trustees of the British Museum

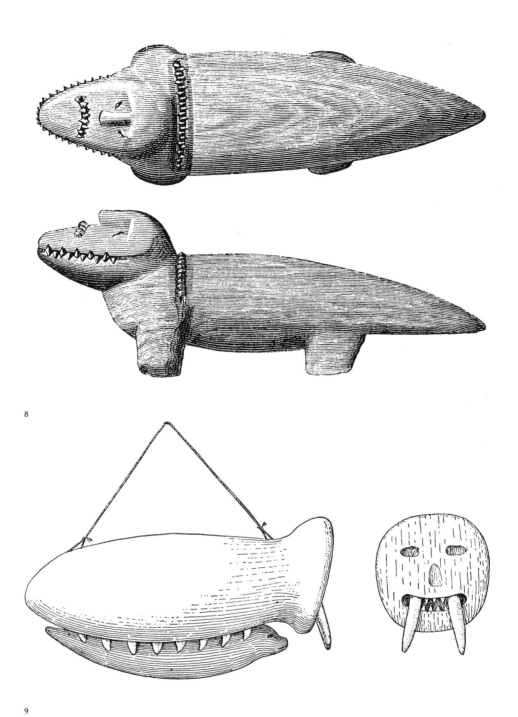

8

9

8 A wooden animal, which probably once belonged to a shaman, Port Clarence, 1879 (Nordenskiöld 1882, p. 580). The original caption said that it came from an Eskimo grave. This Port Clarence figurine is similar to the legendary *kikituk* from Point Hope (fig. 176) and was probably used for a similar purpose. (For further information about this creature see discussion under "Sculpture" in Chap. II and under fig. 176.)

9 Amulet of wood for a kayak, observed by E. W. Nelson at Kotzebue Sound in 1881. Length: about 8 inches (20 cm.). Reproduction of text figure in Nelson 1899, p. 436. The animal held by the teeth is a white whale (beluga). The tusks and teeth were made of walrus ivory. Also see Chapter II, "Sculpture."

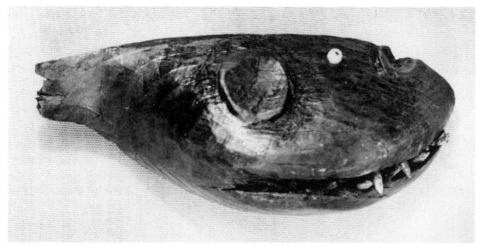

10

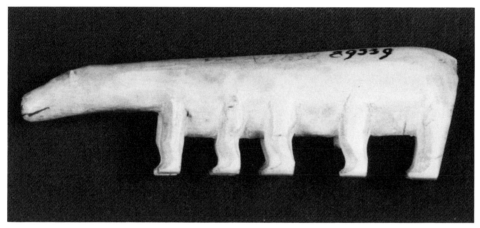

11

10 A composite animal with the face of a fish on the upper side, from Nuwuk (Point Barrow). Length: 4½ inches (11.4 cm.). Peabody Museum NW-H-2260B. The teeth are of walrus ivory and the eye is a white bead. This probably dates from the early or middle nineteenth century. Green and white trade beads that were known as *il^Yuuminiq* were especially valuable as whaling charms at Point Barrow (Spencer 1959, p. 339).

11 Mythological "ten-legged bear" from Nuwuk, carved in ivory. Length: 3¾ inches (9.6 cm.) USNM 89339. Collected by P. H. Ray, 1881–83, as a newly made object and illustrated in line drawing in Murdoch 1892, p. 406. A similar bear carved in the 1960s is illustrated in figure 118. This creature is drawn lying on its back on a drill bow in figure 237. In another ivory engraving, the artist drew this bear standing, with legs in two groups of five, one at the front end and the other at the back (Mason 1927, pp. 263–65).

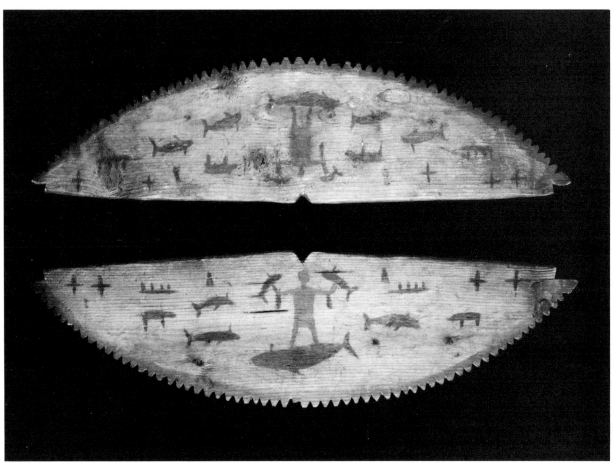

12

12 Dancing gorgets of wood with painted black and red figures. Lengths: 17⅝ inches (44 cm.) and 17⅜ inches (43.4 cm.). Lowie Museum 2–6652, A and B. Collected by the Alaska Commercial Company, probably from Point Barrow. The man standing on the whale is red; all other figures are black. These boards were hung on the chest, although Robert Spencer said some masks had gorgetlike wings protruding out from them. Three gorgets similar to these were collected by P. H. Ray at Point Barrow and deposited in the Smithsonian Institution. Murdoch illustrates two, which are similar to these in shape and painted designs. The giant man holding a whale in his hands was also carved as ivory sculpture when Ray and Murdoch were at Point Barrow (figs. 13, 14). They learned that his name was "Kikámigo" or "Kaioasu," but did not collect any more information (Spencer 1959, p. 294; Murdoch 1892, pp. 370–72).

Photograph by Alfred A. Blaker

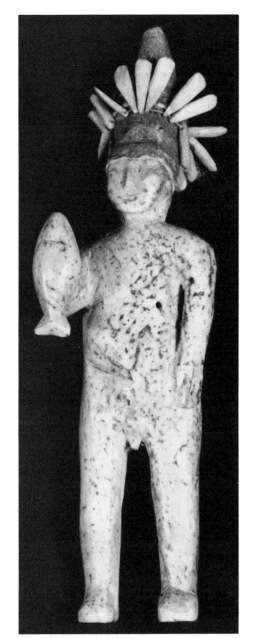

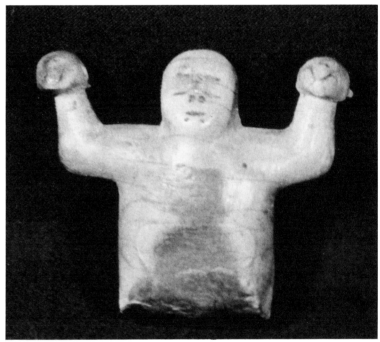

13 14

13 Bone figure of the legendary character "Kikámigo" wearing a dancing cap, from Point
Barrow. Height: 5 inches (12.5 cm.). USNM 89353. Collected by P. H. Ray as a newly
made object in 1881–83 at Nuwuk and illustrated in Murdoch 1892, p. 395. The cap
is made of "deerskin" dyed red with ocher. Fifteen flat ivory pendants are attached to
represent mountain sheep teeth. A tuft of wolf hairs, three inches long, is suspended from
the cap in the original drawing published by Murdoch. Ray also brought back a regular
dancing cap (USNM 89820) made of red-dyed reindeer skin, 10 inches high, including
a tuft of wolverine skin sewed to the top. One hundred forty-nine incisor teeth of the
mountain sheep were suspended in four horizontal rows on the front (Murdoch 1892,
pp. 365–66).

14 An ivory giant from Point Barrow called "Kaióasu," who holds a whale in each hand.
Height: 2⁵/₁₆ inches (5.6 cm.). USNM 89723. Collected by P. H. Ray, 1881–83, Nuwuk.
The ivory was already tan-colored when collected. The line across the nose represents a
tattoo. The figure is flat in the back. Murdoch illustrated this figurine mounted on an ovoid
base of wood painted with stripes of red ocher (1892, p. 406).

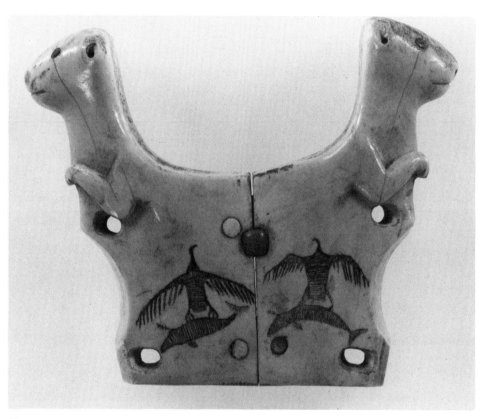

15

15 A harpoon rest of ivory with engraved figures of giant birds catching whales, from Cape Prince of Wales. Height: 4¼ inches (10.6 cm.). USNM 48169. Collected by E. W. Nelson. Many harpoon and spear rests were made with a figure of a whale. On the opposite side of this object the two birds are drawn above the whales, ready to attack (Hoffman 1897, pl. 72; Nelson 1899, pl. 107). Between 1881 and 1883 P. H. Ray collected five rests at Point Barrow, four of which had whales' tails engraved on them. On two, the tips of the arms were whales' heads (Murdoch 1892, pp. 341–43). Two harpoon rests without engraving, but with finely sculptured heads, are illustrated in *The Far North*, figures 88 and 89.

 Photograph by the Smithsonian Institution

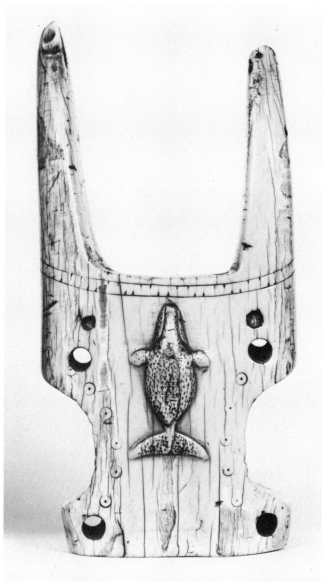

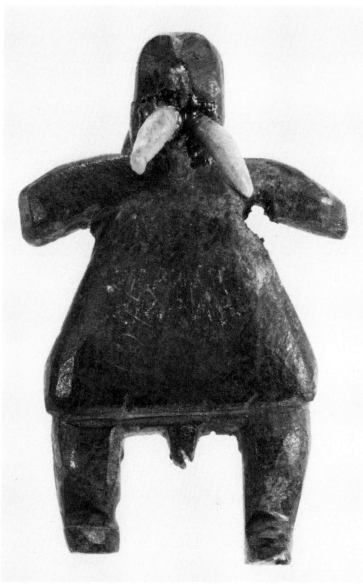

16 17

16 Harpoon rest of ivory with figure of a whale in low relief. Height: 6½ inches (16 cm.). British Museum 1933.11–29.1. Provenience unknown. Murdoch said that harpoon rests were rarely made of one piece of ivory because of the relatively small width of tusks. This harpoon rest is made from a single tusk, which probably dictated the straight shape of the sides. The opposite side has two engraved whales, and it is thought that the two prongs once terminated in whales' tails (Digby 1935). This piece is also illustrated in Fagg 1972, pl. 11, and Burland 1973, fig. 64.
 Photograph courtesy of the Trustees of the British Museum

17 A ''walrus man'' made of soapstone, Point Barrow. Length: 2⅞ inches (7.3 cm.). USNM 89569. Collected by Murdoch and Ray at Nuwuk. It was made between 1881 and 1883 from an old soapstone lamp or pot. The tusks were made of bone and glued in with ''refuse oil'' (Murdoch 1892, pp. 394–95).
 Photograph by the Smithsonian Institution

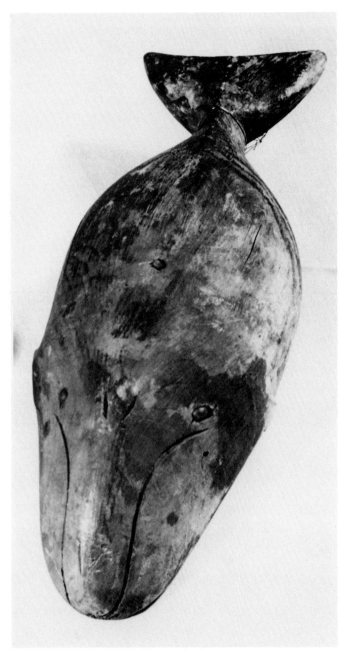

18

18 A wooden whale from Sledge Island. Length: 12 inches (30.5 cm.). University
Museum NA-4781. W. B. Van Valin collected two others besides this in 1912. One
of the others is arched so that it rests on its chin and its tail. All have eyes of blue beads,
as does the charm in figure 21. The museum records say that he collected these and other
pieces on Sledge Island in 1916, but this date is erroneous.

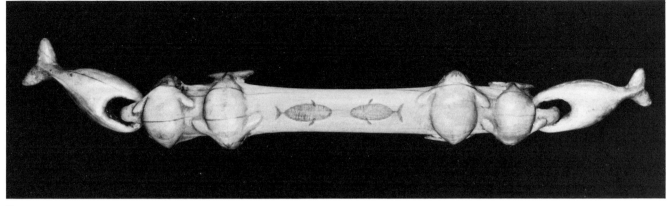

19

20

19 Bucket handle with both sculptured and engraved whales from Sledge Island. Length: 10⅝ inches (27 cm.). USNM 44690. Collected by E. W. Nelson, 1877–81. The ivory is now brownish. The whales have eyes inset with a contrasting material, and incised mouths and blowholes. Also illustrated in Hoffman 1897, pl. 55, and Nelson 1899, pl. 43. The combination of bas-relief and incised whales was also used on the object in figure 26. Stylized whales, seal flippers, and bears were often attached to the ends of ivory chains (see Nelson 1899, pl. 43, no. 1, and pl. 66, no. 19).

20 Handle or ornament in the form of ten whales' heads. Length: 7⅜ inches (18.7 cm.). Eskimo Museum, Nome. Provenience unknown. Originally, each head had a tail carved in relief behind it, but only two tails remain. The eyes are inset with baleen and the mouths are marked with a black substance. Repetitive designs, especially of whale's flukes or tails, were often used on bucket handles, several of which Nelson collected at Cape Darby, Sledge Island, Norton Bay, and in the Saint Michael area. Another popular motif was the repeated use of seal heads. A handle collected by Lucien M. Turner about 1875 at Saint Michael has thirty tiny seal heads in two rows, and another collected by Nelson nearby a few years later had on ''its upper surface the figures of nine seal heads, several etched figures of seals with spears in their backs, rude figures representing otters, and a framework for storing objects above ground'' (Nelson 1899, p. 101 and pl. 43; Hoffman 1897, pls. 55, 80). An unusual repetitive design is that of men on the ivory pipe in figure 245.

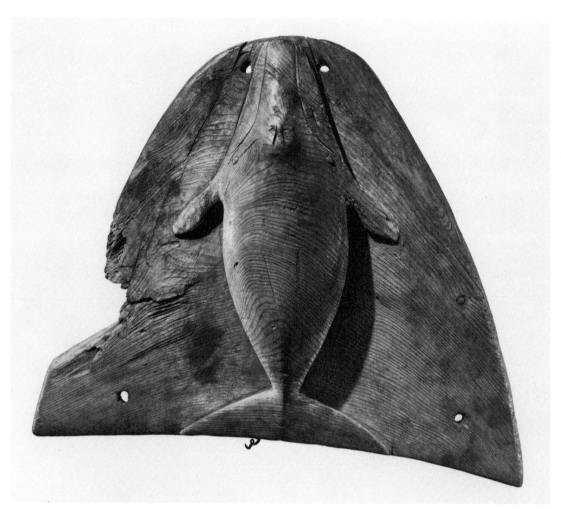

21

21 Whaling charm of wood for an umiak from Point Hope. Width: 14 inches (36 cm.).
FMNH 53424. This charm was probably attached to the bow of an umiak between the
gunwales with baleen or sinew drawn through the holes. The eyes are blue beads. Such
a charm was either inherited or carved by the shaman of the whaling crew. This charm
and a similar carving on a box for whaling charms are illustrated and discussed by VanStone
(1967). Another whale—almost a twin—was collected in 1912 from Sledge Island. It is
in the University Museum and is illustrated in *The Far North* (fig. 87). In the U.S. National
Museum others used for the same purpose were collected from Point Hope (USNM 347758,
347759) and from Little Diomede Island (USNM 347918). Whales in similar low relief
were also used on a small ivory shovel from Little Diomede (USNM 372172).

Photograph by John Bayalis

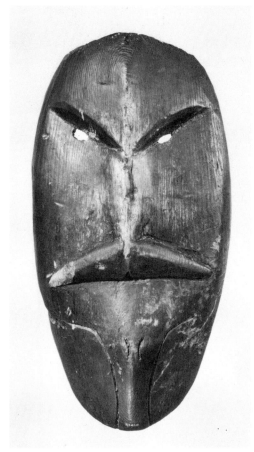
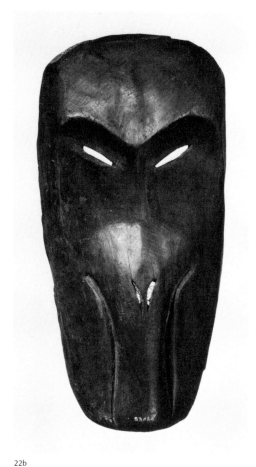

22a 22b

22a Mask with a nose like a whale's tail and a mouth and chin like a whale's head, collected in 1897, Point Hope. Height: 14$^{13}/_{16}$ inches (38 cm.). FMNH 53458. Similar masks are illustrated in Ray and Blaker 1967, pls. 52, 54; VanStone 1968/69, pl. 6; and *The Far North*, fig. 136.

 Photograph by John Bayalis

22b Mask, of which the lower portion represents a whale's head, 1897, Point Hope. Height: 11$^{5}/_{16}$ inches (29 cm.). FMNH 53464. This and similar masks are illustrated in VanStone 1968/69, pls. 6, 7.

 Photograph by John Bayalis

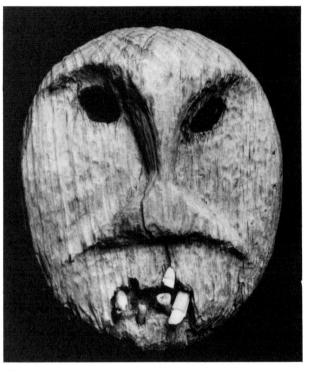

23 24

23 A small human face of wood with nose shaped like a whale's tail, Point Hope. Height: 4¹/₄ inches (10.6 cm.). Washington State Museum 461. Collected by James T. White in 1894 "from old Tigarah grave." The eyes are scooped out and the teeth are from an animal. A wide, deep groove is carved out behind the face so that it looks like a pulley in cross section. Perhaps this was used as a plug for "a harpoon-float of sealskin," as was the Port Clarence face in the upper right of figure 6 (Nordenskiöld 1882, p. 581). Possibly both were similar to the *inyogluk* of Point Hope, which "was supposed to call out and thus lead its owner to the wounded whale" (Rainey 1947, p. 257).

24 Mask with what appears to be an animal emerging from its mouth, collected in 1897, Point Hope. Height: 8³/₈ inches (21.5 cm.). FMNH 53461. The mask, which is almost black, is illustrated and discussed in VanStone 1968/69 (p. 836 and pl. 5B). See under "Masks" in Chapter II for further discussion.

 Photograph by John Bayalis

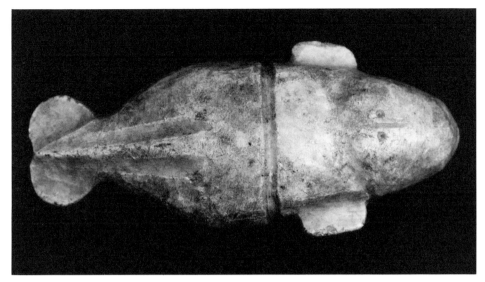

25

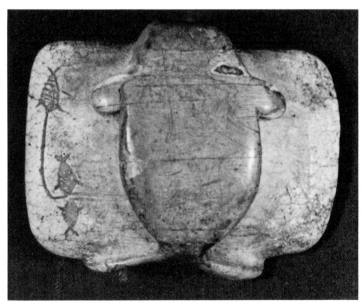

26

25 A stone net sinker in the shape of a whale from Kotzebue Sound. Length: 5¹⁄₂ inches (14 cm.). Constantine Collection, Agnes Etherington M 71–12.
 Photograph by Frances K. Smith

26 Ivory charm with engraved whales and a large sculptured whale, Port Clarence. Width: 2¹⁄₂ inches (6.5 cm.). AMNH 60/1255. Holes were provided on the underside for fastening to an object. See also figure 19.

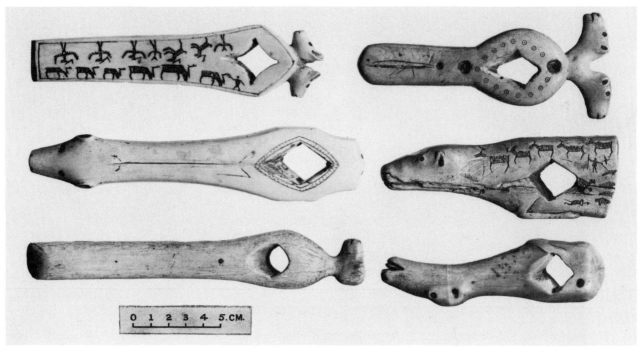

27 Arrowshaft straighteners of bone and ivory decorated with engravings and sculptures
of land animals. Length: top left is 5 inches (12.5 cm.). All are in the British Museum.
The top left object (no. 1895–180), acquired by the museum in 1895, is a well-carved caribou
head of bone. The one below it (1855.12–20.240) was acquired in 1855 and has en-
gravings of caribou and seal hunters. The sculptured caribou head of the straightener is
realistically carved and the legs are depicted in bas-relief. It is very much like one col-
lected by E. W. Nelson from Sledge Island in 1881 and illustrated by Hoffman (1897,
pl. 7, middle). (Also see caribou with carved legs, fig. 35, this book.)

The two heads of the straightener, bottom left (no. 1376), probably represent caribou
heads, shortened because of the limitations of the ivory. The bottom right figure of walrus
ivory was acquired by the museum in 1855 and was probably collected by searchers
for the Franklin expedition at Bering Strait between 1848 and 1854. The dancing caribou
and human figures (perhaps wearing caribou masks) appear to have gauntlets like those
illustrated in figures 144, 145, and 295. This straightener is illustrated in line drawing by
Hoffman (1897, fig. 100). One might deduce that it came from Cape Prince of Wales
after considering the following facts. The same dancing figures were incised on a drill
bow in the British Museum (Fagg 1972, pl. 15-h; Burland 1973, fig. 51), for which no
provenience is given. The engraving and pictorial styles are similar, however, to those
of a Wales drill bow collected by E. W. Nelson (USNM 43360), and the long, serpentlike
motifs on the bow in Fagg are the same as those on another Wales bow (NA-455) in
the University Museum (see also note to fig. 236, below).

Other straighteners collected at roughly the same time from western Alaska, Cape
Nome, Kotzebue Sound, Golovnin Bay, and Norton Sound are illustrated in Nelson 1899,
pl. 40; Hoffman 1897; pls. 7, 8; and Fagg 1972, pls. 13, 14. See also figure 232.

Photograph courtesy of the Trustees of the British Museum

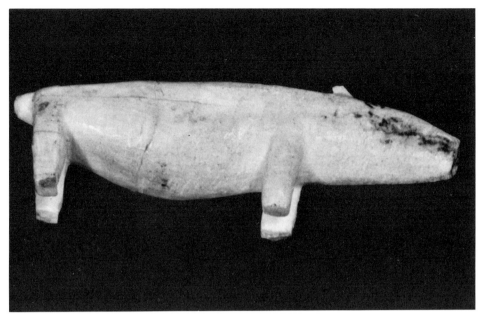

28

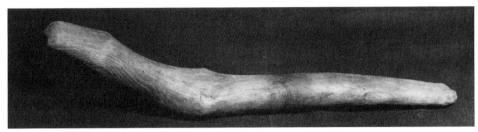

29a

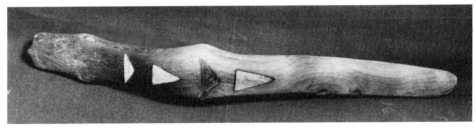

29b

28 Ivory bear from Port Clarence, 1899. AMNH 60/1691. Collected by Miner Bruce. This is typical of the bear form made on the Alaskan mainland during the latter part of the nineteenth century.

29a and **29b.** Both sides of a flint flaker of wood in an imaginative animal shape. From Point Barrow (Nuwuk), possibly Birnirk culture. Total length: 11½ inches (29.6 cm.). Peabody Museum BK-H-3645. The wood is smoothly finished. The three triangular ivory insets and the one of wood on the underside were probably charms. Spencer said that at Point Barrow marks were made on a variety of objects to indicate the number of whales taken by a boat owner or his harpooner. "One man is remembered who inlaid a piece of ivory on the lid of his workbox each time he harpooned a whale" (Spencer 1959, p. 340). Insets were also used as charms (see under "Charms and Amulets" in Chap. II).

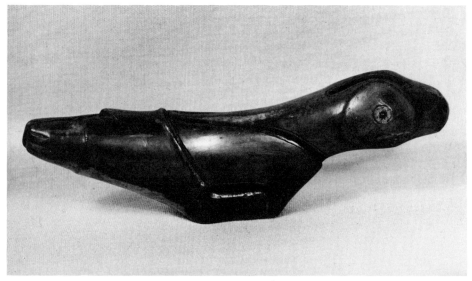

30

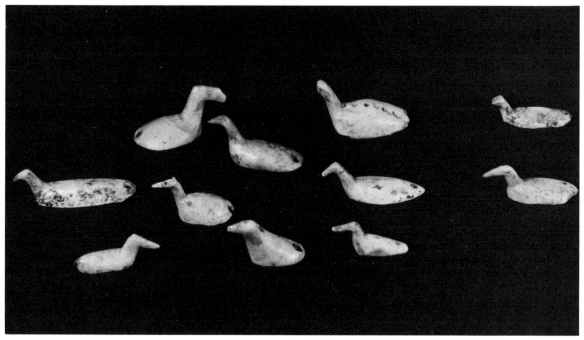

31

30 Ivory ulu handle in the shape of a seal from Point Hope, 1885. Length: 5⁵/₁₆ inches (13.5 cm.). USNM 76680. This carefully finished sculpture was probably made of brown ivory originally. The eyes are inset wood, which is inset with small black beads.

31 Flat-bottomed ivory birds from Saint Lawrence Island, probably eighteenth century. Length: bird on left is 1⁵/₁₆ inches (3.2 cm.). All are in the U.S. National Museum. This kind of bird figurine was common in the Saint Lawrence Island Thule culture, but less common on the Alaskan mainland.

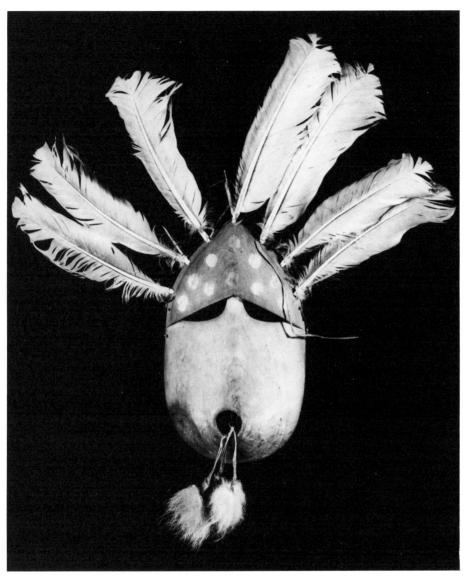

32

32 Mask representing the spirit of the driftwood, Saint Michael. Height: 9⁷/₈ inches
(24.6 cm.). Lowie Museum 2–6926. Collected by H. M. W. Edmonds between 1890 and
1899. The forehead is blue-black with white spots and a top red border, but the face is
unpainted. Seven goose feathers protrude from the top of the mask. Each is fastened into a
hole by the end of its own quill; and all are held in place by a string of braided sinew
tied to all of the quills in succession. Several white fur tassels attached to red-dyed seal
parchment strings fall from the round mouth.

Photograph by Alfred A. Blaker

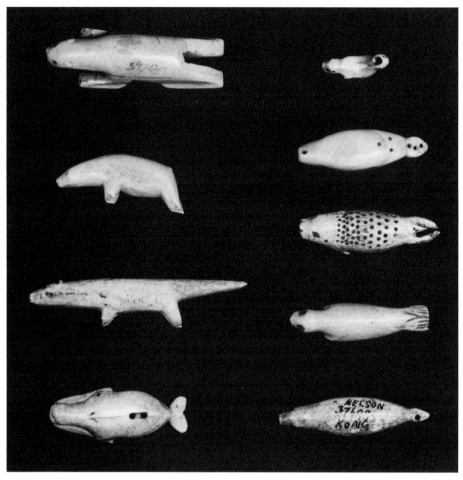

33

33 Ivory animals from Cape Prince of Wales collected in 1881. Length: bear in upper left is 2⁷⁄₈ inches (7.5 cm.). All are in the U.S. National Museum. Museum numbers and specific characteristics are as follows.

Left column, top to bottom:

37712, bear. There is a hole between the front legs for fastening.

37729, bear. This tiny bear, 2³⁄₁₆ inches (5.5 cm.) long, has a baleen inset in the anal passage. There is a hole between the front legs and in front of the rear legs.

45379, otter (?). The four legs are separately carved.

48215, whale. The round eyes are inset with a dark material.

Right column, top to bottom:

43396, seal. Only 1¹⁄₄ inches long, this delicate seal has a hollowed out tail and inlaid eyes, ears, and nostrils. Large holes were made on the underside for attachment.

37686, seal (underside view). Two of the holes in the tail are drilled through to the top and the three holes in front of them are inlaid, as are the ears, eyes, and nose.

37735, seal. The eyes are inset.

37725, seal. The front flippers were carved as stumps. The eyes are inlaid with brown ivory.

37699, seal. The eyes are inset. Two holes were made for suspension on the underside of the neck.

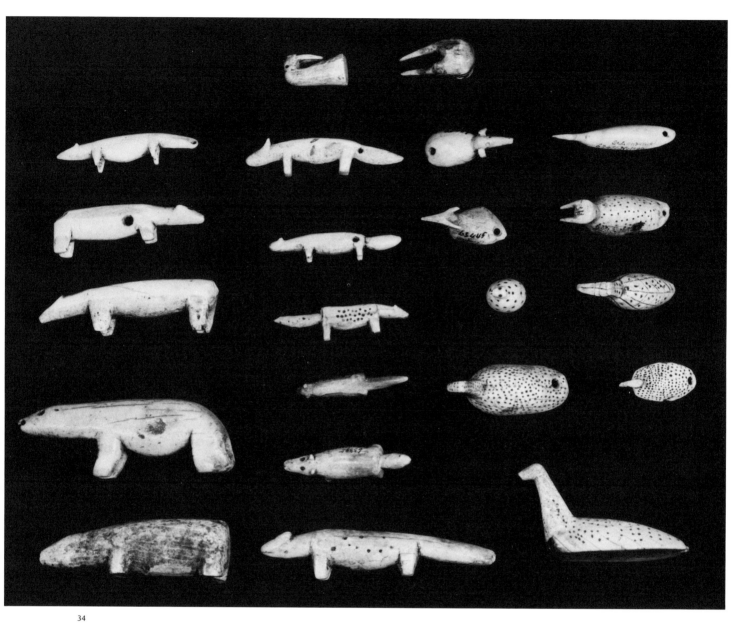

34

34 Ivory animals and birds from Saint Lawrence Island, 1881. Length: lower left bear is 3⅝ inches (9.3 cm.). All were collected by E. W. Nelson and are in the U.S. National Museum. Most of the figurines are provided with holes for suspension. All of the dots and other incisions are colored black with the exception of the upper left walrus head, which has a red-colored nose.

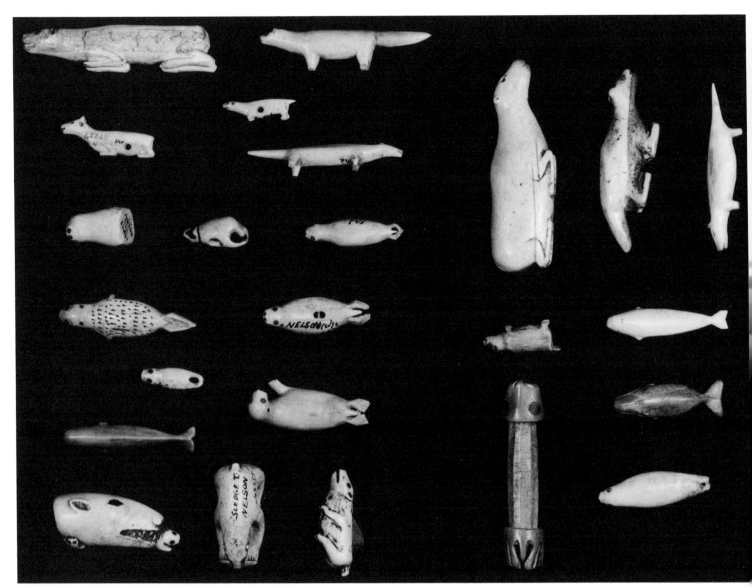

35

35 Animal figurines of the nineteenth century from Sledge Island and Cape Nome. Length: upper left animal is 3⁵⁄₁₆ inches (8.4 cm.). All are in the U.S. National Museum. Cape Nome and Sledge Island people lived only twenty-five miles apart and were on friendly terms. These figurines are representative of the delicate and well-finished work of this area. The tiny bear with a seal in its mouth and one under its neck (lower left, 176217), from Sledge Island, is only 2 inches long; yet the eyes of the bear and of the two little seals are inlaid with dark ivory. In addition, the bear's nostrils and the ears and nostrils of the seal in its mouth are inlaid. The tiny seal

under the neck has fur markings on its back similar to those in figure 38, and delicate flippers. (See the reverse side in fig. 36.) This toggle is illustrated in line drawing by Nelson (1899, p. 172).

Museum numbers and special characteristics of the objects are as follows.

Left row, top to bottom:

44856, "reindeer"(?). Sledge Island. The well-carved ears have round insets of old ivory. Eyes are inset and have incised tapering corners. The toes are cut out. Despite the catalog notation of "reindeer" (i.e., caribou), this is probably a bear because of the position of the legs.

45242, "reindeer"(?). Sledge Island. The hole in the thin body is cut through.

176260, seal head (?). Sledge Island. Eyes and nostrils are inset. Holes are for suspension at the bottom.

44861, seal. Sledge Island. Ears, nostrils, and eyes are inset with old ivory. Eyes and side whiskers are indicated by stippling. Little flippers are carved out, and three holes in a triangular pattern are drilled on the underside in front of the tail.

48877 (?—number almost illegible), tiny seal. Only 1 inch long, it has inset eyes and carved front flippers.

45128, whale. Sledge Island. The mouth is incised, but the eyes are inlaid.

176217, bear head with seals, which is discussed at the beginning of this section.

Second row, top to bottom:

44858, "fox." Sledge Island. Eyes are inset with a double ring of baleen. There are four separately carved legs, but between the right and the left legs a slit is filled with baleen or old ivory.

45243, "lynx." Each slightly carved ear has a hole beneath it.

45244, "land otter." Sledge Island. Ears are carved, and eyes, mouth, nostrils, and anus are incised.

176264, seal (middle of row).

48864, seal. Sledge Island.

44724, seal. Sledge Island toggle. It has inset eyes, nostrils, and ear holes of brown ivory.

44860, seal. Sledge Island. Eyes and ears are inset with brown ivory.

44855, a bear eating an animal. Sledge Island. Eyes are inset. Legs are well cut out, and ears, paws, and tail are carved in detail.

45231, bear(?) shown in side view. Sledge Island. Blue beads are inset in the eyes, and brown ivory in the nostrils and the anus. Two large holes are drilled beneath for attaching.

Third row:

44535, caribou. Cape Nome. Eyes are inset in addition to having a slight corner incision. The tail is slightly carved with a vertical gash beneath it. Another caribou of similar form, but used as an arrow straightener, was collected by Nelson at "Cape Denbigh" (The Far North, fig. 90).

44499, "red bear." Cape Nome.

44433, seal handle. Cape Nome. The seal's head is on one end and its hind flippers on the other. The large eyes and nostrils are inset with very dark ivory. This object apparently was originally made of tan ivory.

Fourth row:

44536, "land otter." Cape Nome. Large inset eyes.

43307 (?), "fox." Golovin.

45343, whale. Cape Nome. White ivory.

176235, whale. Cape Nome. Tan ivory. The eyes are inset and two holes are made underneath for attaching.

44439, seal. Cape Nome. Eyes and nostrils are inlaid with dark ivory. The tail is broken off just behind a drilled hole.

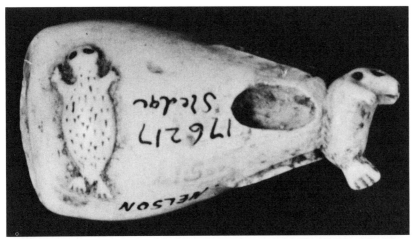

36

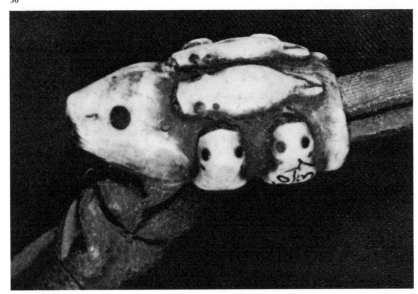

37

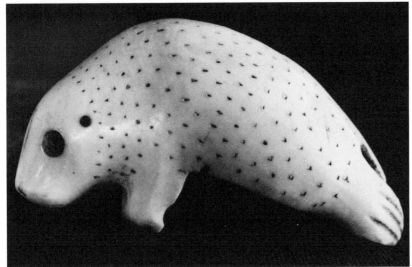

38

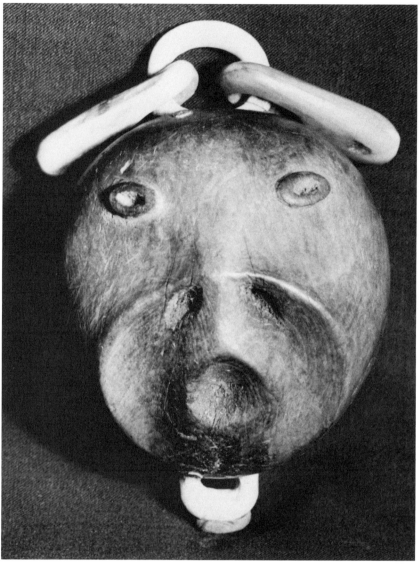

39

36 The underside of the bear's head toggle, lower left in figure 35.

37 Toggle or cord attacher in shape of a seal with six tiny seals carved in bas relief. Length: 1⅝ inches (4.1 cm.). Little Diomede Island? AMNH 60/1237. Nostrils and eyes of all, and the ears of the large seal, are carefully inlaid with baleen. Another example of such delicate carving is an even smaller toggle in ring shape with four seals carved in relief illustrated by Nelson (1899, pl. 66, no. 3). Other toggles and handles, many in animal forms, are also illustrated by Nelson, plates 56 and 66.

38 Cord attacher or kayak ornament in shape of a seal, with inset eyes and ear hole of baleen. Length: 2⅛ inches (5.3 cm.). Collection of Mr. and Mrs. Joseph E. Walsh. The provenience is unknown, but E. W. Nelson obtained a similar one from Sledge Island in 1881 (USNM 50279, 1¾ inches long).

39 Seal net float in form of a seal's face. Height: 3⅜ inches (8.5 cm.). Peabody Museum R-98. The attachments to the float are made of walrus ivory.

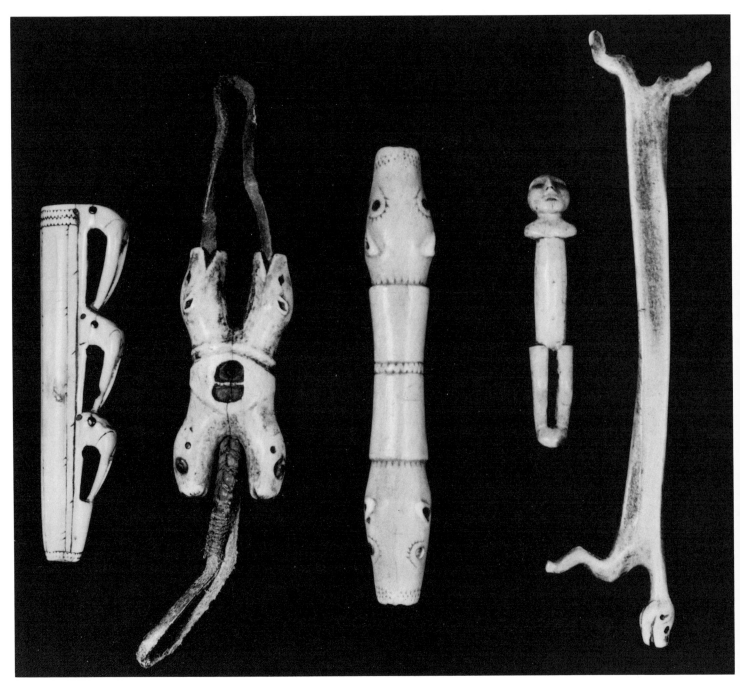

40

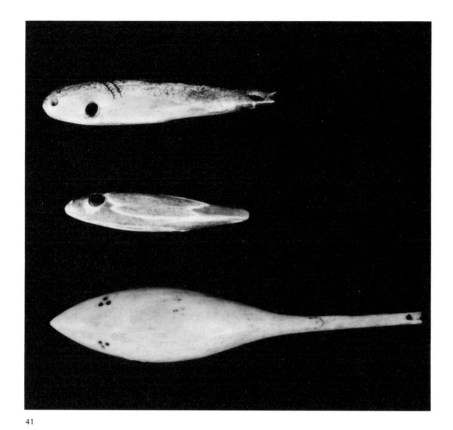

41

40 Nineteenth-century needlecases, drag handles, and a reel. Length of antler reel on the right is 8¹/₄ inches (21 cm.). All are in the U.S. National Museum.

Left to right:

153832. Needlecase of walrus ivory collected at Saint Michael by Lucien M. Turner between 1874 and 1877. Each walrus head has insets of dark ivory.

24692. The drag handle of four bear heads was collected by Turner at Saint Michael, but the workmanship and design (as in needlecase 153832) is characteristic of the Bering Strait area.

129218. Needlecase representing bears' heads, collected by Turner at Saint Michael. The eyes are inlaid and the nostrils are filled with a heavy substance.

63663. Drag handle in human form from Little Diomede Island collected by E. W. Nelson. The mouth is inlaid. A hole passes through under the arm stumps.

45110. Nelson collected the reel made of antler from Sledge Island. Reels like this were used to hold cord for making nets. This unusual specimen and others are illustrated by Nelson (1899, pl. 72).

41 Ivory fishing lures from Cape Prince of Wales, 1905. University Museum. These lures were probably used for flounder fishing. A lure was let down to the bottom of the ocean beneath the ice to attract a flounder, which was then stabbed with a three-pronged fork, usually by the women.

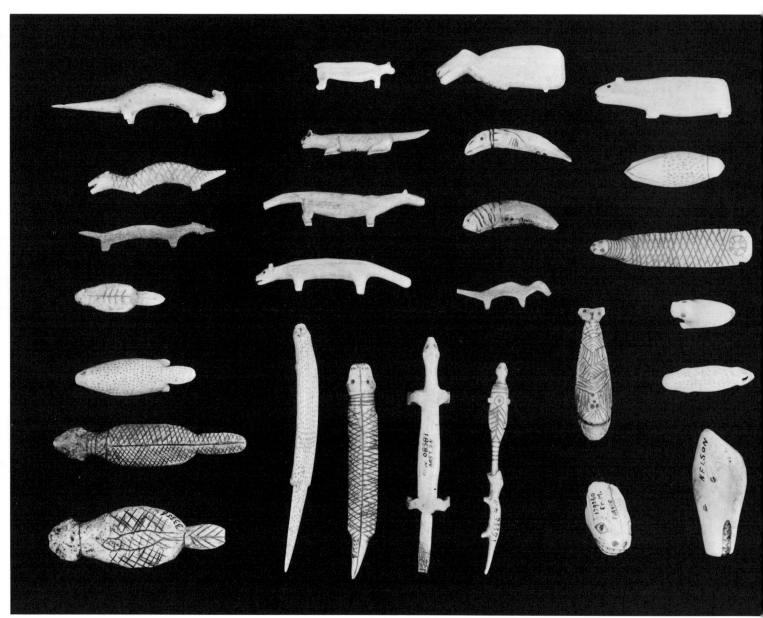

42

42 Animal figures, many of poor workmanship, collected at Saint Michael around 1881. Length of weasel, top left, is 3⁵/₁₆ inches (8.3 cm.). All are in the U.S. National Museum. Most of the markings are black. Some of these objects may have been made as souvenirs for a collection of "typical animals." Represented here are the weasel, beaver, seal, bear, otter, caribou, fox, beluga, mink, beetle larva, wolf, lynx, and mythological creatures. Most of the flat, heavily marked animals are made of bone.

43 Ivory figurine collected by H. M. W. Edmonds at Saint Michael in 1890 or 1898. Height: 4¹⁵/₁₆ inches (12.3 cm.). Lowie Museum 2–7027. Edmonds photographed this figurine, along with numerous other carvings, for inclusion in his manuscript about the Saint Michael Eskimos, which is in the John Francis Pratt papers at the University of Washington. Edmonds' original photograph is illustrated on page 136 of the published monograph (Ray 1966a).

Photograph by Eugene R. Prince

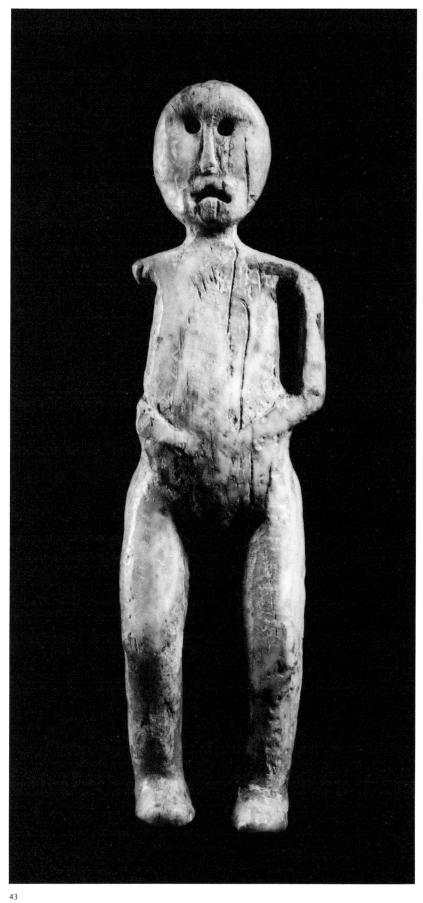

43

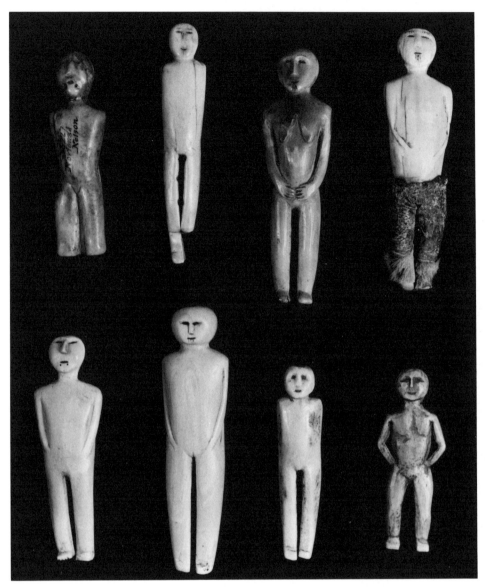

44

44 Human figurines from Norton Sound, late nineteenth century. Height of doll dressed in pants is 4$^{11}/_{16}$ inches (12 cm.). U.S. National Museum. Several of the figurines were marked with the same museum number in 1954. Top row, left to right: 50167 (new no. 33227), 63555, 50205 (Unalakleet), 50265; bottom row, left to right: 50167, 50167, 50218, 50167. All but the top left were probably dolls for children. The bottom right figure might represent a white man since it has no labrets and is standing in a way uncharacteristic of the early-day Eskimo. Despite its big feet, which are larger than on most Eskimo human figurines, it does not stand upright without support. None of the figurines has inlays in eyes or other orifices, although three of them—upper left, upper second from the right, and lower left are filled with greasy dirt.

Figures 50205, 50265, and the three 50167s on the bottom row have grooves down the back indicating a backbone.

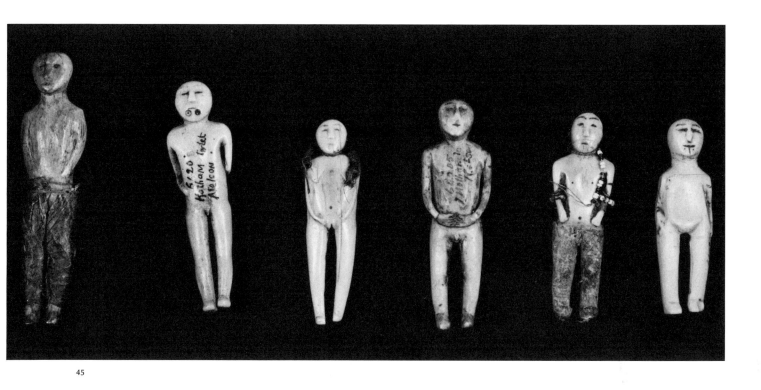

45

45 Human figurines of ivory from Hotham Inlet, 1881. Height of left figure is 4 inches (10.5 cm.). USNM collection, obtained by E. W. Nelson when he was a passenger aboard the revenue steamer *Corwin.*

Left to right:

64207. This figure of tan mammoth ivory wears sealskin pants tied with sinew.

64208. Labrets are represented by small beads on this figurine. The arms are cut free from the body. One arm is held in front, and the other, behind. A number of nineteenth-century male figurines of both ivory and wood have arms in this position; some have one placed at a nipple, and the other at the genitals. A doll with one arm in front and the other in a different position was found by J. L. Giddings at Cape Denbigh from the early Nukleet deposits (A.D.1300–1700) (Giddings 1964, pl. 32).

64206. The hair is wrapped around with baleen and yarn.

64205. The hachured marks above the eyes, which represent eyebrows, are also made as a fringelike design on the back.

64209. The doll wears sealskin pants, baleen and bead bracelets, and a string of beads.

64204. This doll has no clear sexual characteristics, and has unusual chin ornamentation.

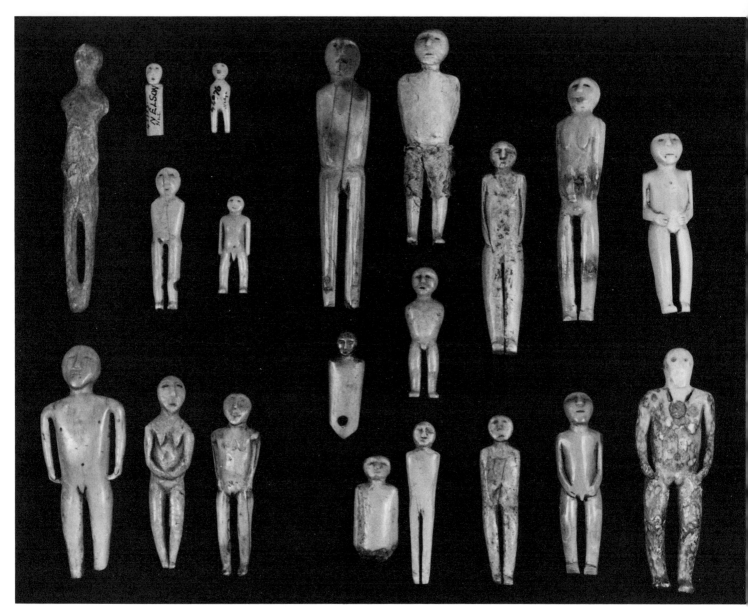

46

46 Figurines from Cape Nome and Sledge Island collected between 1877 and 1881.
Height of long figurine, top left, is 4⅜ inches (11.4 cm.). U.S. National Museum. All of
the left group of eight figures, except the middle one in the bottom row (female figure with
arms held in front), are from Sledge Island, and all in the right group of twelve with the
exception of the tall tan figure at upper left are from Cape Nome. The female figure is
from Cape Nome and the tall figurine is from Sledge Island. The latter is the only one that
has eyes of blue beads.

The upper left Sledge Island figure with feet joined apparently is a very old figurine in a
style that predated those of the nineteenth century. Only three of these figurines were
provided with holes for suspension: middle block figure (holes at the bottom); bottom row,
third from left; and bottom row, third from right (through the head from ear to ear). The
latter also has a slit in its left side from shoulder to the foot, which is filled with a heavy,
dark substance.

The figurine on the extreme bottom right is the only one with inset eyes and ears. The
animallike face was scraped or worn down. The pendant is unique and may represent a
dancing decoration or possibly a medal, several of which were distributed in this area to
various chiefs by Russian explorers between 1791 and the 1840s.

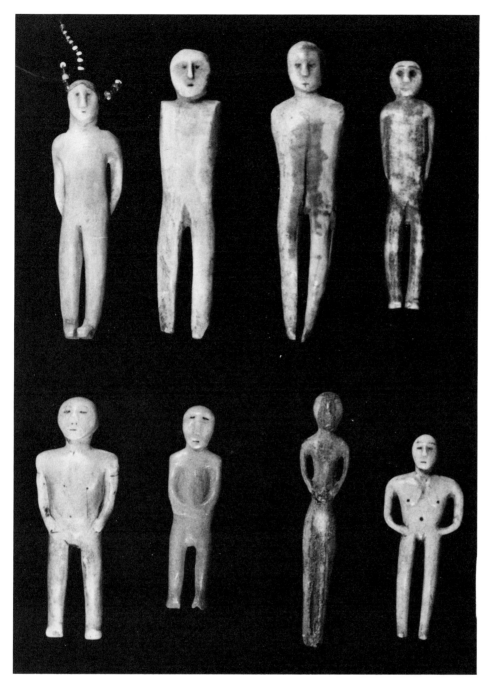

47

47 Human figures in ivory from Cape Prince of Wales, 1905. Height of top right figure: 3 inches (7.6 cm.). University Museum. The top three, left to right, have the same number, NA-1109. The one with beads has holes through the head and incised and blackened hair. The one second from the right has a groove along the backbone and up into the back of the head. A hole was bored through the head from one ear to the other. NA-1110, top right, has big round eyes filled with grease, and a groove down the backbone.

The figures in the bottom row, left to right, are NA-1114, -1115, -1116, and -1117. All have a groove down the backbone except for NA-1115, which has grooved feet and a hole through the ankles.

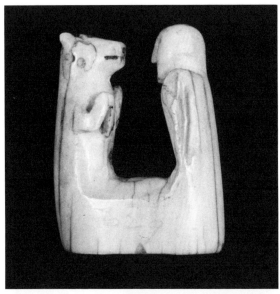

48

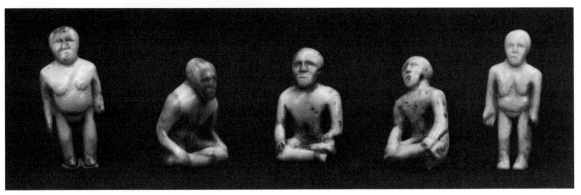

49

48 Ivory carving of a wolf and a man from Norton Sound. Height of man is 2⅛ inches (5.5 cm.). USNM 260187. The man has one labret and a short gash for each eye. The wolf has round eyes, and its teeth are clearly carved. Another sitting animal, apparently a bear, peers over the bowl of an ivory pipe in figure 245.

49 Small, yellowed figurines from Little Diomede Island. Height of standing man and woman is 1¾ inches (4.3 cm.). Anchorage Museum 72.88.1. The seated figure second from the right has a hole in the left side of its neck. The museum received these figures, called *amatunguruk,* from Thomas Menadelook, who said that his family had had them for a long time. Figures in this position are rare in collections. The U.S. National Museum has several, one of which was excavated from the nineteenth-century site of Kauwerak, east of Teller. Murdoch illustrated one from Point Barrow, also "yellow from age and oil" (1892, p. 396).

50 Figures of baleen and bark from Point Barrow, Birnirk age. Height of the face is almost 2 inches (5 cm.). Peabody Museum BK-Q-1065. All are wood with the exception of the three whales, which are baleen. The probable use of the whales is discussed in Chapter II, under ivory "Charms and Amulets." The longest whale is 6⅞ inches (17.6 cm.). The small face is slightly scooped out behind. The seals with their stumpy flippers resemble some of the old stylized dolls.

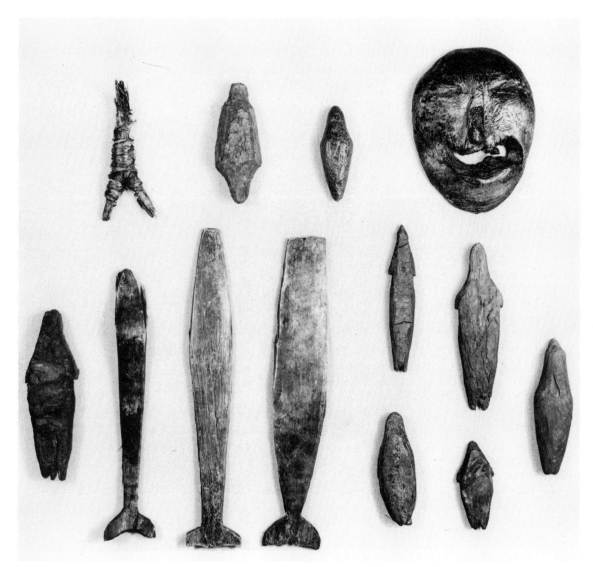

50

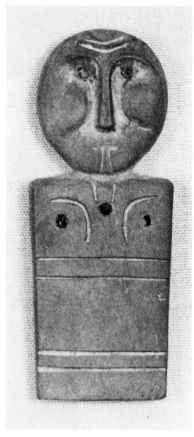

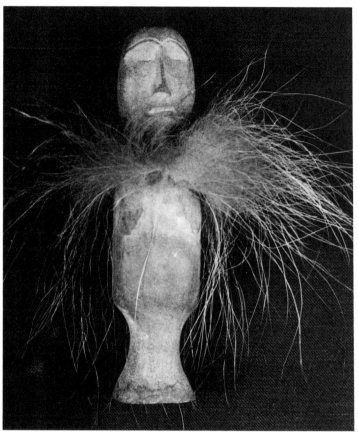

51

52

51 A rare stone sculpture of a woman made in the 1880s. Height: 3³/₁₆ inches (8.2 cm.), but only ³/₁₆ inch thick. Obtained by Lieutenant George M. Stoney on the Kobuk River in 1885. The stone is gray; the eyes and chest ornaments are inset with ivory, and the tattoos indicate that this is a woman. The lines on the forehead are probably a brow decoration or headband. Forehead ornamentation is also seen on masks in figures 66 and 67 and on the man in the drawing from Beechey's expedition (fig. 4). See also the vertical and horizontal lines on the forehead of a mask illustrated by VanStone (1968/69, pl. 5A).

52 Stone figure with a fur collar, late nineteenth century, Point Barrow. Height: 4 inches (10 cm.). University Museum no. 42229. This figure and the one in figure 51 seem to have been made from the same piece of stone, despite the different proveniences.

116

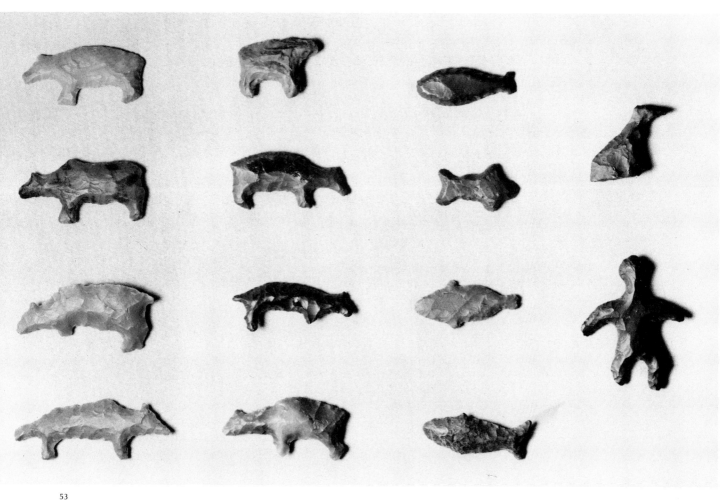

53

53 Flint figures from near Point Barrow, collected about 1918. Height of human figure is $2^7/_{16}$ inches (6.2 cm.). University Museum NA-6605 through -6610. These figures were probably made during the late nineteenth century. Murdoch illustrated two line drawings of whales flaked from red jasper and glass (1892, p. 435). The Alaska State Museum also has a number of these figures collected about the same time as these. See also discussion in Chapter II under ivory "Charms and Amulets."

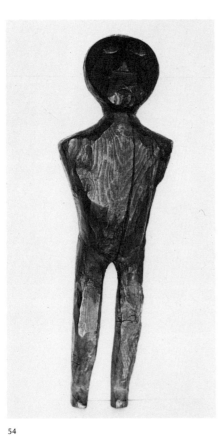

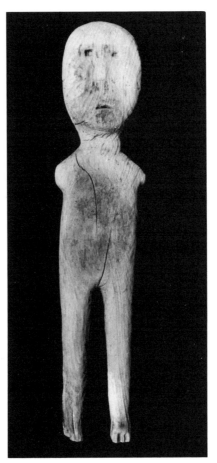

54 55

54 Wooden figurine found on the beach at Nome before 1900. Height: 7³/₈ inches (18.4 cm.). Collection of D. J. Ray. The figurine is very dark, apparently from an original oil stain or dye. The facial features are lightly carved out of a flat face set at about a twenty-degree angle to the neck.

55 Old wooden figurine found hidden under rocks on Cape Nome, probably nineteenth century. Height: 13½ inches (33.8 cm.). Collection of Josephine L. Reader. This figure and the man in the kayak (fig. 56) were found together under big rocks on the slope of the cape in 1968. Only a small part of each one jutted out. They are unpainted and still comparatively light-colored. Because of the wood material and the holes in the kayak for hanging, they might have belonged to a shaman.

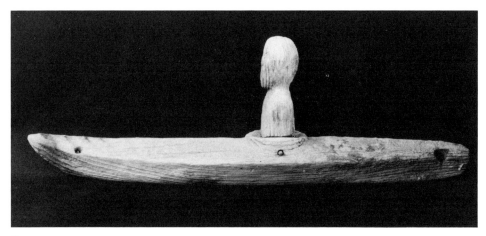

56

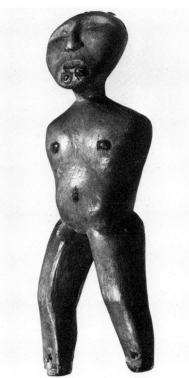

57

56 A wooden man pegged into his wooden kayak, from Cape Nome. Length: 15¼ inches (38 cm.). Collection of Josephine L. Reader. This object and the figure in figure 55 appear to have been carved from the same piece of wood. Holes are drilled through both ends of the kayak, probably for suspension.

57 Figurine of a man with blue glass beads in his eyes, navel, nipples, and chin, made before 1855 at Point Hope. Height: 7½ inches (18.8 cm.). British Museum 1855.11–26.167. This object, which was acquired by the museum in 1855, was probably obtained during the search for Sir John Franklin in northwest Alaska between 1848 and 1854.
Photograph courtesy of the Trustees of the British Museum

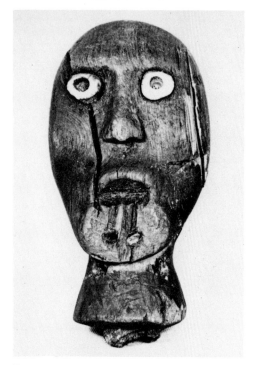

58

58 Expressive face carved of wood with ivory eyes, from Point Hope. Height: $3^5/_{16}$ inches (9.5 cm.). Purchased by Henry B. Collins, archeologist, from Point Hope Eskimos who had excavated it from the old village. Collins thought it was less than two hundred years old. It was probably a head for a shaman's doll or mechanical figure. The walrus ivory eyes are hollowed out and might have been inset with beads. The two holes in the neck connect, as do the two at the base of the neck in back.

59 Three wooden figures, probably from Point Hope. Height of figure on the left is $10^1/_8$ inches (25.3 cm.). AMNH 60.1–4299 (?), 60.1/4301, 60.1/4300 (left to right). These figurines were given to the American Museum in 1916 without provenience; but workmanship, style, and concept leaves little doubt that they were made at Point Hope. All have pronounced male genitals and baleen strips for suspension.

60.1/4299. The eyes and labret of this figurine are inset with blue beads, and the teeth are made of ivory. The ears are carved in relief. A slight trough indicates the backbone. Pegs are stuck into the arm sockets, suggesting attachment of arms. The legs seemed to have been broken off. This figure was suspended from the head.

60.1/4301. The head of the middle figure, which is detachable, is held in place with a wooden peg. The open mouth is deeply excavated, and the ears, nose, and eyebrows are carefully carved. Eyes are incised and hands are represented by knobs. A shallow hole was made on each side below the armpits. This figurine was suspended from the back so that it hung in a horizontal position. Two nails, now rusted, were driven into the break in the bent leg. This may represent Asetchuk, the Point Hope shaman who could fly (see under "Sculpture" in Chap. II).

60.1/4300. This figurine has neatly carved ears, nose, and eyebrows, and has an unidentified object in its mouth. Eyes are incised. Hands are not indicated, and feet are very small. This figurine also hung in a horizontal position. About 1880, Asetchuk flew to Saint Lawrence Island from Point Hope to search for his son. He flew with a knee drawn up, arms outstretched, wings growing from his shoulder blades, and "his mouth grew to extend outward and up to his tattoo markings" (Rainey 1947, p. 277). This mouth may depict such a growth.

60 Two wooden figures from a shaman's cache found on Sledge Island. Heights: $15^3/_{16}$ inches (39 cm.) and $13^{11}/_{16}$ inches (35 cm.). University Museum NA-4790 and NA-4791. Collected by W. B. Van Valin, 1912, and catalogued as a "whaling outfit." The eyes are pieces of quartz.

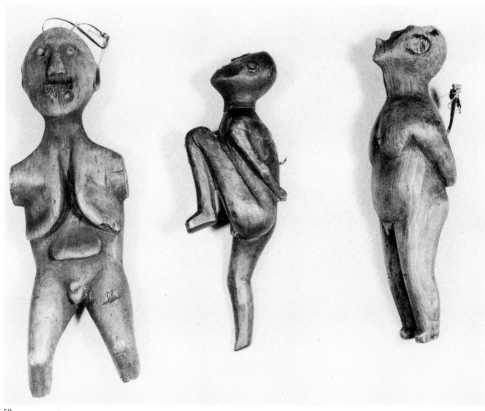

59

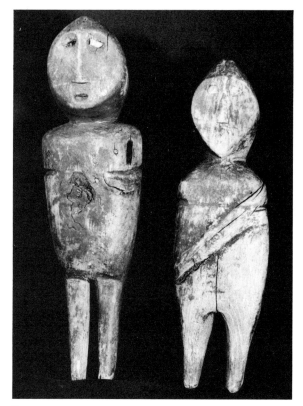

60

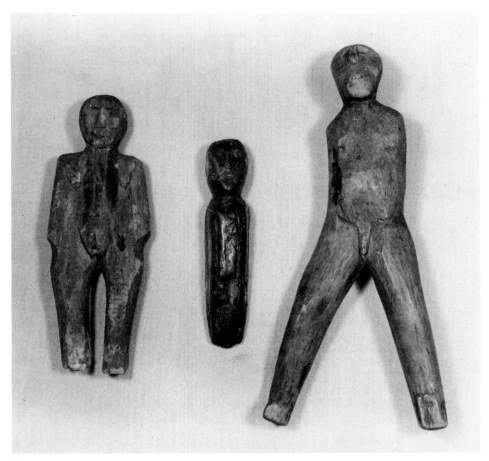

61

61 Figures from Cape Nome and Port Clarence. Height of right figure is 9⅜ inches
(24 cm.). AMNH 60.1/1358, 60/6807, 60/8965. Sometimes the sex of a figurine was
clearly indicated, but sometimes it was not, as exemplified by these three figures. The
long-legged figure was collected by Miner Bruce in 1899 from Port Clarence. Its eyes are
inset with pale blue beads. Although the legs are prominent, there are no arms. A
slight protuberance on each leg indicates a foot.

The middle figure, of dark ivory, from the ''Bering Sea'' (possibly Saint Lawrence Island),
has incised eyes, eyebrows, nose, mouth, and labret holes. Three V-like incisions were
cut on the forehead.

The chunky wooden doll on the left was collected at Nome in 1903. The breasts of
this crudely made piece are placed high on the shoulders, and the oblongs on the sides
appear to be arms. The backbone is indicated by a groove.

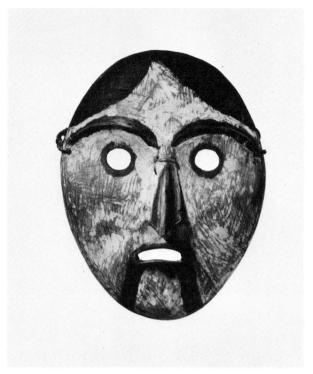

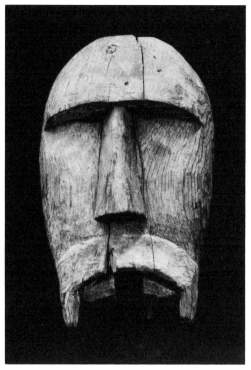

62 63

62 Wooden mask from Port Clarence, 1890s. Height: 6³⁄₄ inches (17.5 cm.). FMNH 12936. Collected by Miner Bruce. The face is painted white. The eyes, nose, mouth, and tattoo lines are dark red, and the hair and eyebrows, black.
 Photograph by John Bayalis

63 Mask from Little Diomede Island. Height: 10¹⁄₄ inches (27.4 cm.). Anchorage Museum 55.3.41.

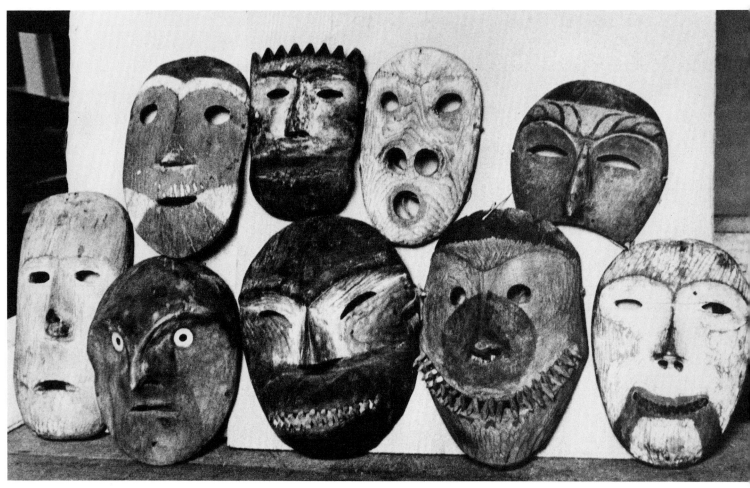

64

64 Masks from King Island in the Sheldon Jackson Museum, Sitka. The mask on the top left has peaks representing the Kigluaik Mountains, as seen on the box drum, figure 146.

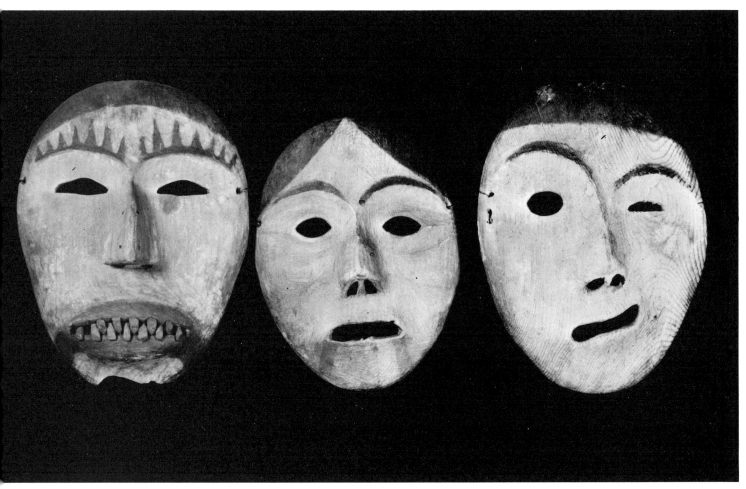

65

65 Three King Island masks, collected about 1915. Height of mask on left is 7 inches (17.5 cm.). University Museum NA-4572, NA-4570, NA-4566 (left to right). Hair and eyebrows are painted red with ocher or hematite. The eyebrows represent the Kigluaik peaks.

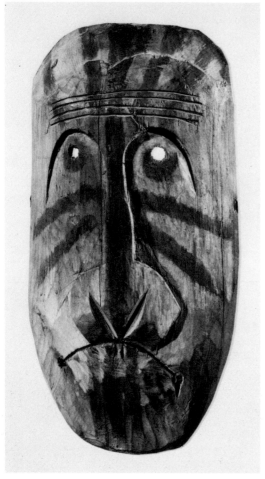

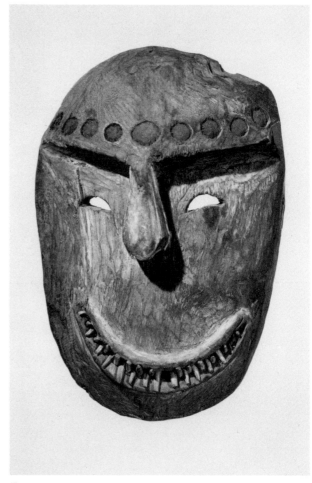

66

67

66 Mask from Port Clarence or King Island with red and black facial markings, from the 1890s. Height: 10³/₁₆ inches (26 cm.). FMNH 53482. Collected by Miner Bruce. This mask has radiating forehead markings, as does a mask in the top row of figure 64. The vertical line that extends from the nostrils to the top of the head is black, as are the lines on the chin. All other markings are dark red.
 Photograph by John Bayalis

67 Mask, collected at Port Clarence in the 1890s, with peg teeth and forehead designs of red circles. Height: 8¹³/₁₆ inches (22.5 cm.). FMNH 13431. Collected by Miner Bruce. The indented circles on the forehead are painted red, and the face was once white. Meshing teeth were used to represent a wolf in the Bering Strait area. They were also used on various charms associated with the shaman (see also figs. 8–10, 64, 65).
 Photograph by John Bayalis

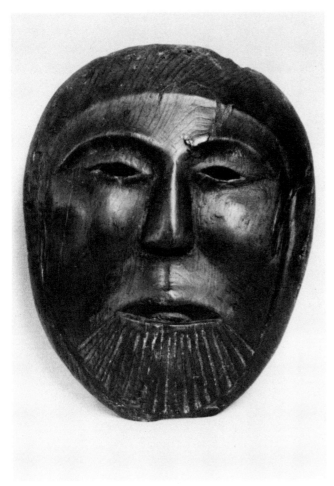

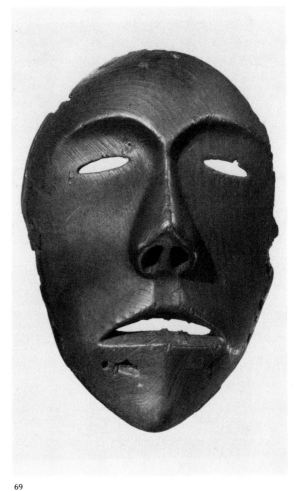

68

69

68 Point Hope mask called "Uvilopalik," which was used as an amulet in whaling ceremonies. Height: 8 inches (20 cm.). Washington State Museum 100/12. Collected by J. Hackman and I. Koenig for the Alaska-Yukon-Pacific Exposition in 1909. Jimmy Killigivuk of Point Hope identified this mask when he visited the museum in 1966. His father, grandfather, and great-grandfather had made similar ones, and he himself had seen it used in whaling ceremonies when he was a child. It remained in one place in the ceremonial building until after the close of whaling season. He carved me a similar one of sugar pine purchased in Seattle after he had seen this one in the museum.

69 Realistic mask of a man's face from Point Hope. Height: 8⅝ inches (22 cm.). FMNH 53478. A ruff of wolverine or caribou fur may have been attached to a groove with holes carved around the edge (VanStone 1968/69, p. 834 and pl. 2C).

Photograph by John Bayalis

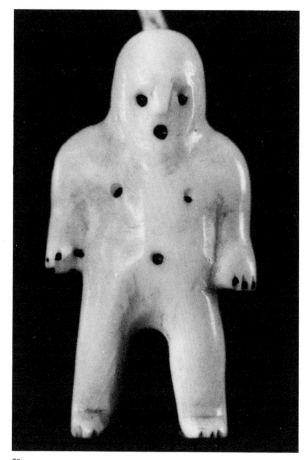

70

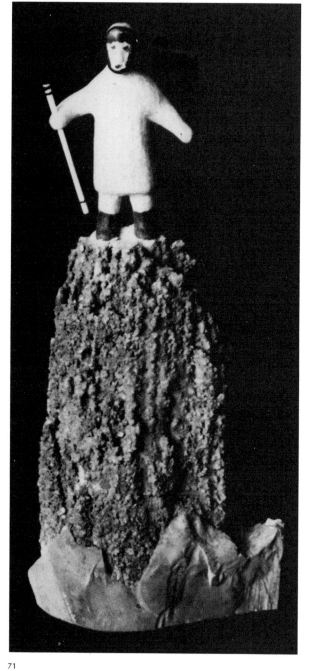

71

70 Amulet made "from memory" by Michael Kazingnuk of Little Diomede Island, 1955. Height: 1½ inches (3.8 cm.). Collection of D. J. Ray. The figure is suspended with sinew from holes drilled through the back of the head. India ink was used for markings.

71 Man made of ivory stands watch on a cliff made from the basal end of a walrus tusk. Height: 5⅞ inches (14.6 cm.). Private collection. The core is tan and the markings are India ink. Although purchased in Anchorage in 1970, it probably was made during the 1950s.

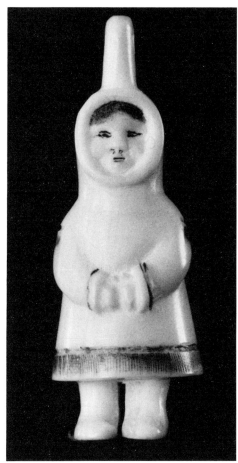
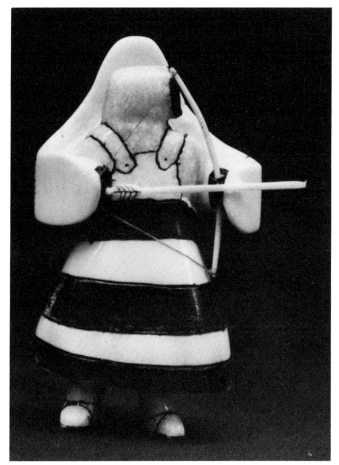

72 73

72 Tiny ivory pendant, only 1³⁄₈ inches high (4.3 cm.), for wearing on a chain. King
Island, 1946. Collection of D. J. Ray. The delicate vertical gashes, the hair, and facial
features are colored with cigarette ash. The horizontal line at the bottom is red ink.

73 Saint Lawrence warrior in battle dress, ivory figurine, 1973. Height: 4¹⁄₄ inches
(10.6 cm.). Anchorage Museum 73.42.1. In the old days, armor was made of two pieces:
the lower portion generally was of thick, double ugruk hide fastened with thin pieces of
rawhide; and the top portion behind the head, a solid piece of hard, flexible double
ugruk hide. The back of the top armor in this figurine has two long lines with short
bisecting gashes, representing the two seams that held pieces of walrus hide together.
Although figurines wearing costumes have been popular during the 1960s and 1970s, they
are not new. Otto William Geist obtained several in 1926 from Saint Lawrence Island,
one of which is illustrated in VanStone 1953, pl. 4, no. 10.

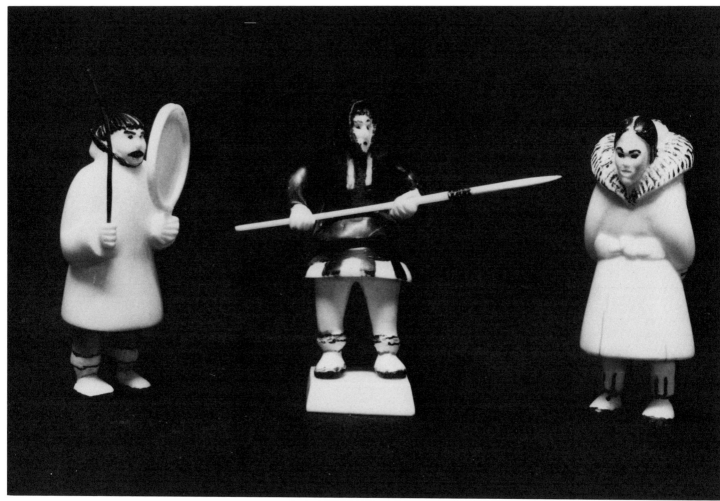

74

74 Ivory figurines showing various kinds of costumes, carved by John Aningayou, Gambell, 1971. Height of drummer on the left is 3¼ inches (8.1 cm.). Eskimo Museum, Nome. The drummer's pants are colored red to simulate dyed reindeer hide. The drum stick is baleen. The hunter in the middle is painted black with India ink to represent a parka made of cormorant skins. The white design represents murre breasts. The hunter's wife on the right wears a parka and boots of reindeer skin, and a wolf ruff. Partly made with power tools (especially the fur and the hair), the figures have acquired a somewhat non-Eskimo feeling, characteristic of those made by commercial producers in Seattle.

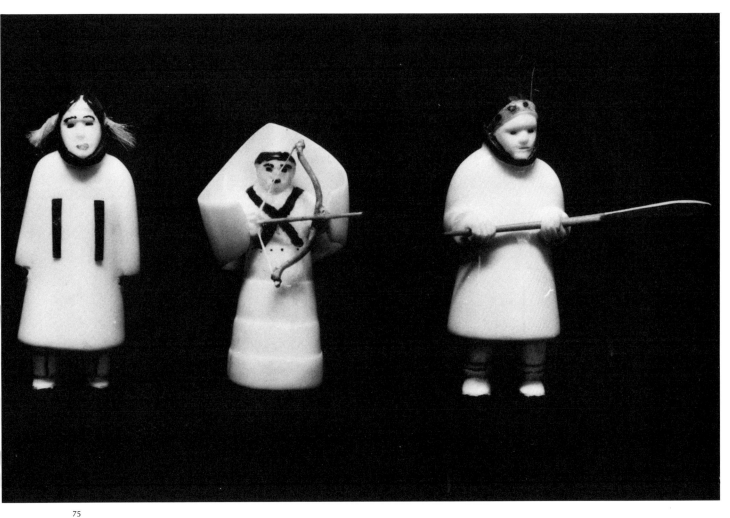

75

75 Three figures in traditional dress carved in ivory by John Aningayou, Gambell, 1971. Height of woman on the left: 3 inches (7.5 cm.). Eskimo Museum, Nome. The woman wears formal ceremonial wear. Real reindeer fur is attached to her head. Strips of wolverine are represented by baleen. The middle figure is a "bow and arrow warrior," who wears a complete set of armor (see fig. 73). The figure on the left, "spear specialist warrior," was a man who excelled at running and jumping. He and other spear specialists had drills to perfect techniques of running down their opponents. He wears a feather headdress of black baleen (representing swans), but it does not show clearly in the photograph.

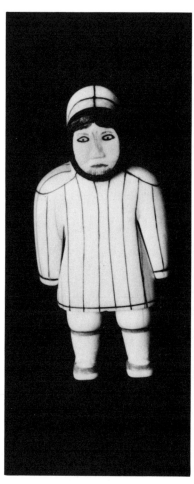
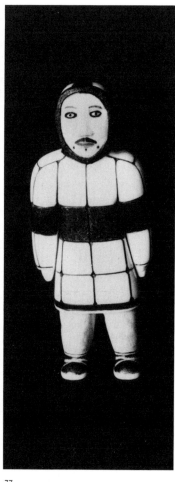
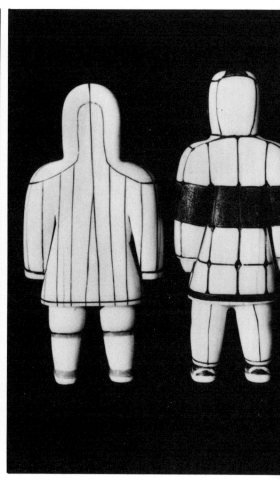

76 77 78

76 Ivory woman in typical Saint Lawrence Island dress carved by Logan Annogiyuk, Savoonga, 1960s. Height: 5¹/₁₆ inches (13.1 cm.). Private collection. All markings are black India ink with the exception of the boots and mouth, which are red. The back of this figurine is illustrated in figure 78. This and figure 77 are also illustrated in color in Anonymous 1973, p. 159.

77 Ivory carving of a man in a birdskin parka, by Logan Annogiyuk, Savoonga, 1960s. Height: 5³/₈ inches (13.4 cm.). Private collection. All markings are black ink with the exception of the mouth, which is red, and faint scratches on the pants, which are a light green. The back of this figurine is illustrated in figure 78.

78 Rear view of the two figures illustrated in figures 76 and 77.

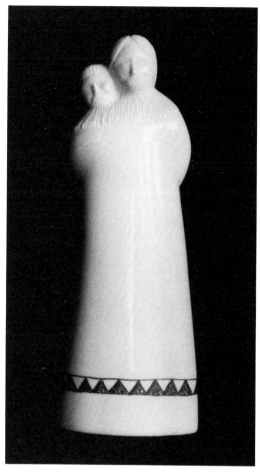

79

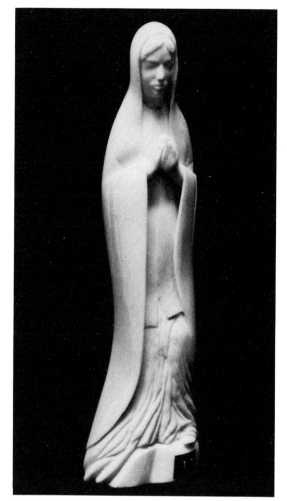

80

79 "Madonna," Eskimo mother and child, an ivory figurine by Justin and Paul Tiulana, 1973. Height: 5⅛ inches (12.8 cm). Private collection. The body was made by Justin, and the faces were carved by his father, Paul. The delicate carving of the features and the fur on the shoulders contrasts with the heavy geometric trimming on the bottom. This and figure 80 were made partially by machine tools.

80 "Madonna," a traditional western subject in ivory by Alvin Kayouktuk. Eskimo Museum, Nome. Height: 7 inches (17.5 cm.).

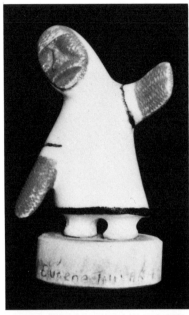
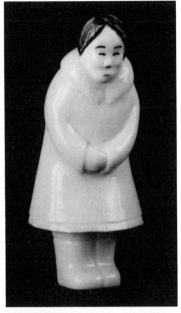

81

82

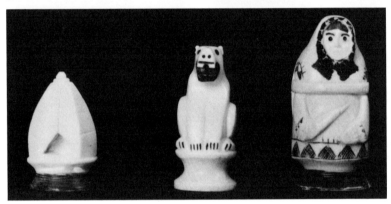

83

81 Ivory figurine of a dancer wearing the bad shaman mask and gauntlet dancing mittens, by Eugene Tiulana, 1973. Height: 2¹¹/₁₆ inches (6.5 cm.) including the bone base. Private collection. Eugene, who was twenty-one in 1973, is from King Island, but he made this figurine while working in the Anchorage shop of his father, Paul. The mask and mittens are colored brown, and lines are black paint.

82 *Eskimo woman, made of sperm whale tooth by Thomas Ekak of Wainwright, 1959.* Height: 3¹/₄ inches (8.1 cm.). Collection of D. J. Ray. Facial features and hair are painted black and the mouth, red. This was made at the commercial establishment of Leonard F. Porter, Inc., Seattle, and is signed "T. Ekak" on the bottom.

83 Commercially made "Eskimo" objects of sperm whale tooth. Height of figure on the right: 1⁷/₈ inches (4.6 cm.). Private collection. These pieces of a chess set were made either in Seattle or in Japan for a Seattle firm. All markings are black except the mouth of the dog (middle figure), which is red. Many figurines like the one on the right have been sold as "man and woman" sets in Seattle and Alaska. The customer was told that they had come "from somewhere up north," or "Little Diomede Island," or "King Island," all untrue. Ones like these are illustrated in the Ernst and Ernst report, page III–41, as "Japanese made."

84

84 "Mutt and Jeff," two old comic strip characters carved from walrus ivory, Saint Lawrence Island, 1920s. Height of the tall figure: 9¼ inches (23.1 cm.). USNM 394,459. The figures were the gift of Mrs. E. D. Jones, whose husband encouraged the Saint Lawrence Islanders in their carving (see under "Figurines" in Chap. III). John Octuck (see fig. 145) and his sons of Igloo were good engravers who copied such things as the "Katzenjammer Kids."

Photograph by the Smithsonian Institution

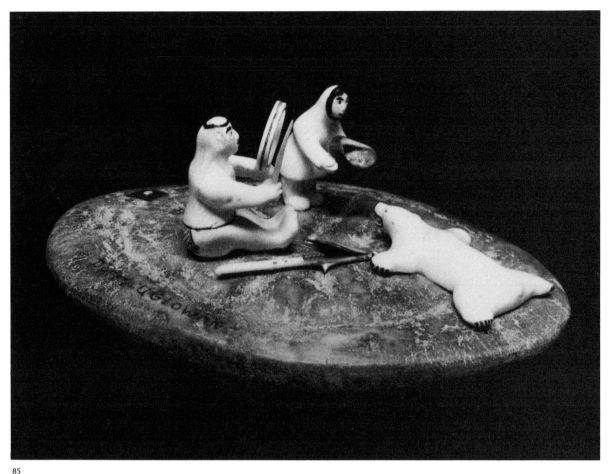

85

85 "Ceremony after Bear Hunt," sculpture in ivory on a whale vertebra disc by Duffy Uglowok, Gambell, about 1971. Height of drummer: 1¾ inches (4.3 cm.). Eskimo Museum, Nome. The markings are red and black ink on the hunter, his wife, and dead polar bear.

86 Ivory figurines represent a ceremony following successful whale hunting, by Harry Koozaata, Gambell, about 1969. Height of figures: 1½ inches (3.8 cm.). Private collection. The base is a brown whale vertebra disc. Most of the ivory is new white ivory, but the extreme left figure and the one in front of him are of tan old ivory, as are the visors on the two hunters in the back. The lines are made of twisted sinew. This is illustrated in color on the cover of Anonymous 1973. In 1973 Koozaata was the curator and principal carver at the Arctic Trading Post Eskimo Museum, Nome.

87 Village scene in ivory by Moses Milligrock, Little Diomede Island, 1964. Height of frame: 2¼ inches (5.6 cm.). Collection of D. J. Ray. The objects—a man drying a skin on a frame, dog, cache, and an umiak on a storage rack—are out of proportion, but all are well finished. The wooden base is covered with sealskin and pulverized rock, and has seal parchment on the sides and blue felt underneath. The lashings and cords are linen thread.

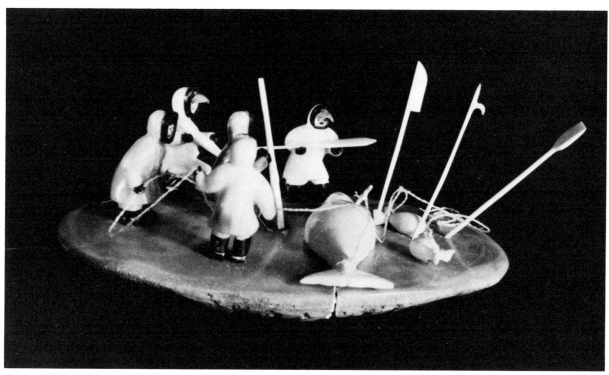

86

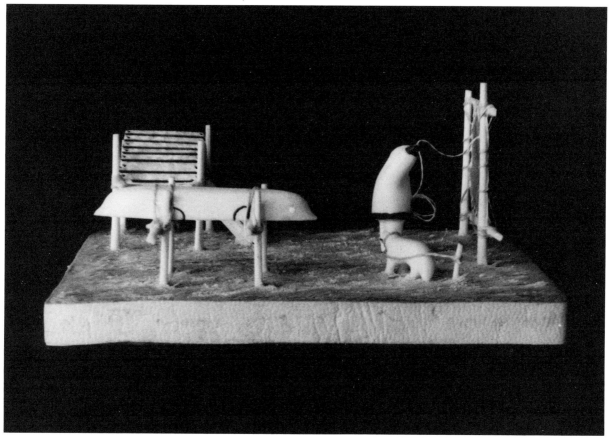

87

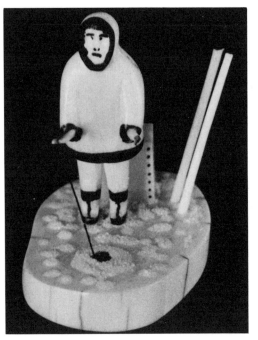

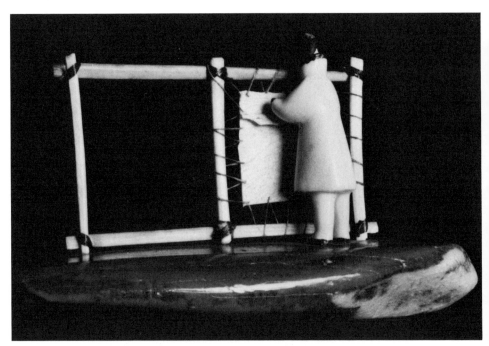

88 89

88 Man fishing for tomcods through the ice, from Little Diomede Island, 1964. Height: 2³/₄ inches (6.8 cm.). Collection of D. J. Ray. This well-made scene has pulverized rock glued to the ivory base. India ink is used for markings, and the tomcod jigging stick (left) is strung with ordinary black cotton thread.

89 Sculpture of a woman splitting a skin, Savoonga, 1960s. Height of woman: 2⁵/₈ inches (6.5 cm.). Private collection. The base is old ivory. A piece of seal parchment is strung to the frame with sinew, and the frame is bound together with strips of baleen.

90 Man using a bow drill, carved of ivory by Abner Noyakak, King Island, 1961. Height: about 1³/₄ inches (4.3 cm.), including the base. Collection of D. J. Ray. The adz (on the left) and the tusk are made of ivory, and the toolbox, tan mammoth ivory. The hair and marks on the clothing are India ink. The bow is strung with black cotton thread.

91 Hunter pulling a seal from water, by Justin Tiulana, 1973. Height: 2¹/₂ inches (6.2 cm.). Anchorage Museum 73.15.1. This figure departs in form from those that were popular during the 1950s and 1960s (see fig. 92), and the facial features are carved rather than painted. The sculpturing of features is also seen in figures 79 and 80. Sinew is used for the line hauling the seal, only the top half of which is carved. The base of old ivory is cut on the side to represent a hole.

92 Two hunters pulling an ugruk, Little Diomede Island, 1954. Height of men: 2¹/₂ inches (6.3 cm.). Collection of D. J. Ray. The ivory figurines are on a thin slab of baleen. India ink is used for markings, and sinew, for the ropes. The men originally carried spears, which are now lost.

90

91

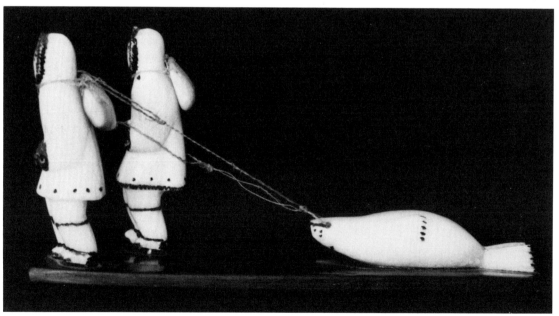

92

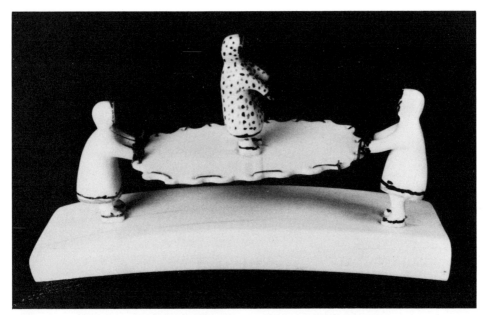

93

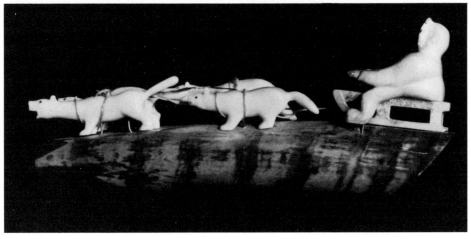

94

93 Blanket toss in ivory, probably Saint Lawrence Island, about 1950. Height of right figure: 2 inches (5 cm.). Private collection. The dots on the parka are red and black, and the stripes on the bottom of the two persons in white parkas are red and black. Sinew is inserted around the "blanket," and the figures are pegged and glued onto the base. For purposes of this carving, only two persons hold the blanket, or walrus skin, but usually there are a dozen or more. Illustrated in color in Anonymous 1973, p. 156.

94 A man drives his dog team on top of an old ivory tusk. Height (overall): $1^{13}/_{16}$ inches (4.4 cm.). Probably from Saint Lawrence Island. Private collection. The sled is made of orange-colored ivory, and the man of new white ivory. The man's foot and the dogs are fastened to the base with wire. The dog harness is made of thread. Three of the dogs have red mouths. Illustrated in color in Anonymous 1973, p. 157.

140

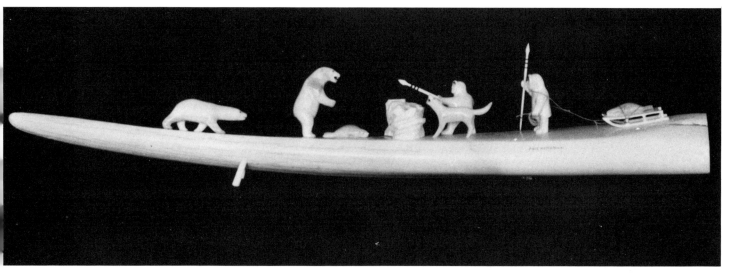

95

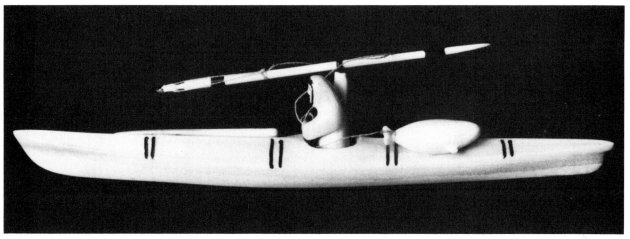

96

95 Two polar bears confront two hunters and their dog over a dead seal, by Paul Nattanguk, King Island. Length of walrus tusk: 28½ inches (71.3 cm.). Sinew is used for the lines.
Photographed by D. J. Ray at Jewels of the North, Anchorage

96 A hunter prepares to throw his harpoon from his kayak, Gambell. Length: 8¾ inches (21.8 cm.). Private collection. On the bottom is written, "St. L. Island. Thomas, Gambell. Alaska." All parts are made of ivory and ornamented with India ink and sinew. The paddle and seal float are glued onto the kayak.

141

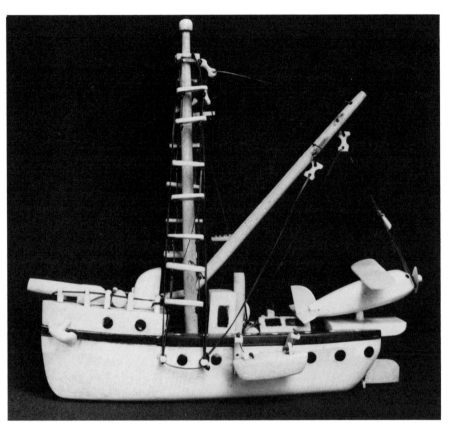

97

97 Ivory and baleen ship with an airplane and cannon on deck. Length overall: 8¼ inches (20.6 cm.). Washington State Museum 10.0/120. The masts are bone, and the lines, baleen. The propellor turns.

98 Ship model made of ivory and baleen, Little Diomede Island, 1953. Length: about 2 feet (60 cm.). In 1961 I said that models such as this cost ''around $250 or $300'' (1961, fig. 65); but now, in the 1970s, with the tremendous upsurge in Eskimo art collecting and rarity of models, one like this might be worth two thousand dollars or more to a collector.

99 A gaff-rigged two-masted schooner made of elephant ivory by Carl Iyakitan, Gambell, 1973. Height 11⅝ inches (29 cm.). Iyakitan was being furnished with elephant ivory to make vessels like this, which retailed at about five hundred dollars. The lines are cotton thread.
 Photographed by D. J. Ray at Jewels of the North, Anchorage

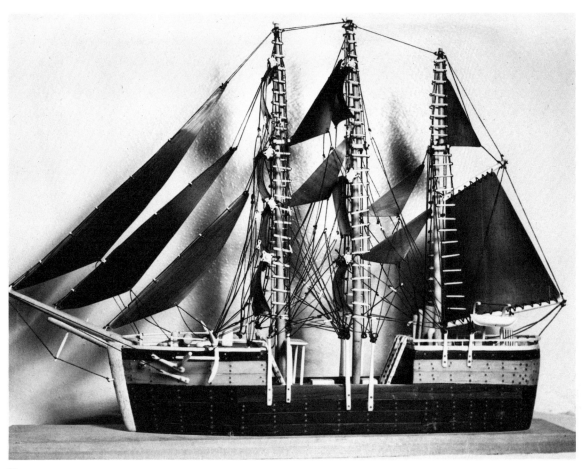

98

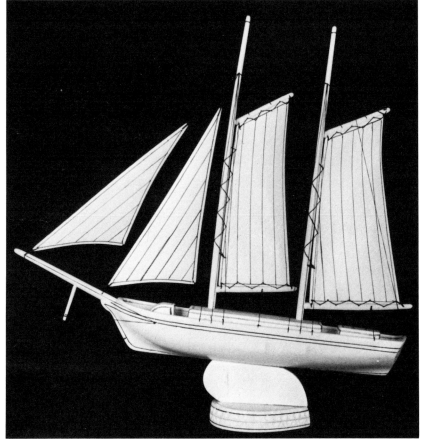

99

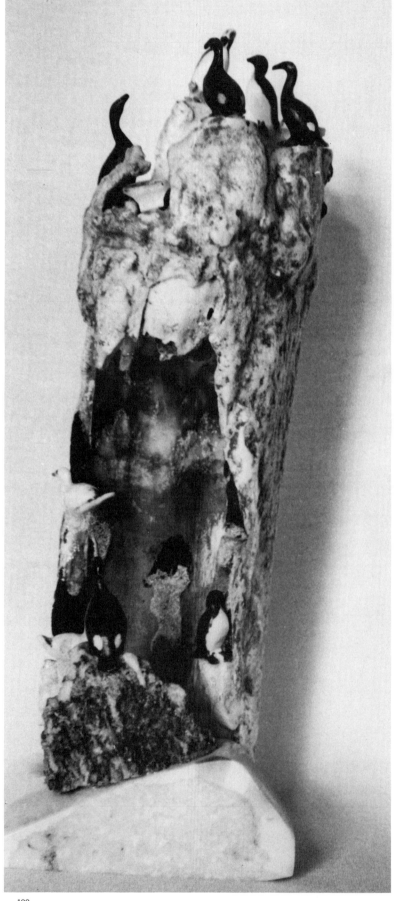

100

101

102

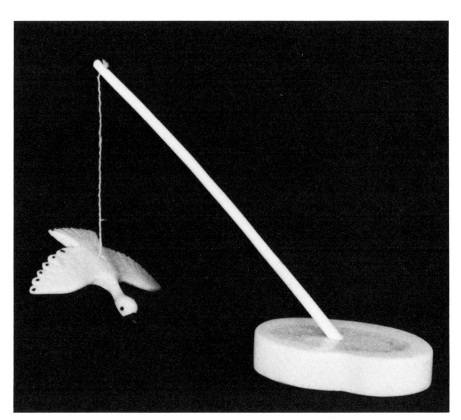

103

104

100 A lofty bird rookery featuring cormorants, murres, and puffins, probably made in the 1960s. Height 8¼ inches (20.6 cm.). Private collection. As raw ivory became scarce and expensive in the 1940s and 1950s, and the demand for carvings increased, carvers began to utilize every scrap, including the basal end of a walrus tusk, which could not be used for ordinary carvings, but is appropriate for the attachment of the tiny bird sculptures. This piece is illustrated in color in Anonymous 1973, p. 153. See also figures 271 and 272.

101 An ivory eagle catches a rabbit in its talons, about 1962. Height: 2⅞ inches (7.1 cm.). Private collection. This was probably made by a Little Diomede man. One of the few sculptures that Happy Jack made before he died in 1918 was an eagle clutching a ball in its talons.

102 An eagle gets a salmon, an ivory sculpture by Lloyd Elasanga of Little Diomede Island, 1973. Height: 2⅝ inches (6.5 cm.). Private collection. Elasanga carved this in Anchorage where he was associated with Cook Inlet Native Association in 1973. On the bottom of this piece he wrote: "Made July 1973. Lloyd Elasanga. Diomede, Ak." The Anchorage Historical and Fine Arts Museum also has a similar carving of an eagle clutching a rabbit, apparently Elasanga's first attempt at this subject (in 1972), after which he switched to the eagle and fish.

103 Ivory eagle on a soapstone base by William Soonagrook, Sr., Gambell, 1972. Height: 5 inches (12.5 cm.) from bottom of soapstone base to the top of the head. Eskimo Museum, Nome. This sculpture was made with power tools. Soonagrook also used the same subject matter for a woodblock print in four colors in the MDTA program in Nome in 1965.

104 A swan swings from a pole, imitating a bird in flight, about 1962. Length of pole: 3¾ inches (9.3 cm.). Private collection. The bird is attached to the pole with sinew, and the pole is imbedded in a thick cross section of a walrus tusk. In 1955 a Diomede carver told me that the Wales people had first tried making "a swan flying on a stand" in 1953, but he predicted that it would not be very popular. I have seen very few like this one.

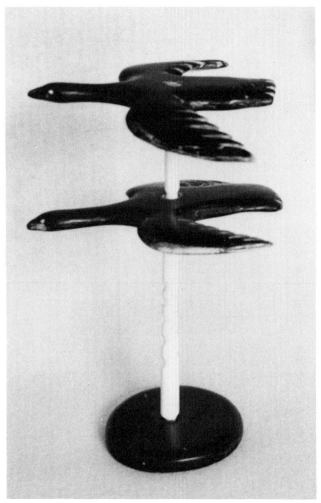

105

106

107

146

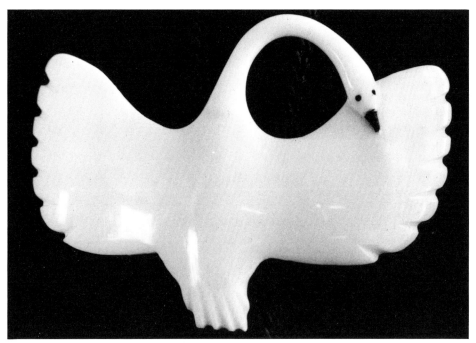

108

105 Two birds in flight, made of baleen and ivory, 1950s. Height: 4 inches (10 cm.). Private collection. The birds and base are made of baleen, and the shaft is ivory. Also illustrated in color in Anonymous 1973, p. 158.

106 Two birds, which show the detailed feather markings characteristic of Saint Lawrence Island birds of the 1950s. Height of bird on the right: 1¹/₄ inches (3.1 cm.). Collection of D. J. Ray.

107 Four ducks swimming on a shiny slab of baleen. Height of duck on the far left: ⁷/₈ inches (2.1 cm.). Private collection.

108 Swan made for a bola tie by Calvin Oktollik, Kotzebue, 1973. Width: 2¹/₄ inches (5.6 cm.).
 Photographed by D. J. Ray at the Kobuk Valley Jade Shop, Kotzebue

109

110

111

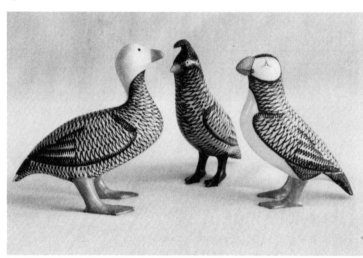

112

148

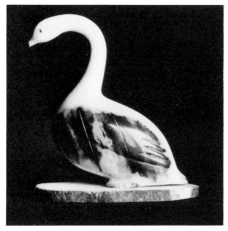

113 114

109 Snowbird salt and pepper shakers made of ivory, 1950. Height: 2³⁄₈ inches (5.9 cm.). Collection of Caroline M. Reader. Comparison with the snowbirds in figure 110 shows great differences of style and finish. These might have been done by a beginner, though there is a special charm in their chubbiness and depiction of feathers. Salt and pepper shakers were usually made from female tusks because of their smaller size, but few shakers were made in the 1970s because of the scarcity of these tusks. Snowbirds were first carved in the 1940s.

110 Snowbirds in winter and summer plumage, carved of walrus ivory by Aloysius Pikonganna, King Island, 1955. Collection of D. J. Ray. Height of bird on the left: 2 inches (5 cm.). The baleen eyes are inlaid so skillfully in a slightly oval-shaped depression that there are no ridges or gaps. Cigarette ash was used for the black markings, and hematite for the red mouth.

111 Pin with engravings of crested auklets, King Island, 1969. Diameter: 1⁵⁄₈ inches (4 cm.). Private collection. All incisions are colored black with the exception of the beaks, which are red. The zigzag design is used to represent feathers on this two-dimensional form as well as on sculptured birds.

112 Small sculptures of emperor goose, crested auklet, and puffin, by Alvin Kayouktuk, 1973. Height of the goose and auklet: 2⁵⁄₈ inches (6.5 cm.). Beaks and legs are orange, except for the auklet, which has black legs.
 Photographed by D. J. Ray at the Kobuk Valley Jade Shop, Kotzebue

113 Goose in ivory, signed on the bottom by John Aningayou, Gambell, 1972. Height: 3 inches (7.5 cm.) without the base. Collection of Judy Johnson. Although made by the same man who carved the costumed figurines, figures 74 and 75, this one exhibits quite a different style and handling of tools.

114 A baby bird emerges from an egg carved by a Shishmaref boy, 1968. Height: 2⁷⁄₈ inches (7.1 cm.). Collection of Beverly Hendricks. This is an unusual departure from the ordinary bird carvings.

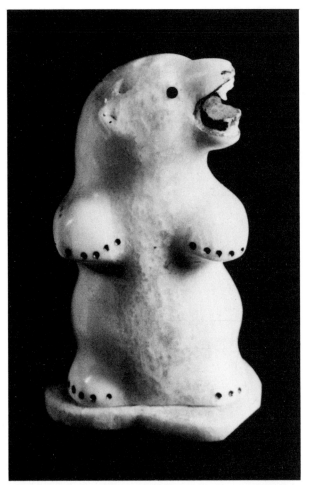

115

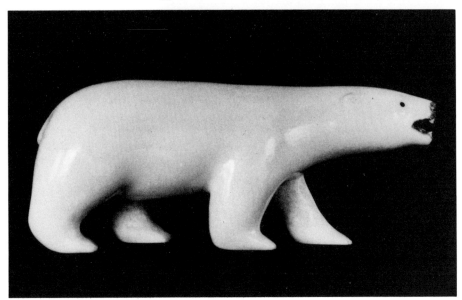

116

150

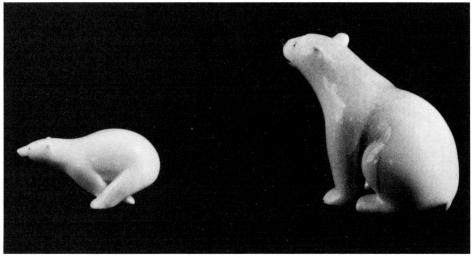

117

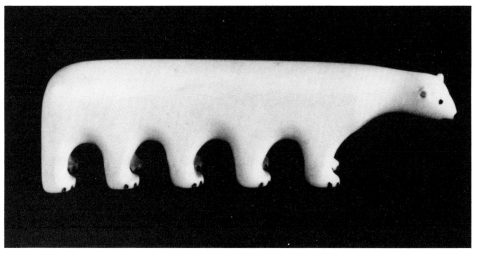

118

115 Salt shaker in form of a bear, by Aloysius Pikonganna, King Island, 1950. Height: 2¼ inches (5.5 cm.). Collection of D. J. Ray. Salt and pepper shakers in imitation of ordinary shakers were first made shortly after the gold rush, but those in the forms of rabbits, bears, and birds were not made until the 1930s and 1940s. Carved from a female tusk, the eyes are inset with baleen and the dots on the paws are colored black. Hematite was used for the red mouth. The hollow body is threaded halfway up to fit onto an opposing grooved spool in the base.

116 Polar bear carved by Aloysius Pikonganna of King Island, 1955. Length: 4⅞ inches (12.5 cm.). Collection of D. J. Ray. This bear and the steps in carving are illustrated in Ray 1961, figs. 64, 96–107. Pikonganna was still carving as well as ever in 1973 at sixty-four years of age.

117 Two ivory bears in unusual poses, carved by Joel Kingeekook, Saint Lawrence Island. Height of bear on the right: 2 inches (5 cm.). Collection of Dr. and Mrs. James P. Jacobson. The smaller bear was carved in 1968, and the larger one, in 1969. Joel and his brother Floyd, another excellent carver, were always far behind on their carving orders.

118 Modern version of the legendary ten-legged bear of Point Barrow. Length: 4½ inches (11.3 cm.). Collection of Beverly Hendricks. See also figure 11 and discussion under "Mythological Creatures" in Chapter II.

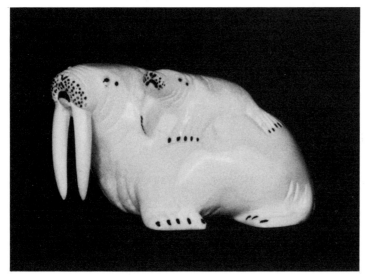

119

119 An ivory carving of a baby walrus resting on his mother's back. Length: 2⁷/₈ inches (7.1 cm.). Private collection. The walrus and baby subject was developed during the 1960s. Walrus figurines vary from sleek, streamlined forms to those representing an old bull with numerous wrinkles. One with unusually fluid lines by Charles Kokuluk of Nome is illustrated in *An Introduction to the Native Art of Alaska* (1972, p. 32). The walrus in figure 120 illustrates the carving of a beginner.

120 A giant walrus stoically listens to a howling polar bear, carved by a young boy, Savoonga, 1955. Length of base: 6 inches (15 cm.). Collection of D. J. Ray. This piece was purchased at the village store of Savoonga for the asking price of four dollars. The storekeeper said that it had taken Hans Gologernan, only fourteen years old, a day to carve it; but Hans's mother said that it took him two days.

121 Ivory seal, only 3 inches long, with delicate designs, 1971. Collection of Dr. and Mrs. James P. Jacobson. The seal was shaped by Lincoln Milligrock, but the engraving was done by his uncle. The eyes are inset with baleen.

122 Bowhead whale in ivory by Harry Koozaata, 1973. Length: 5³/₄ inches (14.3 cm.). Private collection. The dots above the eye are made with a dental drill. This was carved by the same man who made the whaling ceremony scene, figure 86.

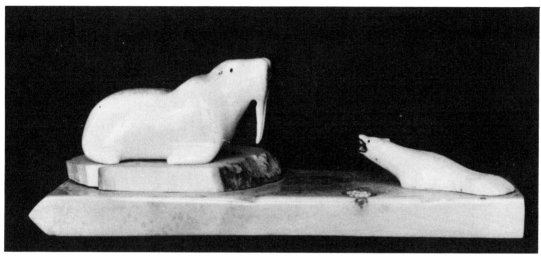

120

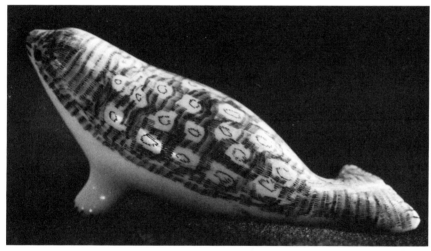

121

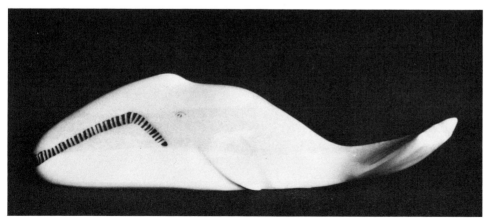

122

153

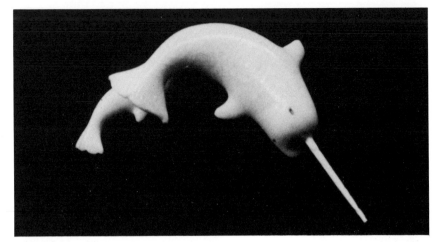

123

124

125

126

123 Two narwhals made of walrus ivory by Earl Mayac, King Island, 1971. Length from tip of tusk to tail: 3⅓ inches (8.3 cm.). Anchorage Museum 71.136.9. The two narwhals (one is almost obscured in this photograph) are mounted on a thin black baleen base.

124 Elephant carved from a brass model at Wales, 1950s. Length: 2¾ inches (6.9 cm.). Private collection. This figurine, which was purchased at the Surprise Shop in Anchorage, was accompanied by the following information: "Eskimo hand carved of Alaskan walrus ivory—carved by the Eskimos from the island of Wales, Alaska off the coast of Nome [?]. They had never seen an elephant so we had to buy one of brass and ship up to them to copy. This is a very unusual carving as the tusks are all one piece with the head." Elephants had been carved for many years by various Eskimos, and have usually been kept in stock by ANAC.

125 Dall ram of walrus ivory perches on an old block of whalebone. Height of ram: 2 inches (5 cm.). Collection of Mr. and Mrs. Joseph E. Walsh. The owners did not know the carver, but it probably came from Point Hope. Another ram is illustrated in Anonymous 1973, p. 156.

126 Two dogs of walrus ivory, 1967. Height: 2 inches (5 cm.). Private collection. The mouths and tongues are red; the other markings, black. I have included these because dogs, except in dog-team sculptures, have rarely been made by the carvers because of the fragility of the legs. I have a dog, 4.4 cm. long, which was recarved by Frank Elanna of King Island in 1966 as a "scratching dog" after the left rear leg of a standing dog had broken.

155

127 128

127 Caribou in ivory by S. Tuzroyluke, Point Hope, 1973. Height: 2½ inches (6.3 cm.). Private collection.

128 Moose on a baleen base by F. Walunga, 1957. Height: about 1⅞ inches (4.6 cm.). Private collection. The antlers are removable.

129 Two rabbits carved of walrus ivory by King Island carvers, 1960s. Height of rabbit on the right: 3½ inches (8.8 cm.). Private collection. The smaller rabbit was carved by Romeo Katexac and the larger, by Charles Penatac. (The latter is illustrated in color in Anonymous 1973, p. 158). Both have inset baleen eyes.

130 Rabbits are often made in linear form or as miniatures. Height of rabbit on the left: 3⅝ inches (9 cm.). Collection of D. J. Ray. The two tall rabbits were made in Nome in 1946, probably by Little Diomede carvers. The date and provenience of the miniature rabbit are unknown, but I think it was made by Romeo Katexac of King Island in the 1960s.

131 Musk ox and baby in ivory on a bone slab, signed by Hubert Kokuluk, 1971. Height of mother musk ox: 1⅝ inches (4 cm.). Private collection. Musk oxen became a popular subject for carvings about 1966 after several young artists had participated in a workshop at the University of Alaska where an experimental herd of musk oxen resided. Oscar Sage of Kotzebue, however, had carved a musk ox of local field stone during the MDTA retraining project of 1964–65 (fig. 175). The musk ox is also the subject of a block printing by Bernard Katexac and has been used as basket designs by women and in masks by men from Mekoryuk on Nunivak Island.

132 Ivory needlecase of the mid-twentieth century, carrying on an old tradition into the souvenir market. Length of walrus: 4⅞ inches (12.1 cm.). Washington State Museum 2–3640. The tail is made of flint and the skin pull is of ugruk leather. The eyes and nose are incised and colored black. Needlecases in this style are still listed in the ANAC catalog.

129

131

130

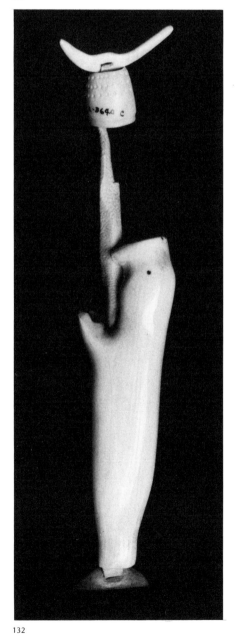

132

157

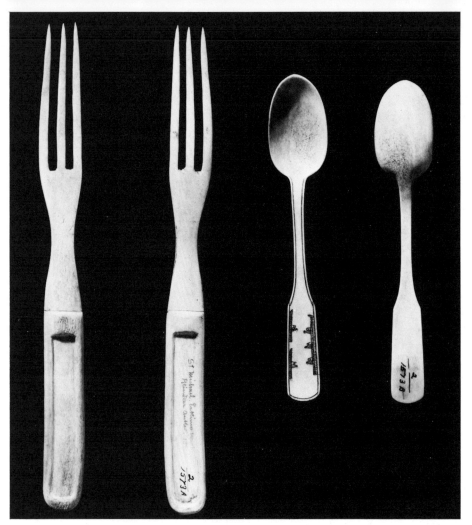

133

133 Fork and spoon made of caribou antler in imitation of metal tableware, Saint Michael, 1890s. Length of fork: 7⅝ inches (19 cm.). Lowie Museum (recataloged) 2/1573 (spoon) and 2/48487 (fork). The white man's useful objects were often copied, on order, as souvenirs, sometimes as almost perfect replicas and sometimes as miniatures, as illustrated in figure 135.

Photograph by Alfred A. Blaker

134 Ivory animals bearing the burdens of toothpick or match holders, 1950s. Height of left holder: 5¼ inches (13.1 cm.). Collection of Mr. and Mrs. David W. Johnson. The incongruity of the skillfully carved animals and the purpose for which they were made makes these pieces unintentionally humorous.

135 Miniature replicas of implements in ivory dating from Nome's early days. Length of hammer: 3¾ inches (9.3 cm.). Nome Museum NM1–30–1 (jackknife), NM1–19–1 (hammer), and NM1–21–1 (razor). The knife has dark ivory pegs. The razor has delicate engravings of a walrus and a ptarmigan.

136 Napkin ring of bizarre animals made of mammoth ivory, probably from Saint Michael. Diameter overall: 3⅛ inches (8 cm.). Constantine Collection, Agnes Etherington M 70–47. Napkin rings were very popular souvenirs for more than fifty years after the gold rushes in the Klondike in 1896 and in the Nome area during 1898–1900. Some were simple, unadorned circles of ivory, but many were covered with tiny sculptures or engravings (see also fig. 266). A favorite during the 1940s was a wide, thick ring featuring a bear's head with open mouth carved in bas-relief on one side.

Photograph by Frances K. Smith

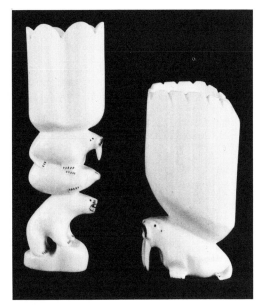

134

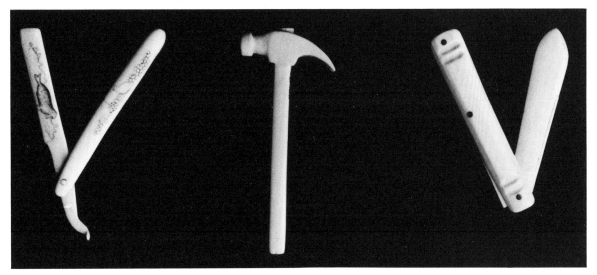

135

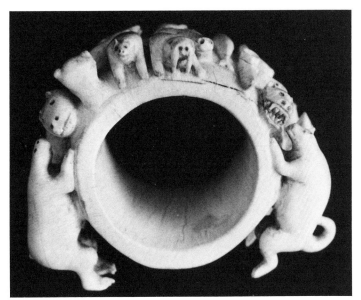

136

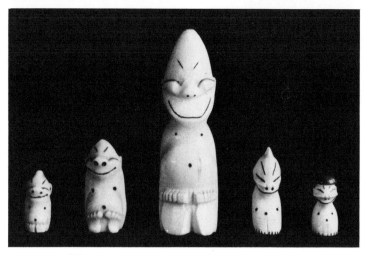

137

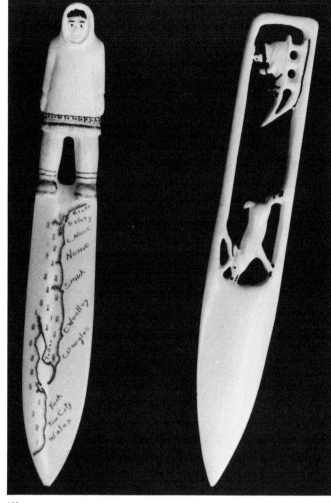

138

137 Five billikens showing variations made by Little Diomede carvers. Height of middle billiken: 3½ inches (8.8 cm.). Collection of Mr. and Mrs. David W. Johnson. The three on the left were carved in 1958; the two on the right, in 1967. The feet of the latter are only horizontal gashes, which are quickly and easily made. The small billiken on the far right is wearing a cap of nephrite.

138 Two letter openers of walrus ivory from Nome. Length of each is 6¾ inches (16.8 cm.). Collection of Caroline M. Reader. The one with the engraved map was made by Tony Pushruk of King Island about 1958, and the cutout design was made in 1947 in Nome, probably by a King Islander, and given to Mrs. Reader by A. Polet, pioneer merchant of Nome, when she was in high school. These objects, which are commonly called paper knives, were first made during the gold rush in a simple style. Several decades later, however, many variations had appeared, of which these are only two. The blade and handle form was more popular than the all-in-one piece, as on the right, and handles were made in a variety of animals, especially a seal figurine and a fish, which was often covered with blackened scales. One of the most unusual knives that I have seen was of one piece, with four exquisitely carved walrus in a row taking up more than three-quarters of its length.

The cutout design is no longer made (also see fig. 186), but the map of the Nome coastline has been a recurring motif on many objects, especially long tusks, and recently was used in an etching called "Nomad's Scrimshaw" by Bernard Katexac. (A tusk and Katexac's etching are illustrated in Ray 1969, figs. 83, 84).

160

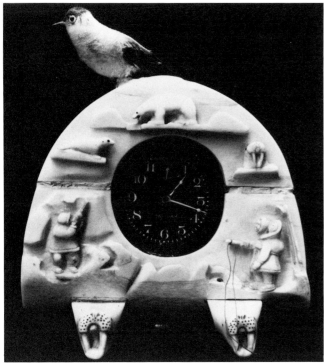

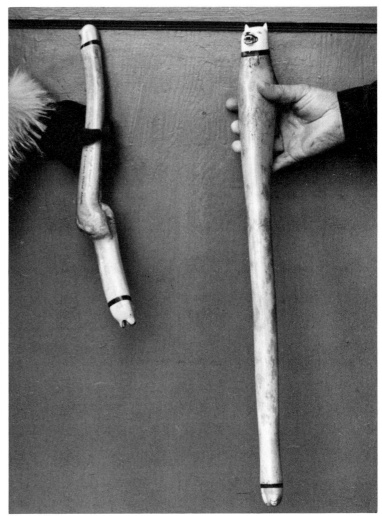

139 Ivory frame for a clock carved by a young King Island man, date uncertain. Height: 4¹/₂ inches (11.3 cm.), excluding the bird. Anchorage Museum 72.71.2. The donor designed and commissioned this piece, which was acquired by the museum in 1972. Within this form and function, each lovely bas-relief carving on the face of the frame combines to form a grotesque parody of Eskimo life and ivory carving. Like the objects in figure 134 it becomes a humorous object. Not only are the subjects and forms incompatible, but the combination of materials is inappropriate: stuffed bird with real feathers, traditional ivory, and mass-produced clock face. Had the bas-relief figures been carved as a sculptural group, we would readily accept this as a fine piece of craftsmanship.

140 Two oosuks with well-carved bear and wolf heads attached to each end, Saint Lawrence Island, 1955. Length of longest piece: about 26 inches (65 cm.). The heads are separated from the bone by heavy strips of baleen. See discussion under "Erotic Objects" in Chapter III.

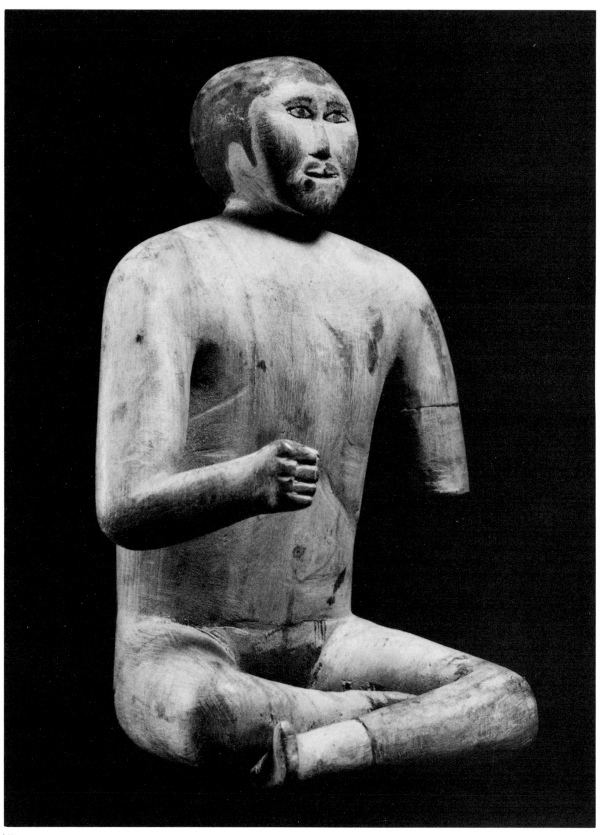

141

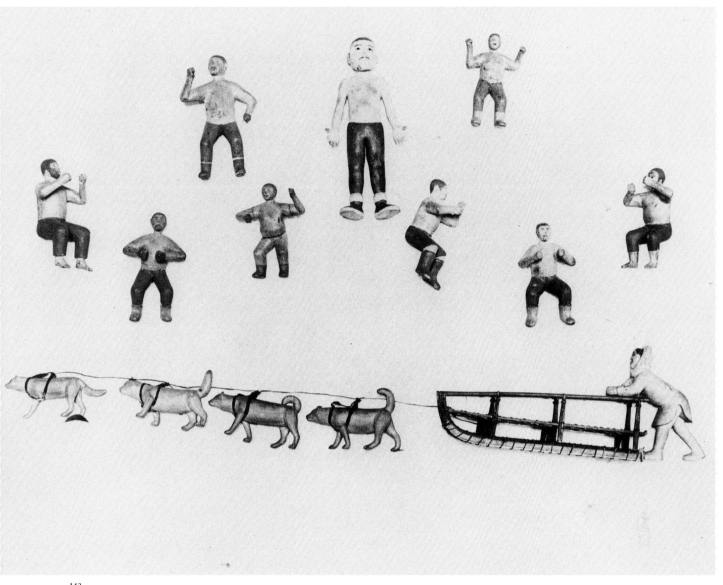

142

141 Seated figure of wood, a delicately finished carving only 4¹⁄₈ inches tall (10.3 cm.). Lowie Museum 2–6989. Collected by H. M. W. Edmonds in 1890 or 1898 at Saint Michael. Others that he collected are illustrated in figures 142 and 143.
 Photograph by Eugene R. Prince

142 One of H. M. W. Edmonds' photographs of wood carvings collected at Saint Michael in the 1890s. From Edmonds' manuscript in the Manuscript Division, University of Washington library. Edmonds wrote in the caption to this photograph that the large figure in the middle represented a man greeting his guests and that the dogs "should be in couples with a single leader." It is easy to identify the sled driver as a woman from her physical attitude. The dancing figures are similar to those in figure 143.

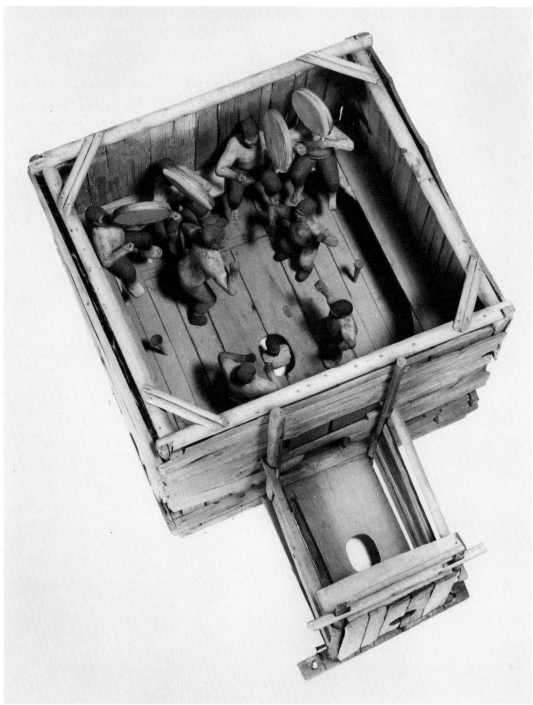

143

143 Four drummers and four dancers greet a man emerging from the underground entrance to a *kazgi*, Saint Michael, 1890 or 1898. Height of the wall: 13⅛ inches (33.5 cm.); height of tallest dancer: 6¾ inches (17 cm.). Lowie Museum 2–6793. This *kazgi* model was obtained by H. M. W. Edmonds, who said in his manuscript that the figures were out of proportion to the building (Ray 1966a, p. 130). A photograph of the exterior with the roof on and two drying racks above it (like those engraved on tusks in figure 249) was also included in Edmonds' manuscript (ibid., p. 129). The drum players wear black pants, and two of the dancers, red-brown pants. The upper bodies have been left natural color, but two dancers have a stained left arm. Three of the drumheads have been re-covered.

Photograph by Eugene R. Prince

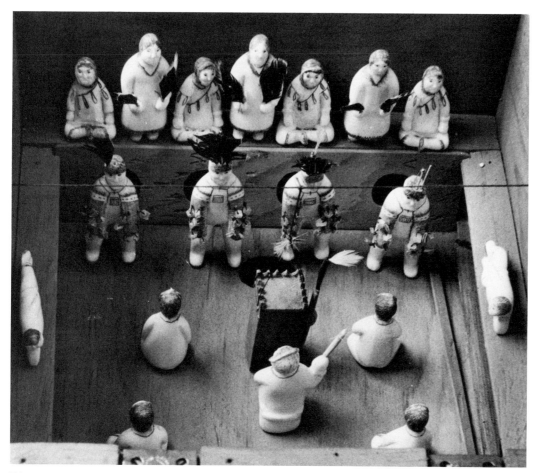

144

144 The "Eagle-Wolf Dance" in ivory, 1920s. Dimensions: 10½ by 9 inches (27 by 23 cm.). Height of tallest dancer: 2⁵⁄₁₆ inches (6 cm.). Alaska State Museum II-A-2858. This dance model and the photograph taken by the Lomens in 1918 should be compared. The model is faithful to details of costume even though the figures are ivory. The medallionlike ornaments on the small figures' chests are the bead decorations in figure 145. The elaborate headdresses made of eagle feathers and eagle down are represented by feathers, and the dancing gauntlets, usually ornamented with puffin beaks, are represented in the model by colored engraving and bits of puffin or auklet beaks. The gauntlets were worn by dancers from Nome to Point Barrow, and are still used for dancing by King Islanders. An unusual pair of mittens was seen at Point Barrow by John Murdoch in 1881. Empty Winchester cartridge shells served as the percussion attachments instead of bird beaks, but "Lieut. Ray did not consider them sufficiently of pure Eskimo manufacture to be worth the price asked for them" (Murdoch 1892, p. 366).

The box drum, which was always used in the dances of the *nilga* or the "eagle-wolf dance" of the messenger feast, is faithfully copied in this model (see also fig. 146), and is even suspended as required for beating.

165

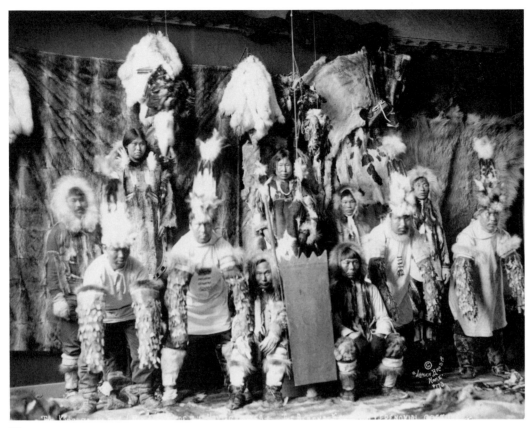

145

145 Photograph of Kauwerak dancers in ceremonial dress of the *nilga* or eagle-wolf dance, 1918. Photograph by the Lomen brothers. Collection of D. J. Ray. This ceremony was staged in 1918 by people from the Teller-Igloo area expressly for the Lomen photographs. The last ''authentic'' celebration of the eagle-wolf ceremonies was at Igloo in 1914 in connection with the first reindeer fair sponsored by the Bureau of Education. In 1964 I took this photograph to Nome and Teller, where many Kauwerak (Igloo) people lived, and the persons in the photograph were identified as follows: front row, left to right: Jimmy Okleasik, Charlie Matoak, Jimmy Eyuk, John Octuck, Harry Kamokin, Paul Sekokuluk, and Pete Peregina; back row, left to right: Mrs. Mike Eyak, Ann (''Auntie'') Aksagosak, Charlie Ezowruk, Frank Napayuk.

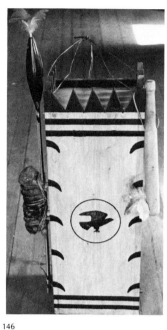

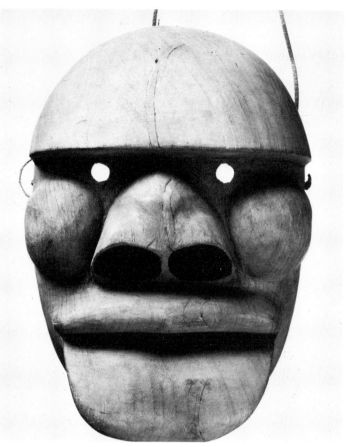

146 147

146 The box drum (*kallukaq*), used in the *nilga* and all messenger feasts, made by King Islanders in 1961. Height: about 3 feet (80 cm.). The triangles on top represent the Kigluaik peaks, and the painted motifs on the sides are eagles' claws, all painted black. A deep booming sound that represents the beating of the giant eagle's mother's heart is made by striking the folded skin with the beater when the box is suspended from the ceiling. Although this drum was still stored in the dance house of the King Islanders in 1973, it is never used for dances staged for tourists, but would be if the dancers were specifically hired to perform the *nilga*. The drum is discussed and illustrated in Ray and Blaker 1967, p. 215 and pl. 55.

147 The "bad" shaman mask, made by Tony Pushruk, King Island, 1964. Height: 9½ inches (23.8 cm.). Collection of D. J. Ray. The mask is made of driftwood and painted with a wash of hematite and water. The nostrils are painted with India ink. This particular style of good-bad shaman masks was developed in the early 1960s. They are illustrated in action in figure 295. The earliest masks of this kind were collected in 1914 by Daniel S. Neuman, a public health doctor stationed in Nome. They are deposited in the Alaska State Museum. Since then, many of these masks have turned up in museums throughout the world, some of them being credited to other groups, even the Quileute Indians of Washington (in the Museum of the American Indian, illustrated in Wingert 1949; pl. 76, no. 1).

The change in the form of these masks from 1935 to 1964 can be seen by comparing a pair illustrated by Hans Himmelheber (1953, fig. 25). Although he identified them as grave posts from the Kuskokwim River, he actually had purchased them from a King Islander in Nome, and a mixup in his notes produced the erroneous caption in the revised edition of his book, *Eskimokünstler* (personal communication).

The good and bad shaman masks are discussed and illustrated in Ray and Blaker 1967, pp. 209–11 and pls. 48, 49.

Photograph by Alfred A. Blaker

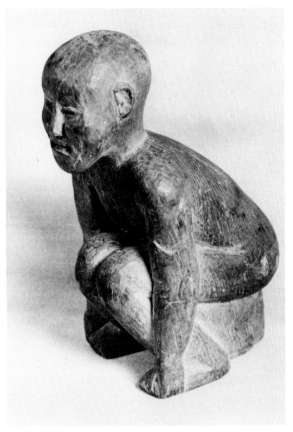

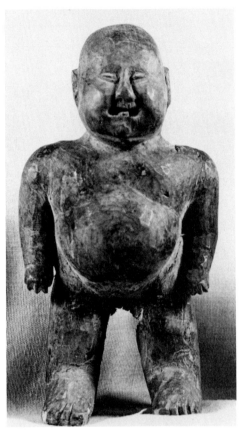

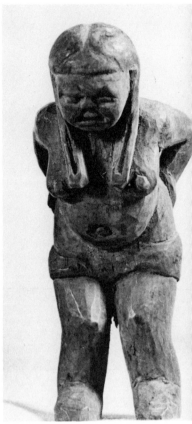

148 149 150

148 Wooden figure of a seated woman carved by Numaiyuk, Saint Lawrence Island, about 1927. Height: 5⅜ inches (13.8 cm.). University of Alaska Museum 1–1927–492. This carving and the two illustrated in figures 149 and 150 were given to sterile women as fertility figures, according to Otto William Geist, who collected them in 1927. Geist visited Numaiyuk, who could not speak English and was "a brother of the strongest shaman on the island, and carver of the many dolls, idols, fetishes, and ornamented household utensils fashioned from driftwood found in many of the island homes" (Geist and Rainey 1936, p. 34).

149 Wood figure of an old man carved by Numaiyuk, Saint Lawrence Island, about 1927. Height: 5⅞ inches (13.8 cm.). University of Alaska Museum 1–1927–491.

150 Wood carving of a woman by Numaiyuk, Saint Lawrence Island, about 1927. Height: 4⅞ inches (11.2 cm.).

168

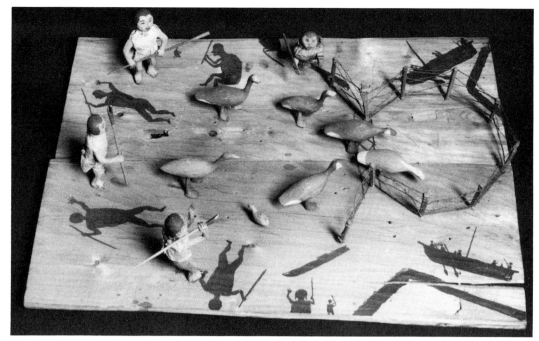

151

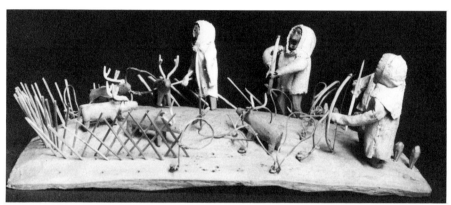

152

151 Eskimos corralling geese, wood carvings and painted figures from Port Clarence, 1894. Height of man with raised spear: 3⅞ inches (9.6 cm.). All of the figures are made of wood. The irregular base is 19¼ by 14⅞ inches, maximum dimensions. Washington State Museum 890. Men with spears, kayaks and umiaks are painted on the base to augment the wood sculptures of men and geese. The men are barefooted, their bodies are washed a light red, and their hair is black. They are wearing clothing of thin seal parchment. The corral is constructed of sinew and wood. The birds are painted different colors in light tones. For example, the first bird going into the corral has a greenish body, a white tail and neck, and a pink beak. The second bird is black with white sideburns and some tail feathers. The smallest bird has a black back and grayish body.

152 Eskimos corralling caribou, a wood model from Point Hope, about 1909. Height of man with bow in the rear: 4¼ inches (10.6 cm.). The base is 15 by 7¾ inches. Washington State Museum 100/295. Collected by J. Hackman and I. Koenig for the Alaska-Yukon-Pacific Exposition. The caribou and the men are made of wood. The men wear winter-tanned sealskin and caribou skin. The nooses are made of thong, and the stakes, of wood. The horns of the caribou and the pickets were restored with antler and red cedar, respectively, in 1972. The knife on the wooden stake appears to be ivory, colored black and red, and is tied to the stake with sinew. Tracks made by the caribou are punched into the wooden base.

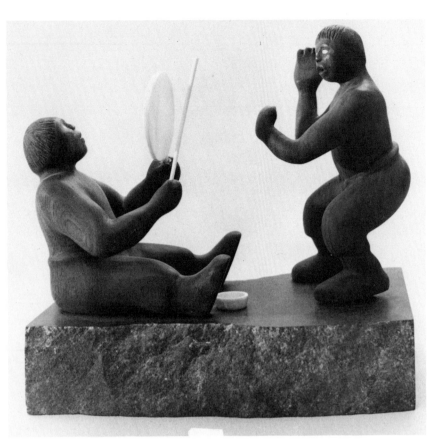

153

154

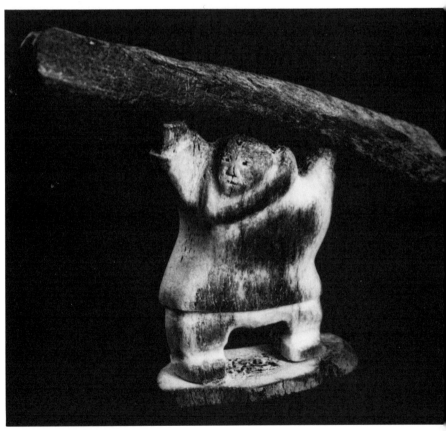

155

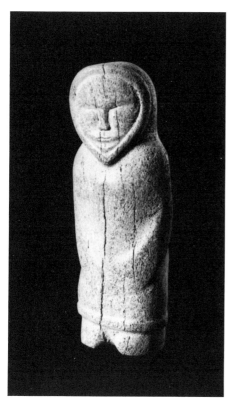

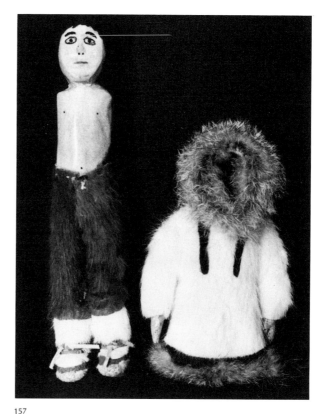

156 157

153 "Dancer and Drummer" by John Tingook, Point Hope, 1965. Height: 8½ inches (21.3 cm.) Alaska State Museum II-A-4298. This dancing scene was made by Tingook during classes in the MDTA Designer-Craftsman Training Project in Nome during 1964–65. The figures are made of walnut with ivory eyes. The drum, water dish, and drum beater are also made of ivory. The base is stone.
 Photograph courtesy Indian Arts and Crafts Board

154 "Land Claims Dancer," made of teak on a mahogany base by Richard Seeganna, King Island, 1973. Height: 16 inches (40 cm.) Collection IACB W-73.29.3. This triumphant dancer is a good example of the new trend in wood sculpture. The title refers to the settlement of 1 billion dollars and 40 million acres of land on the Indians and Eskimos of Alaska by the Congress of the United States in December 1971. This sculpture won first prize in the wood division of the Eighth Alaska Festival of Native Arts, 1973, Anchorage.
 Photograph courtesy Indian Arts and Crafts Board

155 "Man with a Burden," carved of whalebone by Harvey Pootoogooluk, 1972. Height: 6½ inches (16.3 cm.). This object was carved in the Community Enterprise Development Corporation project at Shishmaref.
 Photograph courtesy Indian Arts and Crafts Board

156 Figurine of a man carved in bone by Stephen Weyiouanna, 1972. This carving, which was made during the CEDC project in Shishmaref, was selected by Russell E. Train, chairman of the Council on Environmental Quality, as a gift to his Russian counterpart on the occasion of his visit to the Soviet Union in 1972.
 Photograph courtesy Indian Arts and Crafts Board

157 Horn doll from Shishmaref, 1973. Height: 6⅛ inches (15.3 cm.). Collection of D. J. Ray. Parka, pants, and mukluks are made of reindeer fawnskin. The ruff and parka trim are ground squirrel. Mukluks are decorated with red and green felt trimming.

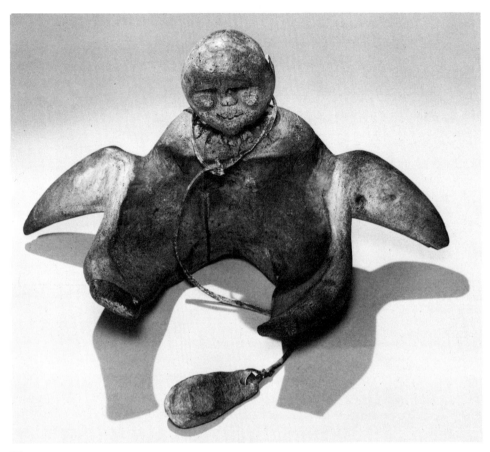

158

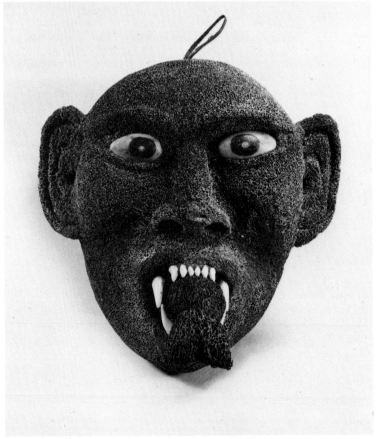

159

172

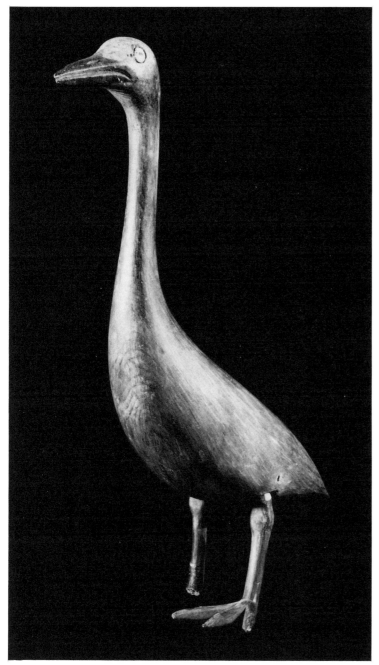

160

158 "Little Man of Flying," from Point Hope. Width: 17 inches (42.5 cm.). Anchorage Museum 55.6.99. Collected in 1943 and donated to the museum in 1970 as "The Flying Medicine Man" (*Tundra Times,* 22 April 1970).
 Photograph by Ward W. Wells

159 Modern whalebone version of wooden mask in figure 24. Height: 11½ inches (27.8 cm.). The eyes and teeth are made of walrus ivory.

160 Crane carved of wood at Saint Michael in the 1890s. Height: 11 inches (28.3 cm.). Lowie Museum 2–7014. Collected by H. M. W. Edmonds either in 1890 or 1898. The body is stained a reddish black with a deeper red face and black legs and beak. The eyes are made of ivory. Identity of the bird was written on this and others collected by Edmonds, and I suspect that he had commissioned them to be carved.
 Photograph by Alfred A. Blaker

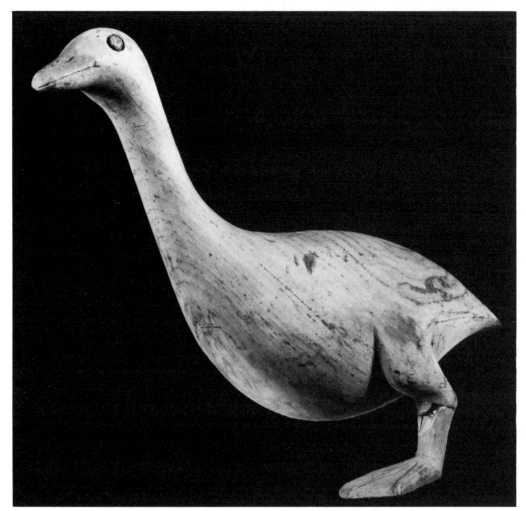

161

162

163

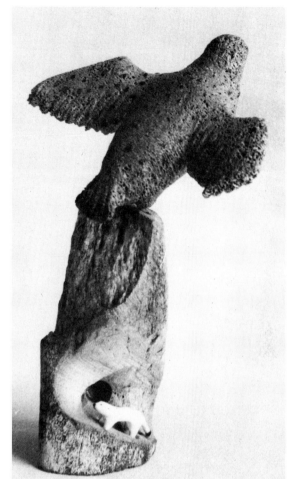

164

161 Wooden sculpture of a goose, Saint Michael, 1890s. Height: 7⁵/₁₆ inches (18.6 cm.). Lowie Museum 2–7008. Collected by H. M. W. Edmonds in 1890 or 1898. The goose is painted a thin coat of blue-black color over a white undercoat. The eyes are wood, incised. Other animals and birds collected by Edmonds are illustrated in Ray 1966a, pp. 104, 131.
 Photograph by Alfred A. Blaker

162 Wooden figure of an owl made to be hung in a dwelling, Buckland, 1952. Length from beak to tip of tail: 6 inches (15 cm.). Collection of D. J. Ray. The eyes are inset with brown old ivory.

163 Soapstone bird carved by Rose Tingook Iyapana, Point Hope, about 1970. Height: 3⁷/₈ inches (9.6 cm.). Collection of Mr. and Mrs. Joseph E. Walsh. The stone is greenish color. Rose Iyapana began working in soapstone only a few years before she made this and has carved a number of very pleasing ivory and stone sculptures, including the walrus, figure 170.

164 Hawk and weasel, a carving in whalebone and ivory by Wayne Hawley, Kotzebue, about 1967. Height: 6 inches (15 cm.). Collection of Mr. and Mrs. Joseph E. Walsh. The tiny ivory weasel is trying to hide from the soaring hawk. The dots on the wing are made of ink and glue.

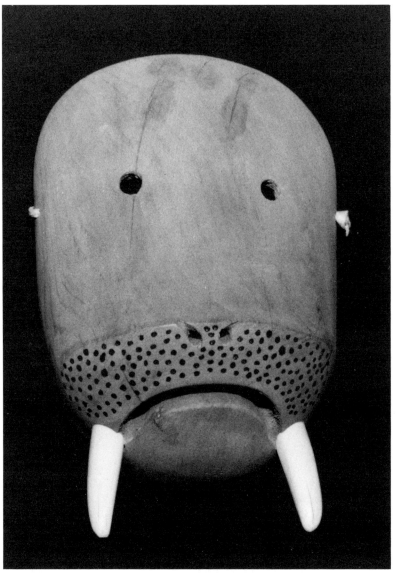

165

165 Walrus mask made of driftwood by Tony Pushruk, King Island, 1964. Height: 8⅝ inches (13.5 cm.). Collection of D. J. Ray. The making of walrus masks was revived in the early 1960s. The entire surface is washed a rust color with ocher, and the whiskers are represented by dots of black paint. The tusks are walrus ivory, and the mask is bound to the head with rawhide thong. It is signed "Tony Poorsuk" in block letters on the back.

166 Wooden box representing the upper part of a walrus, probably from the Saint Michael area. Height: 7¾ inches (19.6 cm.). Lowie Museum 2–1592. Collected between 1894 and 1901. The wood has been colored with ocher, and the nose and mouth, with black ink or soot. The eyes are made of dark red jasper. The tusks are walrus ivory.
 Photograph by Eugene R. Prince

167 Bowl in form of a seal, by Teddy Pullock, King Island, 1964–65. Length: 11 inches (27.5 cm.). This bowl, of walnut inlaid with baleen eyes and "whiskers," was made in Nome during the MDTA program.
 Photograph courtesy Indian Arts and Crafts Board

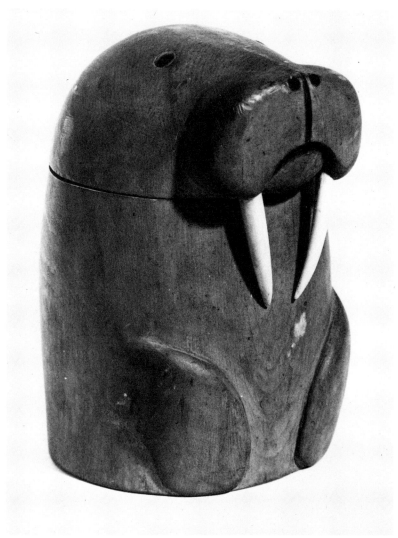

166

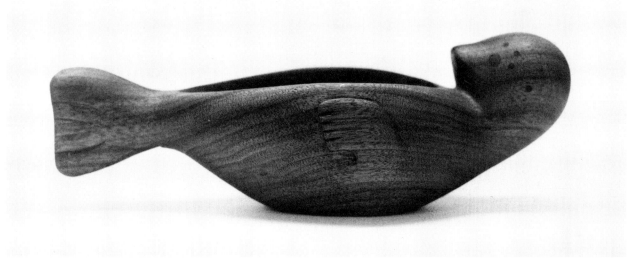

167

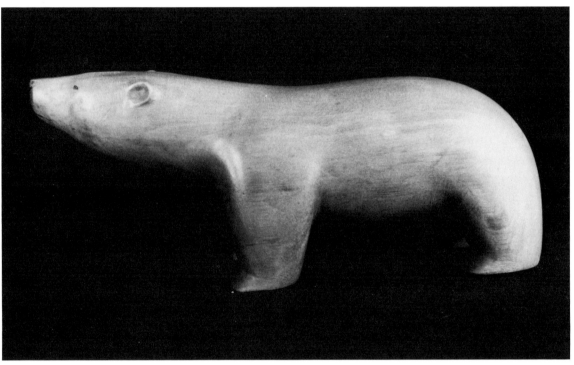

168

168 Polar bear carved of wood, Gambell, late 1950s. Length: 9 inches (22.5 cm.). Collection of Mr. and Mrs. David W. Johnson. The wood is a hardwood, which was found abandoned "around town." An application of clear lacquer retains the original color of the wood. The eyes, mouth, and nose are stained with ink.

169 Wrought-iron sculpture by Larry Ahvakana, Barrow, 1969. Height: about 4 feet. Anchorage Museum A 71.56. This is his interpretation of a wooden mask of the 1890s (see fig. 32).
 Photograph, Anchorage Historical and Fine Arts Museum

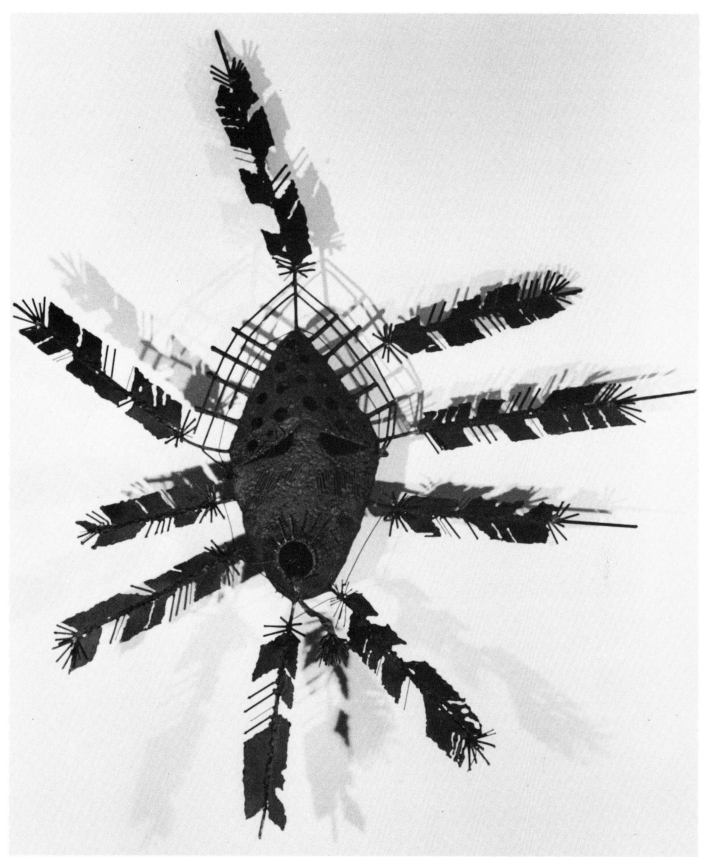

169

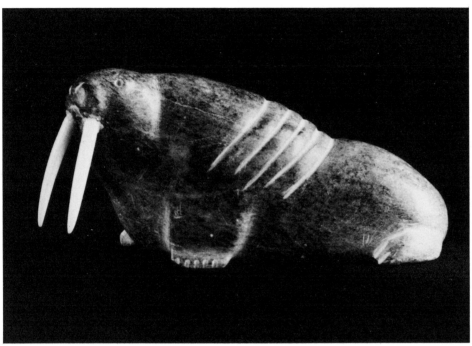

170

170 Soapstone walrus with ivory tusks carved by Rose Tingook Iyapana. Length: 6 inches (15 cm.). Collection of Mr. and Mrs. Joseph E. Walsh. The soapstone is a variegated light green, gray, and tan. Mrs. Iyapana also carved the bird, figure 163.

171 Standing walrus carved from spruce driftwood by Louis Seeganna, King Island, 1965. Height: 24³/₄ inches (61.8 cm.). Alaska State Museum II-A-4299C. This is a wood sculpture done in the MDTA program. It is stained with red ocher. The base is plywood painted gray.
 Photograph courtesy Indian Arts and Crafts Board

172 Reclining walrus made from driftwood by Peter Seeganna, King Island, 1968. Length: 8¹/₄ inches (20.6 cm.). Collection of D. J. Ray. The walrus is stained a deep tan. Its eyes are inset with baleen, and the tusks are made of walrus ivory. This carving is discussed in Chapter IV.

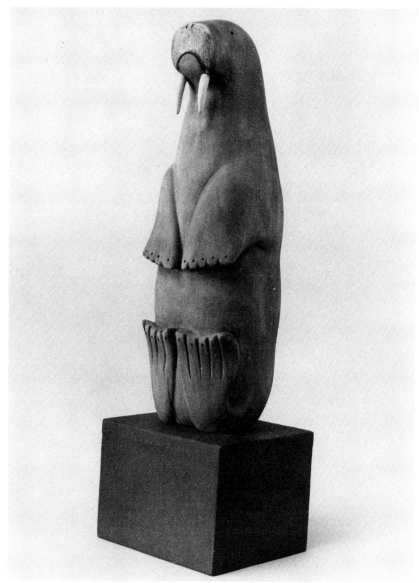

171

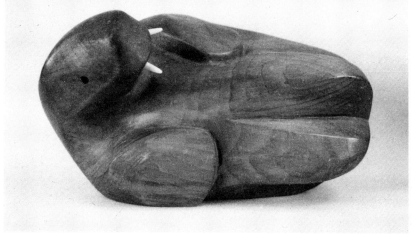

172

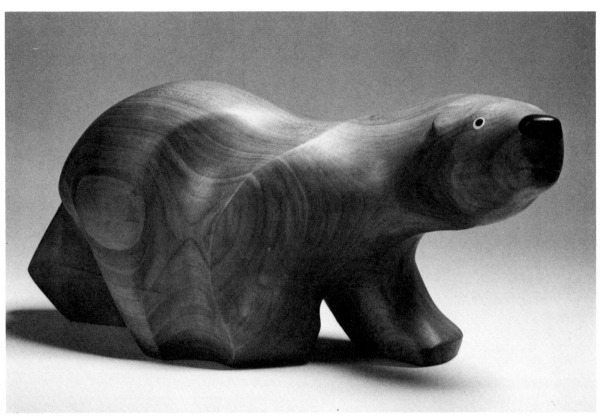

173

173 Bear of cherry wood by Melvin Olanna, 1972. Length: 18 inches (37.5 cm.). The nose is of ebony and the eyes, ivory with ebony insets.
Photograph courtesy Alaska Native Arts and Crafts, Inc.

174 Musk ox in wood by Justin Tiulana, about 1970. Length: 7½ inches (18.8 cm.). Private collection. The wood is treated with clear varnish.

175 Musk ox made by Oscar Sage of greenish field stone from Nome, 1965. Length: 12 inches (30 cm.). Alaska State Museum II-A-4279C. This sculpture was made during the MDTA Craftsman-Designer program in Nome.
Photograph courtesy Indian Arts and Crafts Board

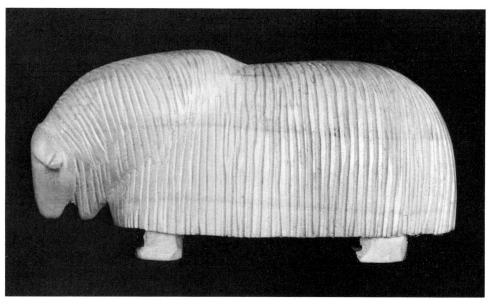

174

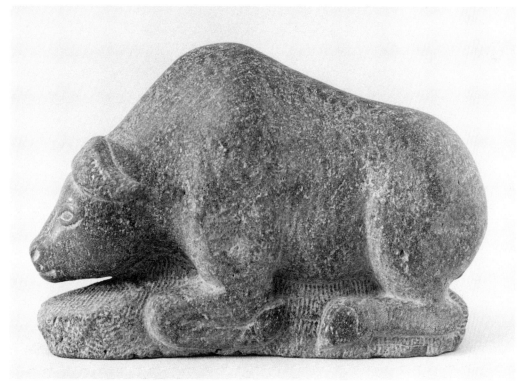

175

183

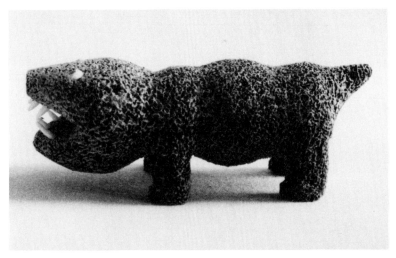

176

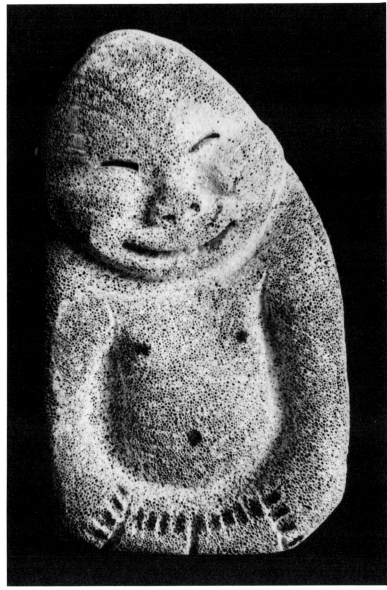

177

184

176 Contemporary version of the *kikituk,* made of whalebone by Alec Frankson. Length: 4³⁄₈ inches (10.9 cm.). Collection of Dr. and Mrs. James P. Jacobson. The teeth and eyes are ivory inset with stone pupils. An old carving of wood with ivory teeth is illustrated in a line drawing by Rainey (1959, p. 13) and in a color photograph by Oswalt (1967, pl. 10). Another of these creatures was carved of driftwood by John Tingook of Point Hope during the Nome MDTA retraining project in 1964–65. It is now in the Alaska State Museum and is illustrated in *Smoke Signals* (Fall-Winter 1966, p. 14) and *Contemporary Alaska Native Art* (1971, p. 15). This object has subsequently become very popular, and carvers from places other than Point Hope were making them by 1975. See also under figure 8 and "Sculpture," Chapter II.

177 Whalebone billiken, by Johnny Evak, Sr., Kotzebue, about 1972. Height: 8³⁄₄ inches (21.8 cm.). Collection of Judy Johnson. By changing the position of the hands from the sides to the front and making a sideways tilt to the head, the carver has made this a whimsical figure.

178 A whaling crew gets their whale in a whalebone sculpture, Lydia Nashoukpuk, Point Hope, early 1960s. Length of baleen base: 16³⁄₄ inches (41.8 cm.). Collection of Mr. and Mrs. David W. Johnson. The harpoon is ivory and the line, sinew. The men hold wooden sticks in their hands.

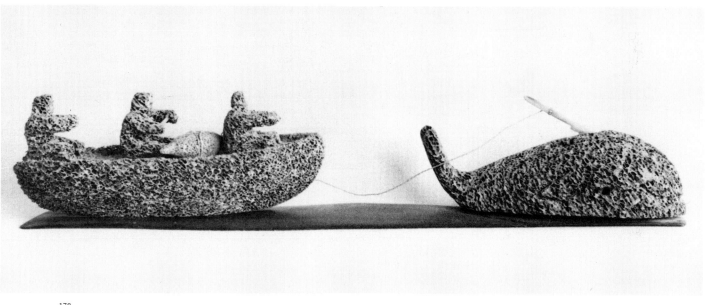

178

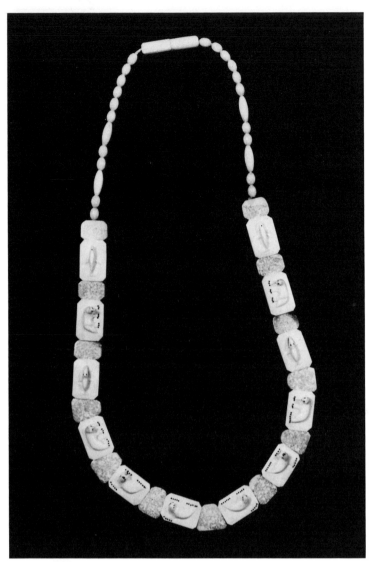

179

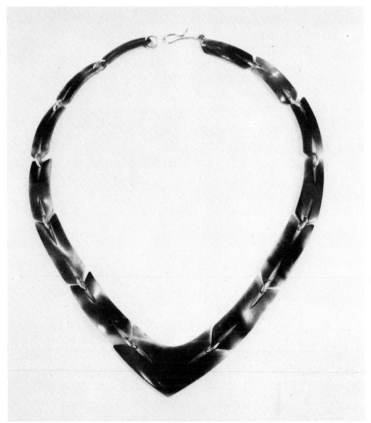

180

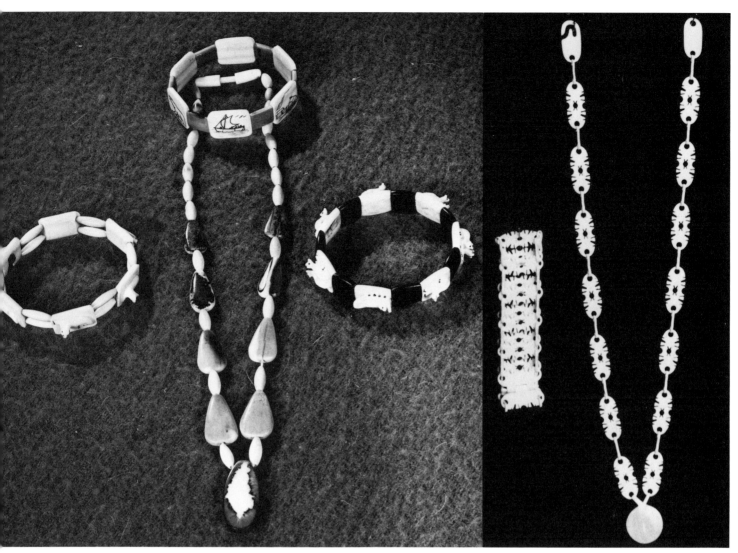

181 182

179 Necklace of tiny animals carved in low relief, Little Diomede Island, about 1955. Length: 21½ inches (55 cm.). Collection of D. J. Ray. The animals of white ivory alternate with links of orange-colored ivory from the core of the walrus tusk.

180 Necklace of reindeer hoof made by Victor Swan, Kivalina, about 1959. Length: 17¼ inches (43.1 cm.). Other examples of reindeer-hoof jewelry are illustrated in *Smoke Signals* (Fall-Winter 1966, p. 22) and ANAC catalogs in the 1960s, for example, 1962 (p. 15) and 1964 (p. 19).
 Photograph courtesy Indian Arts and Crafts Board

181 Bracelets and necklaces of ivory and baleen made in the late 1940s. Outside circumference of middle bracelet: 8 inches (20.8 cm.). Collection of D. J. Ray. The bracelet on the left was called the "animal bracelet"; the one in the middle, the "etched bracelet"; and the one on the right, the "dog team bracelet." These are discussed in the text under the history of jewelry. Except for the "etched bracelet," these particular styles are no longer made. Bracelets of the 1970s are often very wide so that the longest part of the link corresponds to the narrowest part in these bracelets, and sculptured animals are made in low relief.

182 Filigree necklace and bracelet of ivory, Saint Lawrence Island, about 1950. Length of necklace: 21½ inches (53.8 cm.). Private collection. For discussion see "Ivory Jewelry" in Chapter III.

183

184

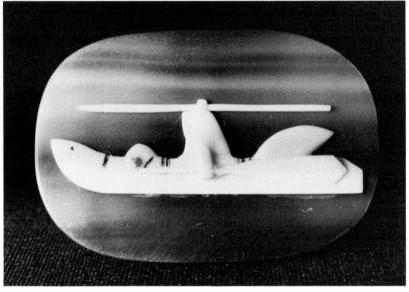

185

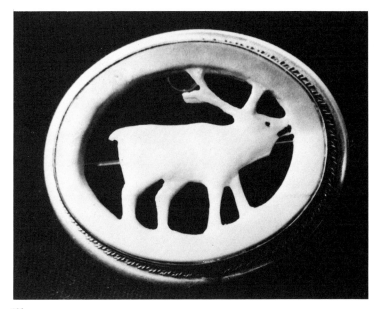

186

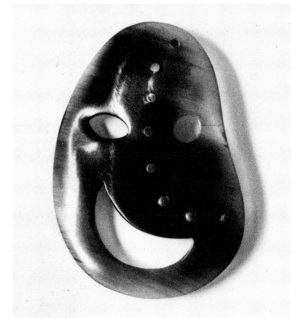

187

183 Two ivory bracelets from Point Hope, 1940s. Width of "ATG" link: ⁷⁄₈ inches (2.1 cm.). Collection of Mr. and Mrs. David W. Johnson. The top bracelet has links of both mammoth and ivory walrus cut in cross section. The principal link of the bottom bracelet, "ATG" (Alaska Territorial Guard) is made of tan mammoth ivory, and the rest are oval links of walrus ivory cut parallel to the core. The texture of mammoth (elephant) ivory is clearly seen in this photograph.

184 Bracelets of ivory and baleen. Height of bottom links: 1¹⁄₈ inches (1.3 cm.). Collection of D. J. Ray. The bottom bracelet, made of alternating white ivory and black baleen links, was made by a Little Diomede carver in 1964. The middle bracelet of white ivory inlaid with brown ivory squares was made by George Washington (Sukrak) of King Island in 1946. The top one is a watchband with tan mammoth ivory links alternating with ivory links inlaid with round old ivory insets, made in 1955. The band terminates at each end with a carved walrus head.

185 A man and his kayak, ivory bas-relief pin on a piece of light-colored baleen, 1950s. Length: 2¹⁄₈ inches (5.3 cm.). Private collection. Like the cutout designs in figures 138 and 186, this idea had only a fleeting popularity.

186 Ivory brooch of reindeer in silhouette, framed with a metal casing, 1950. Width of ivory: 1¹⁄₂ inches (3.8 cm.). Collection of Caroline M. Reader. Brooches of cutout reindeer, bears, and foxes were popular items in the 1940s; but by the early 1950s A. Polet, whose general store dealt in huge quantities of Eskimo-made goods, found that they were not very salable, and he instructed the carvers who were employed by him on the premises at that time not to make any more.

187 Pin of reindeer hoof, Kivalina, about 1964. Height: 1¹⁄₂ inches (3.8 cm.). Private collection.

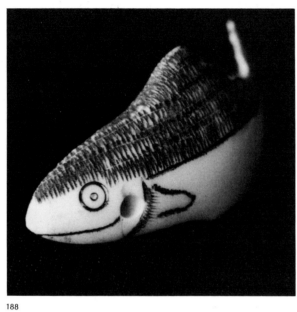

188

189

190

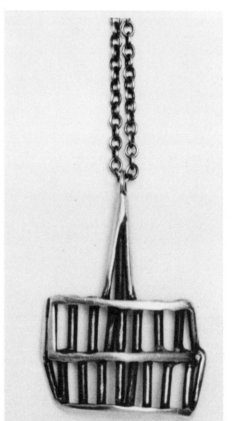

191

192

193

188 Pendant in shape of a curved fish, carved of walrus ivory by a King Island carver, 1946. Length, following the outer curve of the ivory: 1¹¹/₁₆ inches (5 cm.). Collection of D. J. Ray. With the exception of handles on letter openers, fish have rarely been used as subject matter in engravings or sculpture.

189 Nephrite earring in shape of a seal made in the Shungnak Jade Project, 1961. Length: 1¹/₂ inches (3.8 cm.). Collection of D. J. Ray. The nephrite is light smoky green. This same style of seal design was used in reindeer-hoof earrings at Kivalina.

190 Sterling silver pendant representing a seal by Francis Pikonganna, King Island, 1965.
 Photograph courtesy Indian Arts and Crafts Board

191 Sterling silver pendant made by Ronald Senungetuk, about 1966. Width: 1⁵/₈ inches (4 cm.). Collection of D. J. Ray. Photographs of other examples of Senungetuk's silverwork are illustrated in Ray 1967a, p. 91, and in Frost, ed. 1970, pp. 42–54 *passim*. Senungetuk, formerly of Wales, teaches art at the University of Alaska, Fairbanks.

192 Pin, lost wax casting of square elements, by Ronald Senungetuk, 1970. Dimensions: 2 by 3 inches (5 by 7.5 cm.).
 Photograph by Dennis Cowals

193 Pin, lost wax casting with pearl, Ronald Senungetuk, 1972. About 1³/₄ by 2¹/₂ inches (4.4 by 6.3 cm.).
 Photograph by Barry McWayne

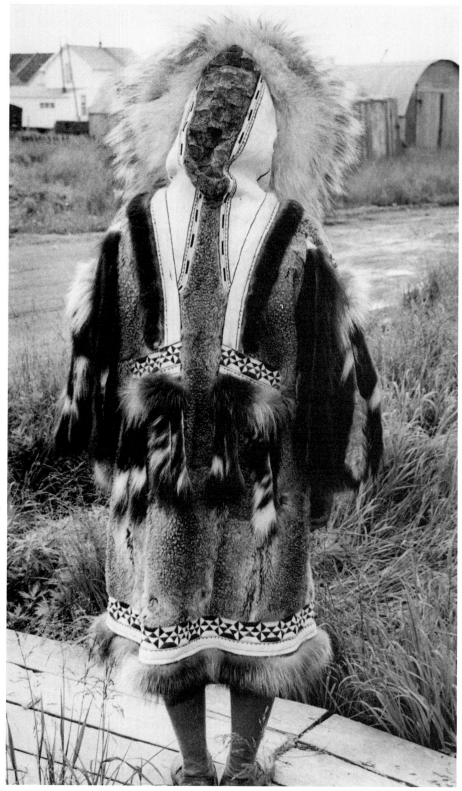

194

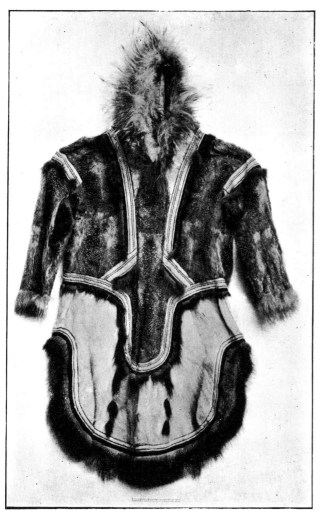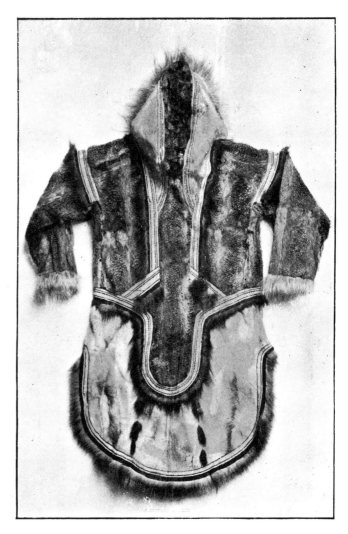

195

194 A "fancy" parka of the mid-twentieth century made of ground-squirrel skins with trim of white reindeer fawnskin and wolverine strips. The back of the hood is made of ground-squirrel heads. The ruff is wolf.

195 A woman's parka from "head of Norton Sound," collected by E. W. Nelson between 1877 and 1881. Reproduced from Nelson's *Eskimo about Bering Strait* (1899, pl. 18). The top part of the garment is made of ground-squirrel skins, and the bottom, white reindeer from Siberia. The back of the hood, which has a wolf ruff, is made of the fur of squirrel heads. The long parallel designs are of white Siberian reindeer welted with fishskin. The trim at the wrists, bottom, and along the welted designs is wolverine fur.

193

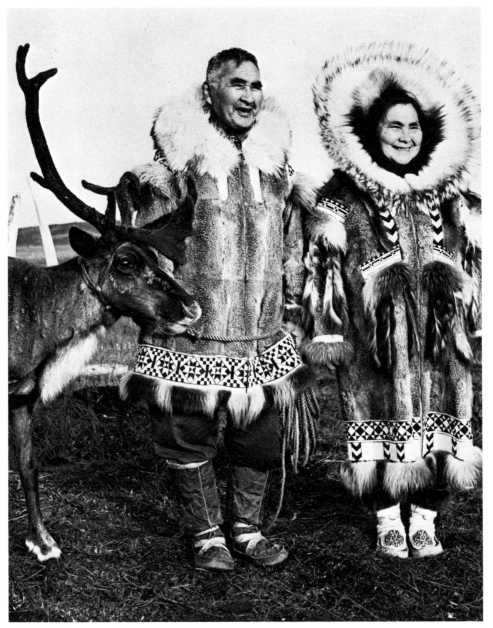

196

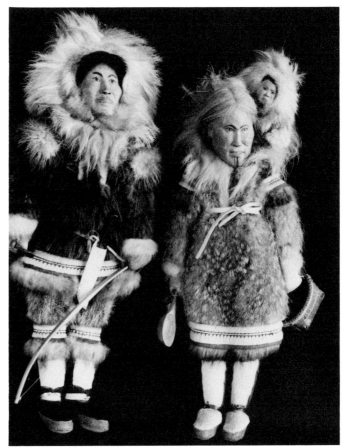

197

198

196 Dress-up parkas of the 1970s, worn by Helen and Chester Seveck. The trim of small geometric pieces is imported white and black calfskin, and the fur trim and hanging pieces are wolverine. Mr. Seveck wears waterproof boots, and Mrs. Seveck has mukluks of white calfskin with toe pieces of beads.

Photograph by permission of Jack Whaley from the book, *The Longest Reindeer Herder*, by Chester Seveck

197 Cloth parkas, the universal garment dating from the trading days of the 1870s, worn by two women at Deering, Alaska, 1950.

198 Dolls made by Ethel Washington, Kotzebue, about 1955. Height: of male doll, 12 inches (30 cm.); of female, 10 inches. Collection of Mr. and Mrs. David W. Johnson. Mrs. Johnson, told me that the man's face looked like a Kotzebue man, Raven Sheldon, and the woman's like Lulu Howarth, wife of the man who made the jaw sled in figure 228. The man wears a muskrat parka and calfskin boots. On his back is a sealskin bag, and the knife in the sealskin sheath is made of baleen. The spoon and the bow are of birch, and the basket is a meticulously made miniature of the typical Kobuk River birchbark basket (see also fig. 219, 303). The woman's parka is made of ground squirrel. Border designs are white calfskin and red felt. Hands are made of sealskin.

The child tucked into the woman's hood is 5 inches high, including the ruff, and wears a squirrel-skin parka and mukluks. Other dolls made by Mrs. Washington are illustrated in *Contemporary Alaska Native Art* (1971, p. 16) and *Smoke Signals* (no. 50–51, 1966, p. 23).

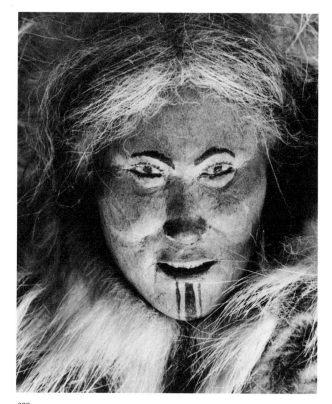

199

200

196

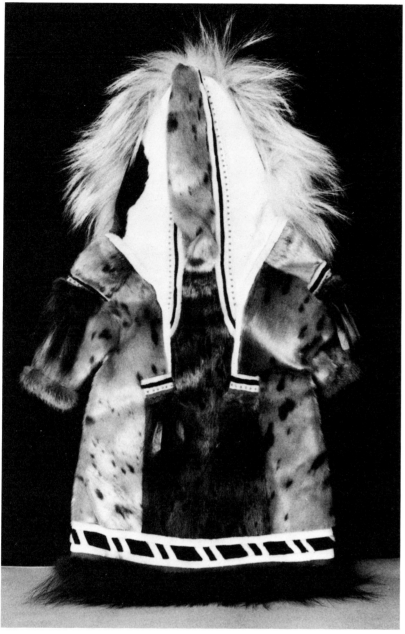

201

199 Face of the male doll in figure 198.

200 Closeup of the face of the female doll in figure 198.

201 Sealskin parka for a doll, made by Margaret Johnsson, 1966. Height: 18½ inches (36.3 cm.). Collection of D. J. Ray. Mrs. Johnsson, formerly of Unalakleet, gave a similar parka, made of ground-squirrel skins in the 1930s for one of her daughters, to the University of Alaska Museum. When she made this for me, as a copy of the original, she was unable to get squirrel skins. The white and brown designs are calfskin; the ruff, wolf; the strips and bottom trim, wolverine; and the sleeve trim, plucked beaver. The band trim is red felt and red beads.

202

202 Doll in typical Saint Lawrence Island dress, made by Hazel Omwari, 1968. Height, excluding ruff: 10¼ inches (25.6 cm.). Collection of D. J. Ray. The ruff of rabbit fur pulls back from the head, on which is tied a kerchief made of the same cloth as the body (see legs in the photograph). The face is made of bleached sealskin, with features of black and red embroidery thread. The biblike half-circle of white and black fur beneath the chin is one of the distinguishing characteristics of Saint Lawrence Island parkas. This bib is made of rabbit hair and calfskin. The doll wears a red diaper cloth and a thin strip of soft, dehaired reindeer skin dyed green round its waist as an amulet belt. A photograph of three other dolls in Saint Lawrence dress is featured in *Tundra Times*, 6 June 1969.

203 Hard-soled slippers with toe designs made of reindeer fawnskin, Nome, 1950. Collection of D. J. Ray. The fur trim is rabbit. The soles, made of ugruk, are separated from the geometric designs by a sealskin strip dyed red.

204 Monarch butterflies made of beads by Frieda Larsen, Nome, 1950. Width between wing tips: 2³⁄₈ inches (5 cm.). Collection of D. J. Ray. These were made for slippers. The orange, yellow, and black beads are sewed with cotton thread to a piece of bleached sealskin. Two tiny pink oblong beads are placed at the top of the body.

203

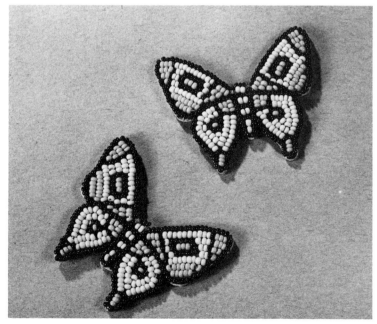

204

199

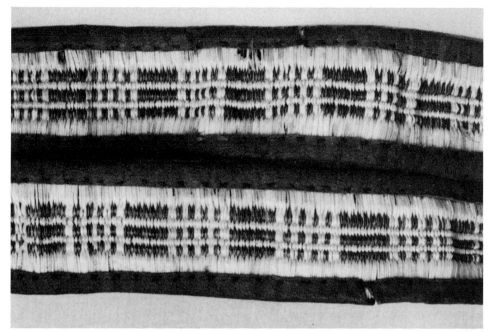

205

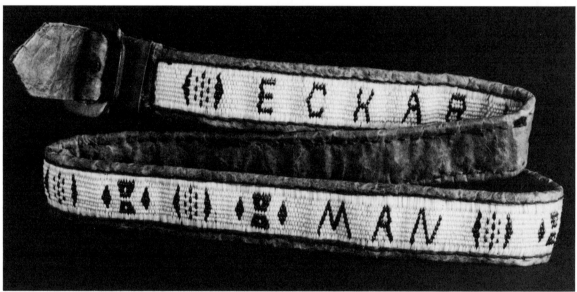

206

205 Belt of ptarmigan quills made about 1909. Length of woven material: 29 inches (72.5 cm.). Washington State Museum H-K 287. Collected by J. Hackman and I. Koenig for the Alaska-Yukon-Pacific Exposition, 1909. The provenience is unknown, but this kind of work is known from Barrow and the Kobuk and the Noatak rivers. The quill design is sewed with cotton thread to rust-colored sealskin. An oval loop of seal fur serves as a buckle for insertion of a large knot of twisted thread. Ptarmigan quill work is discussed in Chapter II under "Sewing."

206 Ptarmigan quill belt, the black tail quills forming the words "Hugo Eckardt Mining Man" when fastened round the waist. Length: 42½ inches (106 cm.). Kotzebue Museum. This belt probably was made in the Kobuk area, where Mr. Eckardt mined. He later owned a store, now Walsh's, in Kotzebue. The quill work is sewed to the reddish brown sealskin with black thread and has a composition buckle with a tongue of baleen.

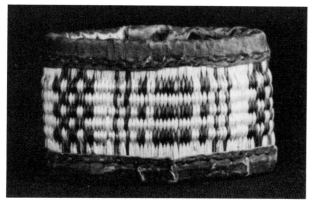

207

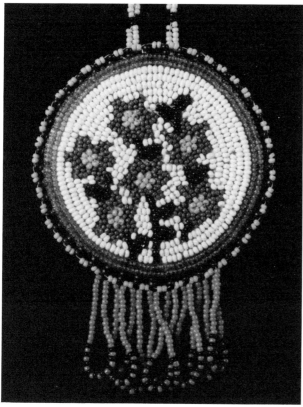

208

207 Ptarmigan quill napkin ring made in Noorvik in the 1950s by Pauline George. Circumference: 6¾ inches (16.8 cm.). Collection of Mr. and Mrs. David W. Johnson. Mrs. George, who lives in Kotzebue, identified this as her work made during a revival of quill weaving at Noorvik. From ten to fifteen ptarmigan are needed for a ring this size. Each ptarmigan has nine or ten black tail feathers.

208 Bead pendant made by Mamie M. Beaver, Kotzebue, in 1973. Diameter: 3½ inches (8.3 cm.). Collection of D. J. Ray. Mrs. Beaver, whose sewing is also illustrated in figures 214 and 215, began making these pendants when a friend brought her one made by a Fort Yukon Indian woman. She makes up her own designs, however, and this forget-me-not (Alaska's state flower) is one of her favorites. The flowers are medium-blue beads with yellow centers and green stems on a white field bordered by two rows of lighter green and an outer circle of yellow and tan beads. The hanging beads are black and orange, and the necklace beads are yellow and black. The beads are sewed onto seal-skin faced with white felt.

209

209 Fur mosaics in Our Savior's Lutheran Church, Nome, 1958. Two of these were made by Eskimo women of Nome; two, from Shishmaref; and one each from Teller and Brevig Mission.

210 Box of seal parchment trimmed with beads by Emma Kiminock of Little Diomede Island, 1968. Circumference: 8³/₄ inches (21.8 cm.). Collection of D. J. Ray. The beads, which are sewed with cotton thread, are white, orange, aqua, and green. The box is lined with green cotton cloth.

211 Sealskin yo-yos from Nome, 1968. Height of faces: 1 inch (2.5 cm.). Collection of D. J. Ray. The faces are embroidered on bleached sealskin and have wolverine ruffs. The rest of the yo-yo is seal fur. The appliqué flower designs are neatly attached with red stitches. Strings on the left are cotton twine, and on the right, twisted sinew.

202

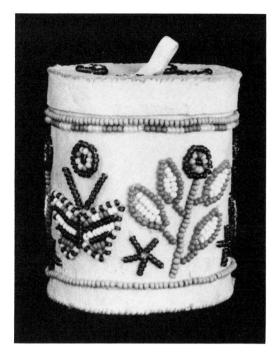

210

211

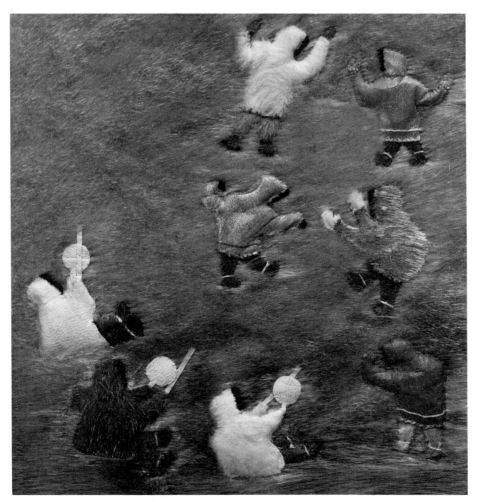

212

212 Dancing scene of appliquéd figures on seal fur, by Hazel Omwari, Saint Lawrence Island, 1968. Length and width: 9½ by 7½ inches (23.8 by 18.8 cm.). Collection of D. J. Ray. The figures are made of dyed seal parchment and seal fur. The parchment is dyed rose (upper right), blue (middle), and red (lower right). Mrs. Omwari used facial tissue under the figures for shaping. She made this plaque while an out-patient at the hospital in Nome.

 Photograph courtesy Indian Arts and Crafts Board

213 Sealskin purse, Nome, 1950. Height: 6 inches (15 cm.). Collection of D. J. Ray. The side shown in this photograph has animals of black embroidery thread and an abstract design of rust-colored and black thread. The opposite side of the bag has three alder-dyed panels, each with an appliquéd polar bear in contrasting natural color sealskin. The dyed parts faded badly subsequently.

214 The perils of being a trout, as portrayed by Mamie M. Beaver, Kotzebue, 1972. Width and length: 5¾ by 7 inches, without fur trim (14.3 by 17.5 cm.). Collection of Dr. and Mrs. James P. Jacobson. The fish are made of real fishskin, and the hook is ivory. The eye of the large fish is a blue bead on top of a sequin edged with black embroidery thread. The mouth and fins are made of red and black thread. The small fish has a red bead eye.

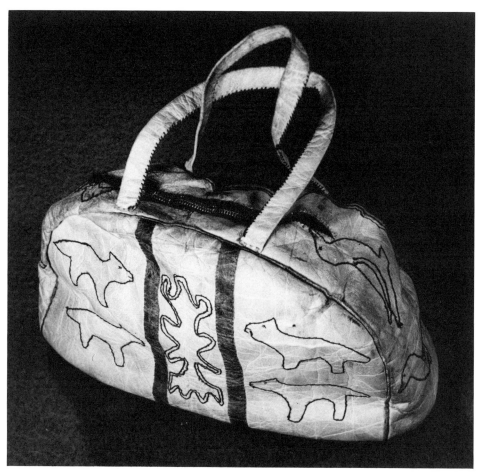

213

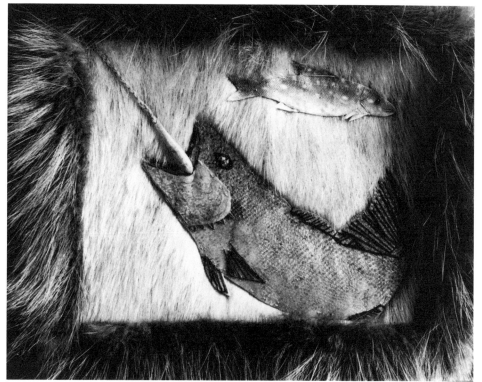

214

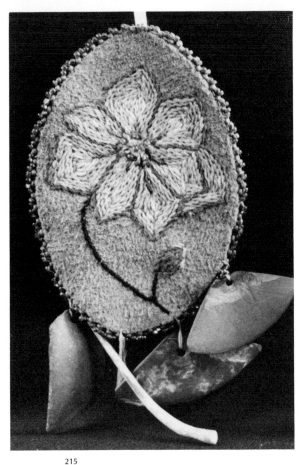

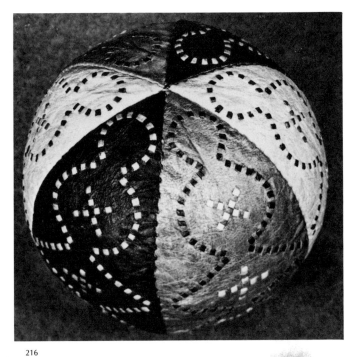

215 216

215 Easter "card" made for friends by Mamie M. Beaver, Kotzebue, 1968. Height: 4½ inches (11.3 cm.). Collection of Mr. and Mrs. David W. Johnson. A flower with glass bead center is stitched onto moosehide. A piece of bone and two pieces of flint shaped like small ulu blades hang from the bottom. Beads are sewed around the edge. Mrs. Beaver's ingenuity has also produced Christmas cards in stitchery and appliqué designs.

216 Sealskin ball stitched with interwoven strips of contrasting sealskin, Nome, 1947. Diameter: about 7 inches. Collection of D. J. Ray. Colors are red, blue, and natural seal parchment. I learned that it was stuffed with reindeer hair when my Malemute puppy ate it shortly after the photograph was taken.

217 Mukluk pincushions of soft-tanned reindeer skin with green felt trim and black rabbit fur, made by Frances Ayagiak, Unalakleet, 1968. Height: 3¼ inches (8.3 cm.). Collection of D. J. Ray.

218 Miniature coiled grass basket decorated with five ivory seals, Nome, 1902. Height: 2 inches (5 cm.). Collection of D. J. Ray. This carefully made basket was obtained in Nome just after the gold rush. When I acquired the basket in 1963, one of the four seals on the side was missing, and only the stump of a string protruded through the lid where an unknown object had been attached. I took it for repair to the Leonard F. Porter Co. in Seattle, which employed Alaskan Eskimo carvers. The man who carved the replacements willingly made a replica of a seal for the sides, but insisted on an up-to-date version of a seal for the lid.

219 Birchbark baskets from Kobuk village, 1961. Length of largest basket: 16½ inches (41 cm.). All but the round basket were made by Susie Stocking. The rims are bound with split spruce root, scraped smooth. The steps in making the envelope birchbark basket are illustrated in Ray 1965. In the 1960s women began to make souvenir baskets with geometric designs (fig. 200).

217

218

219

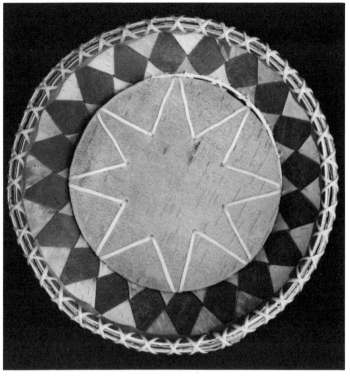

220 221

220 Birchbark basket with geometric designs, made by Florence Douglas, Shungnak, 1967. Diameter: 10½ inches (26.3 cm.). Collection of D. J. Ray. This photograph was taken head-on to the inside of the basket to illustrate maximum design, but it minimizes the fact that the slightly flaring sides are 3⅛ inches high. The geometric design effect is made by the crisscrossing of contrasting oblong pieces of birchbark fastened firmly into the top and bottom with strips of spruce root. Strips of root also form the eight-pointed star design on the bottom.

221 Black baleen basket with an ivory bear's head knob, by Robert James, Wainwright, about 1952. Height, including knob: 3¼ inches (8.1 cm.). Private collection. The eyes of the bear are inset with old ivory. The teeth are carved out, and the mouth is red. The white stitches are light-colored baleen. Other baleen baskets are illustrated in *Contemporary Alaska Native Art* (1971, p. 19); Frost, ed. 1970, p. 21; *An Introduction to the Native Art of Alaska* (1972, p. 56); and *Smoke Signals* (1966, p. 24). Baleen baskets are discussed in Chapter III.

222 Two views of gray baleen basket, George Omnik, Point Hope, 1960s. Height: 4 inches (10 cm.). Collection of Mr. and Mrs. David W. Johnson. The ivory knob, which is more ornate than most, is carved from one piece of ivory. The view looking inside the basket shows the ivory plate, which is in the bottom of every basket. Black baleen forms the bottom of this basket. As indicated by the number above Omnik's name, this basket was the 452nd that he had made. He began his basket-making in 1949, and by May 1974 he had just finished 892 (Morgan 1974, p. 39).

222

222

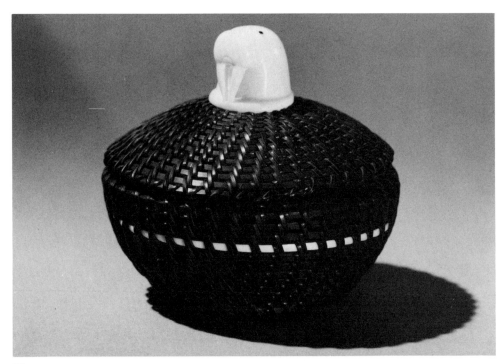

223

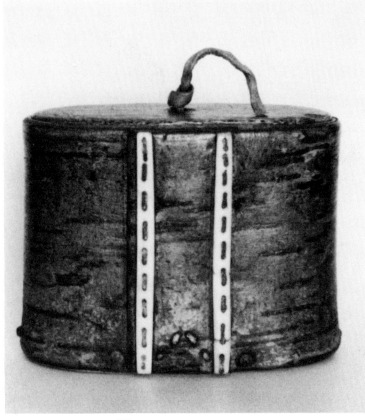

224

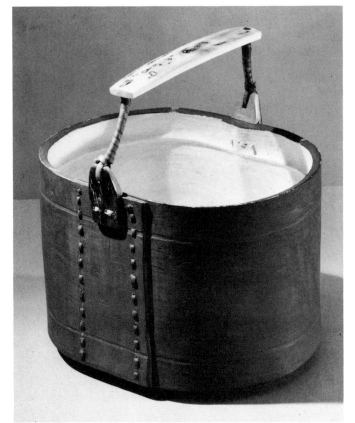

225

226

223 Baleen basket made in ''open weave'' style, by Marvin Sakvan Peter, Barrow. Height: 3¹/₄ inches (8.1 cm.).

 Photograph courtesy Indian Arts and Crafts Board

224 Trinket box of birchbark, Seward Peninsula, probably late nineteenth century. Height: 2⁷/₈ inches (7.1 cm.). Collection of D. J. Ray. The birchbark is bent around a heavy piece of ugruk skin and held together with eight brass nails, three on each wide side and one on each narrow side. The bottom and the lid are made of driftwood. The two decorative ivory strips are sewed to the birch bark with sealskin thong. This box was given to me in 1947 by Emma Willoya, originally of Teller, who had had it in her possession since the early 1900s. Other examples of small wooden boxes are illustrated in Nelson 1899, pls. 62, 63, 87.

225 Bentwood bucket of driftwood by Louis Nakarak, Shaktoolik, about 1962. Height: 6¹/₂ inches (16.3 cm.). Collection IACB X.56. The ivory handle is fastened to ivory tabs with split willow root. It is dyed brown on the outside and painted white inside. Willow root is used for sewing at the fold. This bucket is a copy of those made during the nineteenth century in the Norton Sound area. They are rarely made during the 1970s. The older ones, which were usually used for berry picking, were unpainted and had simple wooden handles.

 Photograph courtesy Indian Arts and Crafts Board

226 Siberian-style pipes of walnut and solder, by Albert Kulowiyi, Savoonga, 1970. Lengths: 6¹/₈, 6¹/₄, and 6¹/₂ inches (15.3, 15.6, and 16.3 cm.). Collection of Mr. and Mrs. Glen C. Simpson. The method used in making these pipes is explained in Chapter III under ''Bentwood Buckets, Horn Ladles, and Horn Dolls.'' Another of his pipes, with a different design, is illustrated in Frost, ed. 1970, p. 38.

 Photograph by Barry McWayne

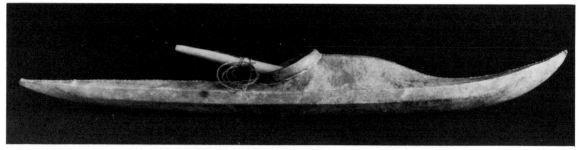

227

228

227 Skin model of a kayak in northern Alaska style, by Gilbert Kennedy, Kivalina, 1963. Length: 16¼ inches (40.5 cm.). Collection of Mr. and Mrs. David W. Johnson. The skin is stretched over a wood frame and sewed with sinew. The harpoon is wood with a baleen point. Two useful illustrations for identifying the general provenience of model kayaks are in Nelson 1899, pl. 79, and Oswalt 1967, p. 164.

228 Model sled made of caribou jaw by Abraham Howarth, Kotzebue, about 1968. Length: 13½ inches (33.8 cm.). Collection of Mr. and Mrs. David W. Johnson. Strips of baleen are pulled through each side from end to end.

229 Caribou skin mask from Anaktuvuk Pass, 1960s. Height, including ruff: 17 inches (42.5 cm.). Private collection. The ears of the wolf were left attached to the ruff. Eyebrows, beard, and mustache are of caribou skin. This kind of mask is discussed in Chapter III under "The Anaktuvuk Skin Mask."

230 Caribou skin mask made by Susie Paneak, Anaktuvuk Pass, about 1962. Height of face: 8 inches (20 cm.). Private collection.

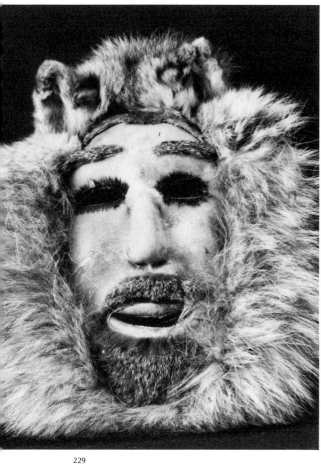

229

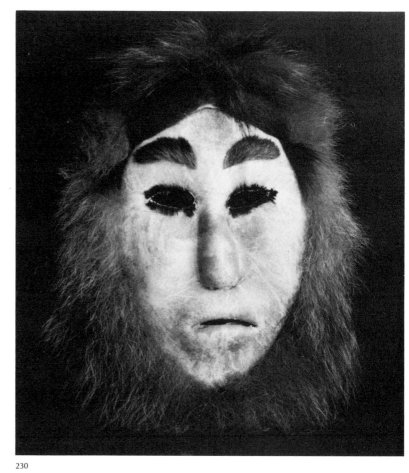

230

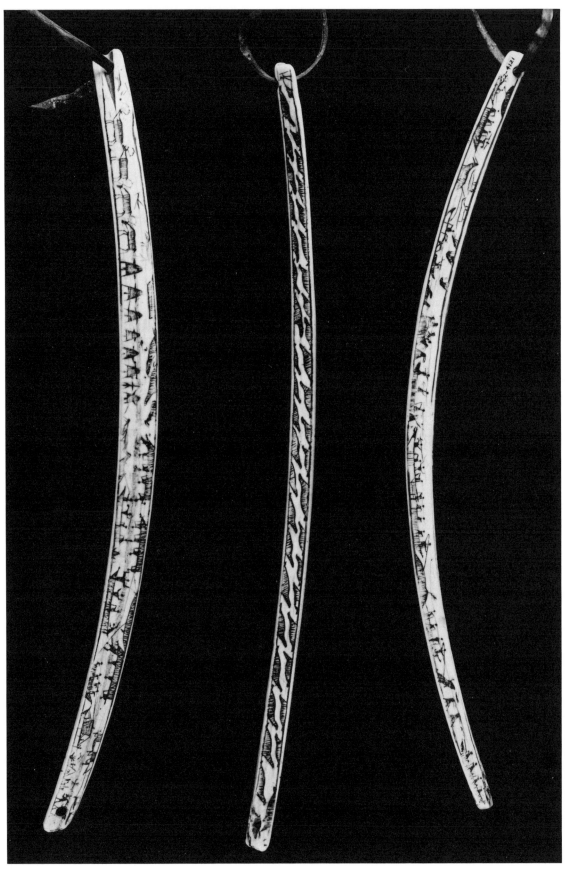

231

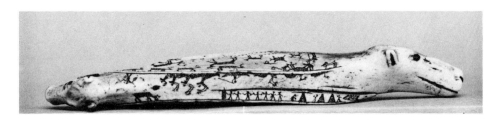

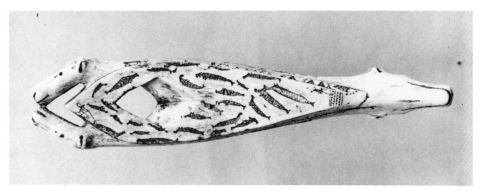

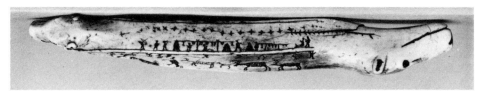

232

231 Three sides of an ivory drill bow, 1880s. Length: 17¼ inches (43.3 cm.). Lowie Museum 2–4121. Collected by Rudolph Neumann of the Alaska Commercial Company, probably in the Saint Michael area, where Mr. Neumann was stationed. Subject matter and engraving style suggest that it was made in the same place and perhaps by the same person as the one illustrated in Fagg 1972, pl. 15-g. It is also similar in style to USNM 48525 (collected between 1877 and 1881 without provenience) and NA 9387 (University Museum), said to have been collected in 1816 (Mason 1927, pp. 266, 268, 270, 272). This date, however, was probably recorded originally as 1876, because the bow depicts a whaling ship and whalers did not sail north of Bering Strait until 1848. (See also under fig. 245.)

Photograph by Alfred A. Blaker

232 Arrowshaft straightener of ivory, with many engravings. Length: 7 inches (17.5 cm.). British Museum 1936.1. This probably came from the Bering Strait or Kotzebue Sound. One end terminates in a caribou head, and the other, in two smaller caribou heads with inlaid eyes. An article in the *British Museum Quarterly* at the time this piece was acquired by the museum suggested that the heads were polar bears, but they are too long and the wrong shape (Digby 1936–37). Many other arrowshaft straighteners had caribou-head sculptures, which was fitting, since the straighteners were made by Eskimos who hunted caribou, not polar bears. Below the kayak-caribou hunting scene are footprints of a dog and a caribou. The portrayal of footprints in Eskimo art is rather rare, but examples are on the wooden caribou corralling sculpture from Point Hope (fig. 152); on the pipe in figure 244; and on a tusk in the Agnes Etherington Art Centre (M 69–20). The latter has footprints marked all the way up to the first caribou of the herd.

The earliest example of caribou footprints is on a drill bow collected by Beechey at Kotzebue Sound (Pitt Rivers Museum 693), which has many other features similar to this arrowshaft straightener. Both may have come from the same locality.

Photograph courtesy of the Trustees of the British Museum

215

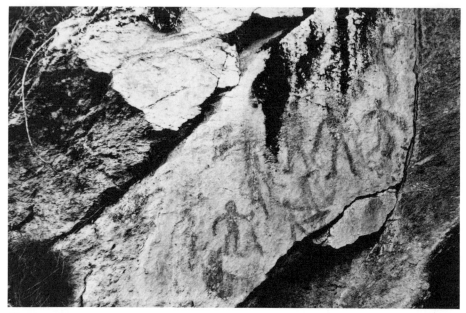

233

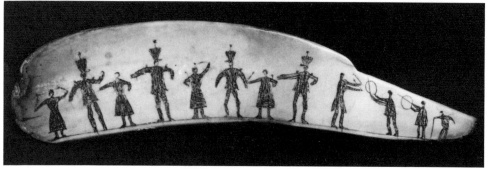

234

233 The only known rock paintings in the territory of the northern Alaskan Eskimos. The figures are located on a steep rock face of the Tuksuk Channel and vary in height from 6 to 9 inches (15 to 22.5 cm.). They are painted red and black, with black predominating. See Chapter II, "Painting and Engraving," for discussion.

234 A flat piece of ivory engraved with Russians as subject matter, collected in 1897. Length: 6¾ inches (16.8 cm.). Washington State Museum 10.0/392. Russian subject matter is rare in Eskimo art, probably because the Eskimos living near the Russians south of Unalakleet had not begun souvenir engraving before the American purchase in 1867. Besides the nine Russian figures there are also two Eskimo dancers and what appears to be a lame man at the far right. On the opposite side are engraved nine Eskimo woman dancers and seven drummers.

235 Three sides of three drill bows collected by E. W. Nelson between 1877 and 1881. Length of shortest bow is 13½ inches (33.8 cm.). USNM: a. no museum number, Cape Darby, 14.1 inches (35.3 cm.); b. 48,115, Cape Darby, 13½ inches (33.8 cm.); c. no museum number, no provenience, 13⅝ inches (34 cm.). The multiplicity of subjects depicted on one drill bow like the one from Cape Darby (a) is staggering: caribou in many poses, a variety of other animals, many human activities indoors and outdoors, houses, sleds, umiaks, and even a scene in which hunters seem to be attacked by clouds of mosquitoes. This drill bow also has drawings of three men apparently riding caribou. Domesticated riding reindeer were not imported from Siberia until 1892, but this bow was made before that date and may represent Siberians riding their animals, or a specific folk tale.

Photograph by the Smithsonian Institution

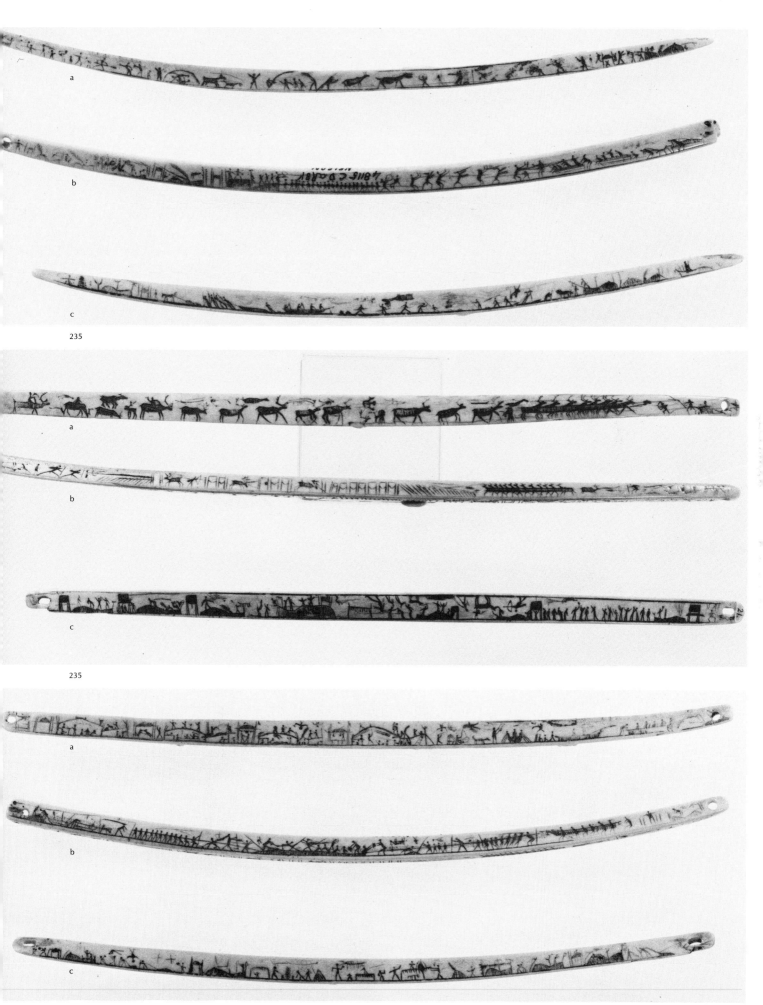

a

b

c

235

a

b

c

235

a

b

c

235

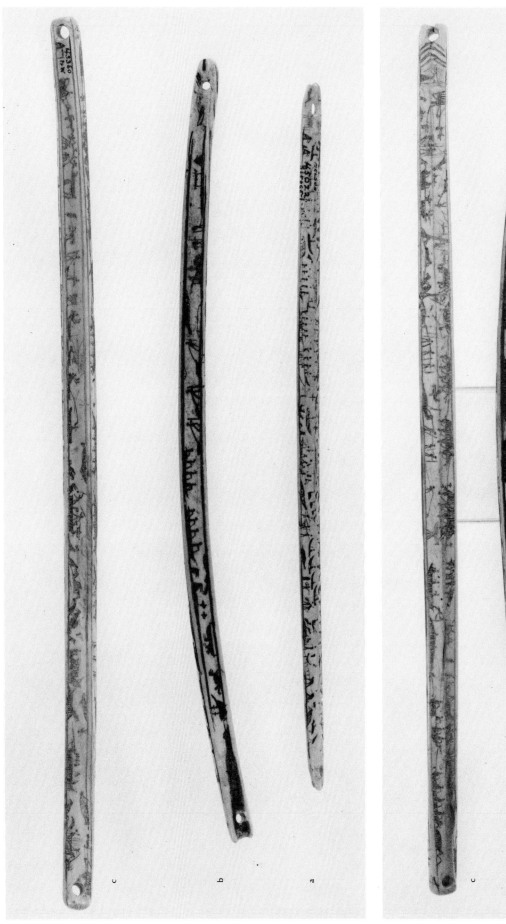

236

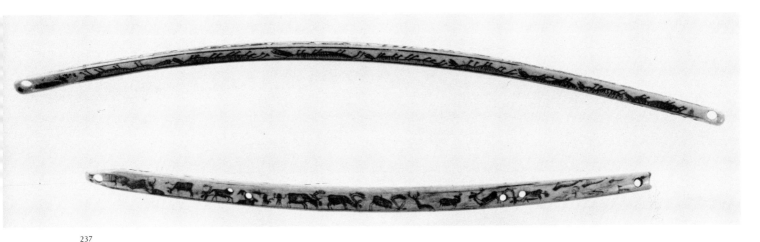

237

236 Two views each of three drill bows from Sledge Island and Cape Prince of Wales, collected between 1877 and 1881. USNM: a. 45,022, Sledge Island, 14.5 inches (36.3 cm.); b. 176,171, unknown provenience, 15⅝ inches (39 cm.); c. 43,360, Cape Prince of Wales, 17¾ inches (44.3 cm.). A number of drill bows without provenience in the British Museum are illustrated in Fagg 1972, pl. 15. Number 15-h is undoubtedly from Cape Prince of Wales since it is similar in style and subject matter to USNM 43,360. An even more definite identification can be made, however, by comparing it to almost identical motifs on a drill bow in the University Museum (NA-455), which is known to come from Cape Prince of Wales (Mason 1927, pp. 276, 277, 279). The incredible delicacy of engraving and minuteness of figures on many of the bows and bag handles has rarely been duplicated today. One exception is the work of Andy Tingook in the 1950s before his eyesight failed (fig. 276).
Photograph by the Smithsonian Institution

237 Engraved scenes of caribou and the legendary ten-legged bear. Length of top bow: 16⅛ inches (35.3 cm.). The top bow, from Cape Nome, has no museum number. The bag handle with caribou on it is USNM 44,210, from Cape Darby. The caribou scene with its great variety of poses was probably engraved by the same man who made the drill bow, figure 35a. Since these animals are rather diagrammatic, there is a possibility that they are dragons, and not bears (see Chapter II under "Mythological Creatures.")
Photograph by the Smithsonian Institution

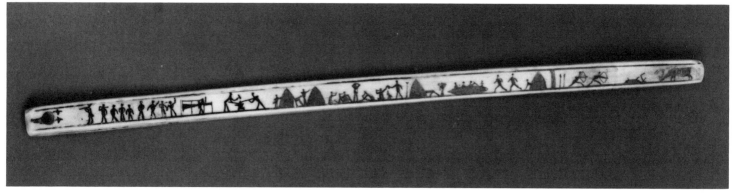

238

238 Drill bow from Port Clarence depicting activities of men searching for the Franklin expedition at Bering Strait, 1848–54. Length: 13¼ inches (33.3 cm.). British Museum 1855.11–26.227. Sir John Barrow collection. This bow was brought back to England by Mr. Spark of H.M.S. *Rattlesnake.* The European scenes could represent the activities of crews of several specific vessels. Eight British Royal Navy vessels and a private yacht searched Bering Strait between 1848 and 1854, and two of them, the *Plover* and the *Rattlesnake,* remained over winter in the ice of both Kotzebue Sound and Port Clarence. A house was built by the *Plover's* crew on the spit across from present-day Teller in 1850/51, and many Eskimos visited the ship both that winter and the next. The *Rattlesnake* wintered over during 1853/54, and the crew also built a house on the spit. On this bow, the European scenes are colored black, and the Eskimo scenes, red. The other three sides were left unfinished, which may mean that these activities referred to the *Rattlesnake,* which left Port Clarence in 1854 before the drill bow was finished.

Photograph courtesy of the Trustees of the British Museum

239 Two drill bows, which probably depict activities of the Omilak miners in 1880 and 1892. Lengths: of top bow, 13¾ inches (34.3 cm.); of bottom bow, 16 inches (40 cm.). The top bow is in the Smithsonian Institution (USNM 176,172) and was collected by E. W. Nelson in 1881 at Golovnin Bay. I have no doubt that the drawings represent the activities of the first mining venture, a silver mine, in western Alaska, which began in 1880. The identification of the second bow (Lowie Museum 2–1559) is not so positive, but the subject matter, especially the horses and the still for making liquor (far right), strongly suggests activities of 1892, when mining was revived after its earlier failures. This bow was collected between 1894 and 1901. In 1892 Michael Healy, skipper of the *Bear,* reported the still; and so far as I know, that was the year that horses were first brought to northwest Alaska, by the Omilak miners. The larger vessel on the bow may be a revenue cutter, but the *Bear* had three masts. The *Corwin,* which had stopped at Golovnin Bay previously, had two masts and looked very much like this vessel.

Photographs from the Smithsonian Institution and by Alfred A. Blaker (bottom)

220

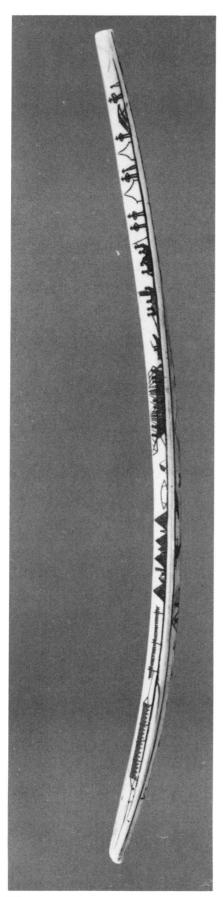

239

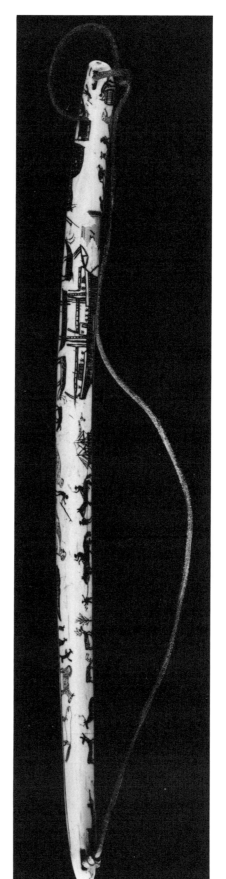

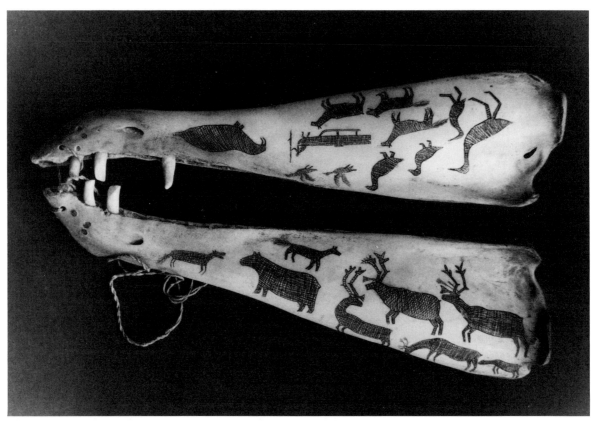

240

240 Pair of animal jawbones, probably engraved as a souvenir by an Eskimo who did not have ivory, Saint Michael area, about 1895. Length: 14¼ inches (35.6 cm.) Constantine Collection, Agnes Etherington M 69–25, a and b.
　Photograph by Frances K. Smith

241 Walrus ivory tusk engraved with unrelated subjects of folklore and everyday life. Length: 16½ inches (41.3 cm.). Lowie Museum 2–156. Collected between 1894 and 1901 in the Saint Michael area. A *tirisuk* and a man-worm are engraved in the upper left and lower right, and specific stories are probably illustrated by the man-bird with four arms, the bear fight, and the man shot in the back. Below the bear fight are bird snares or deadfalls.
　Photograph by Alfred A. Blaker

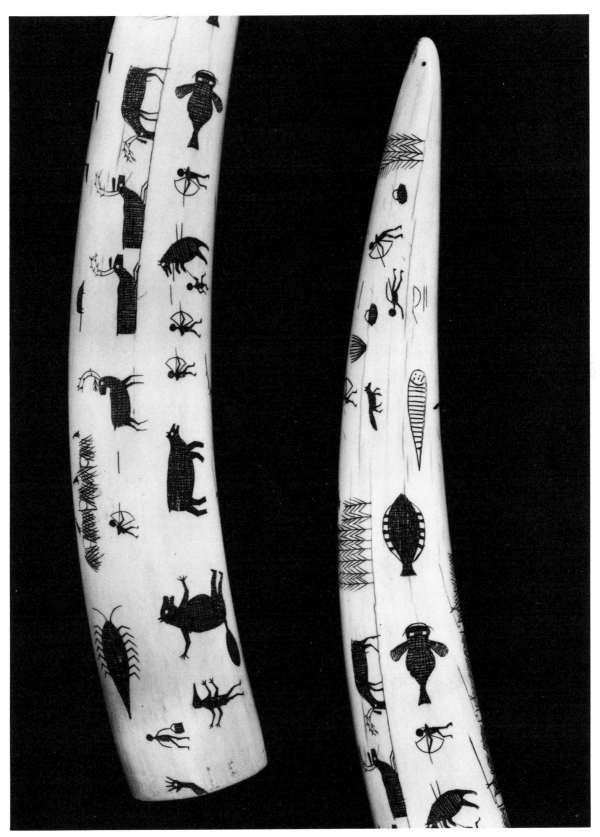

241

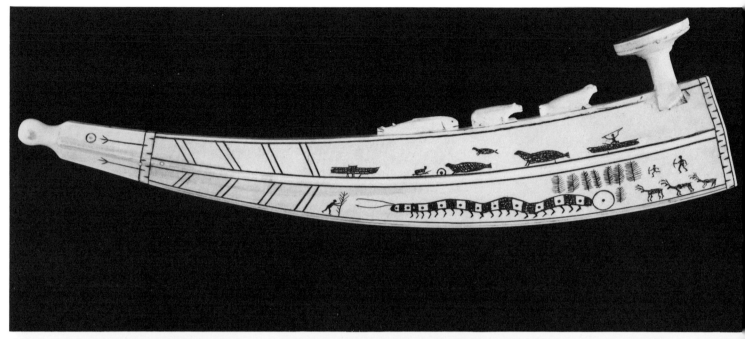

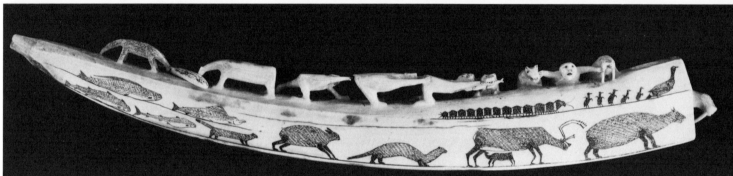

242

242 Two interpretations of the *tirisuk* on ivory pipes of the late nineteenth century. Lengths: of top pipe: 13³⁄₈ inches (33.4 cm.); lower pipe, 15¹⁄₂ inches (38.8 cm.). Lowie Museum 2–167 and 2–159, respectively.

 Photograph by Alfred A. Blaker

243 Two sides of a pipe showing imaginative relationships between folklore and the reality of living off the land. Length: 17¹⁄₄ inches (43.1 cm.). Lowie Museum 2–168. Collected by Charles L. Hall between 1894 and 1901 in the Saint Michael area. This pipe was probably made by the same man who engraved the tusk in figures 247 and 248. The heavy style of depicting density, color, and texture simulates painting since the combination of irregular knife cuts and the application of the darkening substance provide shadings not ordinarily found in engravings of that time, which were either crosshatching (figs. 246, 249, 250) or a slanting gash with white spaces (fig. 242), also seen in those copied from printed illustrations (figs. 251, 253, 254, 258, 260, 261, 263–67).

 The two wrestling bears and the bear being shot probably represent specific stories or folk tales. The legendary creature, palraiyuk, at the end of one tusk appears to be chasing fish into a trap. The name was first recorded by Nelson (1899, pp. 444–45).

 Photograph by Alfred A. Blaker

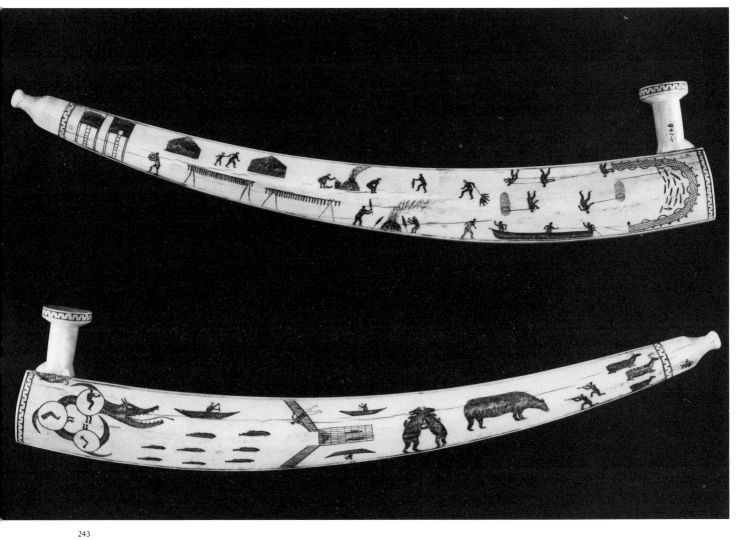

243

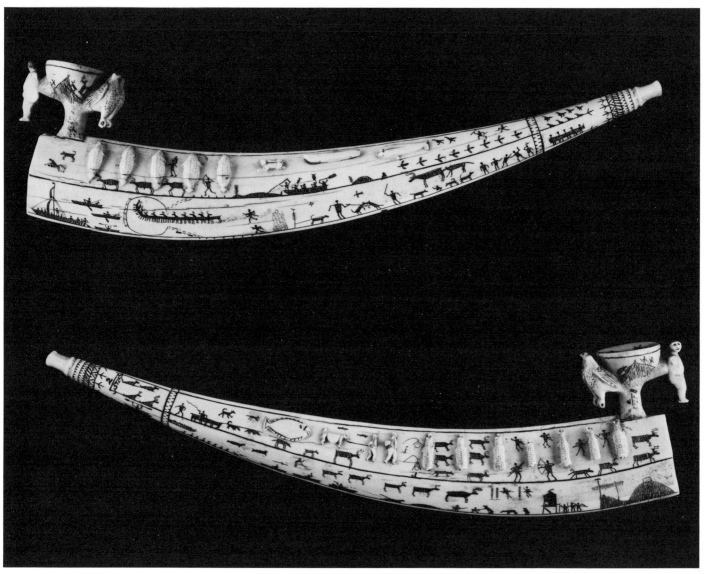

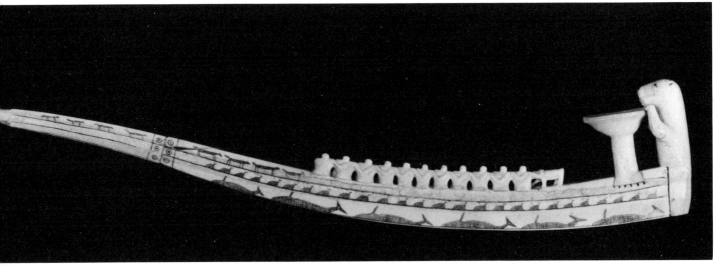

245

246

244 Heavily decorated ivory pipe depicts Eskimo life in engravings and small sculptures, late nineteenth century. Length: 15½ inches (38.8 cm.). Lowie Museum 2–5725. This pipe may have come from King Island or vicinity because no. 2–5724, also a pipe, was from "King's Island." The bowl of the pipe has rare scenes of hunting in the hills. The birdlike objects atop poles are probably amulets.
 Photograph by Alfred A. Blaker

245 Ivory pipe with sculptures of eleven men and a dog. Length: 15⅞ inches (40.3 cm.). University Museum NA 9388. This was said to have been collected in 1816; but pipes were not made until the 1870s, so the collecting date was undoubtedly 1876, not 1816 (see also under fig. 231).

246 Driving birds into a corral, an engraved vignette of the nineteenth century. Lowie Museum 2–153. The engraved scenes on the walrus tusk from which this is taken are for the most part sketchy and poorly done, as if by a beginner; but two scenes are especially well conceived: a pod of walrus on ice and this bird corral. I have seen numerous tusks in this careless style, proof that even poor workmanship eventually found a home.
 Photograph by Alfred A. Blaker

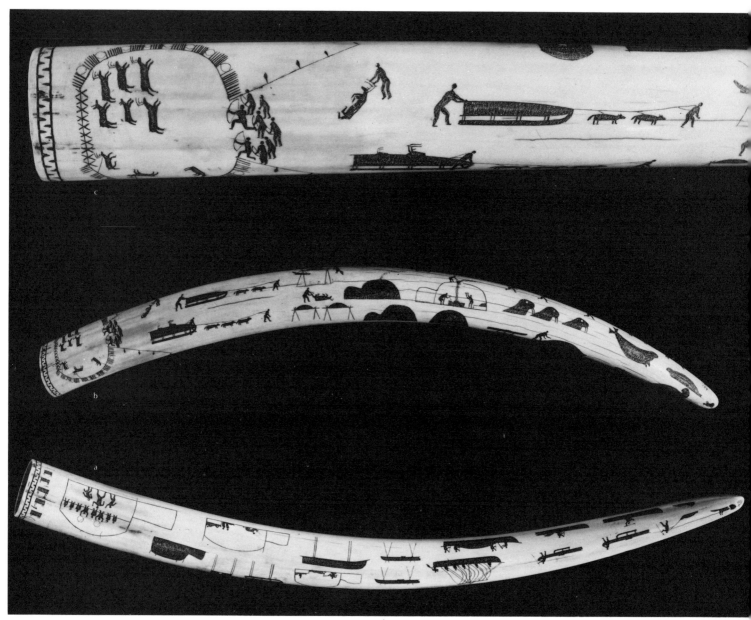

247

228

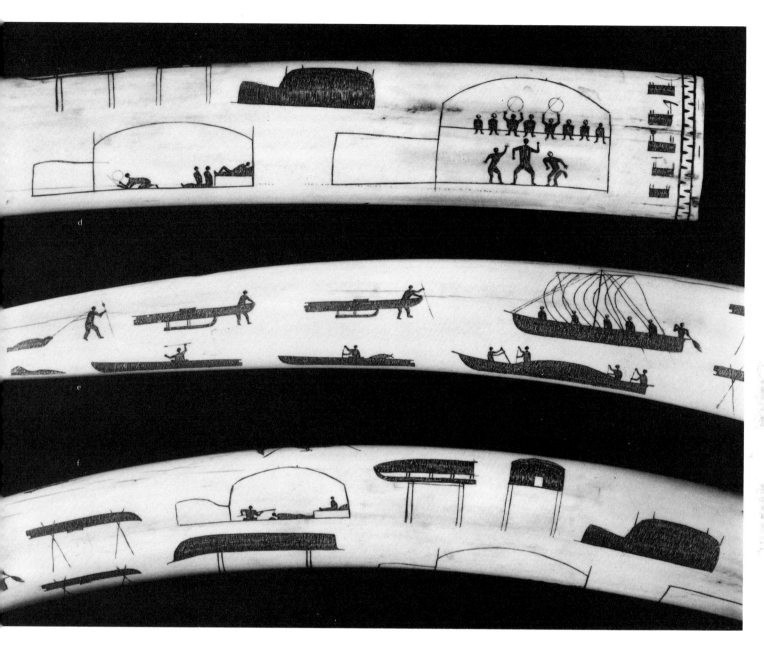

247

247 Two sides of a tusk and enlargements of various activities. Length: 25¼ inches
(63.2 cm.). Lowie Museum 2–154. Collected by Charles L. Hall, 1894–1901, Saint
Michael area. The whole tusks show how the placement of subjects was carried out on
the whole surface, and the enlargements clearly show engraving techniques and close-ups
of the various activities, especially the caribou hunting scene (compare with the wooden
sculpture, fig. 152); the shaman's curing scene and dance scene (247d); the different
modes of transportation; and head-lifting for curing the sick (247f).
 Photographs by Alfred A. Blaker

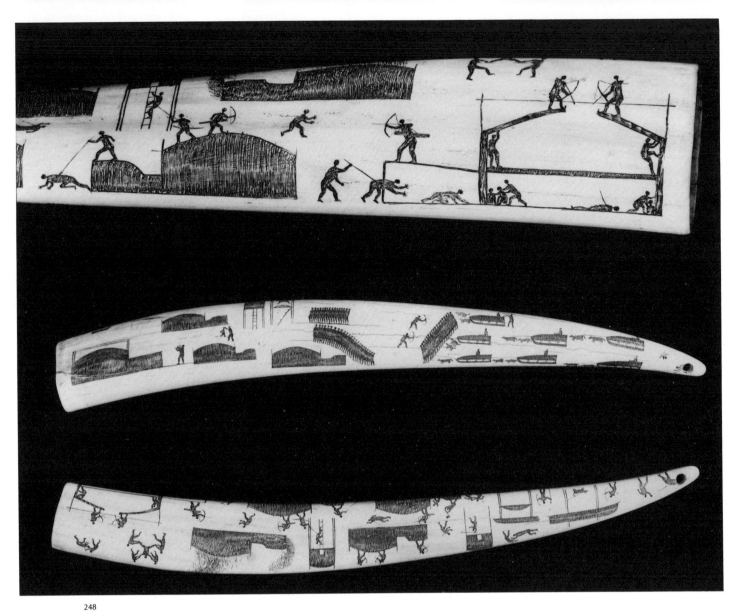

248

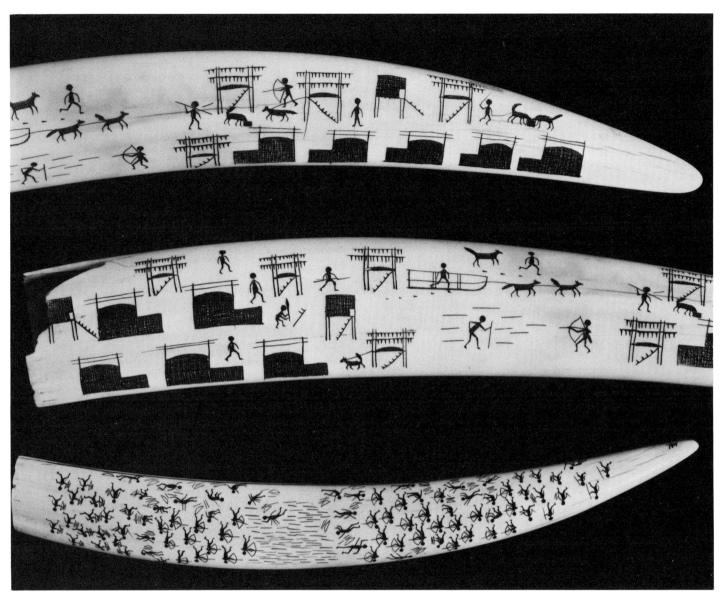

248 Engraved tusk, with war and violence as the main themes, late nineteenth century. Lowie Museum 2–146. Collected by Charles L. Hall, 1894–1901, Saint Michael area. Warfare and raiding were common folk tale subjects among the northwest Alaska Eskimos, especially those who came into contact with Indians and Siberians. The stories ranged from confrontations by a whole village to an attack on a single dwelling, both of which are shown on this tusk. The pulling of the man's arms and legs (248c) was to tear him asunder. An area near Peterson Creek in the Elim area was named Kuyuktalik ("sexual intercourse"), which commemorated the rape and murder of a young Malemiut girl, whose family was also killed by men who had come from Shaktoolik across the bay. Her death was most tragic of all because it was accomplished by tying her to four kayaks, which paddled off in four directions to pull her apart.
Photograph by Alfred A. Blaker

249 Two sides of a tusk, one showing a peaceful village scene, and the other, the artist's interpretation of full-scale Eskimo warfare. Length: 16½ inches (41.3 cm.). Lowie Museum 2–144. Collected by Charles L. Hall, 1894–1901, Saint Michael area. The dwellings with drying racks on top were typical of the Norton Sound area. The warfare scene shows a different way of treating the opposing massed forces from that in figure 248.
Photograph by Alfred A. Blaker

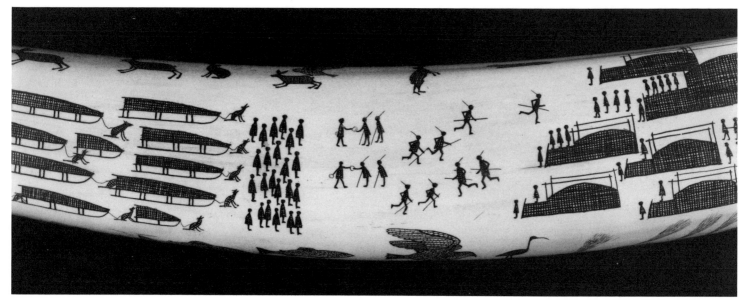

250

250 Ceremonial details of the arrival of guests at the messenger feast on an ivory tusk. Lowie Museum 2-155. Collected by Charles L. Hall, 1894–1901, Saint Michael area. This joyous occasion was celebrated annually or biannually in December if there were enough gifts for exchange, from Nunivak Island to Point Barrow. The *nilga* or eagle-wolf dance of Seward Peninsula was a variation of this complex trading and social celebration (figs. 144–46).

Photograph by Alfred A. Blaker

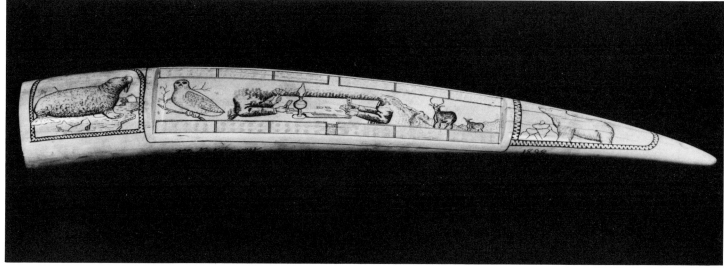

251

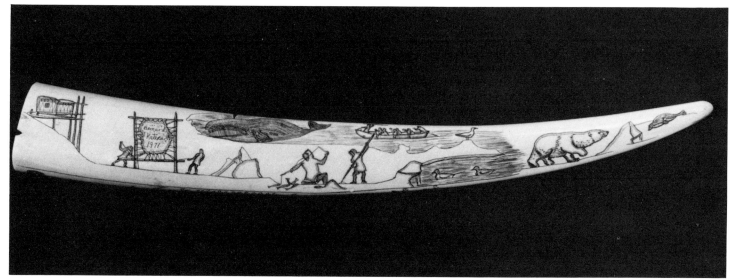

252

251 Cribbage board signed "Joe Kakavgook," 1898. Length: 18½ inches (47.5 cm.). AMNH 60.1/5989. The catalog reads from "northern Alaska," but it was made in Saint Michael by Joe Austin, as explained in Chapter III under "Pictorial Engraving." The carver of this cribbage board probably also engraved the tusk in figure 260, as well as the one in figure 258, which has been attributed to Happy Jack. The two headless men are playing cribbage, which was very popular during gold rush days in the Klondike and on Seward Peninsula. On the reverse side of the tusk a man and a woman are riding on a sled pulled by four dogs.

252 Tusk engraved by Bernard Katexac, King Island, 1971. Length: 19¼ inches (48.1 cm.). Collection of Gerald McKay. The engraving of whole tusks was discontinued shortly after the turn of the century, but was revived at mid-century, especially during the 1960s, some as direct copies of nineteenth-century work. McKay asked Bernard Katexac, the well-known printmaker, to make this tusk. He did so rather reluctantly, but signed it in an emphatic manner.

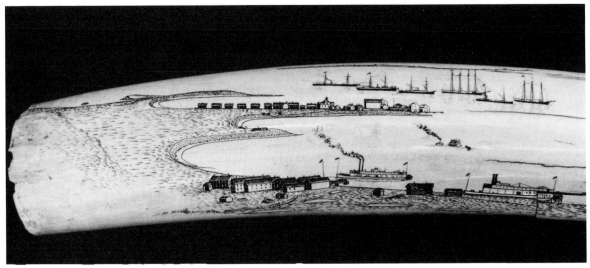

253

253 Busy Saint Michael after the discovery of gold in the Klondike, 1896. Length of outer curve of the entire tusk: 36½ inches (91.3 cm.). Constantine Collection, Agnes Etherington M 69–21. This engraved view of Saint Michael is so much like Guy Kakarook's watercolor in figure 255 that there is no doubt that it is his also. This aerial view is remarkable, for there is no hill high enough to give this perspective. Yet the buildings are drawn so that they are not in too different a perspective from those in the watercolor. The Saint Michael of this picture includes more than the watercolor. The original Russian fort and trading post established in 1833 was on the site of the upper cluster of buildings (which is the principal scene of the watercolor), and the later American warehouses and docks are in the lower part of the drawing. Figure 254 shows the native village of Saint Michael about 1900.
Photograph by Frances K. Smith

254 The Eskimo village of Saint Michael about 1900 engraved on a mammoth tusk. Length on the outer curve of tusk: 42½ inches (106.3 cm.) Constantine Collection, Agnes Etherington M 70–17. This village of European-style homes, which had supplanted the old underground houses, has been identified by Eskimos of the area as Tachik, the old Eskimo village located near the warehouses of figure 253. This tusk was probably engraved by Joe Austin because the walrus and many other drawings are similar to figures 251 and 260; yet the village scene is much like those executed by his stepfather, Guy Kakarook.
Photograph by Frances K. Smith

255 Watercolor and crayon sketch of Saint Michael, by Guy Kakarook. Dimensions: 8 by 9¾ inches (20 by 24.3 cm.). Smithsonian Office of Anthropology 316,702. Sheldon Jackson, agent of education for Alaska, obtained two notebooks, each containing more than thirty watercolors of life in Saint Michael and along the Yukon River made by Kakarook between 1894 and 1903. After Jackson's death, his daughter sold them to the Smithsonian Institution. This and other examples of Kakarook's paintings are illustrated in Ray 1961, figure 58 (river steamer *Michael* at a steamboat fuel landing on the Yukon River); Ray 1969, pp. 47, 48, 49 (Holy Cross in winter and in summer; wolverine in a trap; and stern-wheel steamer on lower Yukon); and Ray 1971, cover and pp. 9–15 (revenue steamer *Bear,* in color; Malemiut family; Siberian visitors; bird hunter near a lagoon; sandhill crane; Forty Mile in summer; Anvik in summer; Russian Mission in summer; and Saint Michael in summer).
Photograph by the Smithsonian Institution

254

255

235

256

256 Sawmill at "Fort Cudahy" on the Yukon River, crayon and watercolor sketch by Guy Kakarook, about 1903. Smithsonian Office of Anthropology 316,702. Almost all of Kakarook's river scenes included the stern-wheel steamer *Michael* ascending the river. From the little information I have been able to gather about Kakarook, the subject matter for his drawings came from the times that he and his sons worked on the Yukon River boats (see also under "Pictorial Engraving" in Chap. III).
 Photograph by the Smithsonian Institution

257 Tusk engraved with two scenes identical to two crayon and watercolor sketches in Guy Kakarook's notebook no. 2. Length: 10¾ inches (26.8 cm.). Lowie Museum 2–150. Collected by Charles L. Hall, 1894–1901. The only conclusion that we can draw about the identity of the engraver of this tusk is that it was Guy Kakarook.
 Photograph by Alfred A. Blaker

258 Two views of a mammoth tusk engraved with a myriad of Eskimo activities, about 1900. Length: 59⅛ inches (178.5 cm.). Royal Ontario Museum acc. no. 917.11. This tusk has been fully discussed and all parts of it illustrated by James W. VanStone (1963). The museum's catalog attributes it to Happy Jack, but I am convinced that Joe Kakarook Austin (Kakavgook), not Happy Jack, engraved it. I am basing this conclusion on my knowledge of many documented examples engraved by Happy Jack (none of which resembles this style of engraving) as well as on a number of tusks engraved by both Joe Austin and Guy Kakarook, or others that are known positively to have come from Saint Michael. My conclusion is further substantiated by the fact that this tusk was purchased from J. E. Standley (founder of Ye Olde Curiosity Shop in Seattle), who probably wrongly attributed it to Happy Jack, knowing that Happy Jack was the most famous of all carvers. (Also purchased from this shop was a drill bow in the National Museum (360,422) with provenience given as "St. Paul's Island"; but such objects and engraving were never done on this island.) Guy Kakarook had been almost forgotten by the time I began my research into his work, and no Eskimos knew about his remarkable paintings and engravings.
The village on this tusk is supposed to be Unalakleet—in Kakarook's home area. It was also done in his style, with his subject matter, for he was the master of village scenes. Except for the strange village illustrated in figure 262, obviously copied from illustrations, I have not seen engraved villages by Happy Jack.
 Photographs courtesy the Royal Ontario Museum

257

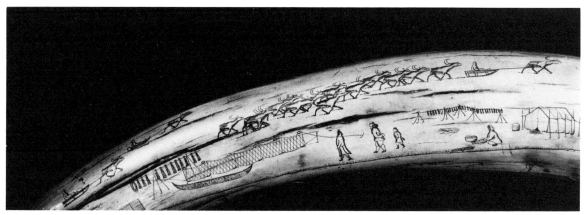

258

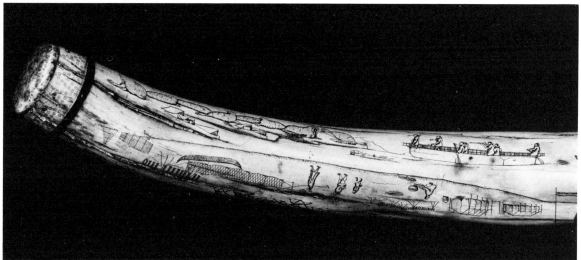

258

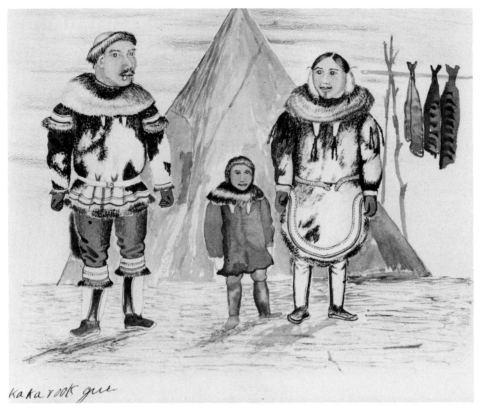

kakarook gue

259

259 Malemiut family in watercolor and colored pencil, by Guy Kakarook, 1903.
Smithsonian Office of Anthropology 316,702. Kakarook's drawing is a faithful record of the
Malemiut costume and summer tent at the end of the nineteenth century. It shows hair
styles, spotted reindeer skins, the fine details of sewing, and the woman's caribou-tooth
belt.
Photograph by the Smithsonian Institution

260 Ivory tusk with a herd of reindeer on one side and walrus and polar bears on the
other. Length: 19½ inches (49.8 cm.). Lowie Museum 2–149. Collected by Charles L.
Hall, 1894–1901. This tusk was engraved before 1894 because the man seated on the sled
and the one watching over the reindeer herd are Siberian (Chukchi) herders, not the
Lapp herders who came to Alaska first in 1894 and again in 1898. Several Siberian herders
were hired in 1892 and 1893 to help with the newly imported domesticated Siberian
reindeer at Teller Reindeer Station. These men are dressed in Siberian clothing. Lap-
landers were always identified in Eskimo engravings at that time by a four-cornered hat
on their heads (see illustration in Ray 1969, fig. 15, bottom). The drawing style of the
walrus, polar bears, and ice formations are like those on the following tusks: figures
254 and 258, this book; and USNM 316,691 and 316,692 (both illustrated in Ray 1969).
Photograph by Alfred A. Blaker

261 Two tusks by unidentified engravers showing Eskimos trading and what is probably
King Island. Lengths of top tusk: 23 inches (57.5 cm.); of bottom tusk, 20 inches (50 cm.).
Lowie Museum 2–197 and 2–196, respectively. Collected by Charles L. Hall, 1894–
1901. These two might have been engraved by Happy Jack, who seemed unable to make
his animals or human beings with any measure of gracefulness without using a model
(see also fig. 262). The bottom tusk would definitely be Happy Jack's if the signature in
figure 262 is genuine. Early in his career, Happy Jack engraved a number of objects
with heavy incisions—for example, figure 266—but he later became known for his
delicate copy work of illustrations and photographs. The village in figure 262 is like no
village in Alaska, and even the houses on this tusk (fig. 261) are not realistic because those
of King Island were mounted on stilts, as seen in figures 252 and 288.
Photograph by Alfred A. Blaker

238

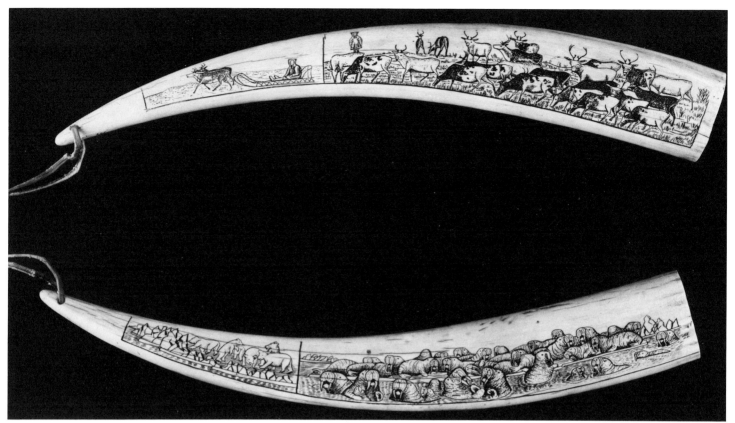

260

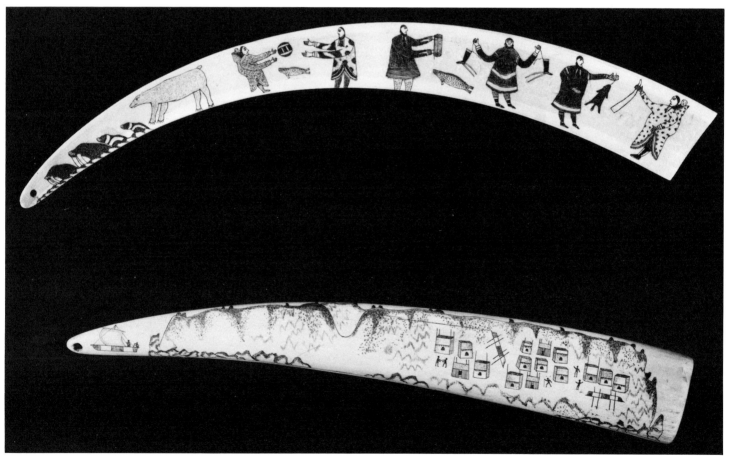

261

239

262

262 Portion of a tusk with the printed signature, "carved/by/Hapy Jack Big Diike."
Collection of Charles E. Derby. This tusk was purchased somewhere on the west coast of
the United States during the 1920s. By comparing it to the tusk in figure 261, it seems
to have been made at the turn of the twentieth century, possibly by Happy Jack. I have
seen four other Happy Jack signatures, all spelled correctly (although that means little,
because Happy Jack could not read). The letters on this tusk are not incised with the
firmness of the rest of the subjects. "Big Diike" perhaps stands for "Big Diomede," where
he lived during his youth after his sister married a man from there. The square dwellings —
as in figure 261 — are not realistic, nor are the rounded ones, which apparently represent
winter semisubterranean stone houses. The costumes may have been copied from playing
cards. The man on the left is holding a cluster of ivory tusks. To his right, a seal and a
rabbit are engraved.
 Photograph courtesy Charles E. Derby

263 Cribbage board made by Happy Jack about 1903. Length: $22^{13}/_{16}$ inches (58.5 cm.).
This was in the collection of Mrs. Ralph S. Hawley when I photographed it in 1960, but
she has since given it to the Washington State Museum along with other pieces of her
collection. Mrs. Hawley's parents purchased this and other objects made by Happy Jack
in Nome in the early 1900s, including the napkin ring in figure 266. Happy Jack's
inability to make lifelike animals is very evident in this piece. (This and the opposite side
are also illustrated in Ray 1961, figs. 54, 55.)

264 Gavel made by Happy Jack and presented by the Eagles to William Henry Milleman,
whose portrait is engraved on the opposite side (fig. 265). Height of gavel head: $3^3/_4$ inches
(10.3 cm.). The handle of tan ivory is $5^5/_8$ inches long. Nome Museum NM1-1-1.
Mr. Milleman went to Nome in 1903 at age thirty-eight as manager of the Standard Oil
Company (personal communication from Carrie M. McLain).

265 Opposite side of the gavel head illustrated in figure 264. Height of the face from the
top of hair to the top of collar is $2^3/_{16}$ inches (5.5 cm.).

263

264

265

241

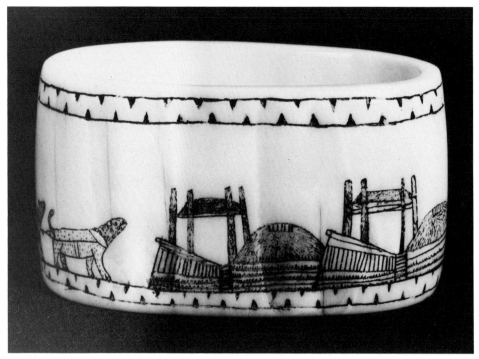

266

266 Napkin ring engraved with Eskimo dwellings by Happy Jack, about 1903. Outside circumference: 6⅝ inches (16.5 cm.). Collection of Mrs. Ralph S. Hawley.

267 Gold panner engraved on the end of a tusk by Happy Jack looks like a carbon copy of a printed page. Height of engraving: 3¹⁵⁄₁₆ inches (10 cm.) on a tusk 22 inches long. Collection of D. J. Ray.
 Photograph by Alfred A. Blaker

268 Drawing by Florence Nupok Malewotkuk, 1920s. Dimensions: 4¾ by 3½ inches (11.8 by 8.7 cm.). This drawing, which was among ninety-seven commissioned by Otto William Geist, appeared on the cover of the Geist and Rainey archeological report (1936). Also see under "Cloth and Fur Products" in Chapter III.

269 Trinket box painted with northern scenes by Robert Mayokok, 1968. Height: 3¹⁵⁄₁₆ inches (8.1 cm.). Collection of D. J. Ray. Five scenes are drawn with a felt-tip pen on the sides and top: a dancing group, a polar bear on an ice floe, a hunter spearing a seal, a bear killing a seal, and (on lid) a man dragging home a seal.

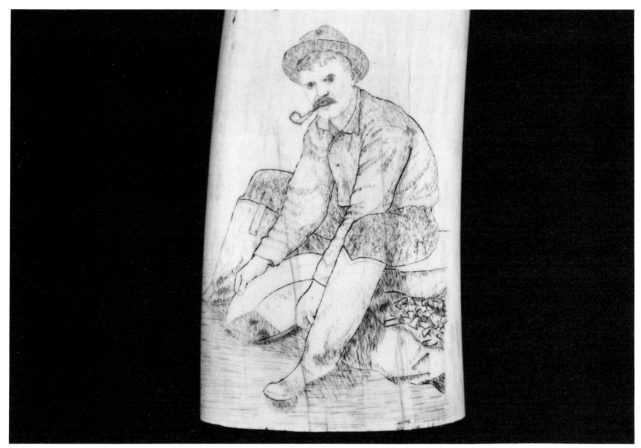

267

268

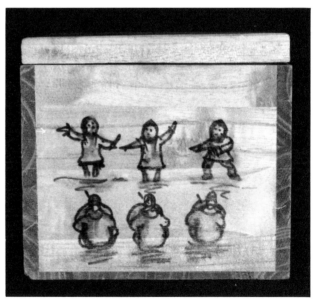

269

243

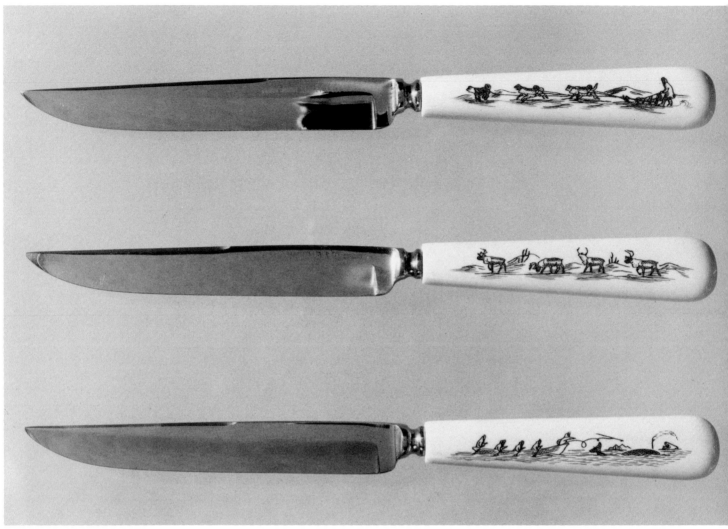

270

270 Steak knives designed by Wilbur Walluk for a Seattle firm, about 1960. Length of handle: 3³/₄ inches (9.3 cm.). Collection of D. J. Ray. Elephant ivory engraved with a pantograph after original design. Leonard F. Porter, whose firm employed many Alaskan Eskimos to design figurines and engravings, told me that the actual engraving was done by another Eskimo after Walluk's death in 1968. Therefore, Walluk's signature is not used on the knives.

Photograph courtesy Indian Arts and Crafts Board

271 Puffins and other birds engraved on a sperm whale tooth, by Peter Mayac, 1972. Height: 4¹⁵/₁₆ inches (10.8 cm.). Collection of Beverly Hendricks. The beaks and feet are colored orange, and the other markings are black. Mayac also makes realistic birds and animals of all kinds, which he copies from printed illustrations. (See his "Loon" in color in Frederick 1972, p. 38.)

272 "Rookery," a wood block print by Bernard T. Katexac, 1966. Dimensions: 4¹/₄ by 8 inches (10.6 by 20 cm.). Collection of D. J. Ray. This print in rust and black on white is another version of the bird rookeries of King Island and other cliffy places of the arctic. (See also figs. 100 and 271.) A similar theme was used by Katexac in "Cliff Dwellers," a wood block print of 1965 (illustrated in *Contemporary Alaska Native Art* 1971, p. 24, and Frederick 1972, p. 36).

244

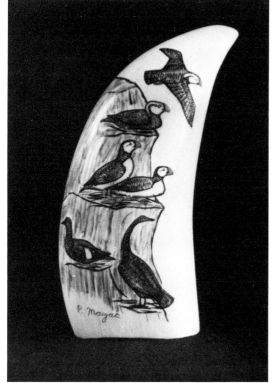

271

272

245

273

274

273 Black and white woodcut of the *Bear* by Warren Adlooat Sowle from *The Eskimo Bulletin,* 1902. Dimensions: 4¹¹/₁₆ by 4¾ inches (11.7 by 11.8 cm.). The early school programs invariably had classes in drawing, where the children always showed great promise. Harrison R. Thornton and William T. Lopp, the first teachers at Wales in 1890, went even further and had their pupils draw illustrations and make woodcuts for their yearly newspaper, *The Eskimo Bulletin,* printed on a hand press. This illustration and the one in figure 274 are only two of the many school drawings found scattered in various archives, articles, and books, a list too long to include here. A number of drawings were printed in the various reindeer reports written by Sheldon Jackson.

Photograph courtesy Indian Arts and Crafts Board

274 Woodcut entitled, ''Herd, and Trains and Supply Sleds Crossing the Divide at Head-waters of the Kevudlena, Kookpuk, and Pitmegea Rivers,'' by Warren Adlooat Sowle, 1898. Dimensions: 2⁷/₈ by 4¹/₈ inches (7.1 by 10.3 cm.). From *The Eskimo Bulletin,* 1898. Herding and driving of reindeer in Alaska was only six years old when Adlooat made this woodcut. This scene commemorates the driving of some of the Wales reindeer and those belonging to Antisarlook, the first Eskimo to own domesticated reindeer, to Point Barrow to ''save'' shipwrecked sailors in 1898. The long, harrowing trip was unnecessary, however, because the sailors had been well supplied with game by the Barrow Eskimos. The reindeer were left to form the nucleus of the Barrow herd.

Photograph courtesy Indian Arts and Crafts Board

275 ''Tutut (caribou),'' engraving by Bernard T. Katexac, 1964. Dimensions: 17⁷/₈ by 11³/₄ inches (44.6 by 29.3 cm.). Collection of D. J. Ray.

Photograph courtesy Indian Arts and Crafts Board

246

275

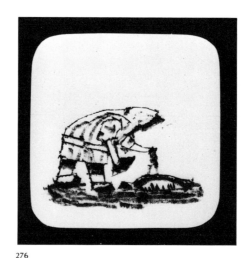

276

276

276 Designs on earrings, only ³/₄ of an inch (1.8 cm.) square, by Andy Tingook, Shish-
maref, 1955. Collection of D. J. Ray. Tingook, who had moved to Nome in the 1950s, was
doing his best work when I purchased these earrings from him in 1955. He was fifty-five
years old, but he was already suffering from failing eyesight. This work is an example
of the best engraving done during the mid-twentieth century and ranks with the finest of
all. In 1973, after several strokes had considerably handicapped him, Tingook, who
prefers to be called Andy rather than Andrew, continued to engrave small pieces cut
and polished by Dennis Corrington. His infirmities have changed the character of his
engraving. Although he is a superior technician, as can be seen in these earrings, he
has limited himself over the years to a few standardized pictures, which he has repeated
over and over instead of broadening out into the varied aspects of the nineteenth-
century engraver and mask-maker, or the young artists' experimentation and
imagination of the 1970s.
 Photographs by Alfred A. Blaker

277 Example of picture-writing for remembering the scriptures, ''Philippians, 4:4–7,'' by
Lily Savok, Nome, 1968. Collection of D. J. Ray. This is a photograph of stitchery done
by a nonnative Canadian woman, Mrs. Thomas M. Croil, who made an exact copy
(enlarged to 2¹/₄ by 1¹/₄ feet on cloth) from the one drawn and published in the article,
''The Bible in Picture Writing'' (Ray 1971a).

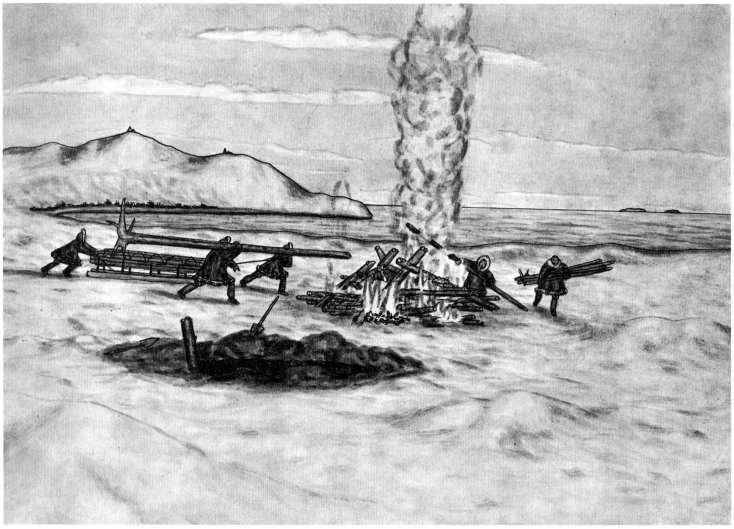

278

278 Drawing by George A. Ahgupuk, which illustrates the folk tale, "How Oo-veva-meak Became a Devil-doctor," 1945. Illustrated in *Igloo Tales* (Keithahn 1945, p. 105). Ahgupuk was one of the first of the so-called Eskimo artists to gain a wide reputation in a medium other than ivory. While recuperating in a hospital from tuberculosis when a young man, he was encouraged to develop his drawing talents and subsequently has earned a living as a professional artist.

279 A herd of reindeer in India ink and wash on reindeer skin by Ahgupuk, 1973. Dimensions: 5⅞ by 3⅝ inches (14.6 by 9 cm.). Collection of D. J. Ray. In 1973 George Ahgupuk was signing only his surname, after the fashion of the one-name signature of the Canadian Eskimos.

280 John Tingook's interpretation of whales in a stonecut, "Whale with Young," 1965. This fine print was made in the printing workshop of the MDTA project in Nome, 1964–65. One of Tingook's carvings in wood is illustrated in figure 153. Under the same program he also carved a *kikituk,* which is illustrated here in bone by another carver (fig. 176).
 Photograph courtesy Indian Arts and Crafts Board

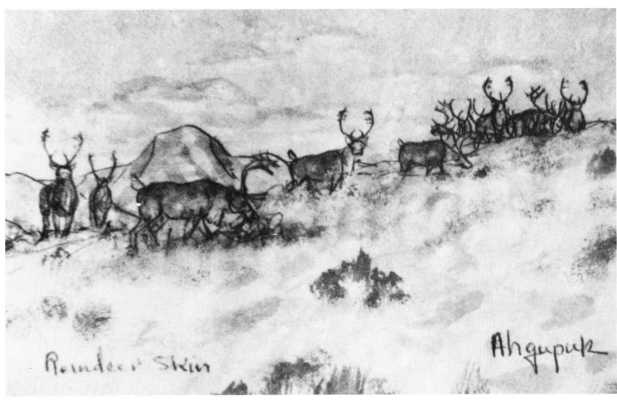

279

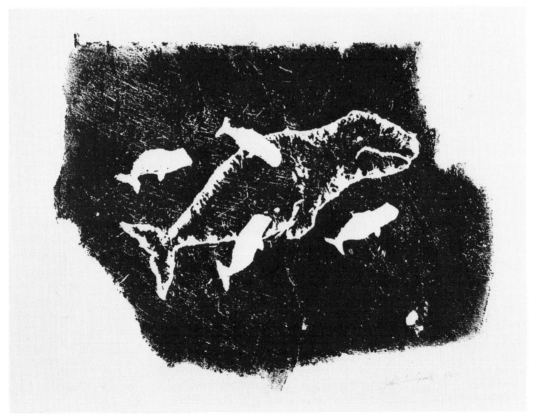

280

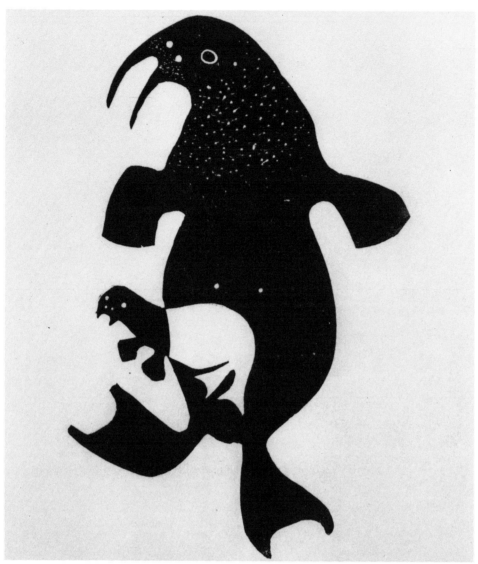

281

281 "Aivik Reborn," by Melvin Olanna, 1971. Collection ANAC.

282 Kivetoruk (James) Moses' business token made of a pebble, with his portrait on one side and his address on the other, 1968. Dimensions: 1 by 1^{5}/$_{16}$ inches (2.5 by 3.7 cm.). Collection of D. J. Ray.

283 "Mermaid," Kivetoruk Moses' interpretation of a mythical being, 1965. Dimensions: 7^{15}/$_{16}$ by 11^{15}/$_{16}$ inches (19.8 by 29.8 cm.). Collection IACB 65.49.8. Combined water-color, photographic coloring pencil, and India ink on paper. Skies of subtle pinks, blues, greens, grays, and orange are a feature of all of Kivetoruk's paintings, even his portraits (see figs. 284 and 285). All of his works are based on specific events, just as most engravings on the old drill bows and bag handles apparently were. In this painting, one of the men is looking at the mermaid through binoculars. The outboard motor of the skin umiak is raised from the water (also see under "Mythological Creatures" in Chap. II). Works by this artist are illustrated in *Alaska Journal* staff 1971; *Contemporary Alaska Native Art* 1971; Frederick 1972; and Ray 1969.
 Photograph courtesy Indian Arts and Crafts Board

282

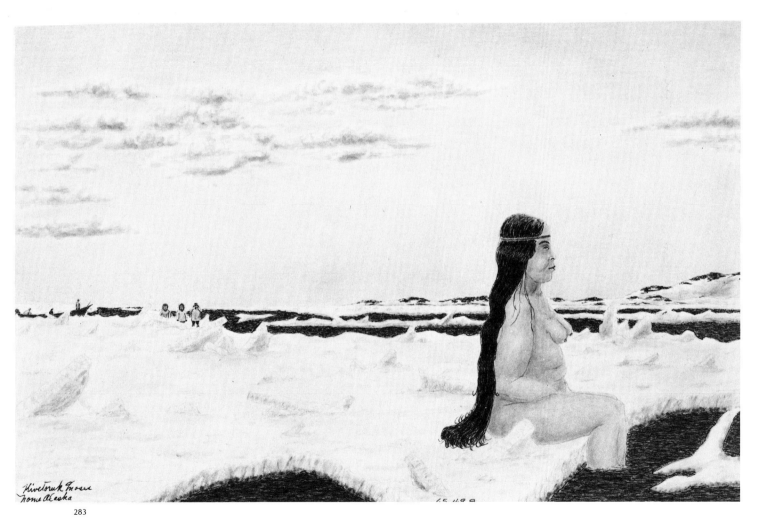

Kivetoruk Moses
Nome Alaska

283

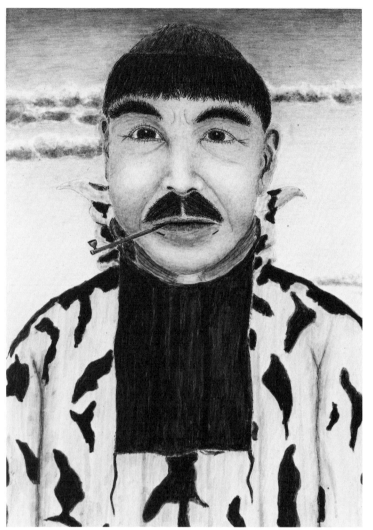

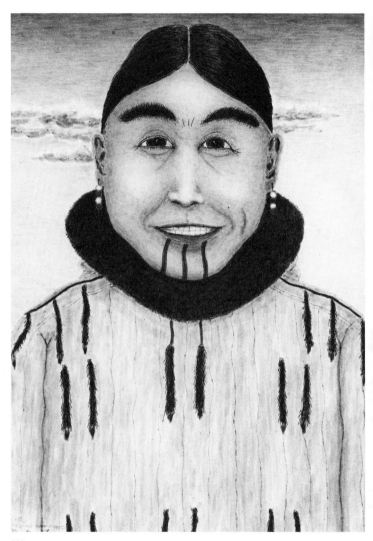

284

285

284 Portrait of a Siberian man, "Mr. Big Chief Navasuk," 1967, by Kivetoruk Moses. Dimensions: 12½ by 8¾ inches (31.3 by 21.8 cm.). Collection of D. J. Ray. This man's portrait and that of his wife (fig. 285) were painted by Kivetoruk especially for Alaska's centennial year in 1967. The story that accompanied the paintings, entitled "Navasuk, North East Cape Siberian Chief, 1909," was handwritten by his wife, Bessie Moses, George Ahgupuk's sister. It tells about Navasuk's long journeys to various parts of Alaska for trading, and his death in a snowslide as a result of the ministrations of a Siberian "witch doctor." (This story and the two paintings are discussed in Ray 1969, pp. 56, 62, and figs. 59, 60.)
Photograph courtesy Indian Arts and Crafts Board

285 Portrait of a Siberian woman, "Big Chief Wife Mrs. Navasuk," by Kivetoruk Moses, 1967. Collection of D. J. Ray.
Photograph courtesy Indian Arts and Crafts Board

286 "Eskimo Celebrating Dancer (at end of World War II)," by Kivetoruk Moses, about 1962. Collection IACB 63.5.1. Dimensions: 12³/₈ by 17½ inches (30.9 by 43.7 cm.). India ink and watercolor on paper. This is a faithful record of a celebration at Shishmaref.
Photograph courtesy Indian Arts and Crafts Board

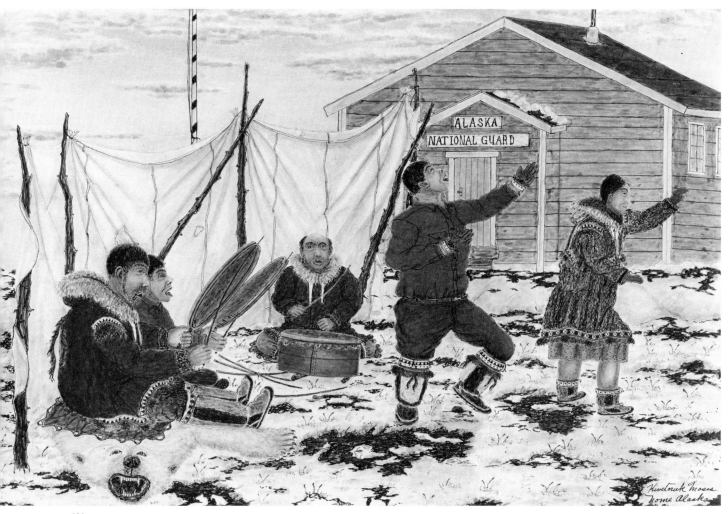

286

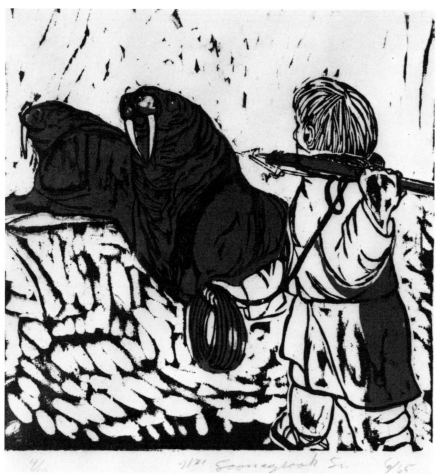

287

287 "Hunter and Walrus," a woodcut by William Soonagrook, Sr., 1965. This is another print that resulted from the MDTA program during 1964–65.
 Photograph courtesy Indian Arts and Crafts Board

288 "Wood-Skin Houses, King Island," etching and aquatint by Bernard T. Katexac, King Island, 1965. Dimensions: 14 by $9\frac{7}{8}$ inches (40 by 24.6 cm.). Collection IACB 65.56.
 Photograph courtesy Indian Arts and Crafts Board

289 "Model," an etching by Bernard T. Katexac, 1965. Dimensions: $7\frac{5}{8}$ by $8\frac{5}{8}$ inches (19 by 21.5 cm.). Collection IACB 65.99.37.
 Photograph courtesy Indian Arts and Crafts Board

256

288

289

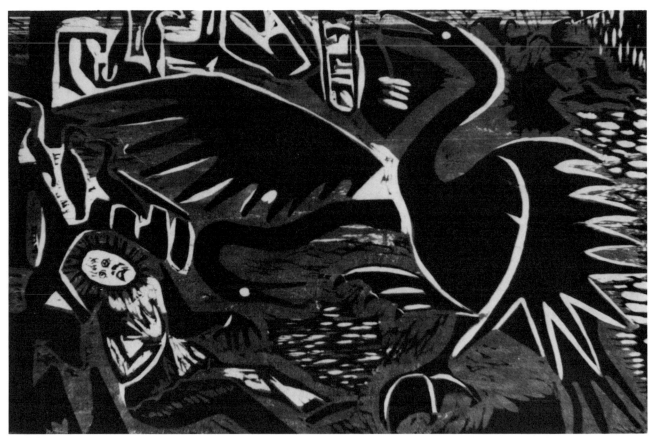

290

290 "Cormorant," by Peter J. Seeganna, woodcut in brown, black, and white, 1967. Dimensions: 15½ by 10¼ inches (38.7 by 25.6 cm.). Collection of D. J. Ray.

291 "Ting Myak Puk" (giant bird), by Joseph Senungetuk, woodcut in rust, green, black, and white, 1966. Dimensions: 21⅛ by 11¼ inches (52.8 by 28.1 cm.). Collection IACB 69.19.6.
 Photograph courtesy Indian Arts and Crafts Board

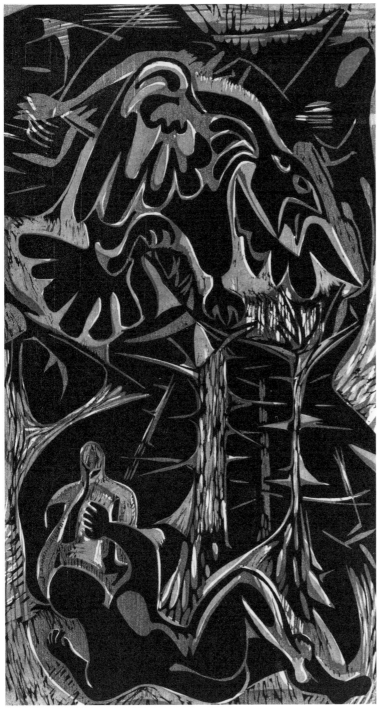

291

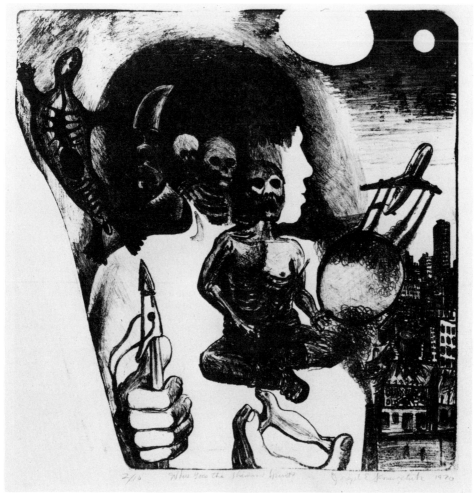

292

292 "Where Goes the Shaman's Spirit?" Lithograph by Joseph Senungetuk, 1970. Dimensions: 14¼ by 14¼ inches (53.6 cm.). This lithograph was entered in the Sixth Annual Festival of Native Arts in 1971 and was illustrated in the catalog as "Whither Thou Goest, Shaman."
 Photograph courtesy Indian Arts and Crafts Board

293 "Bird's Flight," lithograph by Joseph Senungetuk, 1968. Dimensions: 13 by 11¼ inches (32.5 by 28.1 cm.). Collection IACB 69.19.1. Other works by Senungetuk are illustrated in *Contemporary Alaska Native Art* 1971; Frederick 1972; Frost, ed. 1970; Ray 1967a and 1969; and *Smoke Signals* 1966.
 Photograph courtesy Indian Arts and Crafts Board

5/10 Birds Flight J. E. Senungetuk May 68

293

261

294

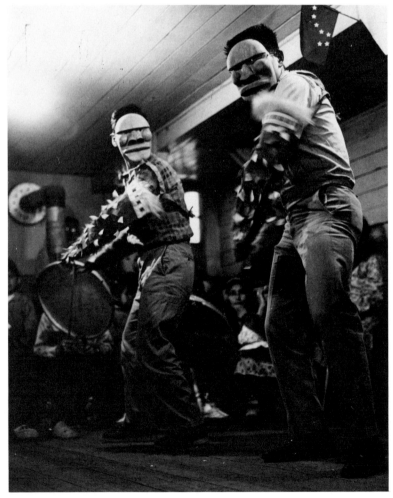

295

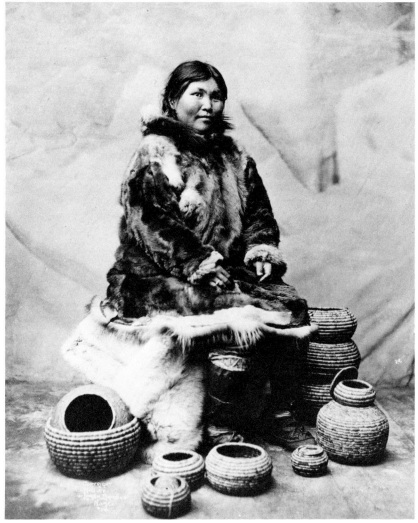

296

294 Andrew McCafferty making decoys of mud for brant goose hunting on Golovnin Lagoon, 1946. The decoys were interspersed with dead geese, propped up, to lure the huge flocks that thunder over the lagoon on their northward journey in June.

295 King Island dancers wearing the traditional good and bad shaman masks, Nome, 1964. The dancer on the left wears the ''bad'' shaman mask, and the one on the right, the ''good.'' The bad shaman is characterized by a thick hanging lower lip, and the good shaman by a thick upper lip. This dance was still performed for tourists by the King Islanders when I was in Nome in 1973. In this photograph the puffin beak mittens worn by dancers in figures 81, 144, and 145 are shown in action. It is apparent that fewer puffin beaks were used in the 1960s than in 1918.
 Photograph by Alaska Visitors Association, courtesy Bernard Katexac

296 A Lomen photograph of an Eskimo woman of Nome with coiled baskets, 1903. Northwest Collection, University of Washington. See also ''Basketry'' in Chapter II.

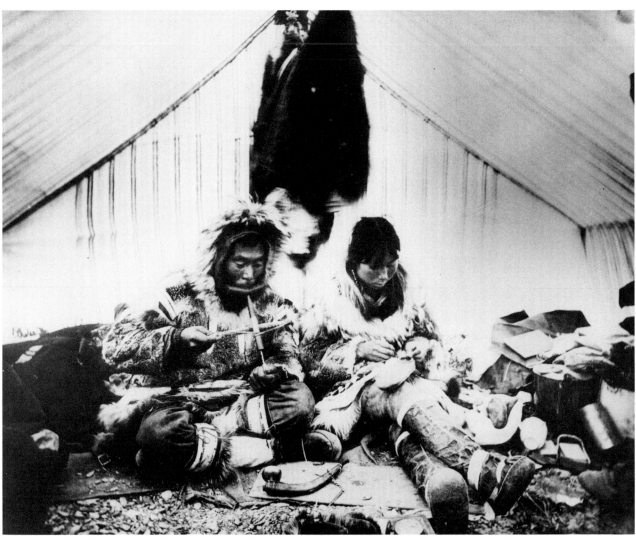

297

297 Port Clarence Eskimos making souvenirs, 1900. Photograph by Eric A. Hegg. Northwest Collection, University of Washington.

298 King Island Eskimos working at Nome under an overturned umiak, in the 1930s. Photograph by Jacobs, Nome

299 King Island men carving in their community building at King Island Village, Nome, 1955.

298

299

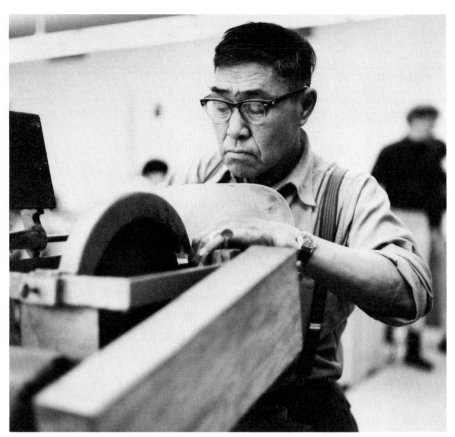

300

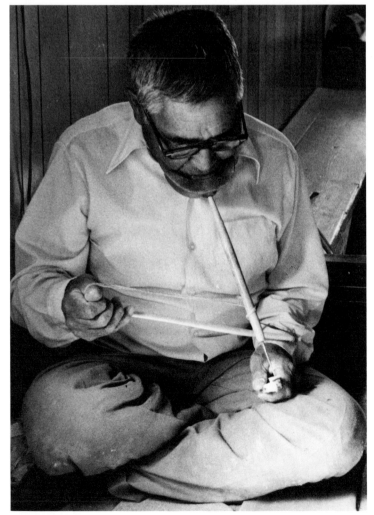

301

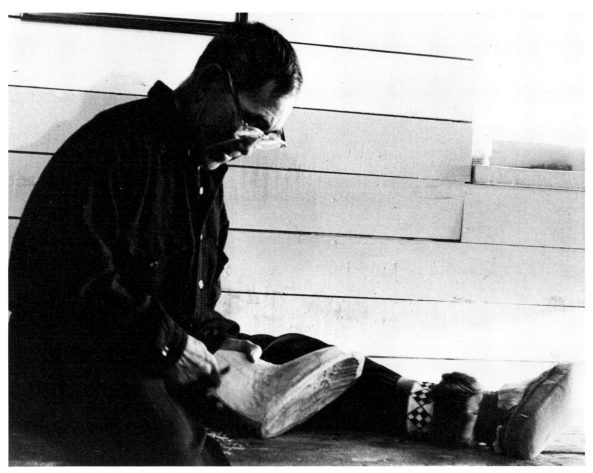

302

300 Aloysius Pikonganna, King Island, cutting jade on a diamond saw, 1965. Pikonganna was a participant in the MDTA Designer-Craftsman Training Project.
 Photograph courtesy Indian Arts and Crafts Board

301 In 1973 Aloysius Pikonganna demonstrated the bow drill, which is still an indispensable tool for the ivory carver.

302 Tony Pushruk, mask-maker, carves a crow mask, King Island Village, 1964.

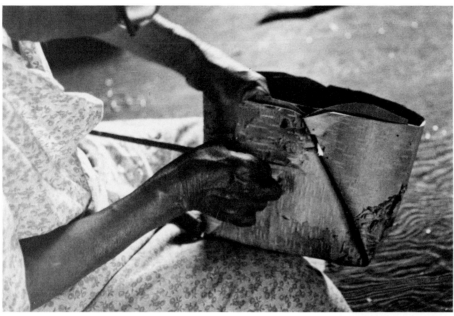

303

304

305

303 An Eskimo woman from Kobuk village puts a thin strip of willow root around a birchbark basket, 1961. A completed basket with the strip in place is illustrated in figure 219.

304 Emma Willoya twisting sinew for sewing parkas, Nome, 1955.

305 Margaret Johnsson sews in the same manner as her mother did in Unalakleet seventy years ago, including use of the ulu. Mrs. Johnsson was photographed in her present home in Edmonds, Washington, 1974.

306

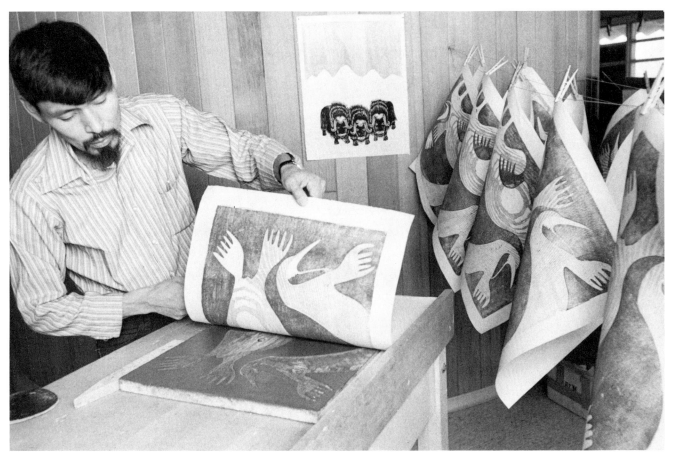

307

306 Florence Malewotkuk works on one of her drawings, Nome, 1965. Mrs. Malewotkuk was the only woman participant in the MDTA program of 1964–65.
 Photograph courtesy Indian Arts and Crafts Board

307 Peter J. Seeganna, photographed at work at the Visual Arts Center of Alaska, Anchorage, 1973.
 Photograph courtesy the Anchorage *Times*

Glossary of Special Terms

BALEEN. Glossy, hornlike slats on either side of the upper jaw of the bowhead whale. The approximately seven hundred slats are from six to twelve feet long, usually black, but occasionally white or greenish. Also called "whalebone."

BELUGA. The white whale, *Delphinapterus leucas* (Pallas).

CARIBOU. The wild reindeer.

CEREMONIAL HOUSE. A building and a community organization. Also known as men's house. Each dialect has its own pronunciation of the term: for example, *kazgi, kazigi, karigi, qalegi.* The term *kashim,* used for this structure by the Russians, is said to have been taken from Kodiak Island speech (Zagoskin 1967, p. 115).

DRIFTWOOD. Driftwood used in traditional art was almost exclusively spruce, but sometimes cottonwood or alder driftwood was used. Occasionally cottonwood, willow, or alder were obtained from some of the larger trees growing in the areas. In later years, hardwood, which was salvaged from derelict vessels or "found" around the villages, was used.

ENGRAVING. Incising with a knife or graver on ivory.

ETCHING. Local term to indicate engraving. True etching, with acid, is now done by Alaskan artists.

INUPIAK (pl. Inupiat). Northern Eskimos and language.

IVORY. *Elephant ivory* is sometimes imported for carving. *Mammoth ivory* from the tusks of the extinct woolly mammoth is used for small objects. It is usually a tan color, and the laminated circles are normally thick enough only for bracelet links. *Mastodon ivory* is very rare but is almost indistinguishable from mammoth. Both are crosshatched in cross section like elephant ivory. *Sperm whale tooth* is often imported from the south for carving. A sperm whale has from twenty to fifty teeth from four to ten inches long in the upper jaw. *Walrus tusks* are the main source of ivory for the Alaskan Eskimo; they also use the small round walrus teeth for such items as earrings and beads. An ivory tusk rarely exceeds thirty-six inches in length. The new white ivory is called "green" ivory; and ivory discolored by many years' burial in the sand and mineral deposits of the seashore is called "old" ivory or often erroneously, "fossil" ivory.

JADE. The variety called nephrite is found in Alaska near Shungnak on the Kobuk River.

KAZGI. *See* Ceremonial house

MALEMIUT. A term that referred to persons who came from the north to the Saint Michael area. Zagoskin said that it meant those who lived in blanket "yurts" or tents during their travels to the south. The breed of dog is spelled Malamute or Malemute.

MESSENGER FEAST. A trading festival, which also reinforced kinship and political ties. One village invited another to festivities, which lasted for about two weeks at the end of December.

REINDEER. The domesticated reindeer was first brought to Alaska from Siberia in 1892 to form the permanent herds. Before that, the skins of the reindeer were traded across the Bering Strait from Siberia to Alaska. The words reindeer or deer were often used in nineteenth-century writings when caribou was meant.

SPEAR THROWER. A wooden device into which a spear was fitted to extend its throwing distance.

ULU. A semilunar cutting utensil with a handle on the top, used by the Eskimo woman to cut many things from fish to furs.

UMELIK. Literally, "boat owner," this term has also been used to signify "chief" or "boat captain." It is rendered variously in English as, for example, *omalik* and *umealiq*.

UNALUK (pl. Unalit). Name for the language and people living on the coast between Golovnin Bay and Pastolik.

WHALEBONE. This term can refer to either the skeleton of the whale (long bones or vertebrae) or to the horny fibrous plates (baleen) in the whale's mouth.

YUPIK, YUKPIK. Name for the language and people living southward from Golovnin Bay to the Alaska Peninsula, especially during the early nineteenth century.

Acknowledgments

I AM GRATEFUL to many persons for their valuable assistance over the quarter of a century that I have been pursuing the study of Eskimo art. In my two books, *Artists of the Tundra and the Sea* and *Eskimo Masks,* I acknowledged their help, and since this present work is a culmination of all data that went into those publications, I again wish to extend my thanks.

For the present study, many persons should be singled out for support of my project and their help by supplying data, photographs, objects for photography, and hospitality: Penny K. Bateman, British Museum; Betty Bockstahler; John R. Bockstoce; Dennis R. Corrington, Arctic Trading Post Eskimo Museum, Nome; Marjorie Croil; Charles E. Derby; Robert A. Elder, Smithsonian Institution; Albert B. Elsasser, Lowie Museum, Berkeley; George W. Fedoroff and Myles Libhart, Indian Arts and Crafts Board; Ingeborg Handeland; Mrs. Ralph S. Hawley; Albert H. Heinrich, University of Calgary; Marie and Ray Heinrichs, Kobuk Valley Jade Shop, Kotzebue; Beverly Hendricks; Margo Howard, Kegoayah Kozga Public Library, Nome; Betty L. Hulbert, Alaska State Museum, Juneau; Mae and James P. Jacobson; Judy Johnson; Mabel Johnson, Kotzebue Museum; Margaret Johnsson; Doris and George R. Jones; Bernard Katexac; Harry Koozaata; Dinah Larsen, University of Alaska Museum; Frieda Larsen; Gerald McKay; James D. Nason, Washington State Museum; May Nock, Jewels of the North, Anchorage; Phyllis Nottingham, Alaska State Library, Juneau; Rosie Omelak; Aloysius Pikonganna; Lucy and John Poling; Josephine L. Reader; Elizabeth E. Reed, Visual Arts Center of Alaska; Edward S. Rogers, Royal Ontario Museum; Jane Schuldberg; Peter J. Seeganna; Ronald W. Senungetuk, University of Alaska; Erna V. Siebert, Institute of Ethnography, Leningrad; Glen C. Simpson, University of Alaska; Frances K. Smith, Agnes Etherington Art Centre, Kingston, Ontario; Henry D. Tiffany III, Alaska Native Arts and Crafts Cooperative Association, Inc.; Clara and Paul Tiulana; Ruth Towner; James W. VanStone, Field Museum; Mabel and Joseph E. Walsh; Frank Whaley; Emma Willoya; and Mary Pat Wyatt, Anchorage Historical and Fine Arts Museum.

I am especially grateful to Alfred A. Blaker for his help in photographic matters; to Mabel and David Johnson, Caroline McLain Reader, and Rachel and Robert P. Simmet for their warm hospitality during the summer of 1973; and to Verne F. Ray for reading the manuscript.

NOTE: In 1976 after this book was already in page proofs I visited Nome and Anchorage again. Both Milligrock's Ivory Shop and Sunarit Associates Cooperative had closed, and the destructive storm of 12 November 1974 had destroyed the King Island Village community house. The Tiulanas no longer had their shop in Anchorage, but were working in their home (see pp. 40–41).

Bibliography

THIS BIBLIOGRAPHY consists of a few selected articles and books on special topics in addition to references used in the text. It is not a comprehensive listing of publications on either Alaskan Eskimo art or general Eskimo art. Should a reader wish to pursue a topic further, several other publications have excellent bibliographies: Martijn 1964; Swinton 1972; and the *Beaver* special art issue, 1967. The *Arctic Bibliography* (Arctic Institute of North America, 15 volumes) has numerous references listed according to geographical area. Both the *Beaver* (Winnipeg) and *North* (Ottawa) devote space periodically to Canadian Eskimo arts, as do *Alaska* and the *Alaska Journal* to Alaskan arts.

Ackerman, Robert E.
 1967 "Prehistoric Art of the Western Eskimo." *The Beaver* (Autumn), pp. 67–71.

Adams, Ralph T.
 1966 "Sailing North for Whalebone." *Alaska Sportsman* 32 (no. 7):10–13.

Ahgupuk, George
 1953 *18 Reproductions of Paintings by . . . George Ahgupuk.* Seattle, Wash.: Deers Press.

Alaska Monthly magazine published in Anchorage, Alaska.

Alaska Journal staff
 1971 "More Native Art." *The Alaska Journal* 1 (no. 4):31–34. Photographs by Richard W. Montague. (Color photographs of the 1969 entries in the Alaska Festival of Native Arts. Sixteen of the twenty-eight entries are by Eskimos.)
 1975 "Kotzebue School Art." *The Alaska Journal* 5 (no. 2):89–103. Color photographs by Richard W. Montague. (Report about Paul Forrer's art instruction at Kotzebue.)

Aldrich, Herbert L.
 1889 *Arctic Alaska and Siberia, or, Eight Months with the Arctic Whalemen.* Chicago and New York: Rand, McNally and Co.

Anchorage Historical and Fine Arts Museum
 1972 *An Introduction to the Native Art of Alaska.* Anchorage: Anchorage Historical and Fine Arts Museum, Department of Parks and Recreation, and the City of Anchorage.

Anonymous
 1958 "Kokogiak, Legendary Monster of the Ice Floes." *Alaska Sportsman* (November), pp. 1, 43.

Anonymous
 1973 "Confessions of an Alaskan Collector." *The Alaska Journal* 3 (no. 3):153–60 and cover. (Thirty-seven photographs in color of contemporary ivory objects.)

Antropova, V. V.
 1953 "Sovremennaia chukotskaia i eskimosskaia reznaia kost" [Ivory carving of the present-day Chukchi and Eskimo]. *Sbornik Muzeia antropologii i etnografii* (Akademiia Nauk) 15:5–96; 20 plates. (About 150 objects illustrated of a total collection of 352, which were made in a workshop in Uelen between 1945 and 1949. Many are walrus ivory tusks engraved with scenes of traditional and contemporary northern life. Other objects include animal sculptures, paper knives, napkin rings, and three billikens.)

Atamian, Sarkis
 1966 "The Anaktuvuk Mask and Cultural Innovation." *Science* 151 (no. 3716): 1337–45.

The Beaver
 1967 Eskimo art issue, Autumn, Outfit 298. (Contains comprehensive bibliography and articles by numerous writers. *See* Ackerman; Gimpel; Martijn; Meldgaard; D. Ray; Taylor and Swinton; and Vastokas.)

Beechey, Frederick W.
 1831 *Narrative of a Voyage to the Pacific and Beering's Strait.* 2 vols. London: Henry Colburn and Richard Bentley.

Bernardi, Suzanne R.
 1912 "Whaling with Eskimos of Cape Prince of Wales." *The Courier Journal* (Louisville, Ky.), issue of 20 October, pp. 1, 2.

Blaker, Alfred A. *See* Ray, Dorothy Jean, and Alfred A. Blaker

Bockstoce, John R.
 n.d. *The Beechey and Belcher Collections.* Anthropological Papers of the Pitt Rivers Museum, vol. 1. Oxford, Eng. (in prep.).

Bogoras, Vladimir G.
 1904–9 *The Chukchee.* Memoirs of the American Museum of Natural History. Vol. 11, pt. 1: *Material Culture* (1904); vol. 11, pt. 2: *Religion* (1907); vol. 11, pt. 3: *Social Organization* (1909).

Bronson, William
 1970 "Eskimo." *The American West* (July), pp. 34–47.

Brower, Charles D.
 1942 *Fifty Years Below Zero.* New York: Dodd, Mead and Co.

Burch, Ernest S., Jr.
 1971 "The Nonempirical Environment of the Arctic Alaskan Eskimos." *Southwestern Journal of Anthropology* 27 (no. 2):148–65.

Burkher, Howard H. and Pauline V.
 1954 "Behind Baleen Baskets." *Smoke Signals,* no. 10 (February), pp. 13–15.

Burland, Cottie
 1973 *Eskimo Art.* New York: Hamlyn. (The photographs are interesting, but the text is unreliable and full of errors.)

Burrus, Don
 1953 "The Alaska Native Arts & Crafts Clearing House." *Smoke Signals,* no. 6 (February), pp. 7–11.

Cammann, Schuyler
 1954 "Carvings in Walrus Ivory." *Bulletin,* University Museum, University of Pennsylvania, 18 (no. 3):3–31. (Historical, world-wide survey of uses of walrus ivory.)

Carpenter, Edmund
 1973 *Eskimo Realities.* New York, Chicago, San Francisco: Holt, Rinehart and Winston.

Chard, Chester
 1960 "First Iron Artifact from the Old Bering Sea Culture." *Anthropological Papers of the University of Alaska* 9 (no. 1):57.

Choris, Ludovik
 1822 *Voyage pittoresque autour du monde.* Paris.

Cline, Michael S.
 1969 "Anaktuvuk Masks." *Alaska Sportsman* 35 (no. 4):32–33.

Cochrane, John D.
 1824 *Narrative of a Pedestrian Journey through Russia and Siberian Tartary . . . 1820, 1821, 1822, and 1823.* London: John Murray.

Collins, Henry B.
 1929 *Prehistoric Art of the Alaskan Eskimo.* Smithsonian Miscellaneous Collections, vol. 81, no. 4.
 1959 "An Okvik Artifact from Southwest Alaska and Stylistic Resemblances between Early Eskimo and Paleolithic Art." *Polar Notes,* no. 1, pp. 13–27.
 1962 "Eskimo Cultures." *Encyclopedia of World Art,* vol. 5, pp. 1–27 and pls. 1–12. New York: McGraw Hill.

Contemporary Alaska Native Art
 1971 University of Alaska, Fairbanks. Catalog, Festival of the Arts, Spring.

Curtis, Edward S.
 1930 *The North American Indian.* Vol. 20. Chicago.

DeWitt, Esther T.
 1971 "Melvin Olanna." *The Alaska Journal* 1 (no. 4):35–37.

Digby, Adrian
 1935 "An Eskimo Harpoon Rest from Alaska." *Man* 35 (April):49–50 and pl. D.
 1936–37 "An Ivory Arrow-straightener from Alaska." *British Museum Quarterly* 11:12, 13–15.

Dirlam, Peter Brackett
 1967 "Arctic Ivory and Its Working." *Polar Notes,* no. 7, pp. 29–36. (Short section describing steps in engraving walrus ivory and sperm whale teeth.)

Douglas, Frederic H.
 1955 "Influences on Indian Art." *Smoke Signals,* no. 15, pp. 5–8.

Edmonds, H. M. W. *See* Ray 1966a.

Ernst and Ernst, Management Services Division
 1967 *Alaska Native Arts and Crafts Cooperative Association, Inc.: A Recommended Program for Alaskan Native Handcraft Development.* Seattle, Wash.

The Eskimo Bulletin
 1898, 1902 Annual newspaper published at Wales, Alaska, by the teachers.

Eyman, Frances. *See* Witthoft, John, and Frances Eyman

Fagg, William, ed.
1972 *Eskimo Art in the British Museum.* London: British Museum. (Plate 3 is probably not Eskimo.)

The Far North. See National Gallery of Art

Firm, Jo Ann
1972 "Parkas." *Alaska* 38 (no. 11):42–50. (Survey of contemporary parkas with thirty-seven photographs in color and five in black and white.)

Flayderman, E. Norman
1972 *Scrimshaw and Scrimshanders.* Edited by R. L. Wilson. New Milford, Conn.: N. Flayderman and Co.

Frederick, Saradell Ard
1972 "Alaskan Eskimo Art Today." *The Alaska Journal* 2 (no. 4):30–41 and cover.

Frost, O. W., ed.
1970 *Cross-Cultural Arts in Alaska.* Anchorage: Alaska Methodist University Press.

Geist, Otto William, and Froelich G. Rainey
1936 *Archaeological Excavations at Kukulik, St. Lawrence Island, Alaska.* Washington, D.C.: U.S. Government Printing Office.

Giddings, James Louis
1964 *The Archeology of Cape Denbigh.* Providence, R.I.: Brown University Press.
1967 *Ancient Men of the Arctic.* New York: Alfred A. Knopf.

Gimpel, Charles
1967 "A Collector's View." *The Beaver* (Autumn), pp. 72–75.

Graburn, Nelson
1967 "The Eskimos and 'Airport Art,'" *Trans-action, Social Science and Modern Society* (October), pp. 28–33.

Harkey, Julius M.
1959 "The Shishmaref Horn Doll." *Alaska Sportsman* 25 (no. 8):24–25.

Hatt, Gudmund
1969 "Arctic Skin Clothing in Eurasia and America: An Ethnographic Study." Translated from the Danish by Kirsten Taylor. *Arctic Anthropology* 5 (no. 2): 3–132.

Heinrich, Albert
1950 "Some Present-Day Acculturative Innovations in a Nonliterate Society." *American Anthropologist* 52 (no. 2):235–42. (Changes in ivory carving on Little Diomede Island.)

Hill, Anne
1960 "The Secret of the Eskimo Waterproof Boot." Alaska Sportsman 26 (no. 10): 14–15, 58.

Himmelheber, Hans
1953 *Eskimokünstler.* 2nd ed. Eisenach, Germany: Erich Röth-Verlag.

Hoffman, Walter James
1897 "The Graphic Art of the Eskimos." *USNM Annual Report for 1895,* pp. 739–968. Washington, D.C.: U.S. Government Printing Office.

Holtved, Erik
1947 *Eskimokunst.* Copenhagen: O. Testmans Bogtrykkeri. (General discussion of Eskimo art in Danish with short English summary. Most illustrations are from Greenland.)

Hooper, C. L.
1884 "Report of the Cruise of the U.S. Revenue Steamer *Thomas Corwin,* in the Arctic Ocean, 1881." 48 Cong.: 1 session, Sen. Ex. Doc. 204 (serial 2169), Washington, D.C.

Hooper, William H.
1853 *Ten Months among the Tents of the Tuski.* London: John Murray.

Institute of Alaskan Native Arts Committee
1975 *Report of the Institute of Alaskan Native Arts.* Committee on a Study of the Proposed Development of an Educational Institution for: Native Cultures in the State of Alaska. Fairbanks: Eskimo, Indian, Aleut Printing Company.

An Introduction to the Native Art of Alaska. See Anchorage Historical and Fine Arts Museum

Israel, Heinz
1961 "Bemerkungen zu einigen verzierten Walross-zähnen aus Südwest-Alaska." *Beiträge zur Völkerforschung, Museums für Völkerkunde zu Leipzig* 11:303–12, pls. 65–70.
1971 "Beinschnitzerei der Eskimo." *Abhandlungen und Berichte des Staatlichen Museums für Völkerkunde Dresden* 33:113–39 and pls. 1–46. (Information about contemporary ivory carvings from Greenland, Labrador, and southwest Alaska, many collected by Moravian missionaries.)

Ivanov, S. V.
1949 "Chukotsko-eskimosskaia graviura na kosti" [Chukchi–Eskimo engraving in bone]. *Sovetskaia etnografiia,* no. 4, pp. 107–24.
1974 See Kaplan, N., comp., and S. Ivanov, ed.

Jacobi, A.
1937 "Carl Heinrich Mercks Ethnographische Beobachtungen über die Völker des Beringsmeers 1789–91." *Baessler-Archiv* 20 (pt. 3–4):113–37.

Jacobsen, Johan Adrian
1884 *Capitain Jacobsen's Reise an der Nordwest-küste Amerikas, 1881–1883.* Edited by A. Woldt. Leipzig.

Kaplan, N., comp., and S. Ivanov, ed.
1974 *In the Land of the Reindeer: Applied Art in the North of the Soviet Union.* Leningrad: Aurora Art Publishers.

Katituat
Irregularly published newsletter of the Norton Sound Health Corporation, Nome.

Keithahn, Edward L.
1945 *Igloo Tales.* Illustrated by George Aden Ahgupuk. Lawrence, Kans. United States Indian Service, Education Division, Haskell Institute. Reprint. Anchorage: Alaska Northwest Publishing Co., 1974.

Koranda, Lorraine D.
1964 *Some Traditional Songs of the Alaskan Eskimos.* Anthropological Papers of the University of Alaska, vol. 12, no. 1, pp. 17–32 (messenger feast songs, and others).

Lantis, Margaret
1947 *Alaskan Eskimo Ceremonialism.* The American Ethnological Society, Monograph 11. Reprint. Seattle: University of Washington Press, 1966.
1950 "Mme. Eskimo Proves Herself an Artist." *Natural History* 59 (no. 2):68–71 (Nunivak Island basketry).

Larsen, Dinah W.

 [1974] *Eskimo Dolls in the Collection of the University of Alaska Museum.* Poster-pamphlet.

Lucier, Charles V.

 See VanStone, James W., and Charles V. Lucier

McCartney, A. P., and D. J. Mack

 1973 "Iron Utilization by Thule Eskimos of Central Canada." *American Antiquity* 38 (no. 8):328–39.

Mack, D. J. See McCartney, A. P., and D. J. Mack

Martijn, Charles A.

 1964 "Canadian Eskimo Carving in Historical Perspective." *Anthropos* 59:546–96. (Overview summary of all archeological art, and basic reference for Canadian art. Exhaustive bibliography of all Eskimo art.)

 1967 "A Retrospective Glance at Canadian Eskimo Carving." *The Beaver* (Autumn), pp. 5–19.

Mason, J. Alden

 1927 "Eskimo Pictorial Art." *The Museum Journal,* University of Pennsylvania 18 (no. 3):248–83.

Mason, Otis T.

 1904 *Aboriginal American Basketry.* USNM publication no. 128. Washington, D.C.: U.S. Government Printing Office.

Matthews, Mildred

 1973 "Florence Lives." *Alaska* 39 (no. 10):20–21, 59–61. (About Florence Malewotkuk; contains errors, some of which were corrected by Mrs. Margaret E. Murie in *Alaska* 39 (no. 12) [1973]:17.)

Meldgaard, Jørgen

 1960 *Eskimo Sculpture.* London: Methuen and Co. (Plate 50, "Smiling Buddha" is a billiken; plate 36, from "Norton Sound," is Chugach; similarly illustrated in Rainey 1959.)

 1967 "Traditional Sculpture in Greenland." *The Beaver* (Autumn), pp. 54–59.

Merck, Carl H. *See* Jacobi, A.

Miles, Charles

 1962 *Indian & Eskimo Artifacts of North America.* New York: Bonanza Books.

Morgan, Lael

 1974 "A Powerful Spring in the Arctic." *Alaska* 40 (no. 10):33–39, 54–55. (Photographs in color of several persons whose work is mentioned or illustrated here: Robert James, Elija Kakinya, George Omnik, Simon Paneak, Howard Rock, and John Tingook.)

 1975 "Rock, the Artist." *The Alaska Journal* 5 (no. 1):25–31.

Mozee, Yvonne

 1975 "George Ahgupuk." *The Alaska Journal* 5 (no. 3):140–43.

 1976 "Robert Mayokok." *The Alaska Journal* 6 (no. 4): 242–49.

Murdoch, John

 1892 "Ethnological Results of the Point Barrow Expedition." *Ninth Annual Report of the Bureau of Ethnology,* pages 1–441. Washington, D.C.

National Gallery of Art

 1973 *The Far North: 2000 years of American Eskimo and Indian Art,* Washington, D.C.

Nelson, Edward William
 1899 *The Eskimo about Bering Strait.* Bureau of American Ethnology report, vol. 18,
 pt. 1. Washington, D.C.

New, Lloyd
 1968 "Institute of American Indian Arts: Cultural Difference as the Basis for Creative
 Education." Native American Arts 1. Washington, D.C.: Indian Arts and
 Crafts Board.

Nordenskiöld, A. E.
 1882 *The Voyage of the Vega round Asia and Europe.* Translated by Alexander
 Leslie. New York: Macmillan (one-volume edition).

Oquilluk, William A.
 1973 *People of Kauwerak: Legends of the Northern Eskimo.* With the assistance of
 Laurel L. Bland. Anchorage: Alaska Methodist University Press.

Orchard, William C.
 1916 *The Technique of Porcupine-Quill Decoration among the North American
 Indians.* New York: The Museum of the American Indian, Heye Foundation.
 Contributions, vol. 4, no. 1.

Orlova, E. P.
 1964 *Chukotskaia, Koriakskaia, Eskimosskaia, Aleutskaia reznaia kost* [Ivory carving
 of the Chukchi, Koryak, Eskimo, Aleut]. Novosibirsk: Akademia Nauk,
 SSSR, Sibirskoe Otdelenie.

Osgood, Cornelius
 1940 *Ingalik Material Culture.* Yale University Publications in Anthropology no.
 22. New Haven, Conn. Yale University Press.

Oswalt, Wendell H.
 1953 "Recent Pottery from the Bering Strait Region." *Anthropological Papers of the
 University of Alaska* 2 (no. 1):5–18.
 1957 "A New Collection of Old Bering Sea I Artifacts." *Anthropological Papers of
 the University of Alaska* 5 (no. 2):91–96.
 1967 *Alaskan Eskimos.* San Francisco, Calif.: Chandler Publishing Co.

Petroff, Ivan
 1884 *Report on the Population, Industries, and Resources of Alaska.* In U.S. Tenth
 Census, Census Office. Washington, D.C.: U.S. Government Printing Office.

Porter, Robert B.
 1893 *Report on Population and Resources of Alaska.* Eleventh Census, 1890.
 Washington, D.C.: U.S. Government Printing Office.

Rainey, Froelich G.
 1936 *See* Geist, Otto William, and Froelich G. Rainey
 1947 *The Whale Hunters of Tigara.* Anthropological Papers of the American
 Museum of Natural History, vol. 41, pt. 2. New York.
 1959 "The Vanishing Art of the Arctic." *Expedition* 1 (no. 2):3–13.

Rasmussen, Knud
 1927 *Across Arctic America.* New York and London: G. P. Putnam's Sons.
 1932 *The Eagle's Gift.* New York: Doubleday, Doran and Co.
 1952 *The Alaskan Eskimos.* Report of the Fifth Thule Expedition, 1921–24, vol. 10,
 no. 3, edited by H. Ostermann. Copenhagen: Gyldendalske Boghandel,
 Nordisk Forlag.

Ray, Dorothy Jean
1959 "The Eskimo Raincoat." *Alaska Sportsman* 25 (no. 11):13, 44.
1960 "Skins against the Weather." *Alaska Sportsman* 26 (no. 1):26–27, 36–38.
1961 *Artists of the Tundra and the Sea.* Seattle: University of Washington Press.
1965 "Birch Bark Baskets of the Kobuk Eskimos." *Alaska Sportsman* 31 (no. 3):15–17.
1966a "The Eskimo of St. Michael and Vicinity as Related by H. M. W. Edmonds (editor)." *Anthropological Papers of the University of Alaska* 13 (no. 2).
1966b "Eskimo Sculpture as Art." *Journal of Canadian Studies* 1 (no. 1):59–64. (Review article of George Swinton's *Eskimo Sculpture.*)
1966c "Pictographs near Bering Strait, Alaska." *Polar Notes* 6:35–40.
1967a "Alaskan Eskimo Arts and Crafts." *The Beaver* (Autumn), pp. 80–91.
1967b "Rock Paintings on the Tuksuk." *Alaska Sportsman* 33 (no. 8):31–34. (Photographs in color of pictographs, Ray 1966c.)
1969 *Graphic Arts of the Alaskan Eskimo.* Native American Arts 2. Washington, D.C.: Indian Arts and Crafts Board.
1971a "The Bible in Picture Writing." *The Beaver* (Autumn), pp. 20–24.
1971b "Kakarook, Eskimo Artist." *The Alaska Journal* 1 (no. 1):8–15 and cover. (Nine of Kakarook's crayon and ink drawings from his notebooks in the Smithsonian Institution.)
1972 "Eskimo Sculpture." *American Indian Art: Form and Tradition.* Catalog and collection of essays presented for an exhibition of Indian art by the Walker Art Center and the Minneapolis Institute of Arts, 22 October–31 December 1972.
1974a "The Billiken." *The Alaska Journal* 4 (no. 1):25–31.
1974b "The Omilak Silver Mine." *The Alaska Journal* 4 (no. 3):142–48.
1975 *The Eskimos of Bering Strait, 1650–1898.* Seattle and London: University of Washington Press.

Ray, Dorothy Jean, and Alfred A. Blaker
1967 *Eskimo Masks: Art and Ceremony.* Seattle and London: University of Washington Press. Paperback edition, 1975.

Ray, Patrick Henry
1885 *Report of the International Polar Expedition to Point Barrow, Alaska.* Washington, D.C.: U.S. Government Printing Office.

Rearden, Jim
1969 "Alaska's Walrus Ivory Artists." *Alaska Sportsman* 35 (no. 6):10–11. (Romeo Katexac and Paul Nattanguk.)
1973 "The Federal Marine Mammal Act of 1972." *Alaska* 39 (no. 6):9–13, 51, 53–56.

Rock, Howard
1974 "Arctic Survival—the Parka." *Tundra Times,* issue of 27 February; originally published 21 January 1964.

Seveck, Chester Asakak
1973 *Longest Reindeer Herder.* Fairbanks, Alaska: Rainbow Ventures.

Smoke Signals
1951–68 Published by the Indian Arts and Crafts Board. (Fall-winter 1966 is devoted to recent Alaskan art.)

Société des Amis du Musée de l'Homme, Paris
1969 *Masterpieces of Indian and Eskimo Art from Canada* (catalog to exhibition, Paris, March–September 1969; Ottawa, November 1969–January 1970).

Spencer, Robert F.
1959 *The North Alaskan Eskimo* Bureau of American Ethnology Bulletin 171. Washington, D.C.: U.S. Government Printing Office.

Stirling, Matthew W.
 1968 "Aboriginal Jade Use in the New World." 37th Congreso Internacional de
 Americanistas (1966), *Acta y Memorias*, vol. 4, pp. 19–28.

Swinton, George
 1958 "Eskimo Carving Today." *The Beaver* (Spring), pp. 40–47.
 1965 *Eskimo Sculpture*. Toronto and Montreal: McClelland and Stewart.
 1967 *See* Taylor, William E., Jr., and George Swinton
 1972 *Sculpture of the Eskimo*. Toronto: McClelland and Stewart.

Taylor, William E., Jr., and George Swinton
 1967 "Prehistoric Dorset Art." *The Beaver* (Autumn), pp. 32–47.

Thornton, Harrison R.
 1931 *Among the Eskimos of Wales, Alaska*. Baltimore, Md.: The Johns Hopkins
 Press.

Tundra Times
 1962–75 Weekly newspaper published by Eskimo, Indian, Aleut Publishing Co., Inc.,
 Fairbanks, Alaska.

VanStone, James W.
 1953 "Carved Human Figures from St. Lawrence Island, Alaska." *Anthropological
 Papers of the University of Alaska* 2 (no. 1):19–29.
 1960 "An Early Nineteenth-Century Artist in Alaska." *Pacific Northwest Quarterly*
 51 (no. 4):145–58.
 1963 "A Carved Mammoth Tusk from Alaska." *Annual* (1962), Art and Archaeology
 Division, The Royal Ontario Museum, University of Toronto, pp. 69–73,
 123–24.
 1967 "Eskimo Whaling Charms." *Bulletin*, Field Museum of Natural History 38
 (no. 11):6–8.
 1968/69 "Masks of the Point Hope Eskimo." *Anthropos* 63/64:828–40.

VanStone, James W., and Charles V. Lucier
 1974 "An Early Archaeological Example of Tattooing from Northwestern Alaska."
 Fieldiana (Anthropology), Field Museum, vol. 66, no. 1.

Van Valin, William B.
 1944 *Eskimoland Speaks*. Caldwell, Ida.: Caxton Printers.

Vastokas, Joan M.
 1967 "The Relation of Form to Iconography in Eskimo Masks." *The Beaver* (Au-
 tumn), pp. 26–31.

Weyer, Edward Moffat
 1932 *The Eskimos*. New Haven, Conn.: Yale University Press. Reprint. Hamden,
 Conn.: Archon Books, 1962.

Wilkinson, Paul F.
 1971 "Musk Ox, Misunderstood Animal." *Tundra Times,* five-part article in the
 8, 15, 22, 29 September and 6 October issues.

Wingert, Paul S.
 1949 *American Indian Sculpture*. New York: J. J. Augustin.

Witthoft, John, and Frances Eyman
 1969 "Metallurgy of the Tlingit, Dene, and Eskimo." *Expedition* 11 (no. 3):12–23.

Zagoskin, Lavrentii A.
 1967 *Lieutenant Zagoskin's Travels in Russian America 1842–1844*. Edited by
 Henry N. Michael. Translated by Penelope Rainey. Arctic Institute of North
 America. Anthropology of the North: Translations from Russian Sources, no. 7
 (1956 Russian edition). Toronto: University of Toronto Press.

Index

The names of collectors, museums, and photographers, with a few exceptions, have not been indexed. Where an entry about an object states "illustrated," the page number refers to the catalog text, and the object will be found on that, or the opposite, page.

of Visual Arts Center, 67; mentioned, 63. *See also* Block prints
Programs: in art, 40, 41, 54, 55–63. *See also* Manpower Development and Training Act
Provenience: of objects, discussed, ix
Ptarmigan quill work, 33–34; illustrated, 200, 201
Puffins: in ivory, illustrated, 145, 149; in engravings, illustrated, 244
Pullock, Teddy, 60, 62, 176
Punuk period, 6
Puppets, 11, 13, 15–16, 22
Purse: of sealskin, illustrated, 204. *See also* Bags
Pushruk, Tony, 39, 160, 167, 176, 267

Qalegi. See Ceremonial house
Qiviut, 63
Qologogoloq (sacred figures), 14
Quileute Indians, 167
Quill belt. *See* Ptarmigan quill work

Rabbits: in ivory, illustrated, 156
Rabbit skins, vii
Rainey, Froelich, 14, 15
Rapid City, S.D., 55
Rasmusson, Knud, 12, 15–16
Rattlesnake, 30, 220
Ray, Patrick Henry, 19, 73, 85–89 passim, 165
Realism: in Alaskan Eskimo art, 66
Rearden, Jim, 40n
Reel: illustrated, 107
Reindeer: in ivory, illustrated, 189; as woodcut subject, 246; as drawing subject, 250; explained, 274
Reindeer fair, 166
Reindeer herding: in engraving, illustrated, 238
Reindeer hoof: objects of, 191; —illustrated, 187, 189. *See also* Caribou hoof
Reindeer-horn doll. *See* Horn doll
Reindeer skins: in trade and clothing, 31–35 passim
Religion: of Eskimos, 5, 42–43; objects made for, 9, 10, 18, 66. *See also* Whaling: ceremonies for
Repetition: as motif, discussed, 91
Replicas, 43, 48, 66
Rochester, N.Y., 61
Rock, Howard, 56
Rockefeller Foundation, 62
Rock paintings. *See* Pictographs
Rocky Point, 43
Rogers, Edward S., 44n
Rogers and Post memorial: in ivory, 49
Rookery: illustrated, 100
"Rookery" (block print): illustrated, 244
Royal Ethnological Museum of Berlin, 14
Royal Ontario Museum, 44n
Rural Alaska Community Action Program, 63
Russian explorers, 112
Russian Mission, 234
Russians: as subject matter, 216

Sage, Oscar, 156, 182
Saint Lawrence Island: art tradition of, 4; dolls of, 10, 17; tattooing of, 22n, 23; and geometric ornamentation, 24; and pipes, 28, 211; traditional wood and ivory carving of, 29, 41, 45, 46, 47, 51, 168; clothing of, 31, 32, 198; amulets of, 77; ivory birds from, 98; contemporary objects from, 129–32, 135, 136, 138,

140, 141, 142, 145, 147, 151, 152, 161, 178, 187, 204, 211; mentioned, 3, 60, 83, 120
Saint Michael: establishment of, viii; trade at, ix; art tradition of, 4; souvenir industry in, 7, 27, 28, 58, 108, 222; wood objects from, 12, 13, 18, 83, 99, 163, 164, 173, 175; bladder festival at, 15; and ivory pipes, 21, 27; and Guy Kakarook, 43, 44; handles from, 91, 107; ivory objects from, 108, 215, 222, 224, 229, 231, 232, 233; bone objects from, 158, 222; as engraving and watercolor subject, illustrated, 234; mentioned, 6, 22, 24, 31, 36, 46, 55
Saint Paul Island, 236
Salmon skins: in clothing, 31
Salon of Alaskan Artists, 63
Salt and pepper shakers: illustrated, 149, 151
San Francisco, Calif., 15, 27, 44
Santa Claus boot, 54
Santa Fe, N.M., 61
Savok, Lily, 53, 248
Savoonga, 41, 50, 132, 138, 152, 211
Schools: arts programs in, 40, 54, 55, 61, 62–63
Scrimshaw, 44
"Scripture writing," 53, 248
Seals: as a basic animal, 5; in ivory, 38, 46, 48; in nephrite and caribou hoof, 57, 191; illustrated, 81, 98, 100, 102, 103, 105, 108, 114, 138, 141, 152, 206; in sculpture, 83; as art motif, 91; on letter openers, 160; as wood bowl, illustrated, 176; as earrings, illustrated, 191. *See also* Bearded seal
Sealskin: in clothing, 31, 33, 35; float, plug for, 94
Seated figurines, 10, 114, 163, 168
Seattle, Wash., 38, 44, 68n, 127, 134, 206, 236
Seeganna, Louis, 180
Seeganna, Peter J., 66, 68–69, 259, 271
Seeganna, Richard, 171
Sekokuluk, Paul, 166
Senungetuk, Joseph, 259
Senungetuk, Ronald, 61, 191
Seveck, Chester, 195
Seveck, Helen, 195
Seward Peninsula, viii, ix, 7, 10, 16, 23, 31, 232, 233
Seward Skill Center, 42
Sewing, 5, 9, 10, 60; discussed, 30–36; implements used for, 32; on King Island, 41; in contemporary times, discussed, 51–55; projects for, 63; in traditional times, 64. *See also* Bags; Clothing; Footwear; Gut parka; Mukluks; Parkas; Sealskin; Skin
Shaktoolik, 49, 211, 231
Shamanistic scenes: in engravings, illustrated, 78, 229
Shaman masks. *See* Bad shaman mask; Good and bad shaman masks
Shamans: role and performances of, 5, 6, 12, 14; female, 9; objects used by, 11, 12, 13–15, 17, 84, 120, 126; and whaling ceremonies, 23, 34; at Point Hope, 29; and clothing, 35, 36; last one of Bering Strait, 66; as artists, 66; of Saint Lawrence Island, 168
Sheldon, Raven, 195
Sheldon Jackson Museum, 12
Shields, [Walter], 11
Ship models: illustrated, 142
Ships: in engravings, 215
Shishmaref: and mermaids, 21, 252; and ivory jewelry, 47, 248; sewing of, 54, 202; and cook-

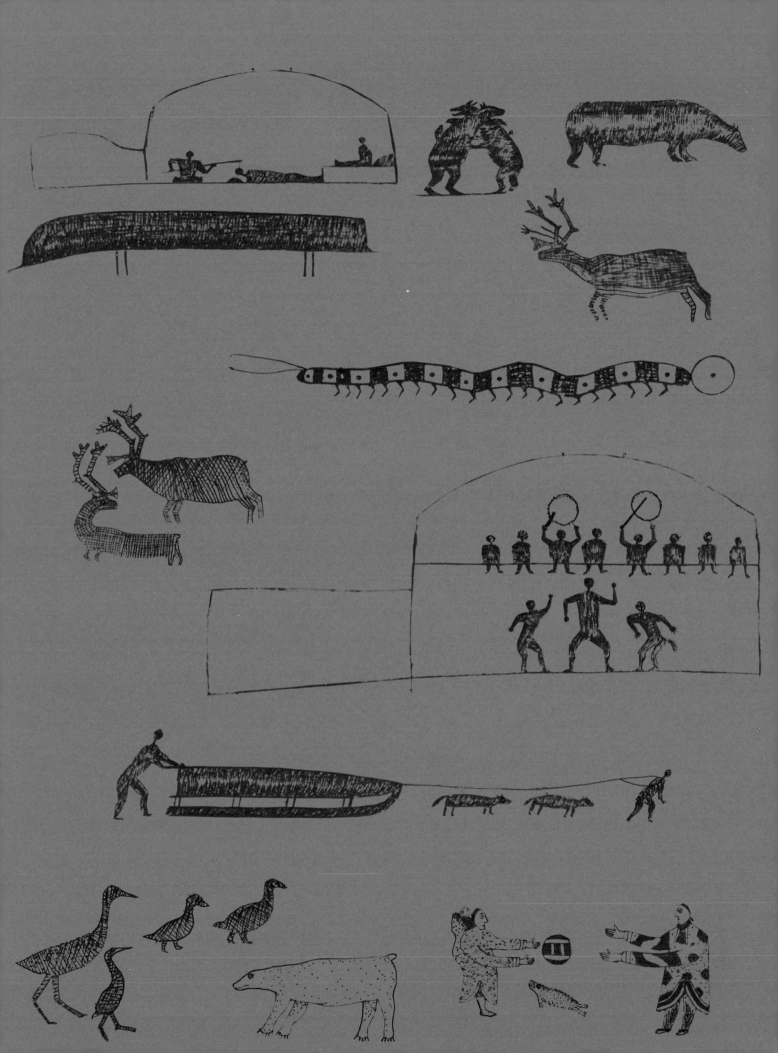